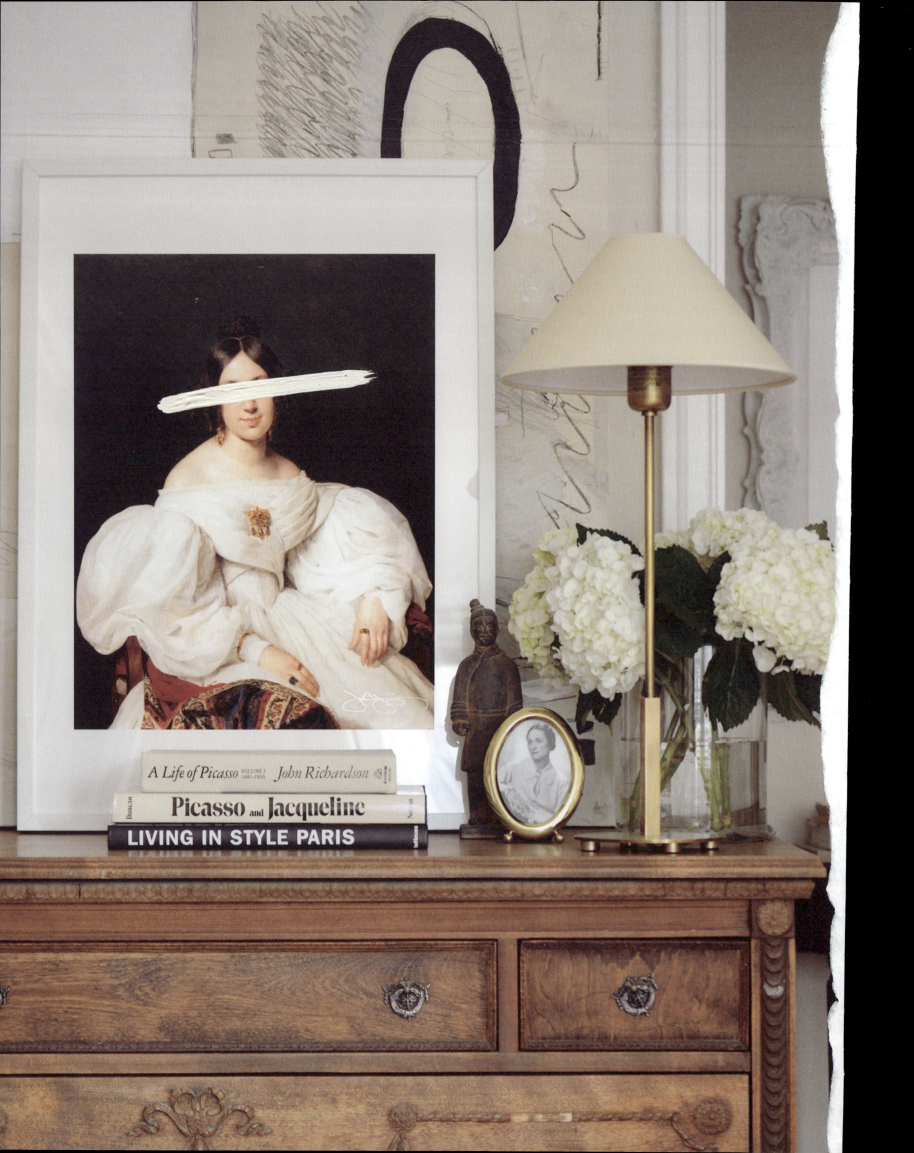

ARTFUL HOME

JOSH YOUNG

ARTFUL HOME

PHOTOGRAPHY BY
KIRSTEN FRANCIS

RIZZOLI
NEW YORK
New York Paris London Milan

To Ignacio. For always seeing
and believing in me.

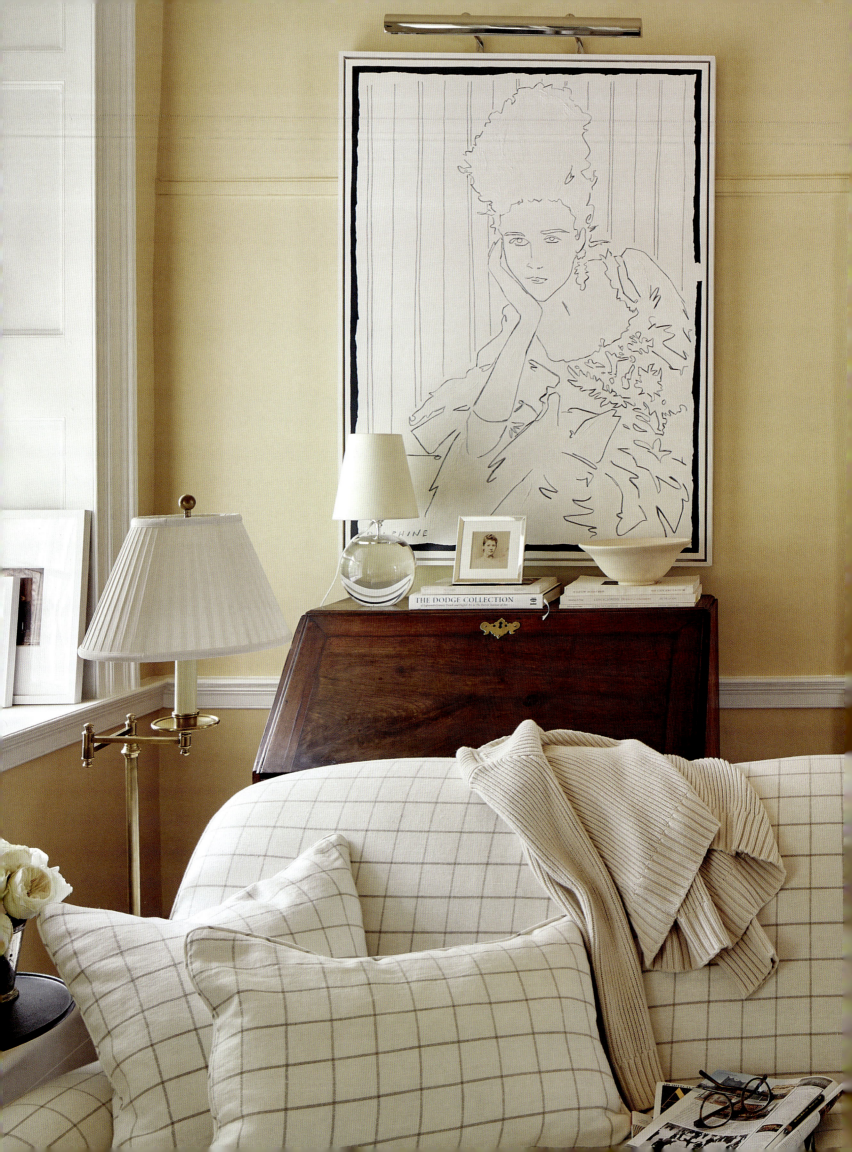

TABLE OF CONTENTS

INTRODUCTION 8

PALETTE 14
TEXTURE 64
FORM 122
LAYERS 162
NOSTALGIA 210

ACKNOWLEDGMENTS 254

CREDITS 256

INTRODUCTION

I've been creating all my life. Even as a child, I was painting, drawing, decorating, and expressing myself in an artistic way. Finding one's calling can sometimes take a lifetime, but not for me. I've always been an artist.

Surrounded by a family of athletes, I stood out and felt different. At a very young age, while most of my peers were interested in the latest video game or action figure, I was checking out books on Braque and Monet from the local library. I remember when I was twelve I asked my parents only for art supplies for Christmas. Nothing else.

I loved to curate environments in my childhood bedroom that felt like an escape, an experience. When I was nine, I fell in love with Paris and all thing Parisian. I painted and cut out an Eiffel Tower taller than I was for my closet door. French flags adorned the windows, and my recreations of the works of Cézanne and Gauguin on construction paper filled the walls. It was my own take on the Louvre. At Christmastime, from the age of seven, I would turn my bedroom into a little village. Paper wreaths were looped through red yarn and taped from one corner to another. A four-foot tree sat in the middle of the room, and vintage and handmade ornaments filled its branches. I still have and use them to this day. All the lights had dimmers to help set a cozy mood, and Christmas carols would play on my boombox when you walked in.

When I was nineteen years old, I got on a plane to Milan. It was my first time leaving the East Coast of the United States and I could barely form a sentence in Italian. I was fearless and hungry for change. After I had come out to family and friends, there was something appealing about going to a place where no one knew me. A place where I could, for the very first time, introduce myself in an authentic, unapologetic way.

It was 2009. I was chasing an Italian boy and simultaneously fulfilling a childhood dream of living in Europe. What was supposed to be just a youthful summer of fun turned into a

nearly six-year chapter abroad. I enrolled as a full-time student at the Università Cattolica del Sacro Cuore and began working numerous odd jobs to support myself. Living and working in the design capital taught me so much. A city of juxtaposition, where history and modernity collide, Milan is the place where I came of age and in many ways the place that cemented and refined my artistic point of view. Being surrounded by countless other creatives and artists in the city showed me that my creativity and artistry could not only be appreciated, but that they also could become a career. Amongst many other wonderful things, Milan is also where I met my amazing husband, Ignacio.

After graduation I took a job in New York as a textile designer, a short-lived career and move that taught me very quickly that the only creative vision I could ever truly follow and be satisfied with was my own. Numerous other corporate jobs followed, as did many firings and an overall sense of unhappiness. For the first time in my life, I was having an identity crisis. In 2017, Ignacio and I moved to Chicago, a city that would change the trajectory of my career and life.

We moved to the Windy City for Ignacio's job, and I was able to do a transfer with the PR and marketing agency I was working for at the time. After we had lived there for only two weeks, I was laid off. Unpacked boxes were still scattered throughout the apartment. Panic ensued, as we had moved based on having both of our jobs and the dual income. It was an incredibly stressful time, but as is so often the case, I had to hit a low to make a change.

One night, after having gone on several unsuccessful job interviews, I retreated in frustration to my bedroom to paint something for our new apartment. Ignacio entered the room and could sense my overall stress and anxiety. "Why don't you do this? Full time." I didn't even register his meaning in the moment. "People love your work and you've always identified as an artist. Even when I met you. Why don't you sell your pieces and start your own studio?" There was nothing outrageous or even brilliant about his idea or concept. I had, in fact, always wanted to have my own studio and to be a full-time fine artist. A dream really. But there was something about the way he said it, and when he said it, so that everything finally clicked for me. Again, I thought back to my days in Milan and realized I could make an actual career out of my work. Why not?

The rest is a blur of history. Just a few months after I launched Josh Young Design House, my studio took off. Thanks in large part to social media, my artwork began to gain popularity. Customers from all over the world were purchasing my work, and collections I released would sell out in a matter of minutes. Notable interior designers and celebrities were reaching out for commissions, and it felt like every day more and more opportunities were presented to me. I quickly had to move from working at the dining room table of our 1,000-square-foot apartment to renting my own studio space just eleven floors above. I had not only found my calling—I was living it.

In July of 2020, in the middle of the pandemic, I decided it was time to move back to the East Coast to be near family and friends. It was a dream of mine to own a historic townhouse, and Ignacio and I eventually settled on one in Washington, D.C. Furthermore, it was a dream to own a place that could accommodate my art studio and living space. Where both worlds could coexist. We acquired our country property, Sycamore House, shortly afterward. Built in 1780 and located in Virginia's beautiful Hunt Country, the home is a respite for Ignacio and me, and a laboratory for me to play with my take on the country home aesthetic.

To know me is to know that in many ways, I'm still that little boy who grew up in a small Pennsylvania town. My taste and interests have certainly evolved, but certain aspects remain unchanged. Toward the end of photographing this book and discussing my life and work in depth with my photographer, Kirsten, she looked at me and said, "Wow. You've *always* had this point of view, haven't you?" An accurate observation.

My artwork, our homes, and the designs I create are all interconnected. Whenever I'm approaching a project, I defer to a set of elements that have become a keystone in my overall artistic and creative point of view both in the studio and at home: palette, texture, form, layers, and nostalgia. These elements have been critical to establishing my signature style and form the backbone of the book you are about to read.

This book is a look into my world—both the tangible surroundings and the abstract space that lives in my head. It is a look into my love of art and home, and my own take on what makes an artful home.

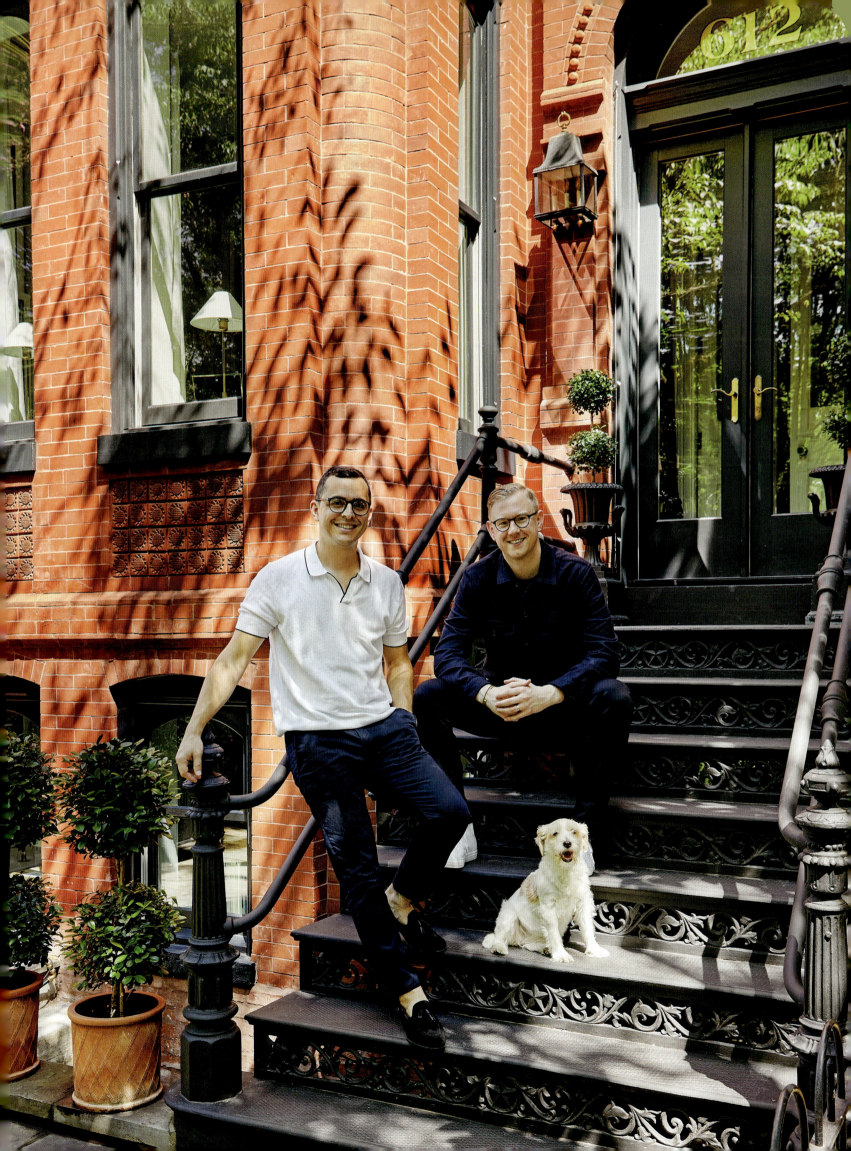

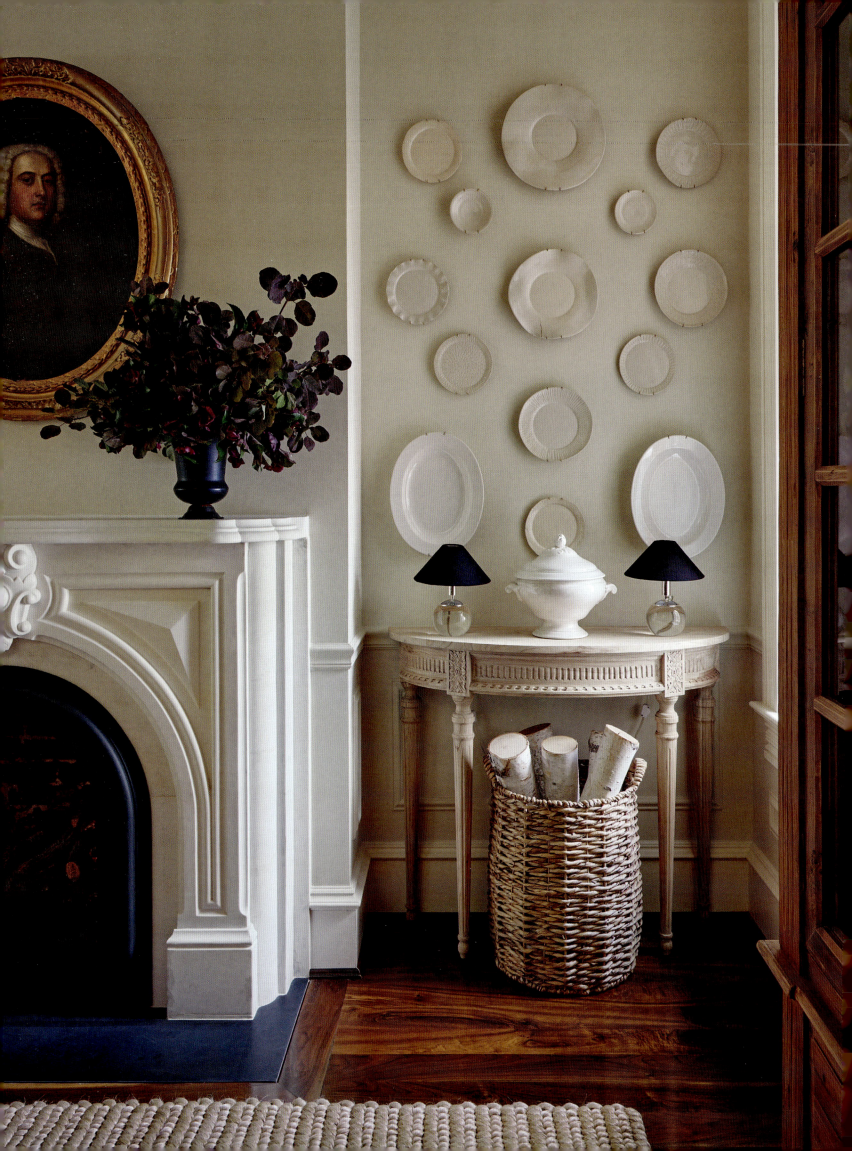

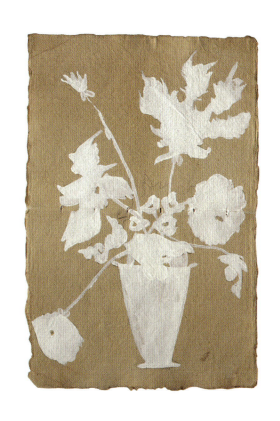

PALETTE

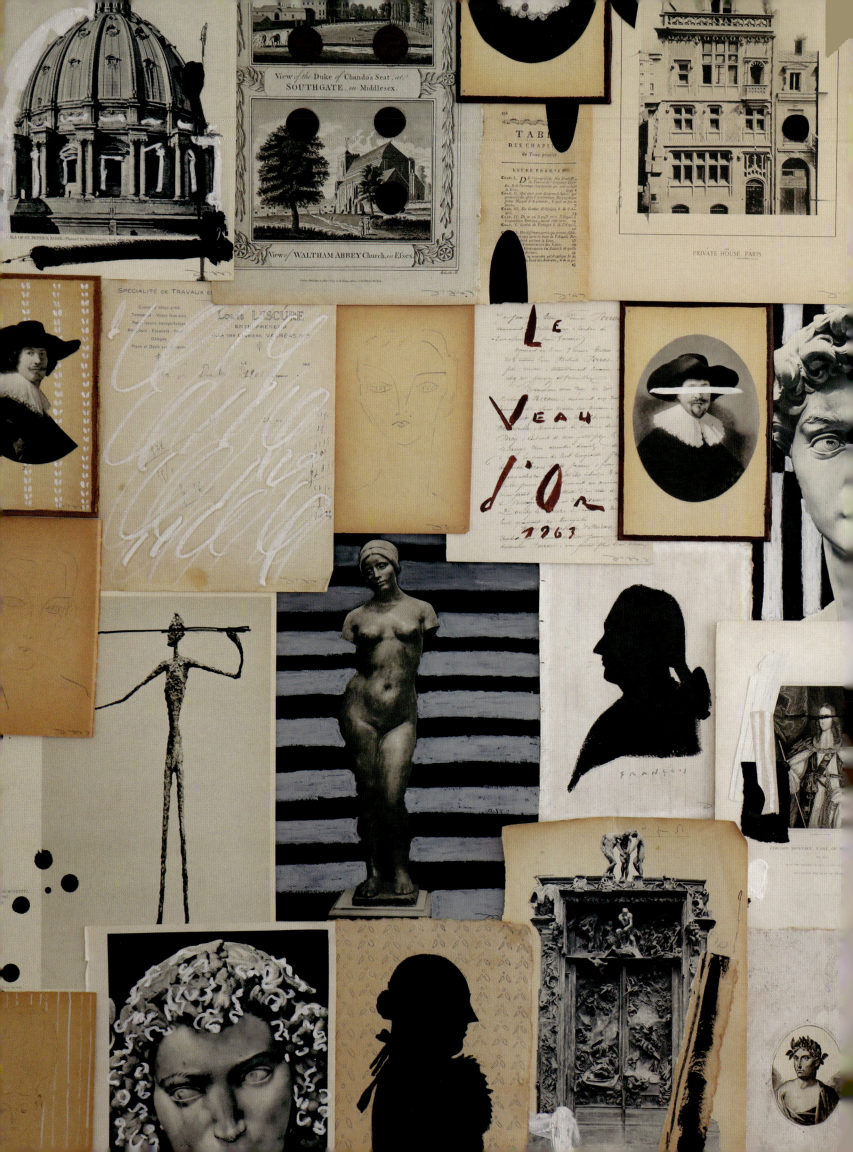

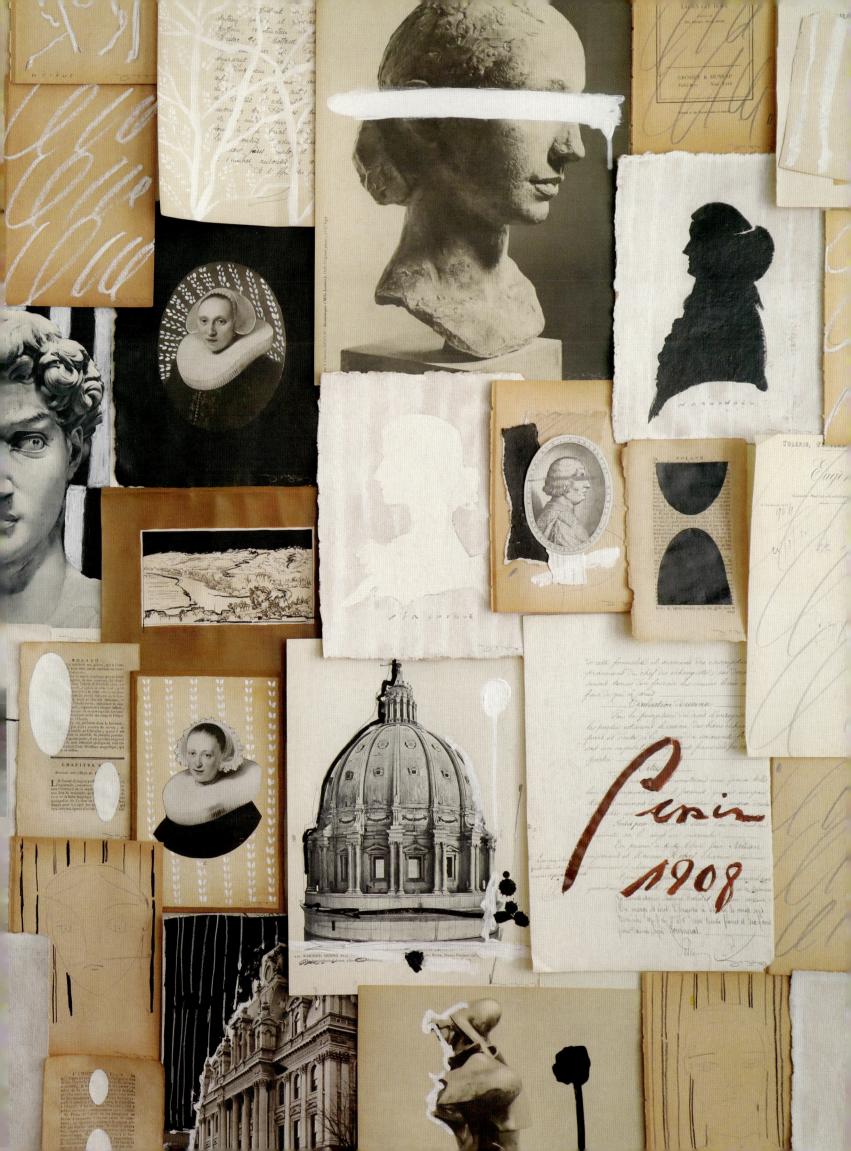

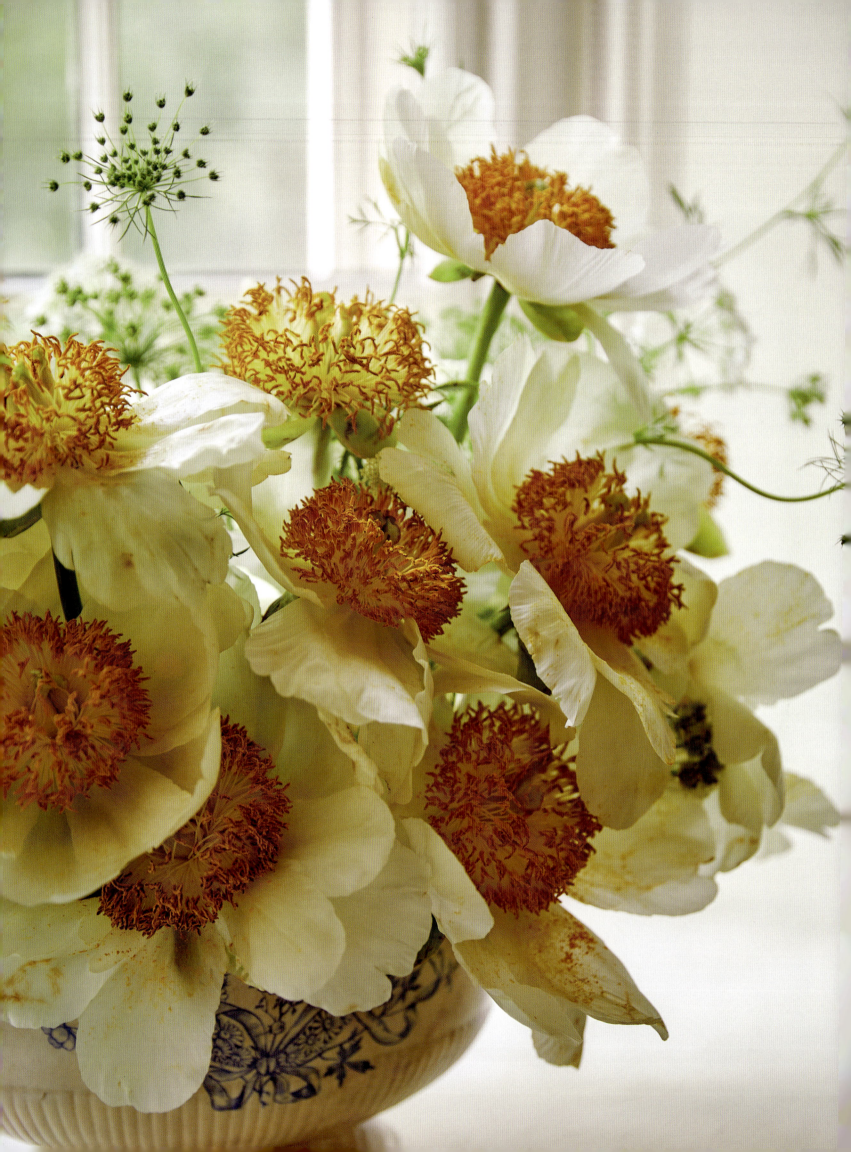

One of my favorite things to do is to lay out a variety of objects and see how their colors work with one another. Observing the way textiles or tubes of paint interact has always intrigued me. Whether I'm in the studio beginning a new painting or sourcing for an upcoming interior project, I begin by establishing the palette. There's a certain magic that occurs when the right combination results in harmony and balance.

Palette matters. Used repeatedly, a set of colors can become a recognizable part of one's design DNA. A specific and intentional palette helps to tell a story and create a mood. In my work, I look to neutrals and a monochromatic, restrained arrangement of color. Regardless of trends, neutrals—off-white, ivory, ecru, tan, and brown—are my go-to. It's a subtle range that feels natural, light, and grounded. These combinations are instinctual to me. Identifying my personal palette was key to establishing my own signature look.

As much as I love neutrals, I don't avoid color. However, I apply the same discipline and restraint to working with color that I do with neutrals. Ever the purist, I love each color to have its own moment—to be appreciated and prominent on its own without competition. For me, adding too much color to a room creates noise and a heightened sense of visual distraction. I can certainly appreciate it, and I love to visit rooms filled with it. But I can't live in it. In my home, I use a single shade in a room, allowing it to take center stage through something as simple as upholstery or paint on the walls. When everything else around the color is kept more subdued, the color acts as a neutral.

OPPOSITE: A grouping of Moonrise peonies arranged in a vintage tureen. The mustard-yellow and golden tones accent the palette of the parlor-floor living room at Sycamore House. **FOLLOWING PAGES:** The parlor-floor living room at Sycamore House features white slipcovered furniture that is simple, allowing the yellow walls take center stage and establish the overall palette.

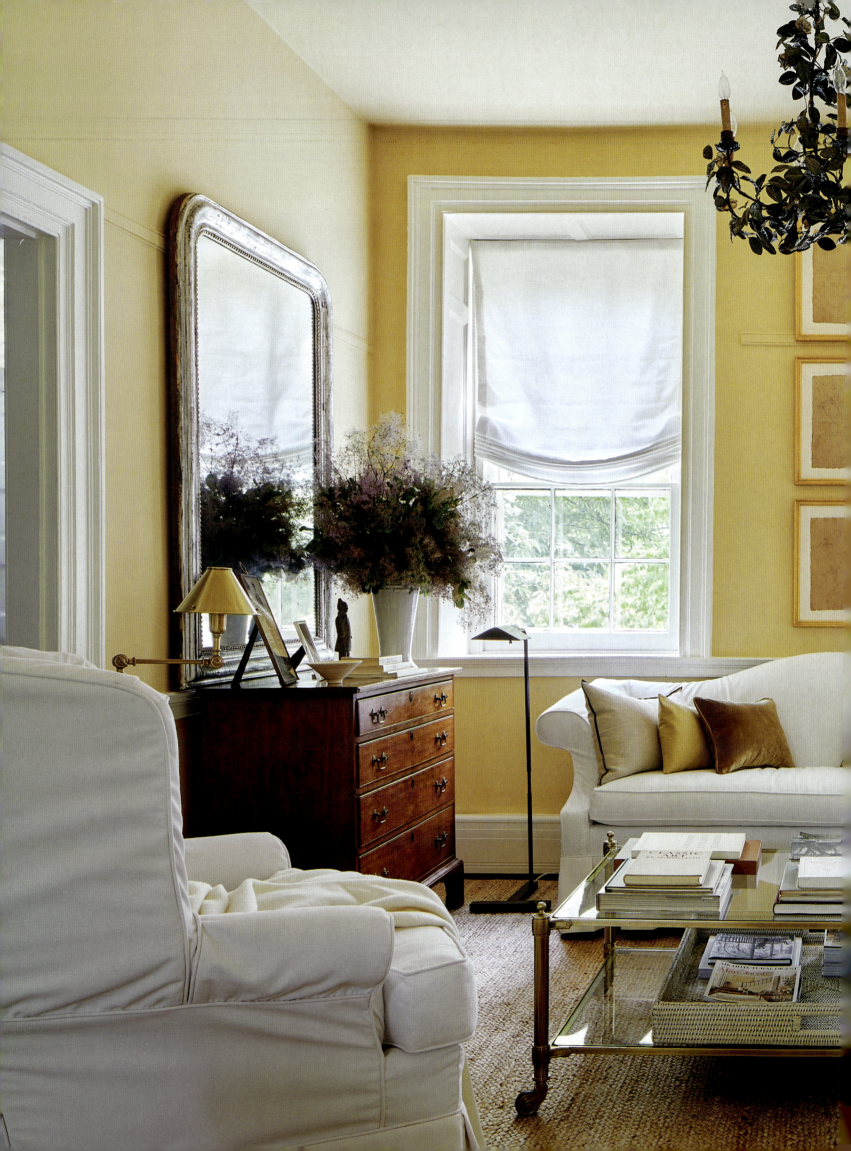

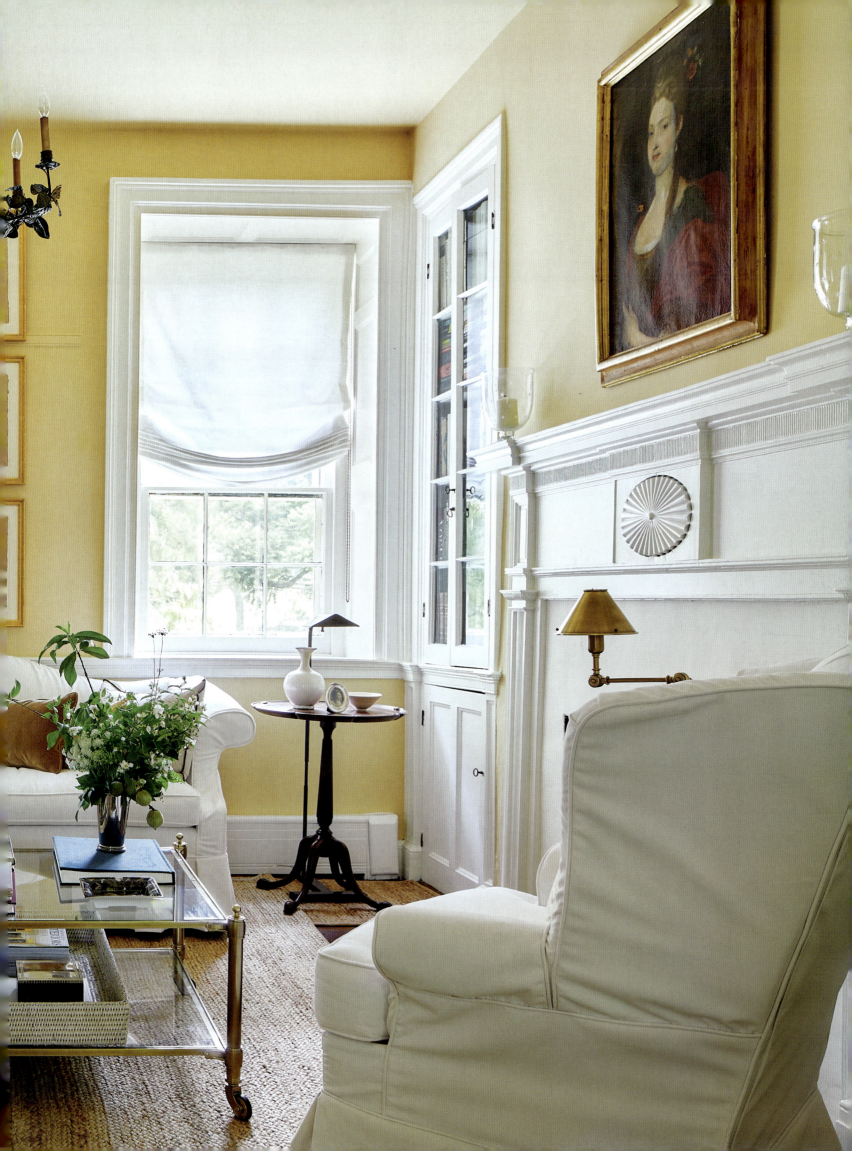

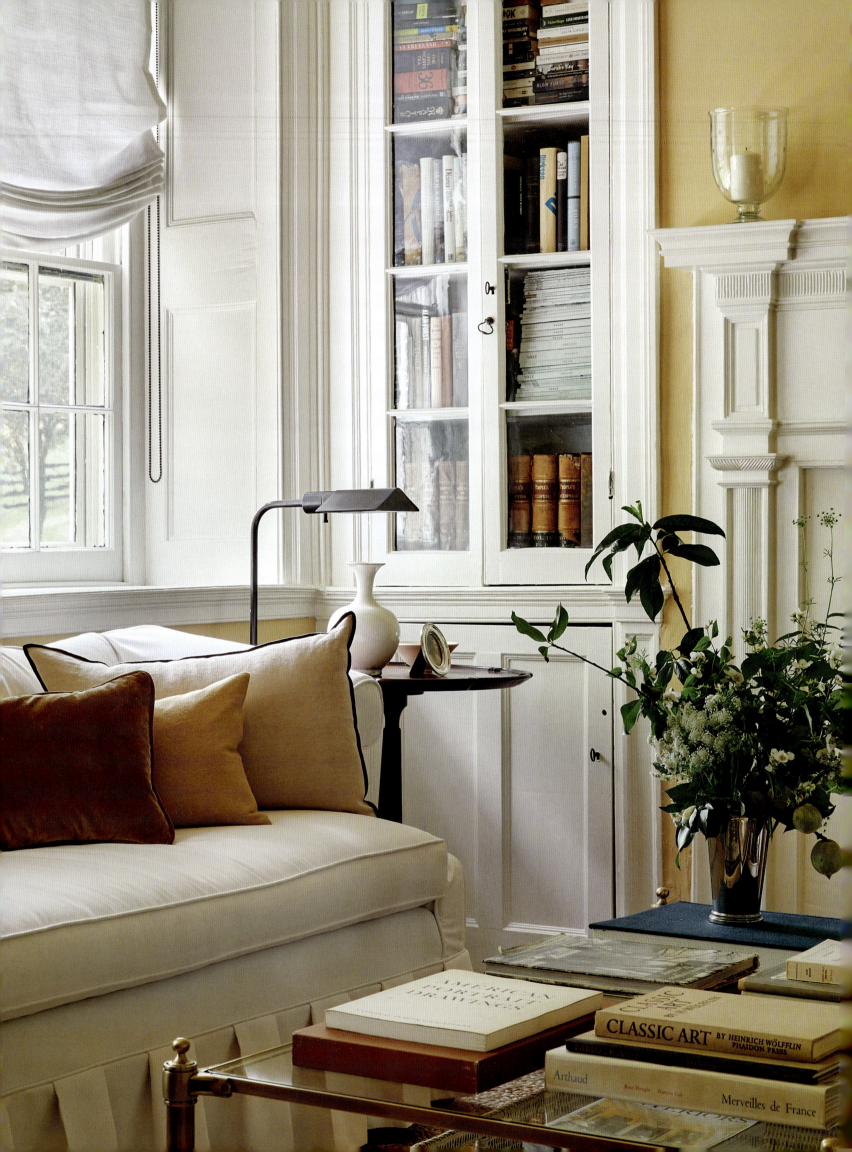

A perfect example of the way I like to work with color is the parlor-floor living room at our country home, Sycamore House. When we first started the design process there, I knew I wanted the palette to reflect the warmth of my feelings for the property and its setting. Along with my usual lineup of neutrals, I wanted to lean into colors I didn't often use in my interiors but that I've always gravitated toward—a variety of warmer tones, including reds and yellows. I wanted to create a cozy and inviting environment, not only for Ignacio and me, but for those we host and entertain.

Yellow in all its various shades and hues has always been special to me. Even as a child, I listed it as my favorite color on elementary school worksheets and dressed head to toe in it. I think there are certain colors we gravitate toward and love for no rhyme or reason. Yellow is mine. It's exciting and fresh, but it's also classical and traditional: a perfect juxtaposition of modern and nostalgic when done right. I knew it was the color for the living room at Sycamore House. For the walls I chose a soft, creamy mustard that brings boldness to the space and purposefully dominates the room. It's impactful, yet it feels understated. To keep the room soft while allowing the wall color to be the focal point, I slipcovered much of the furniture in white and cream fabrics for a relaxed, casual look. I turned to warm wood tones and brass accents to complement and accentuate the yellow palette. This has become the room that I spend most of my time in while visiting Sycamore House. Being in this yellow room brings me so much comfort and joy.

OPPOSITE: The accessories, such as the pillows on the sofa and various books on the coffee table, create a cohesive color palette, as all relate back to the warm yellow walls of the room.

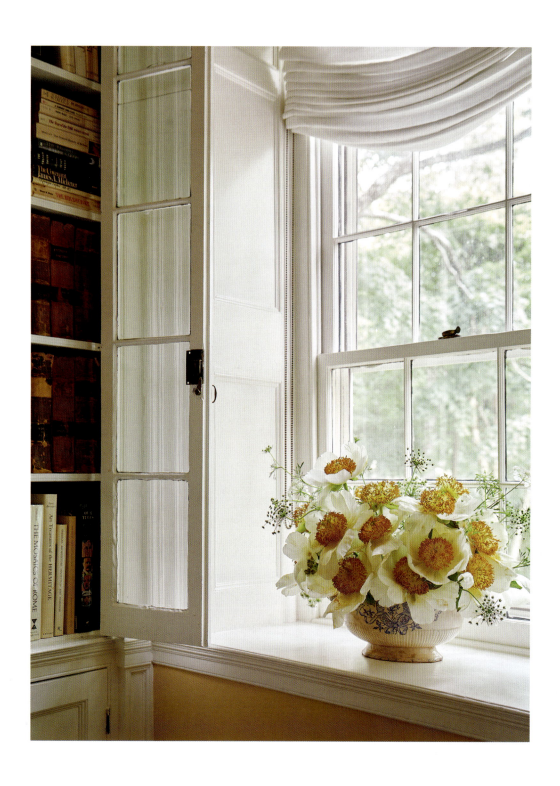

ABOVE: Two of my favorite details at Sycamore House: the large, deep windowsills and wavy glass.
OPPOSITE: An eighteenth-century portrait of Diana the Huntress hangs above one of Sycamore House's five original woodburning fireplaces and greets all who enter the living room.

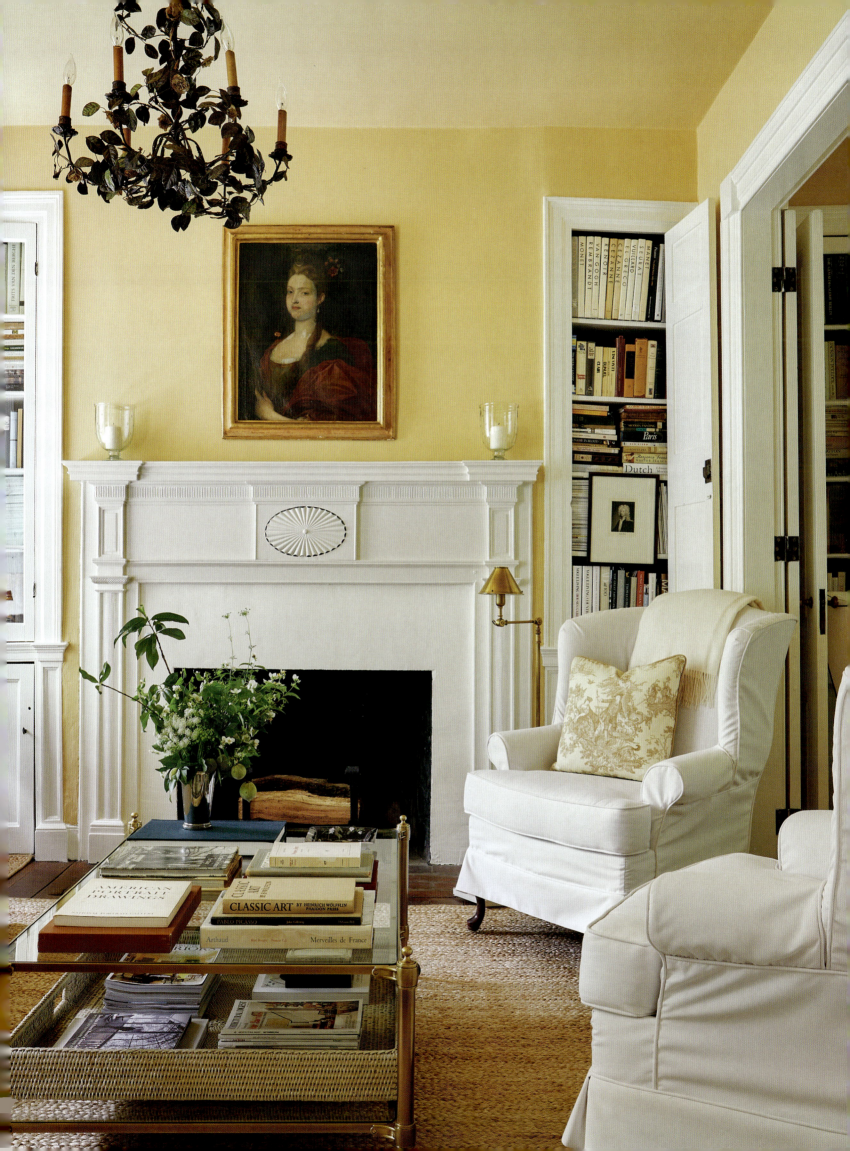

Nothing is more noticeable and intentional in design than a well-executed palette. So much of my initial approach with interiors relies on establishing a foundational palette. Being consistent with it, but not afraid to expand on it, is key. Colors can be inspired by our past, influenced by our setting, or chosen because they spark a certain feeling and emotion. Identifying our signature colors and understanding their origins makes them truly ours.

Merriam-Webster defines a palette as "a particular range, quality, or use of color." As an artist, I find a specific combination of colors used in a room or in a painting can heavily influence my overall mood. Therefore, I'm intentional when deciding on a palette to feature. Does it calm me? Discourage me? How do the various colors interact within their array and placement in a painting or in a room? Are they harmonious? Is there tension? Do the colors clash? Were they meant to clash?

A pared down, neutral palette can be the ultimate elimination of noise and distraction. Similarly, neutral interiors instantly shift the focus to form and composition. They're the first indicator of a disciplined design plan. Working within a proscribed range of colors demonstrates intent and purpose behind their application and curation. When done right, such spaces can be the definition of raw, understated beauty. But elegant does not have to mean cold: in fact, neutral rooms can be warm and inviting.

OPPOSITE, CLOCKWISE FROM TOP LEFT: A vintage tole leaf and flower chandelier adds patina. A Chippendale sofa features a custom slipcover I designed with a box pleated skirt. Three framed pieces from my *BLOOM* series, done on warm, tea-stained parchment paper, continue the monochromatic palette. Neutral-colored ceramics and a cameo form a vignette.

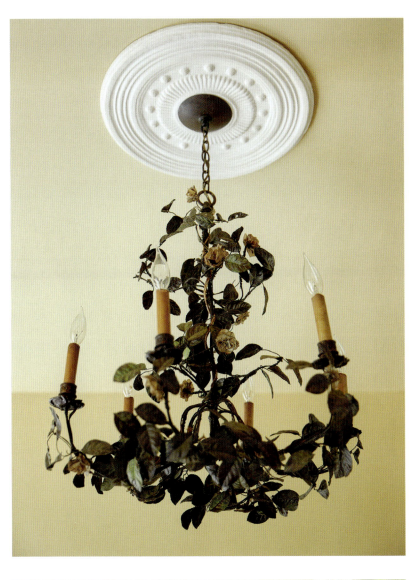
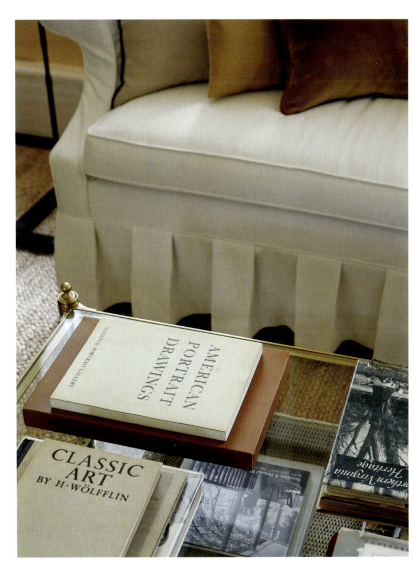
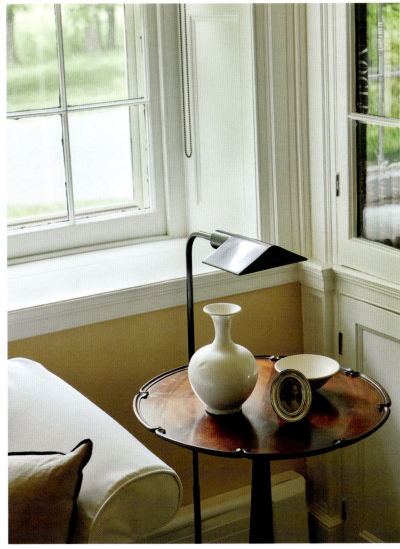
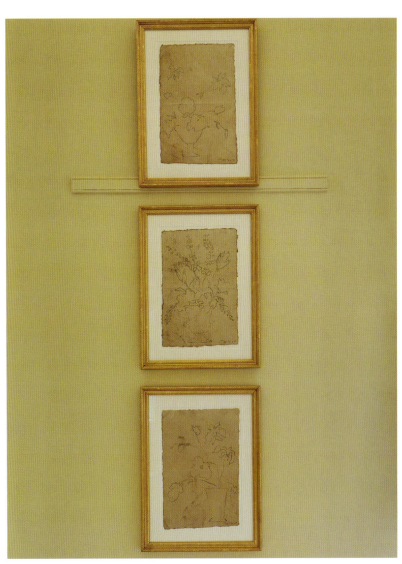

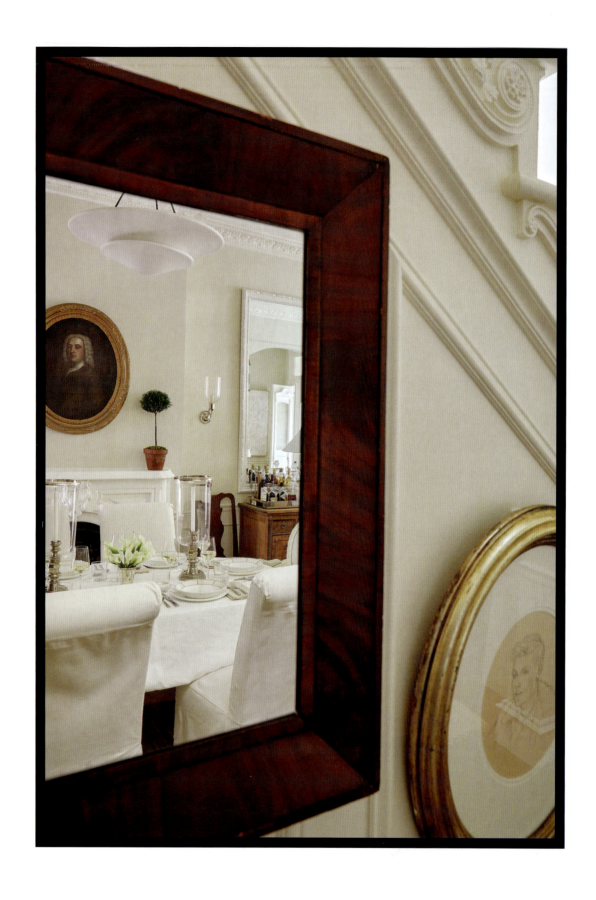

ABOVE: A vintage wooden mirror on the parlor-floor staircase of the townhouse affords a glimpse of the dining room. OPPOSITE: A simple, understated table featuring off-white and ivory table linens is a favorite of mine.

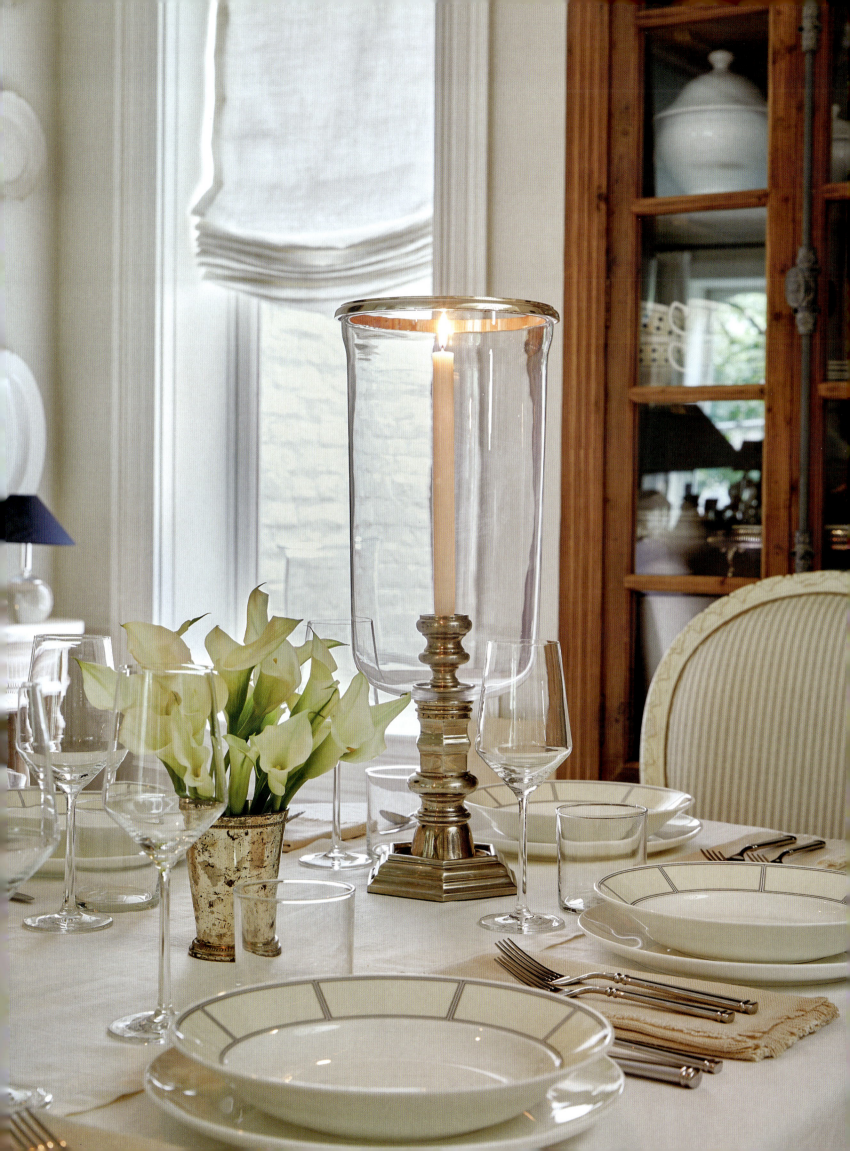

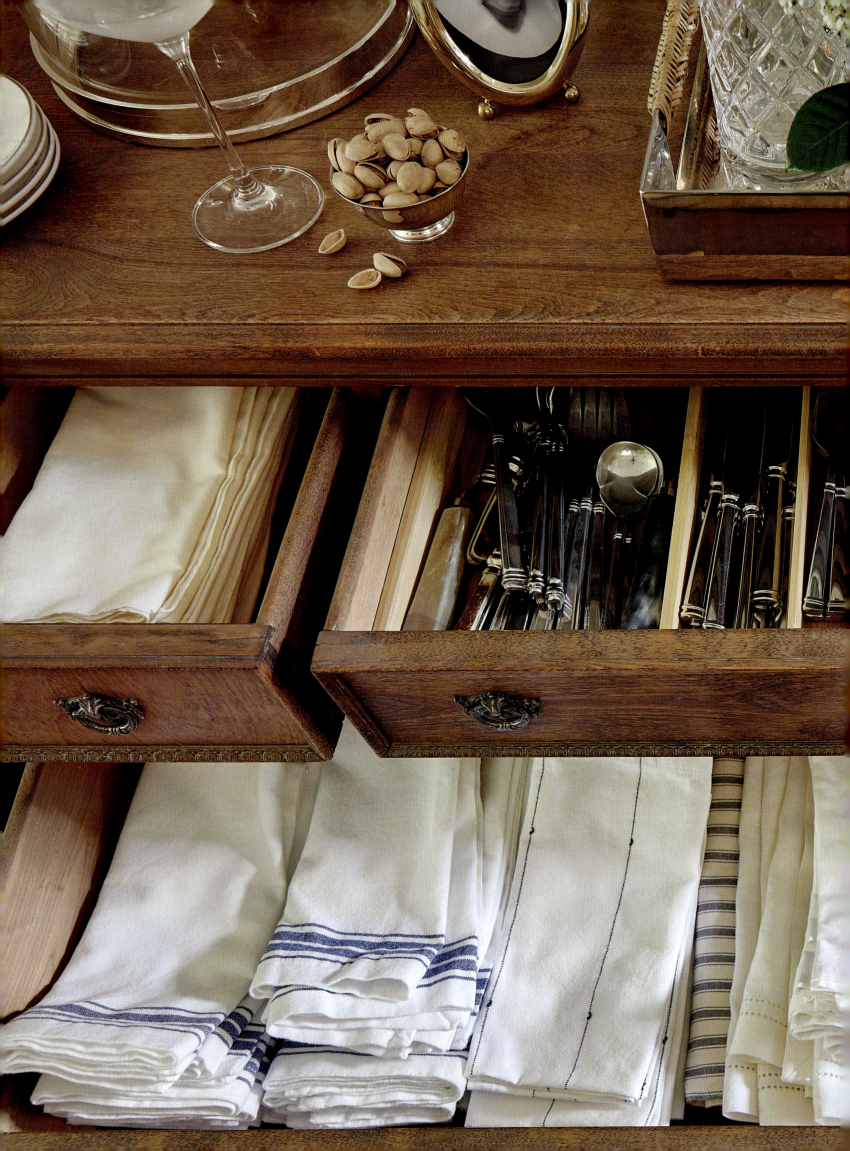

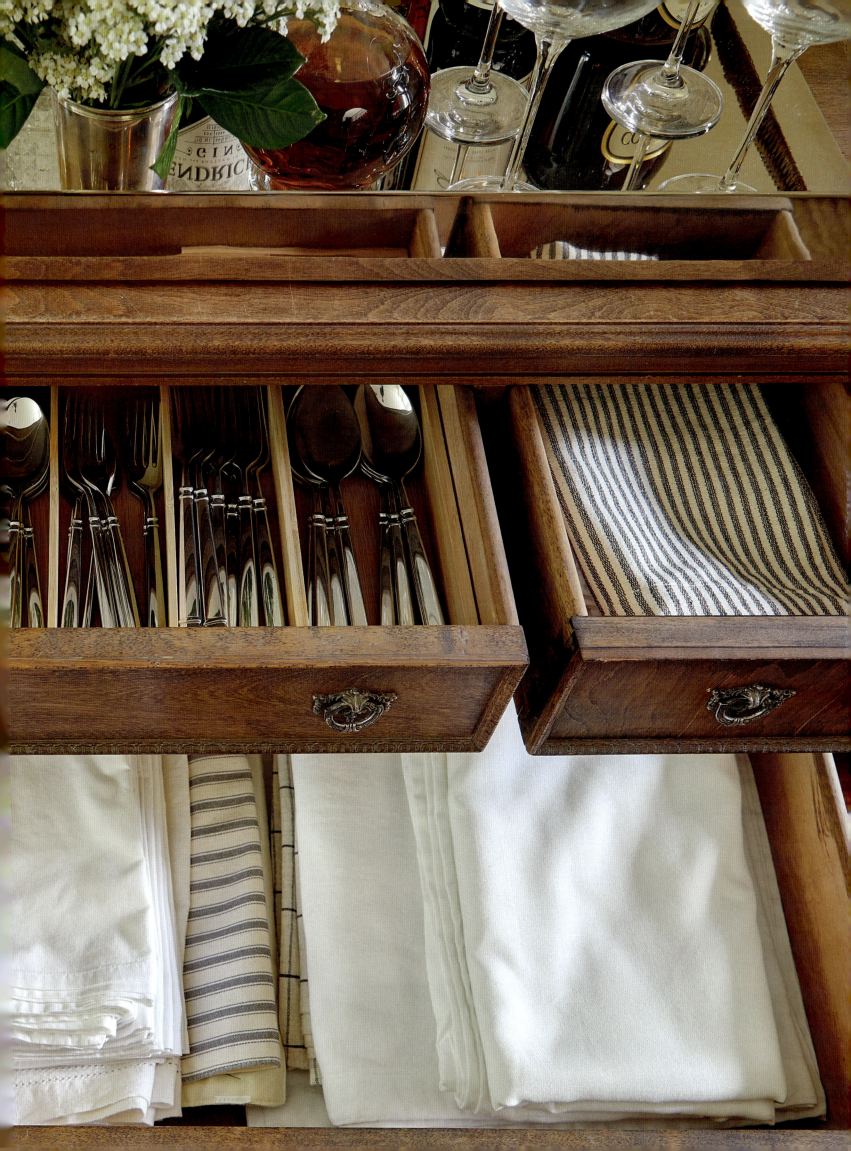

 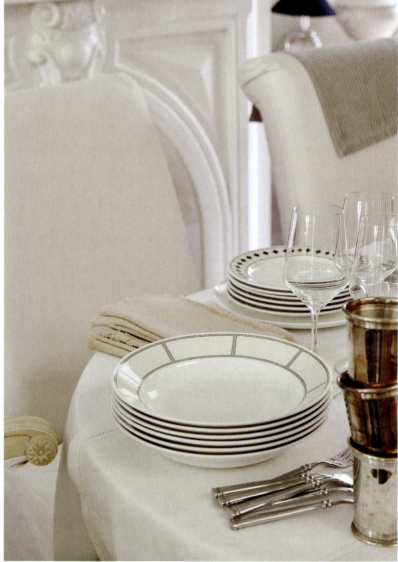

PRECEDING PAGES: We turned a vintage dresser found in Chicago into a buffet for the dining room. The drawers are filled with some of my favorite table linens and silverware. **ABOVE:** I like to lay out various tabletop pieces and linens to get a feel for how they work as a group. **OPPOSITE:** In the dining room at Sycamore House, china cabinet shelves are filled with antique ironstone dishes and platters in different shapes.

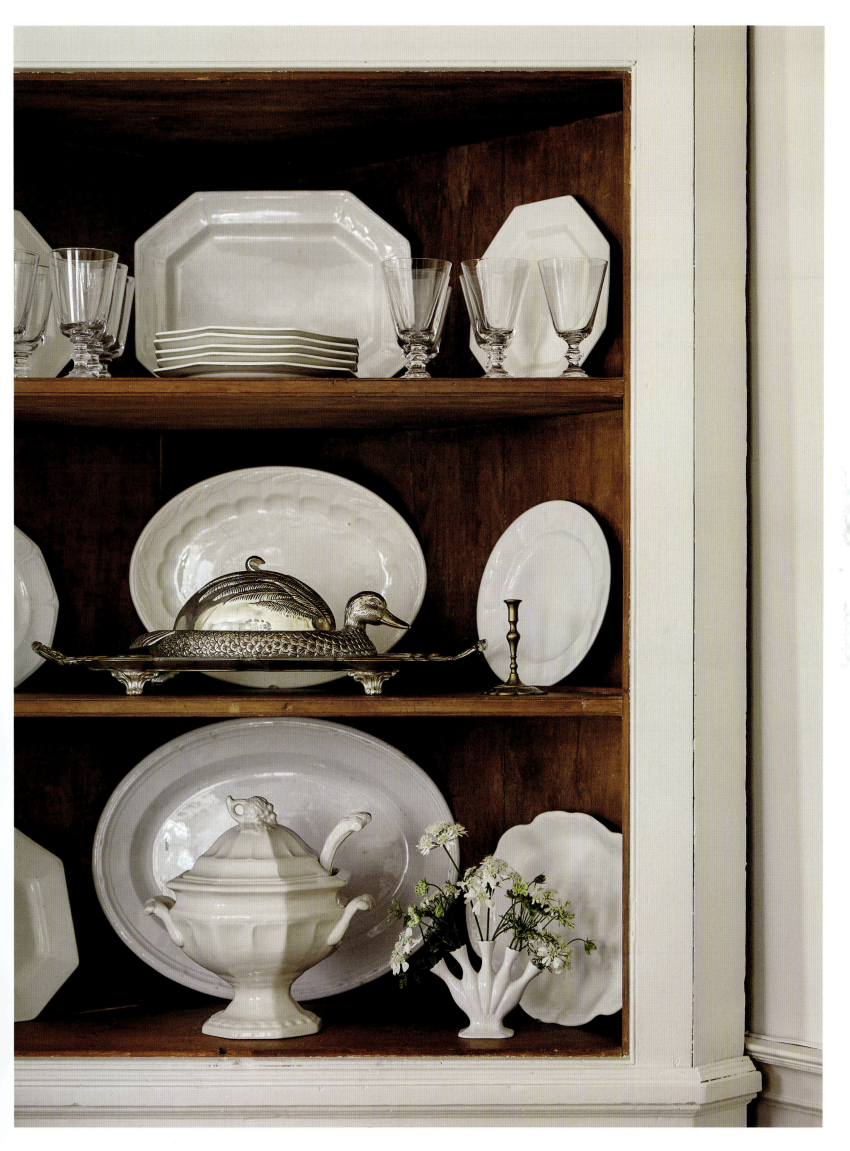

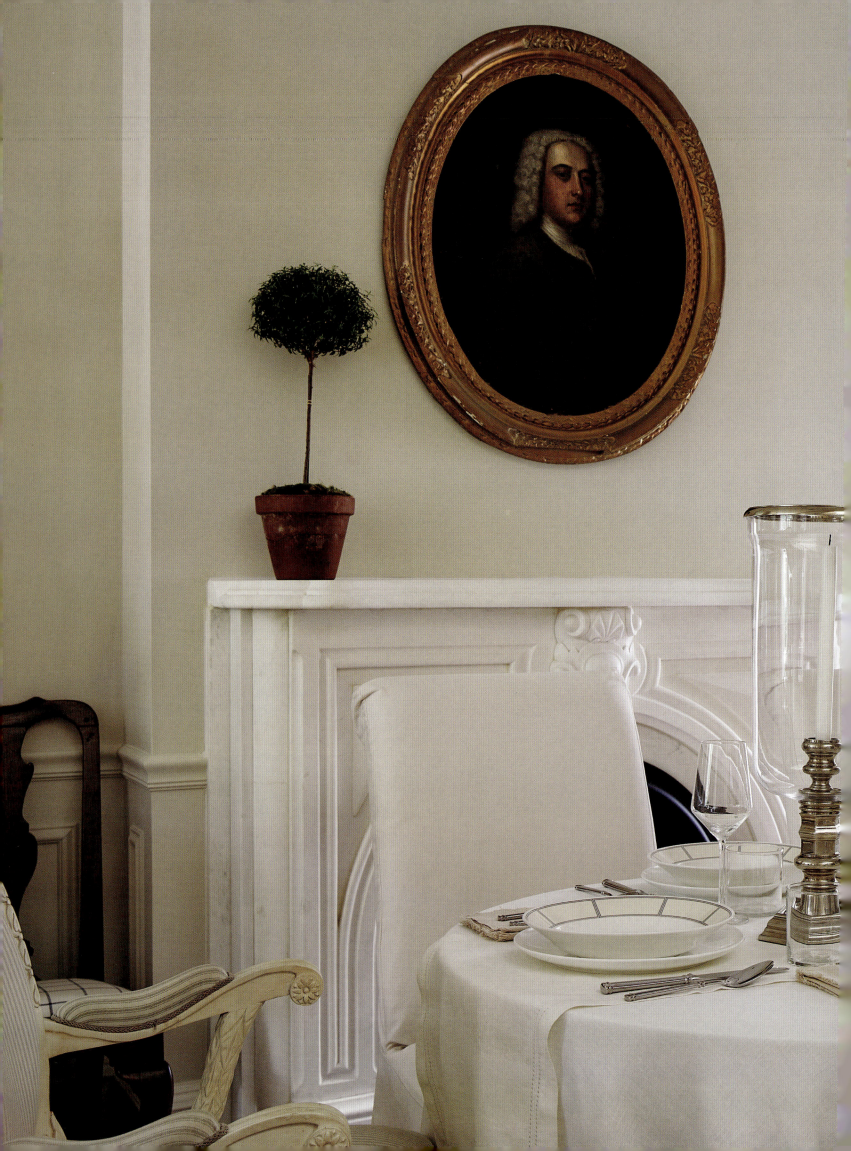

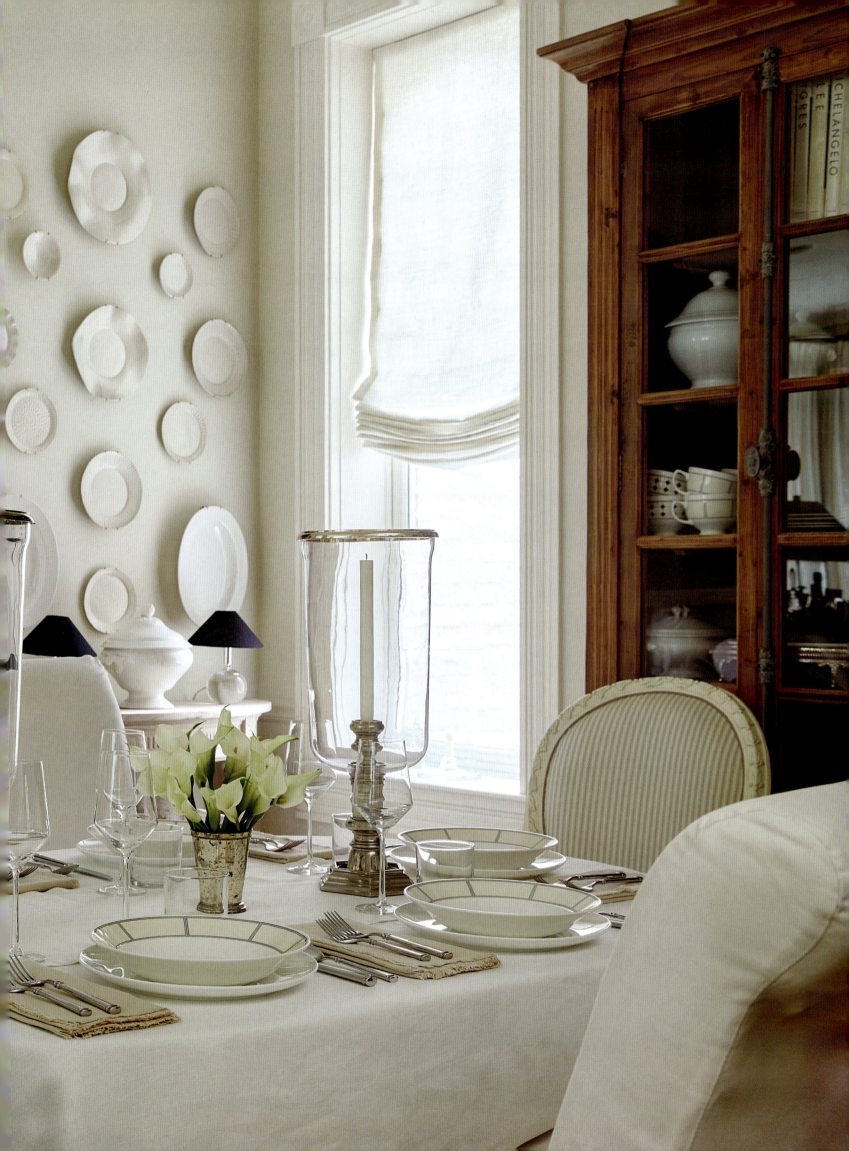

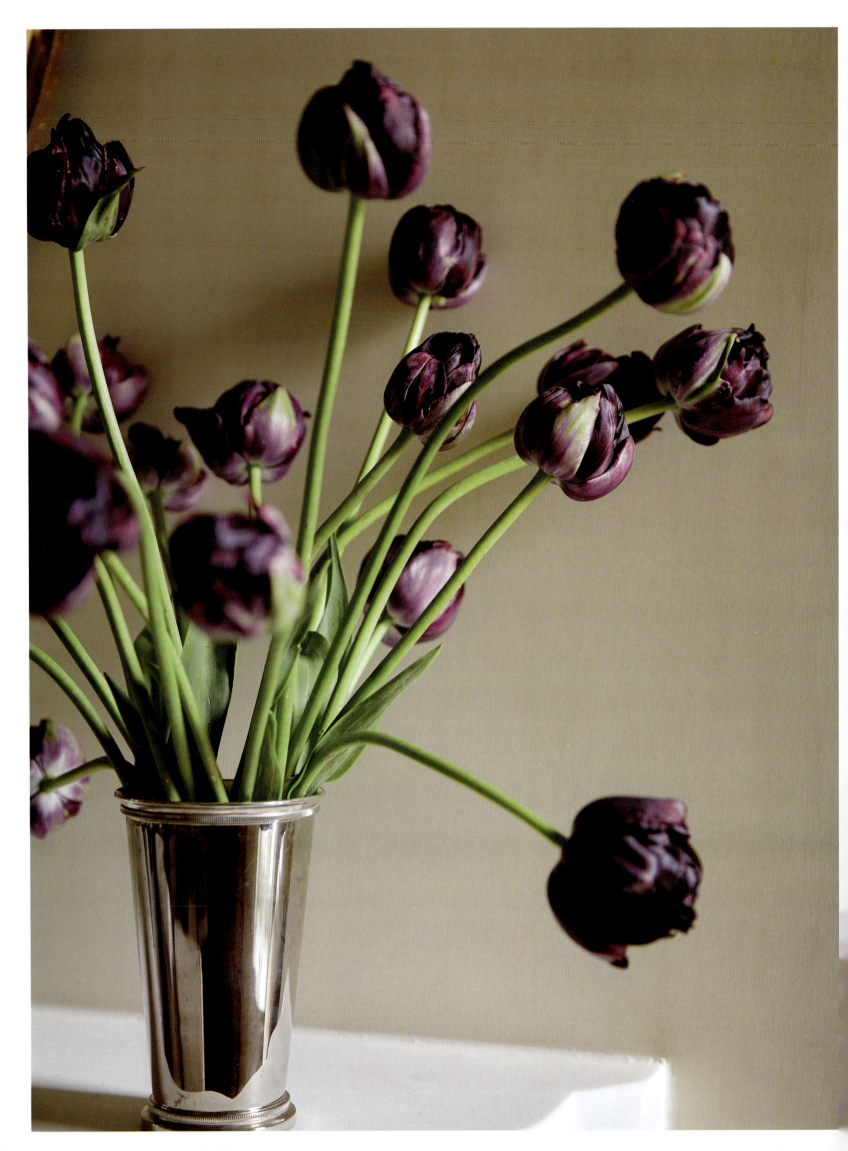

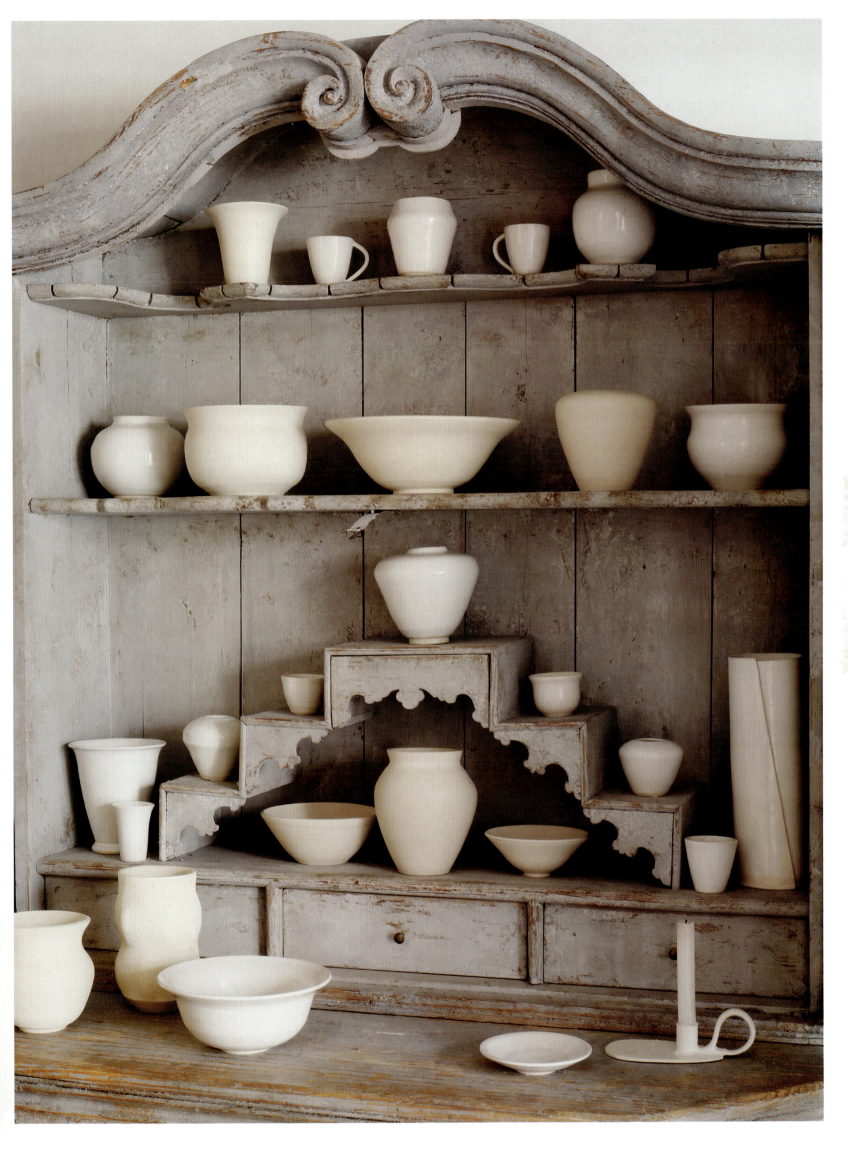

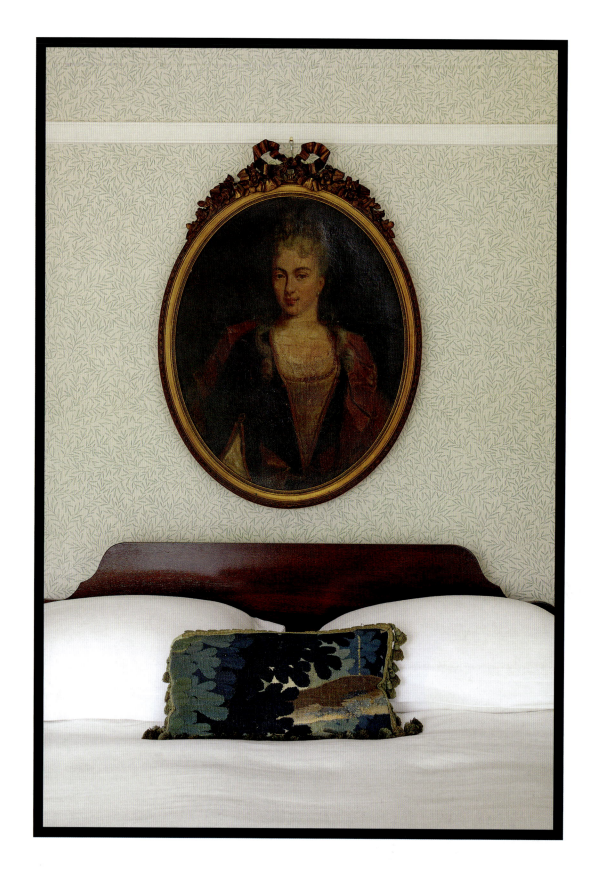

PAGES 34–35: The formal dining room at the townhouse explores many tones of white. PRECEDING PAGES, FROM LEFT: Black Hero French tulips lend a moody aubergine color. An eighteenth-century Swedish Gustavian cabinet stores items from Alfaro Pottery, Ignacio's line of hand-thrown vases and other ceramics. ABOVE: An eighteenth-century portrait overlooks the four-poster bed in one of the guest bedrooms at Sycamore House. A classic, soft green leaf-patterned wallpaper embraces the room.
OPPOSITE: Simple skirted end tables and bedding in white Belgian linen keep the room serene and airy.

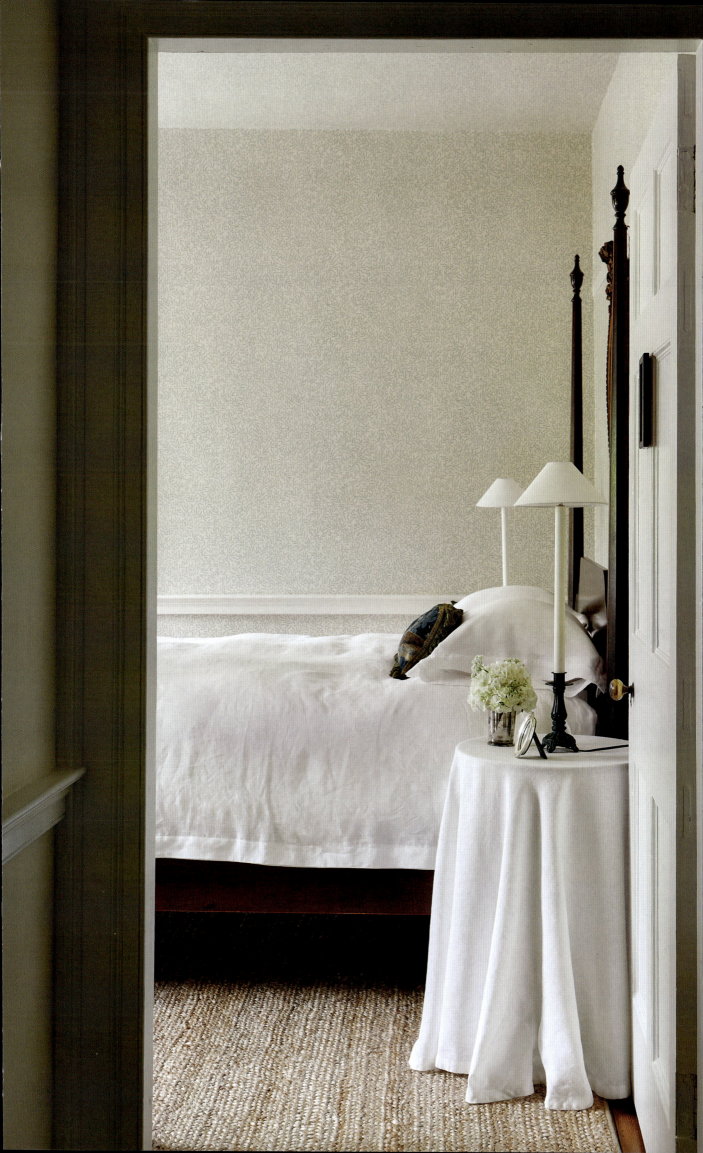

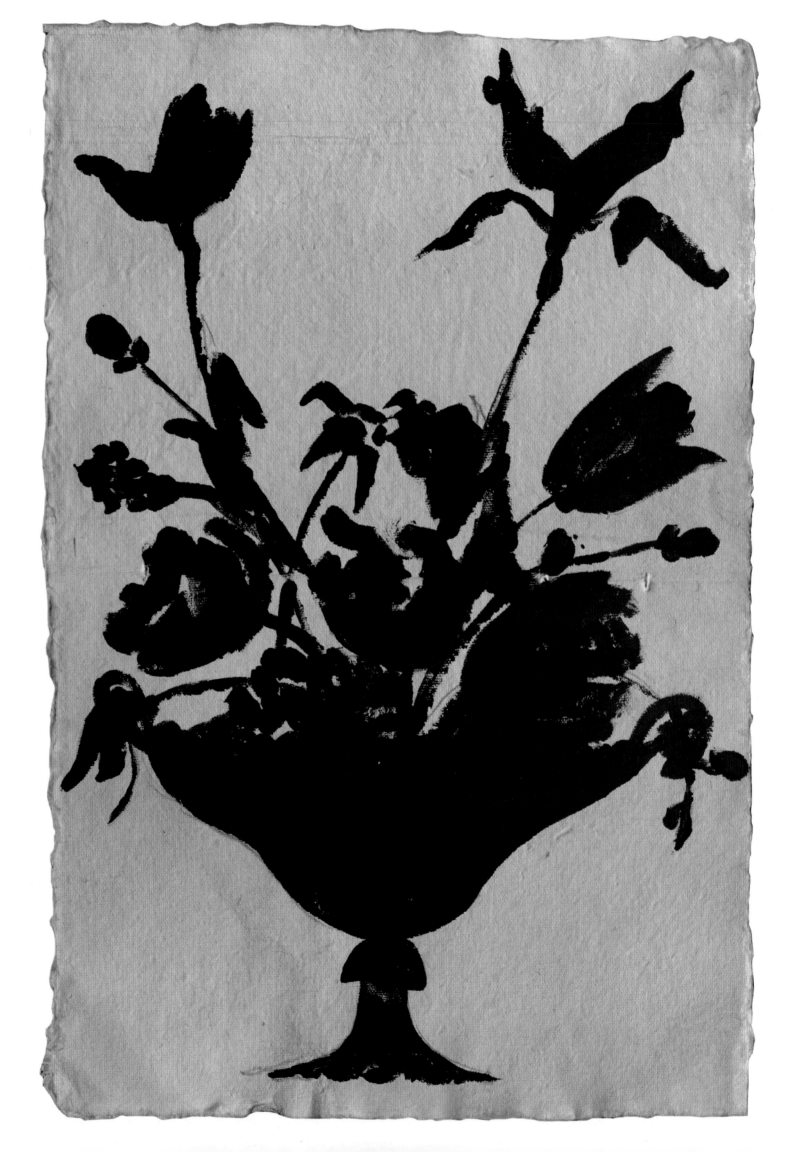

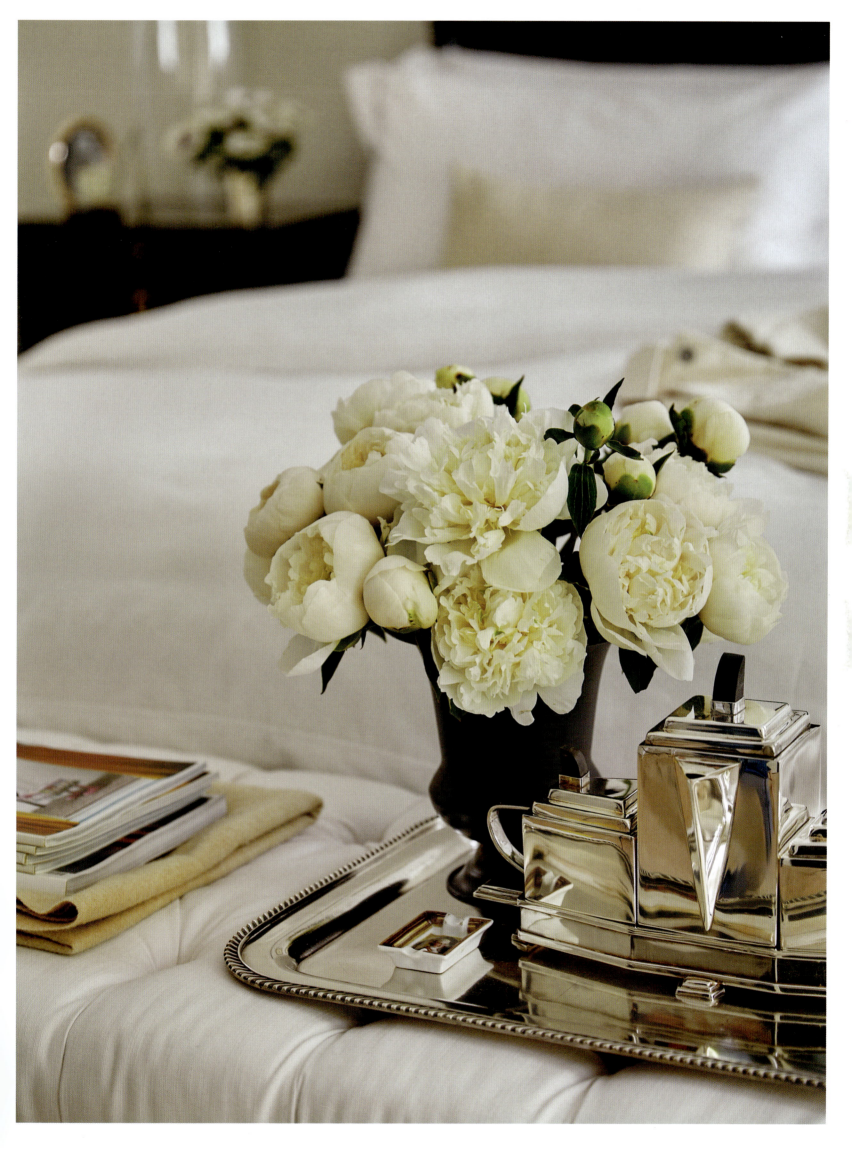

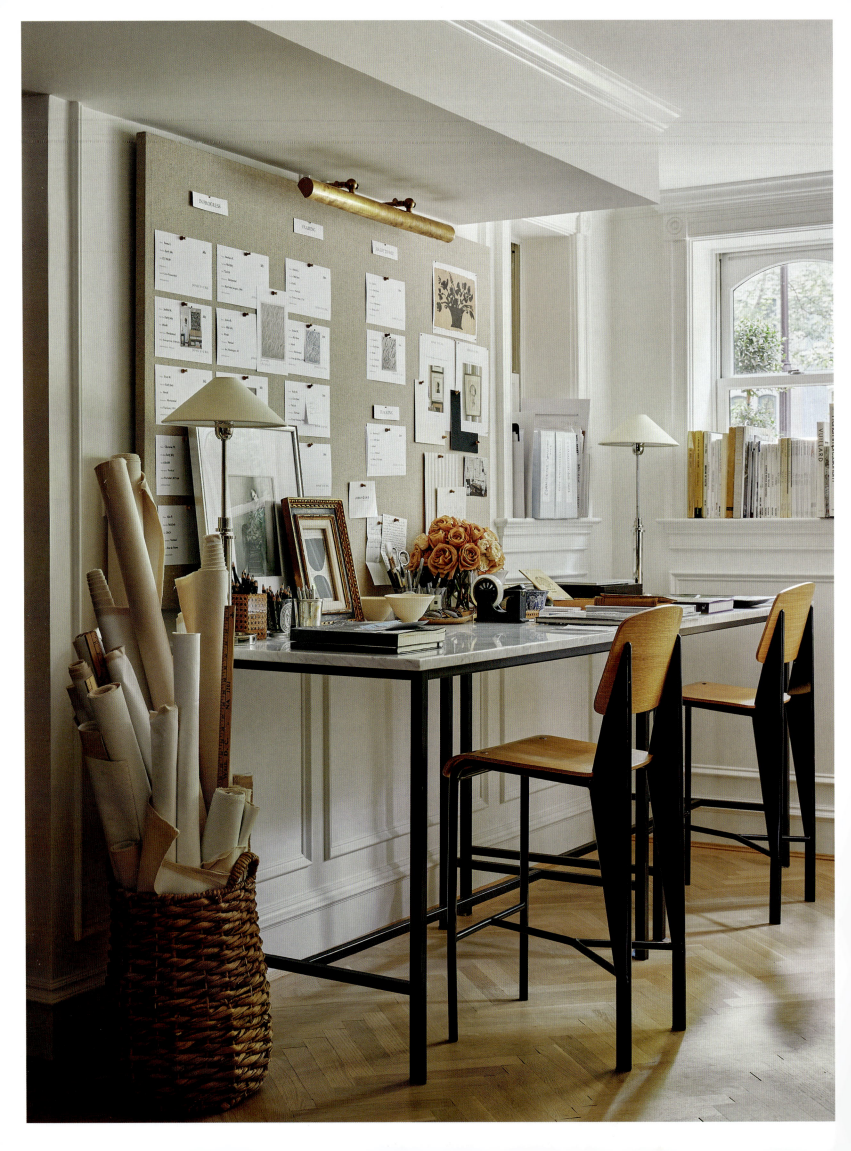

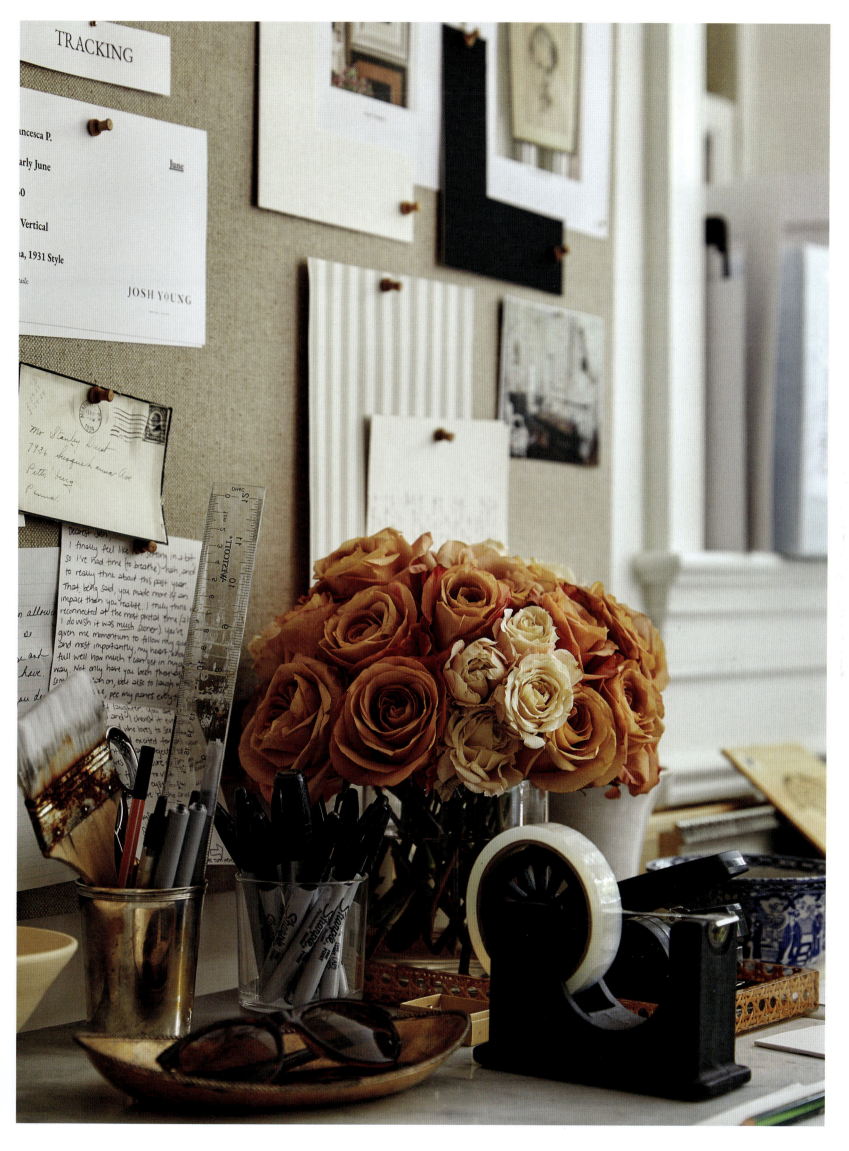

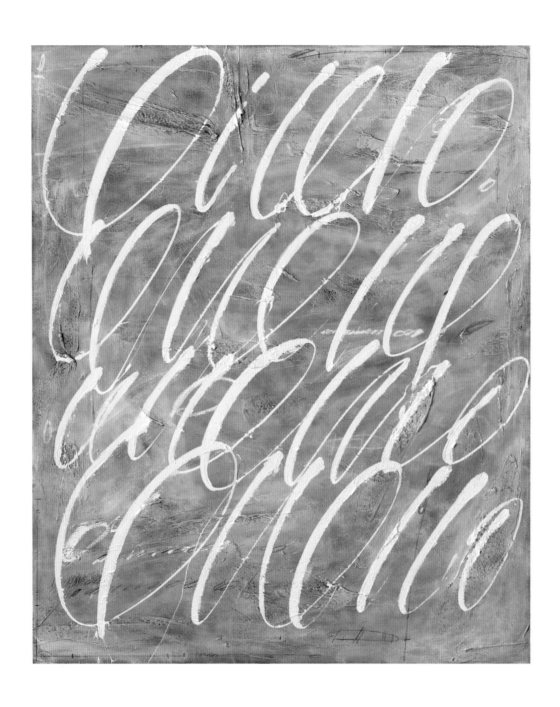

PAGE 40: A piece from my *BLOOM* series, created with oil and graphite on aged, textural, cotton rag paper. **PAGE 41:** A mono-botanical grouping of cream-colored peonies sits on an ottoman in the primary bedroom at the townhouse. **PRECEDING PAGES:** The desk in my D.C. art studio. **ABOVE:** *Marseille*, 1926. Oil, oil pastel, graphite, and plaster on canvas. **OPPOSITE:** The bulletin board in my studio organizes ongoing commissions.

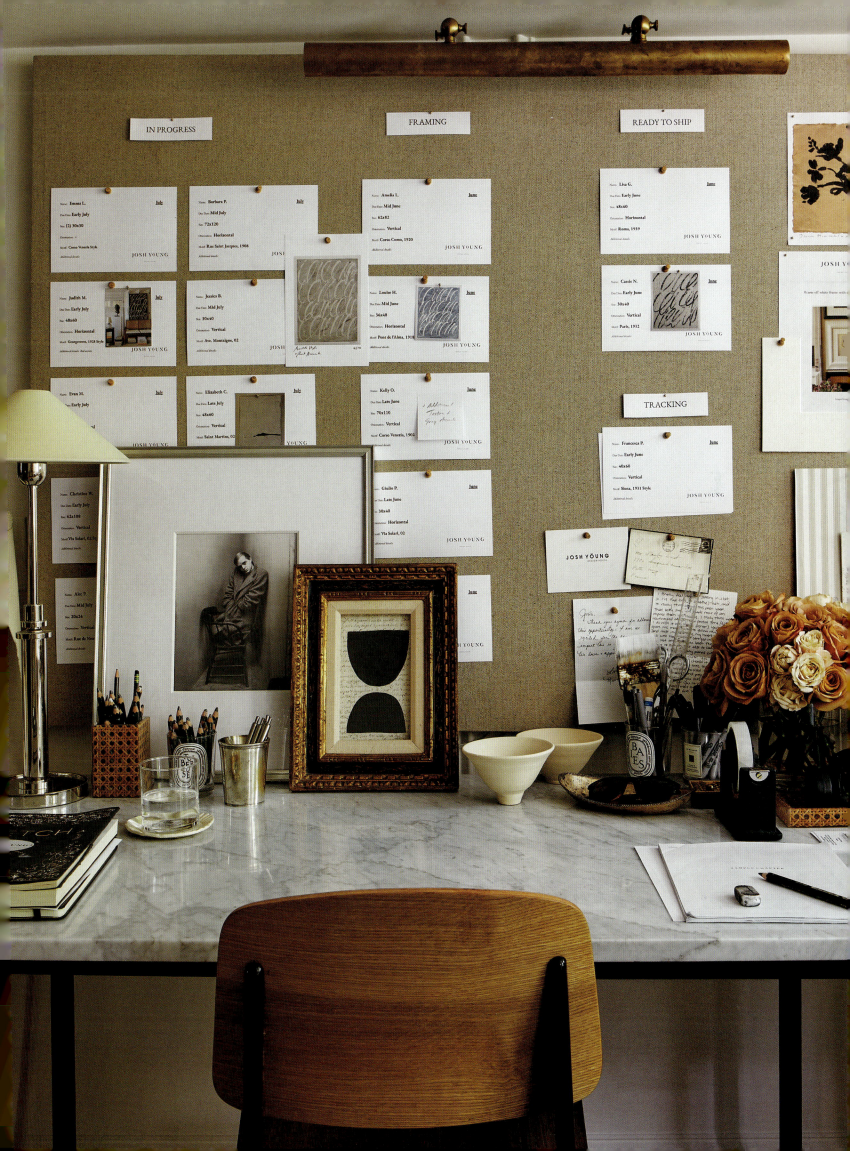

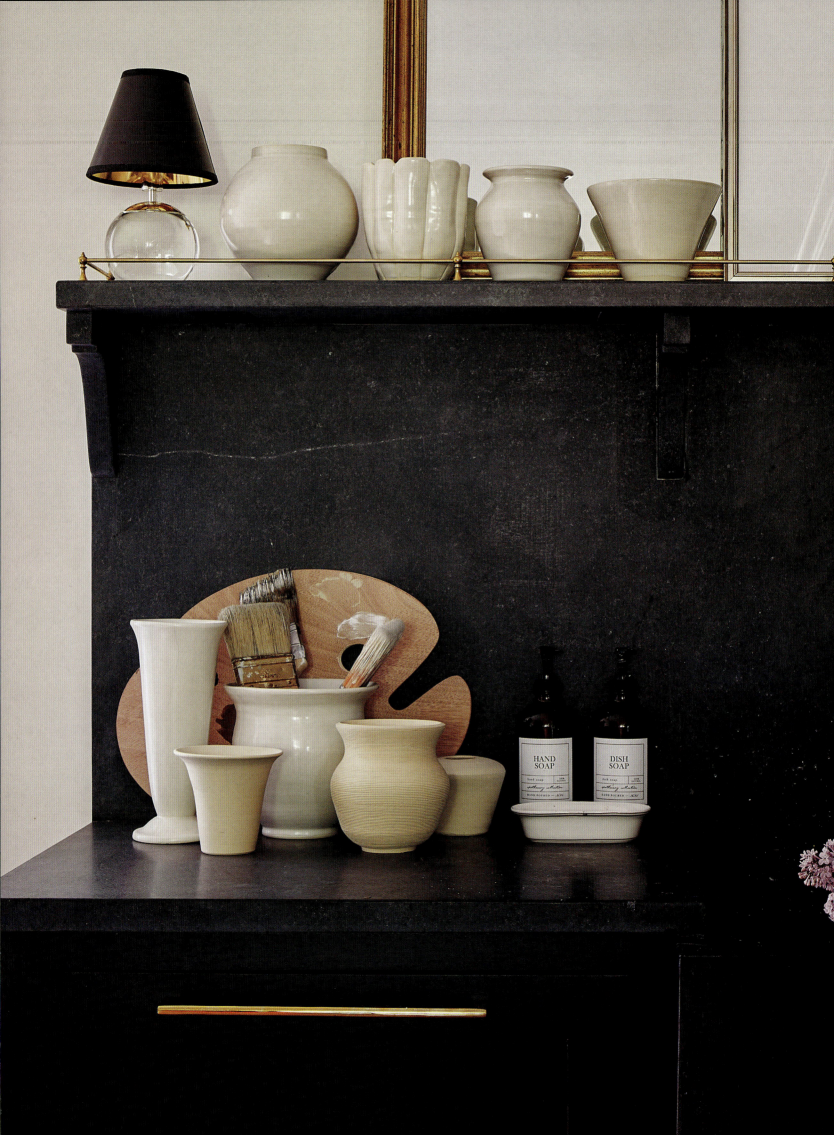

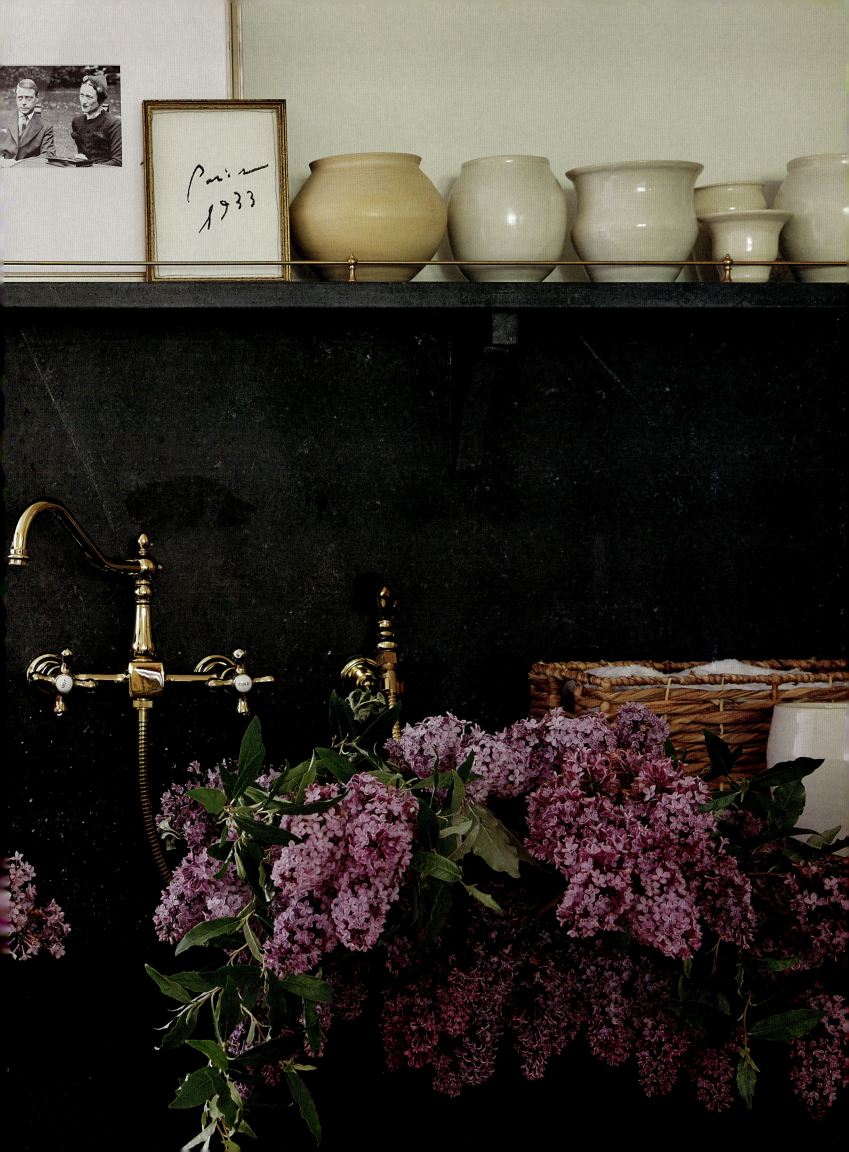

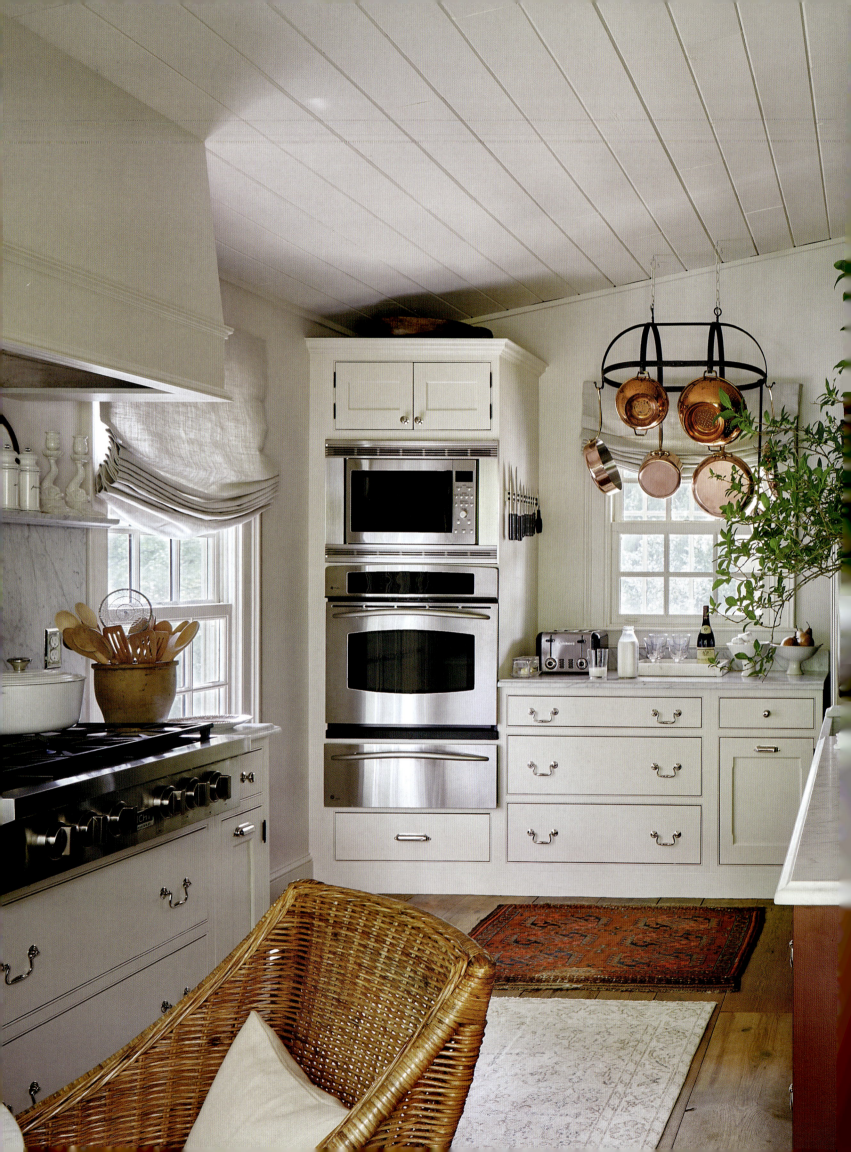

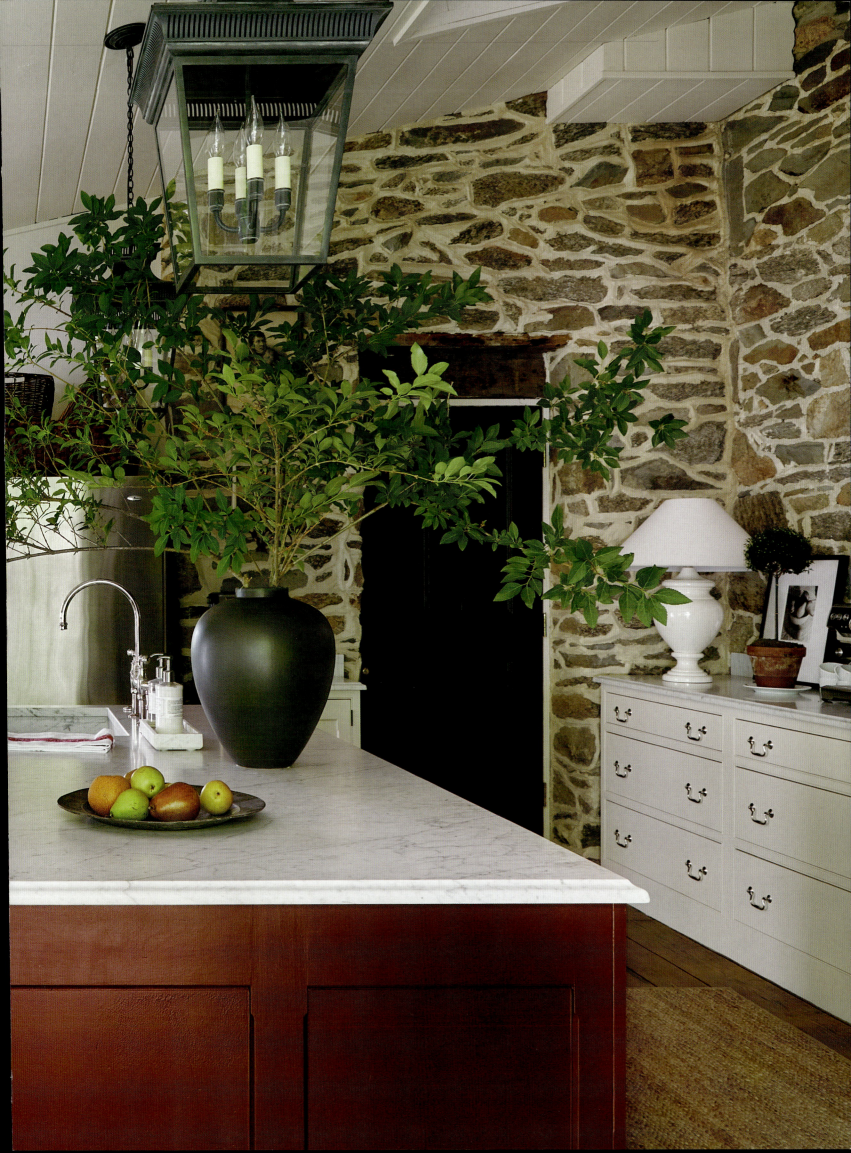

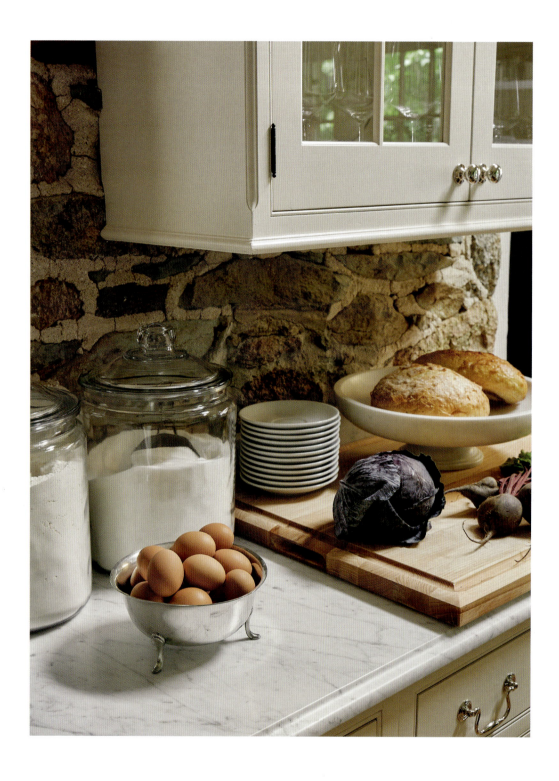

PAGES 46–47: For the studio I designed a custom workstation that incorporates an oversized soapstone sink and brass accents. PRECEDING PAGES: The kitchen at Sycamore House features custom cabinetry and an island painted in a warm, deep red for a bit of color. ABOVE: The palette stays unified, even in the workspaces. OPPOSITE: The kitchen includes a cozy eating area.

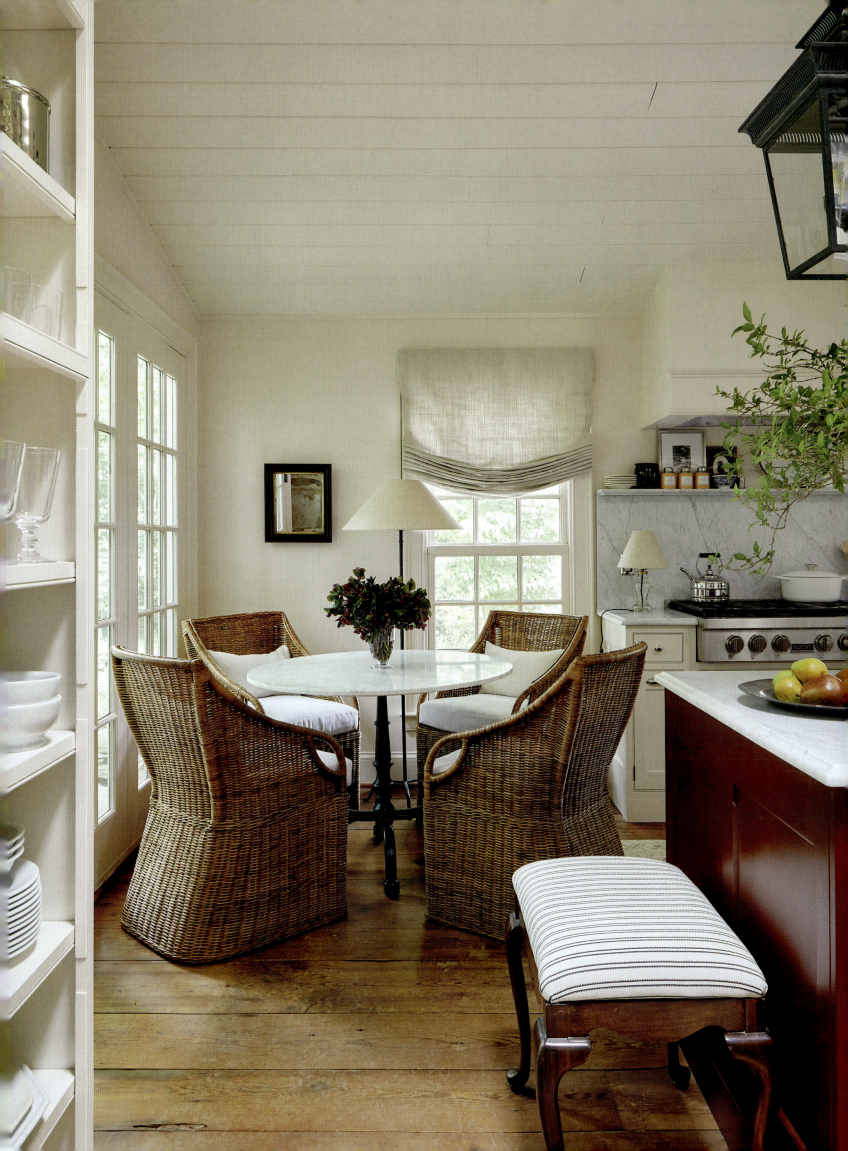

When I was growing up, my mother maintained a refined, neutral palette throughout our home. Admittedly, I used to despise this. As a child, I longed for bright red or blue walls, bold prints and patterns on our sofas, multi-colored lights instead of white lights at Christmastime. As I grew older, however, I began to appreciate my mother's discipline. Our home was friendly and welcoming, a classic 1990s neo-traditional house filled with warm ivory colors, mahogany furniture, skirted tables, slipcovered chairs, wicker baskets, and iron lamps with Empire-style shades. A minimalistic, tone on tone arrangement with a layered, classic sensibility. Think Jackie Harrison's home in the film Stepmom or Will Truman's apartment in the television show Will and Grace. Timeless, and still relevant today. My childhood home remains with me as a design blueprint for creating and utilizing a palette that is breathable and restrained and looks to texture and contrast for structure and support.

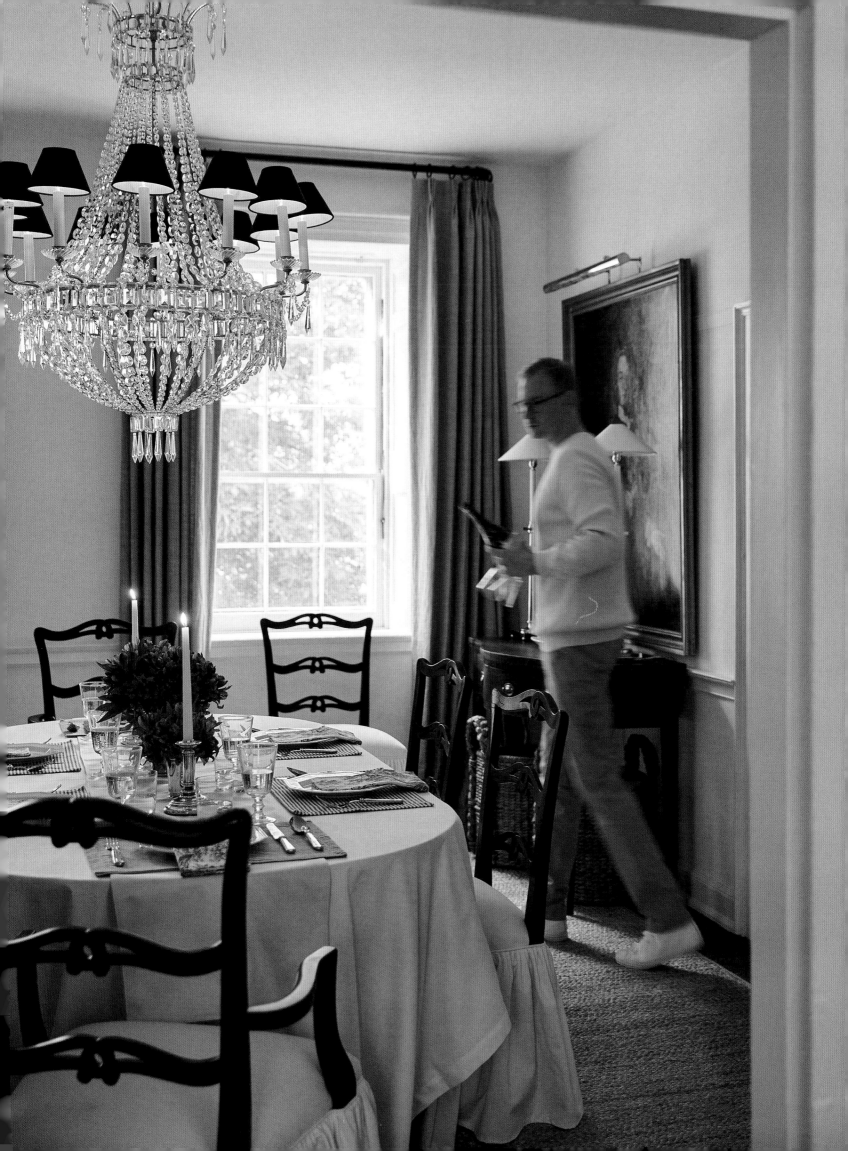

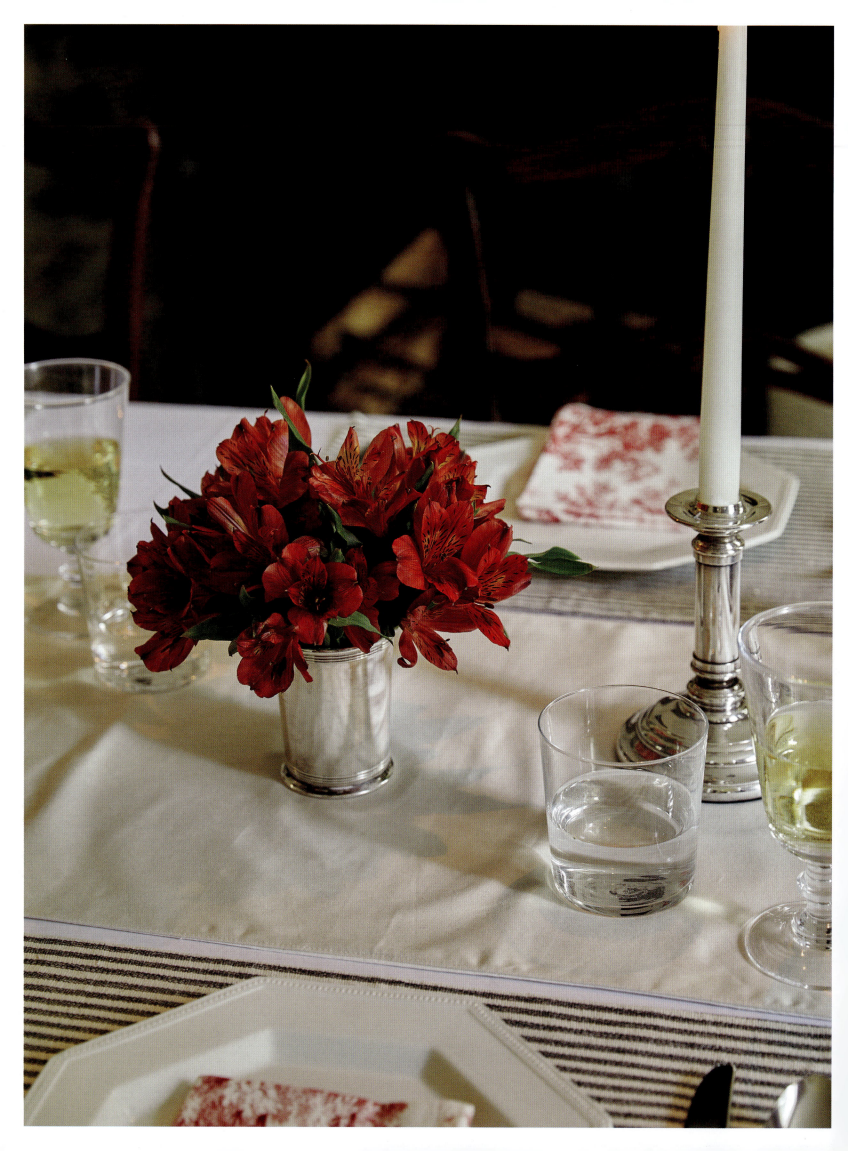

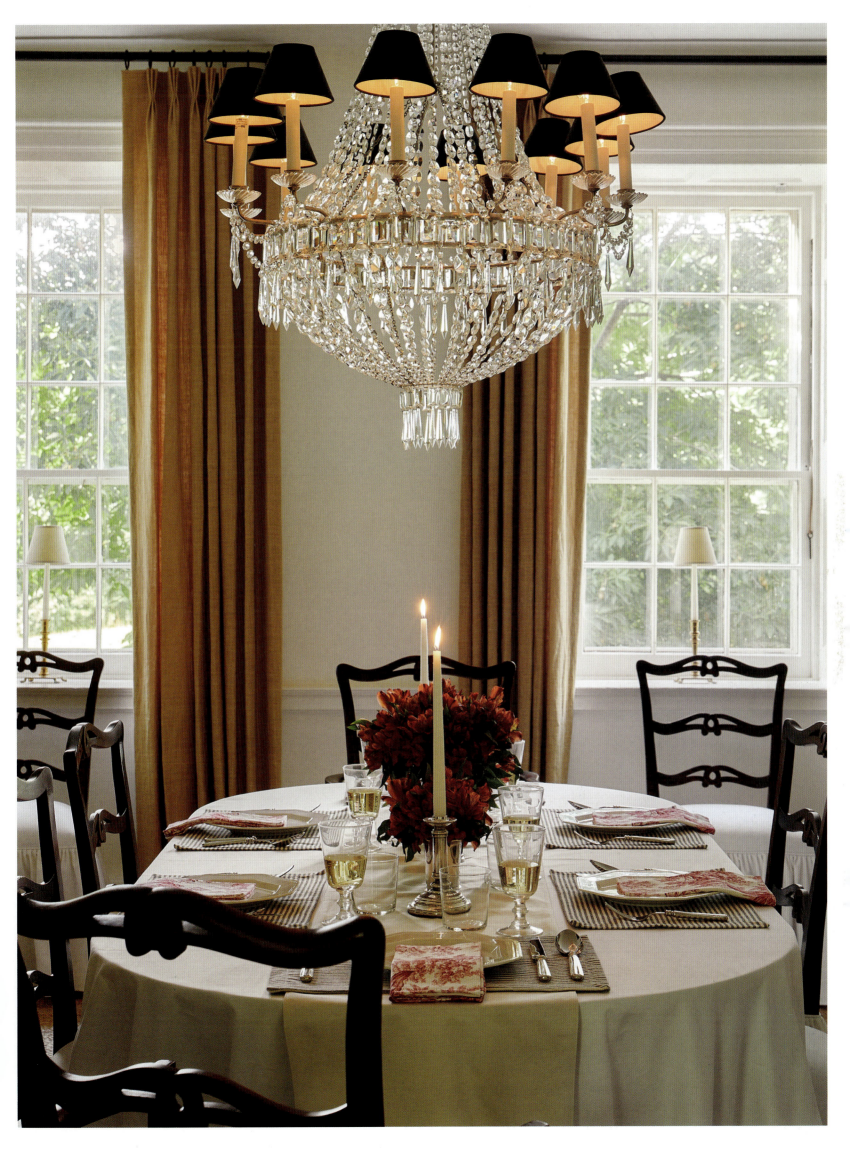

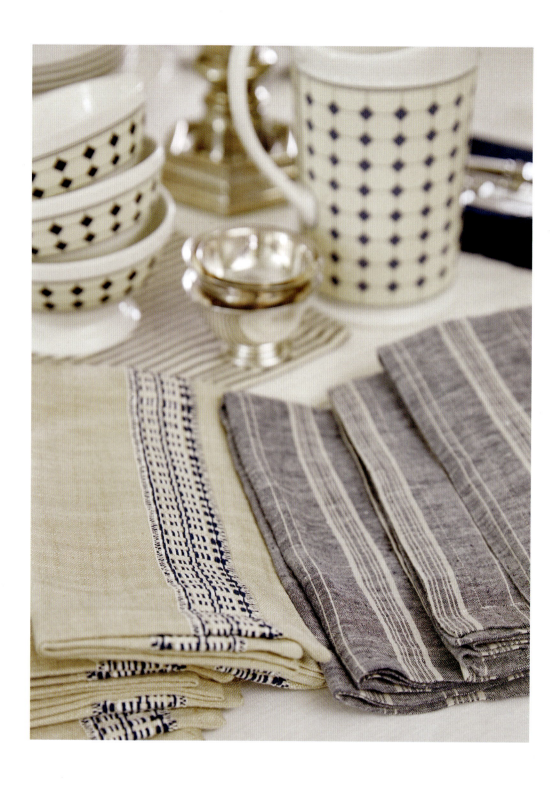

PRECEDING PAGES: The table in the dining room at Sycamore House is set with pops of red. **ABOVE**: I like to organize table linens by color and material for easy reference. **OPPOSITE**: Neutral-colored patterns combine in a fun and graphic tablescape.

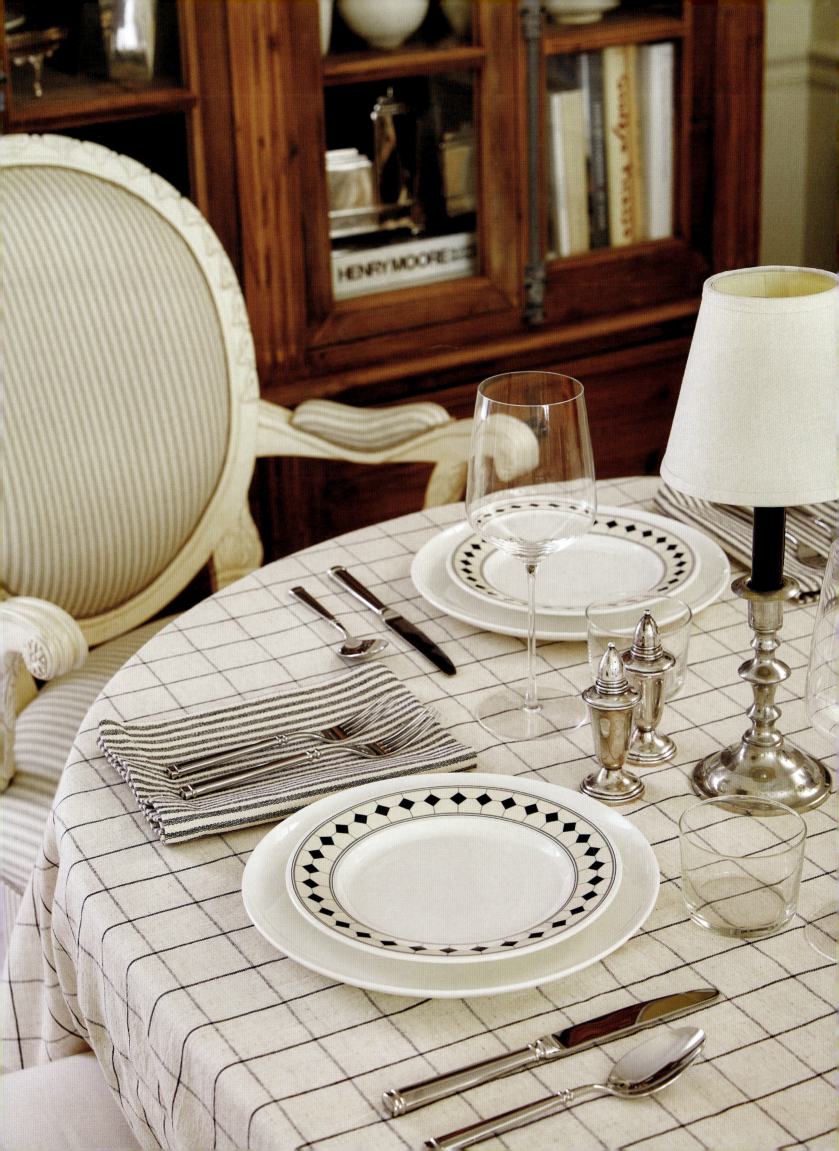

When Ignacio and I entertain, we usually divide and conquer; he focuses on the meal while I prepare the setting. It's a collaborative process, because the meal that will be served influences the dinnerware, linens, flowers, and stemware I select for the table. I think it's worth mentioning that the process of entertaining should feel like fun and not a chore. Otherwise, what's the point?

Entertaining can also be an artform, and the table can act as your canvas. The artist in me looks at not only what will be served, but how everything will work together visually on the table. From the linens to the stemware, everything is considered. For years, I've collected and sourced various pieces of china and dinnerware for this exact reason. Nothing overly expensive—in fact, some of my favorite pieces were an absolute steal from a variety of antique and thrift stores I stumbled into during my travels. My trove includes blue-and-white porcelain, antique stoneware, pewter chargers, and elaborate bone china. To know me is to know that I love to collect, and I love having options.

I love to place everything on our kitchen island to see how the various pieces look together and with the food to be served. If Ignacio plans to offer a colorful, summer meal consisting of beautiful vegetables and greens, I may opt for a subdued palette; neutral linens and simple white plates allow the beautiful colors of the meal to be elegantly displayed. If we're making a more monochromatic meal, like my beloved beef Bourguignon, I may opt for more color or pattern to be featured to create some visual interest. The way I approach a table is no different from the way I approach a blank canvas or an empty room. All roads begin with establishing the palette.

OPPOSITE: I keep an assortment of table linens on hand at Sycamore House so I can mix and match patterns, colors, and materials.

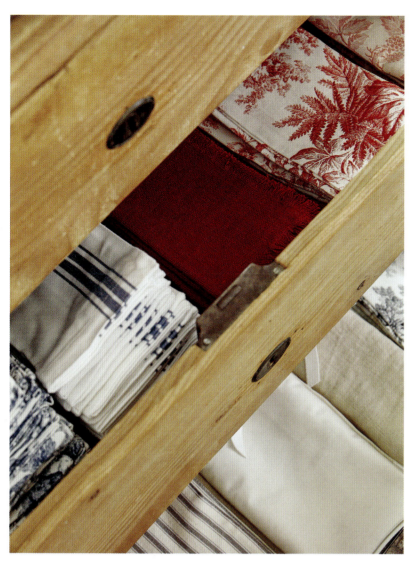
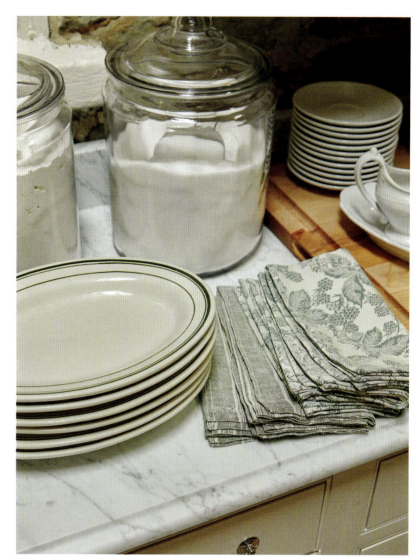
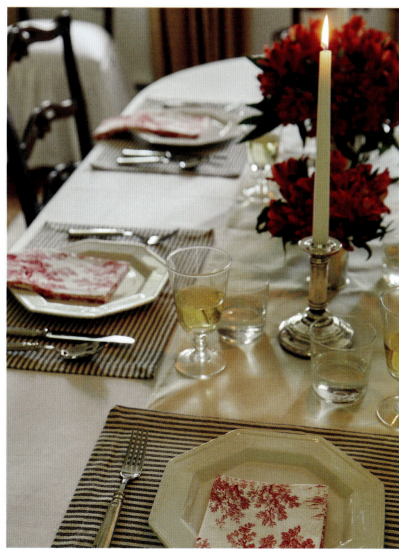
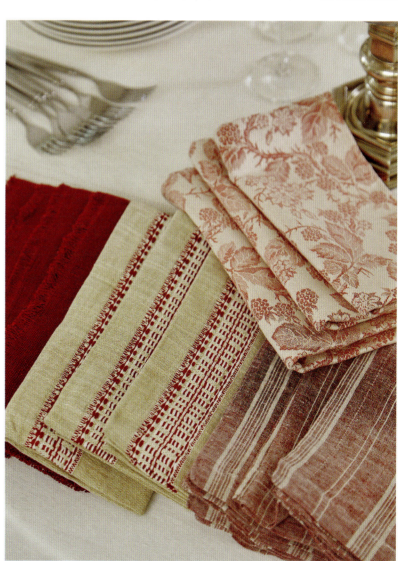

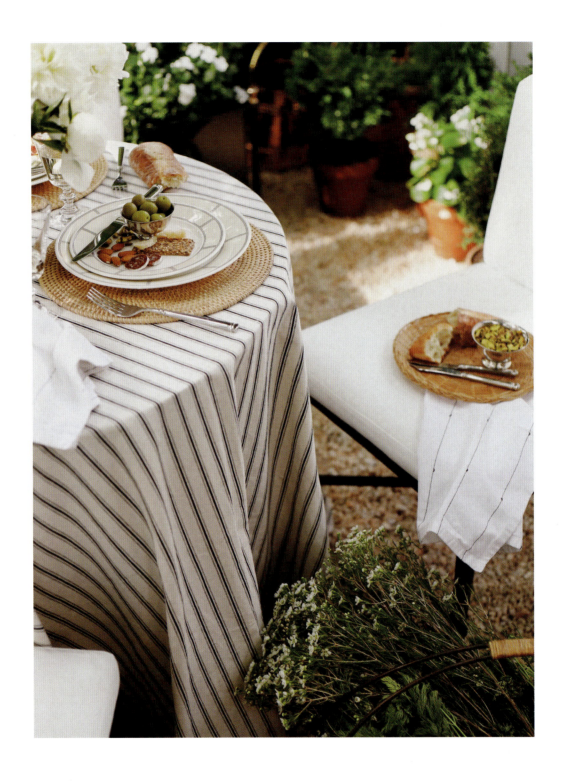

ABOVE: An evening aperitivo in the back garden of the townhouse. **OPPOSITE:** Iron furniture sits below a vintage lantern hanging from a red Japanese maple tree. The surrounding plants create a subdued backdrop in a palette of green and white. **FOLLOWING PAGES:** Outdoor dining calls for a simple palette. Rattan placemats and napkin rings pair with the natural setting.

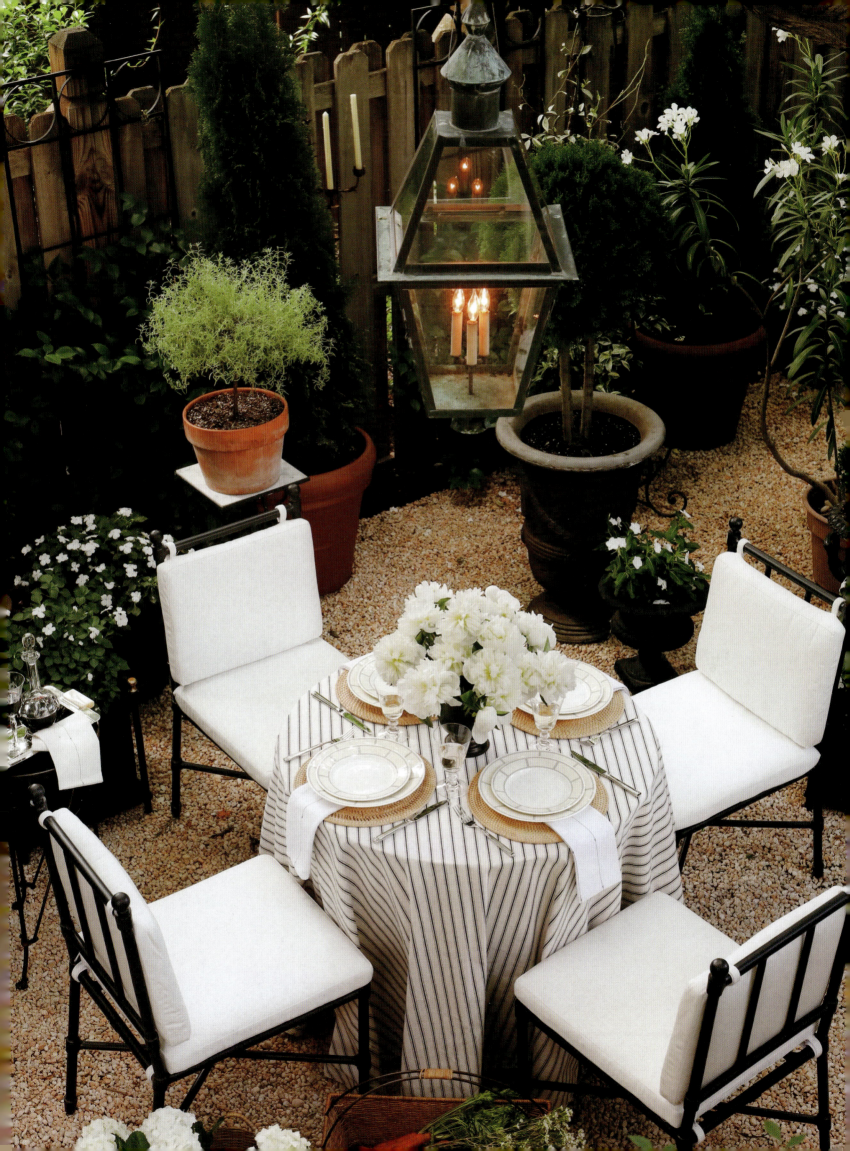

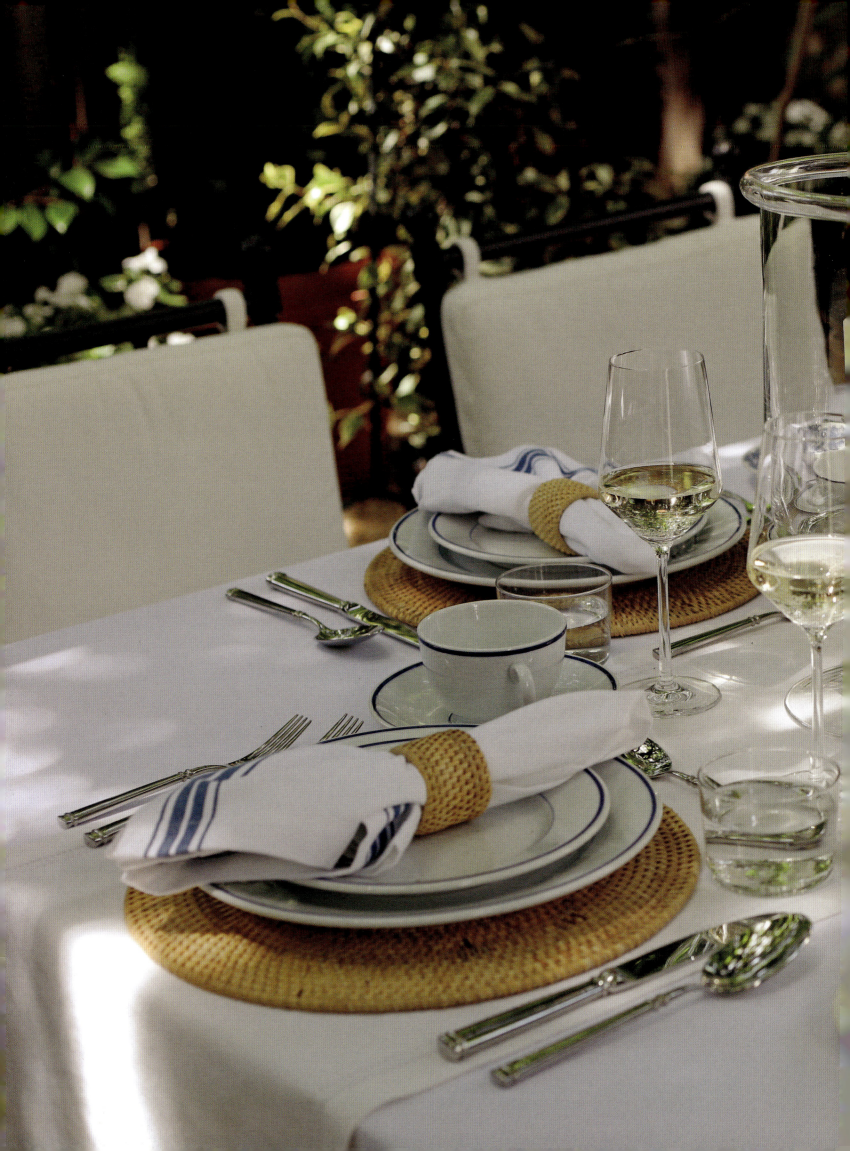

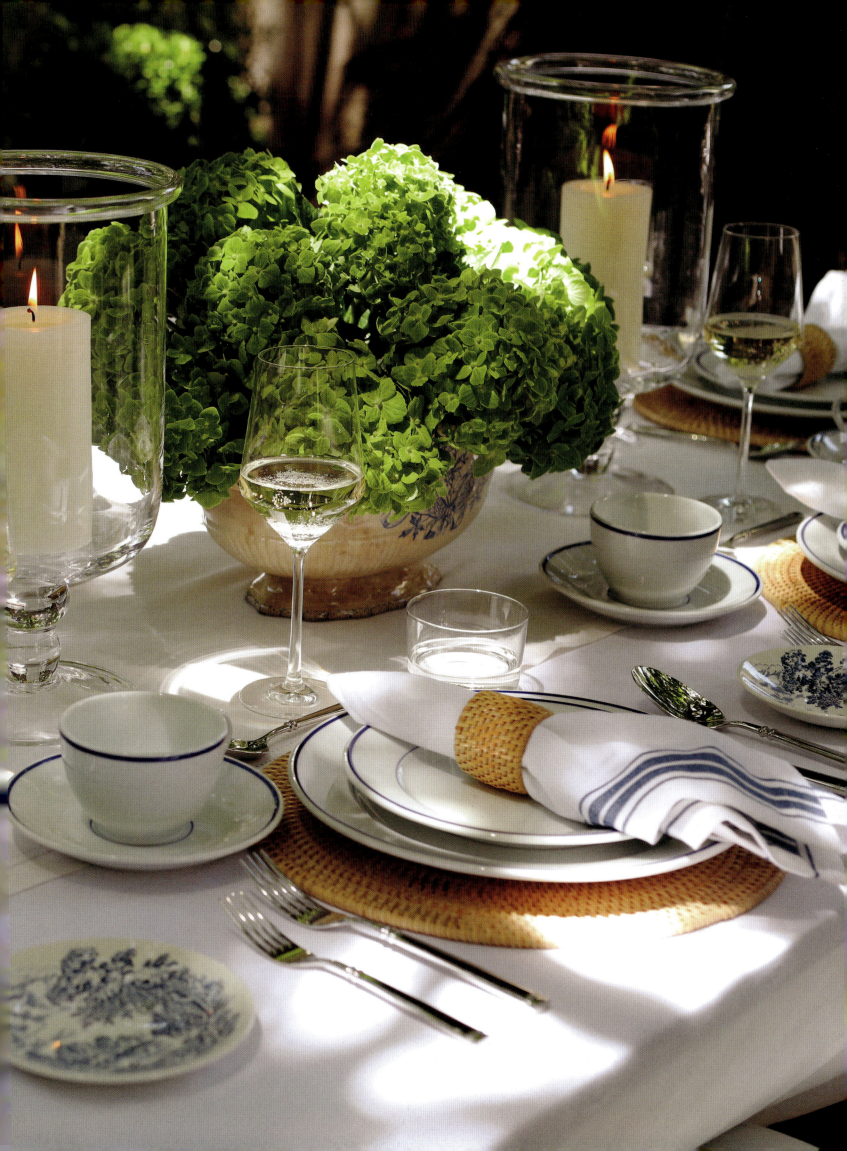

TEXTURE

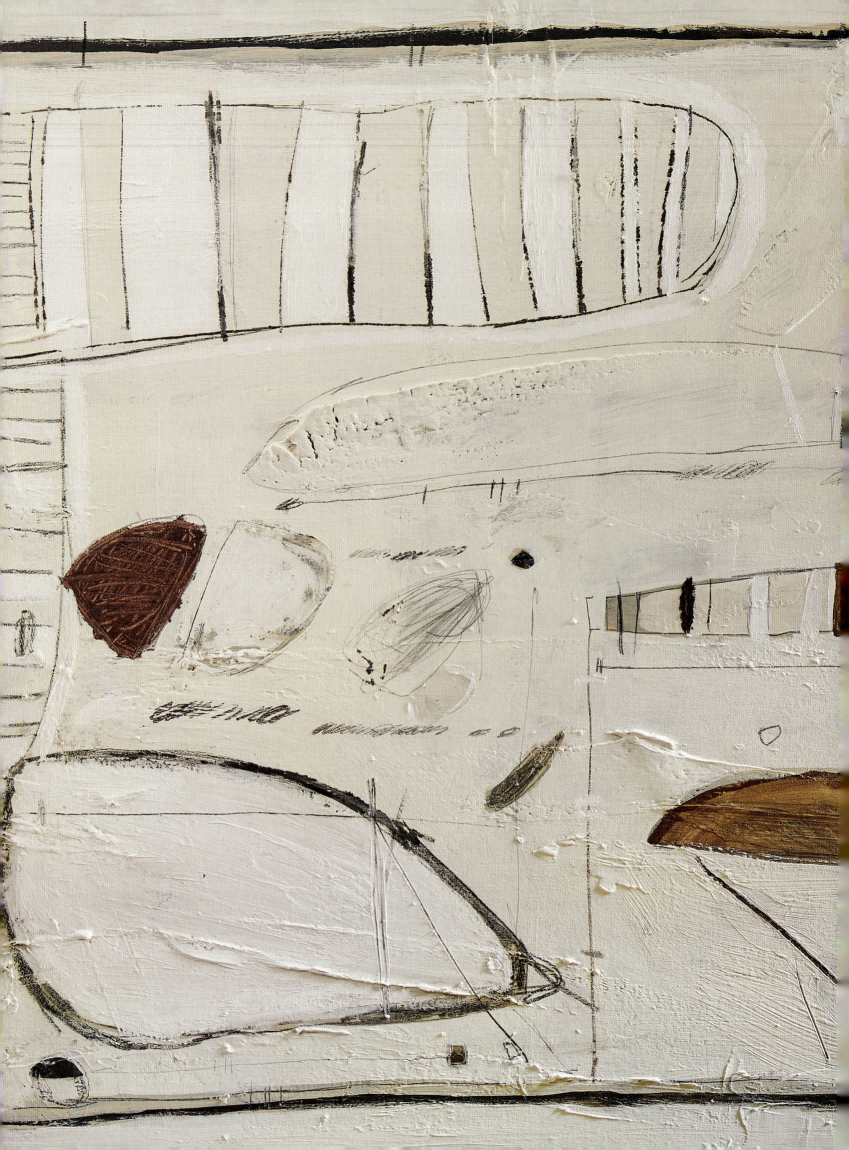

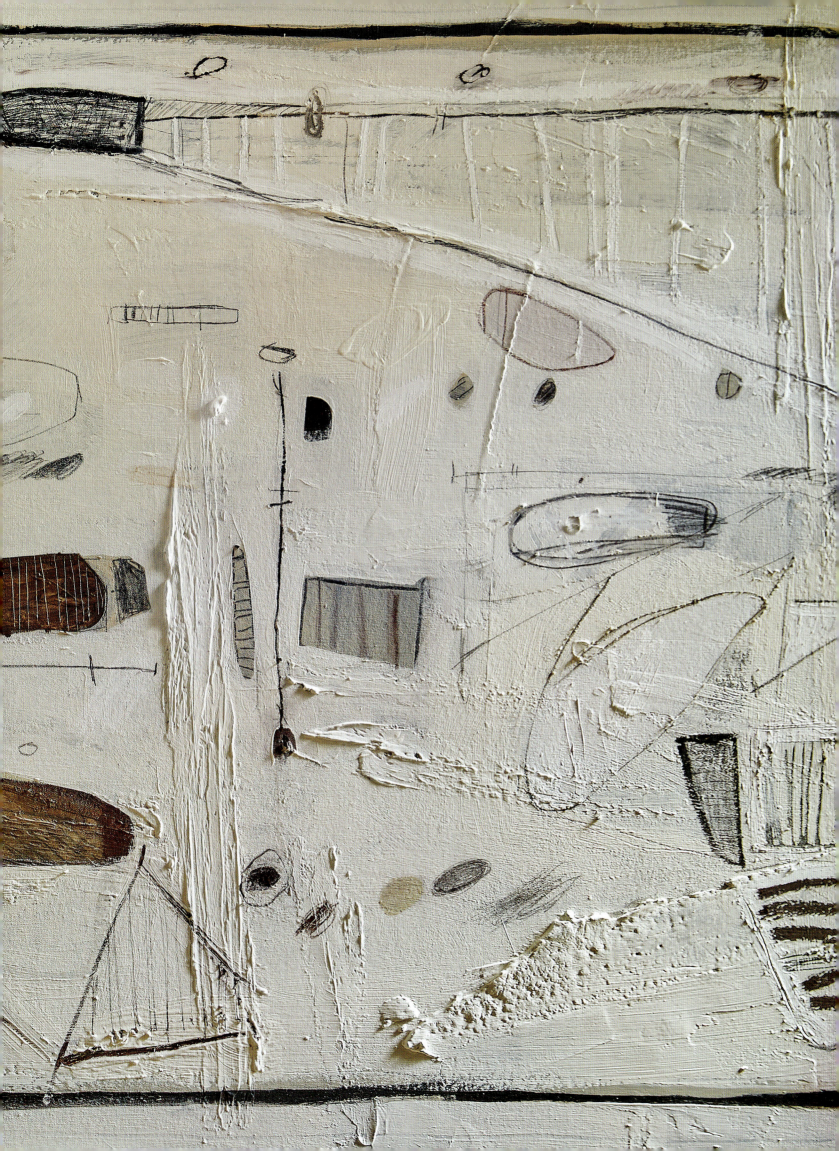

My love of texture intensified during the years I spent living in Milan. The stucco and plaster buildings that lined the city's streets captivated me with their stature, elegance, and refined details. The characteristic that left the biggest impact on me, however, was their decay and dilapidation. Large, broad swaths of plaster chipping away from the facades, exposing years' worth of paint, stone, and brick. These buildings were a true testament to the city's age, existence, and depth. The textures added a layer of complexity that made the buildings and the city more beautiful.

Texture has always taken center stage in my creative process, whether in my art, my home, or other parts of my life. Texture can enhance a piece of art, resulting in a more substantial and impactful work. Among other things, texture makes a painting come alive. Texture is the antithesis of sterility. Its beauty lies in its unique ability to stimulate both visually and tactilely. It allows one's eye to "feel."

I approach an empty room the same way I approach a blank canvas: I begin with texture. I consider how I want a space to feel both visually and tangibly. First impressions are everything, and when entering a room my eyes want to travel. As they roam from object to object, I'm dissecting the physical makeup of the items in the room and the sensations they evoke. Smooth and rough. Varnished and tarnished. Rigid and sleek. After taking that quick, visual snapshot, I assess the materials and textures and how they work together. Curating the textures of a room is key to making it feel elegant and intentional. They say the devil is in the details, and this aspect of design is a detail not to be overlooked.

PRECEDING PAGES: In the majority of my abstracts, I use plaster for its textural quality. For this work on canvas I also employed oil, oil pastel, and graphite. **OPPOSITE:** I fell in love at first sight with our Washington, D.C. townhouse because of the intricate decorative details on the exterior.

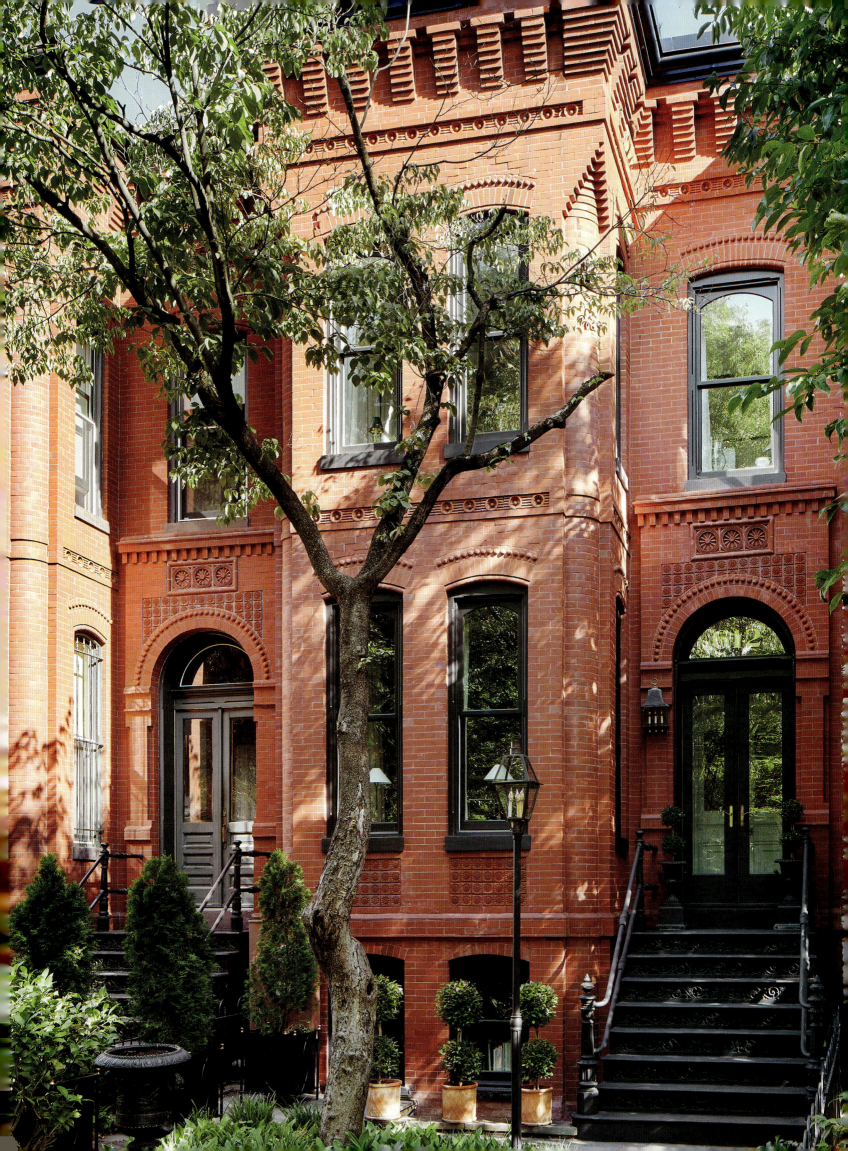

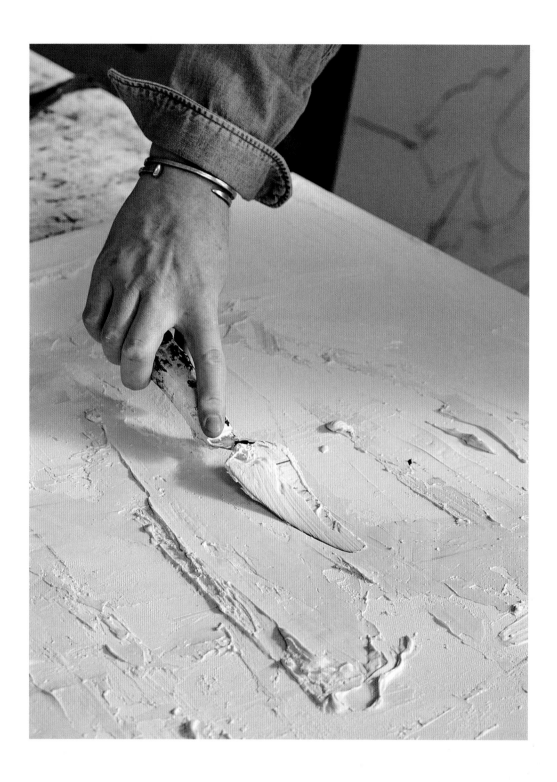

ABOVE: In the studio, applying a mixture of gesso and plaster to canvas as a three-dimensional base layer. **OPPOSITE:** On the small landing leading to the primary bedroom at the townhouse, a quadriptych of textural pieces I created hangs above a narrow console. The sisal rug and baskets and the glass transom over the door all contribute to the play of different surfaces.

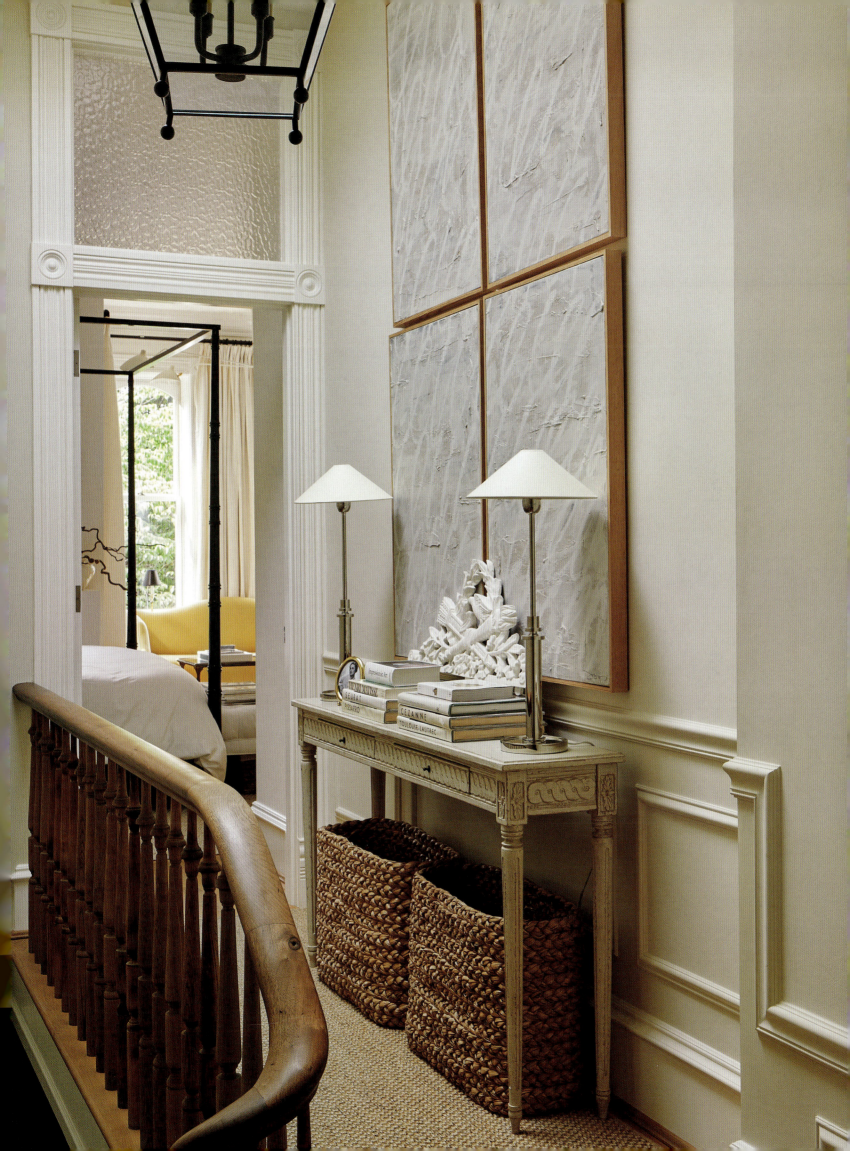

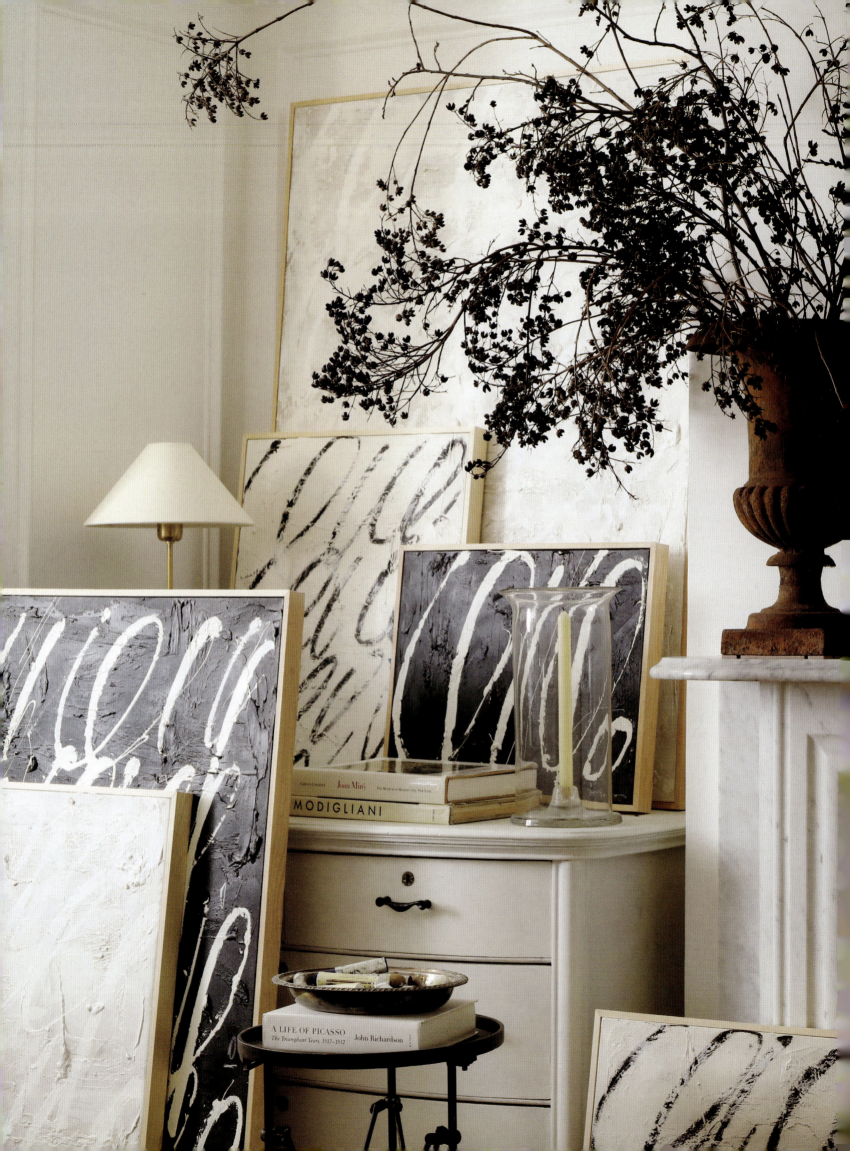

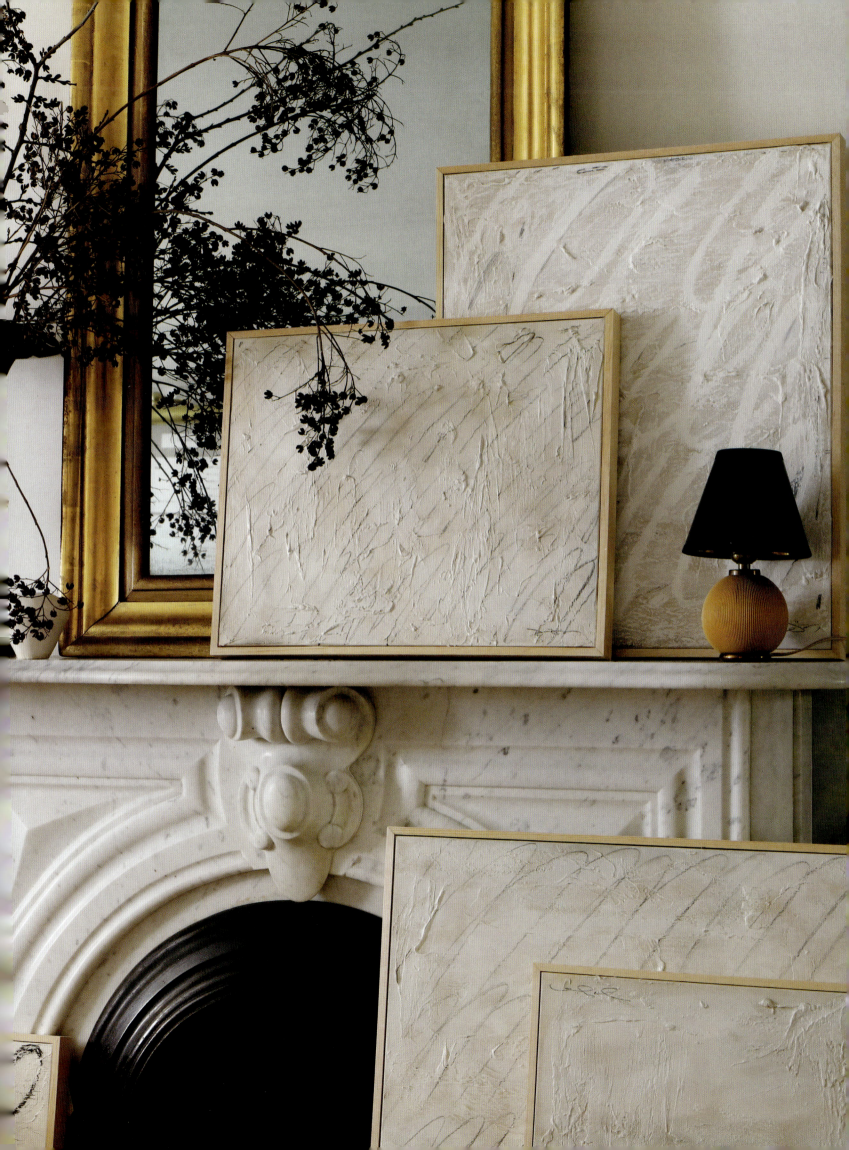

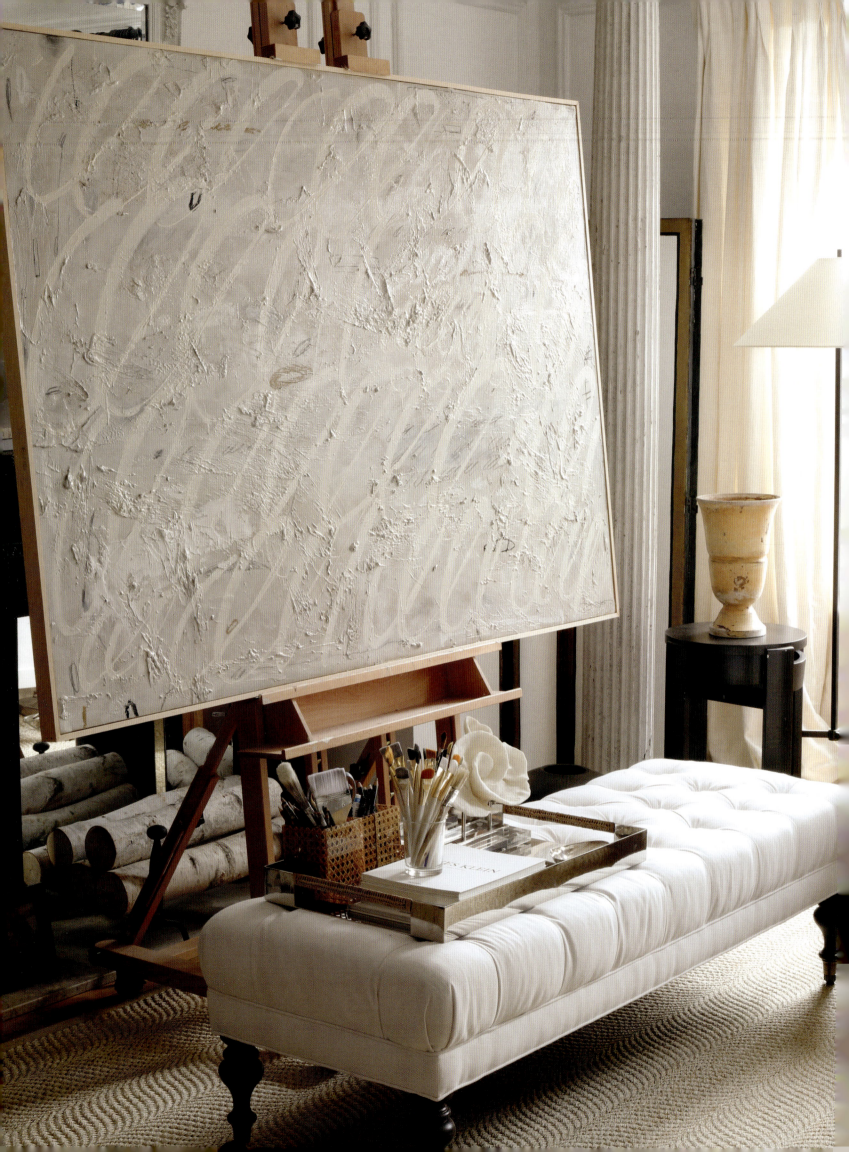

I have always been taken with the simple beauty of natural fibers. From sisal rugs to woven rattan baskets and trays, their raw, neutral composition and pronounced texture brings casual sophistication to any room. Using things made from natural fibers is a great way to incorporate pattern without going too bold or graphic. No matter how precious or polished you ultimately want a space to feel, integrating something organic and raw helps ground it and highlights the more finished materials by contrasting with them.

This idea of contrast is important when utilizing texture. When decorating, I am always mindful of including opposites. If I source something coarse and primitive, I then place something sleek and refined nearby. It's a game of give and take, and each and every object ought to have its own textural moment. That not only creates texture and contrast, but sends the eye on a true textural journey as it travels around the room.

I never want a room to feel flat and lifeless. While styling a room or vignette, I'm constantly cross-checking the textural elements that have been used, and listing those that are still missing. If I'm on a sourcing trip or just casually out with my husband antiquing and come across a piece that grabs my attention, I analyze what is it about it texturally that I'm drawn to. How does it make me feel? How does it actually feel to the touch? And how will it live within a room? Being mindful in this way helps you identify what you're drawn to—an important factor in establishing your overall creative point of view.

PRECEDING PAGES: A collection of abstracts on canvas, layered in my D.C. studio, contrast with an urn filled with dried branches, an Italianate marble mantel, and the smooth glass of a mirror. **OPPOSITE**: A large (48 by 60–inch) textural piece made with oil, acrylic, oil pastel, graphite, and plaster on canvas sits on an easel in the main salon of my Chicago studio.

ABOVE: The original nineteenth-century vestibule door at the townhouse features decorative carvings.
OPPOSITE: In the salon area of my Chicago art studio, I used a weathered and distressed dresser to store antique documents, textiles, and papers from my various collections.

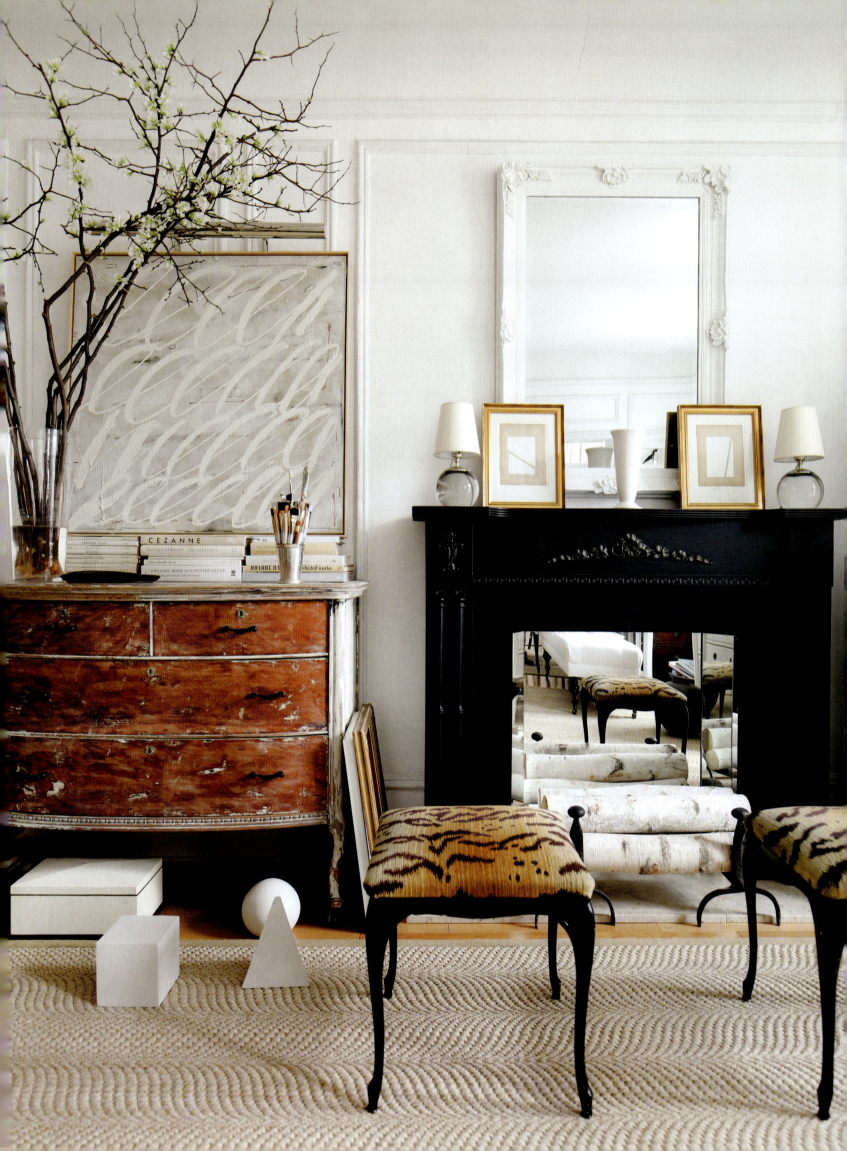

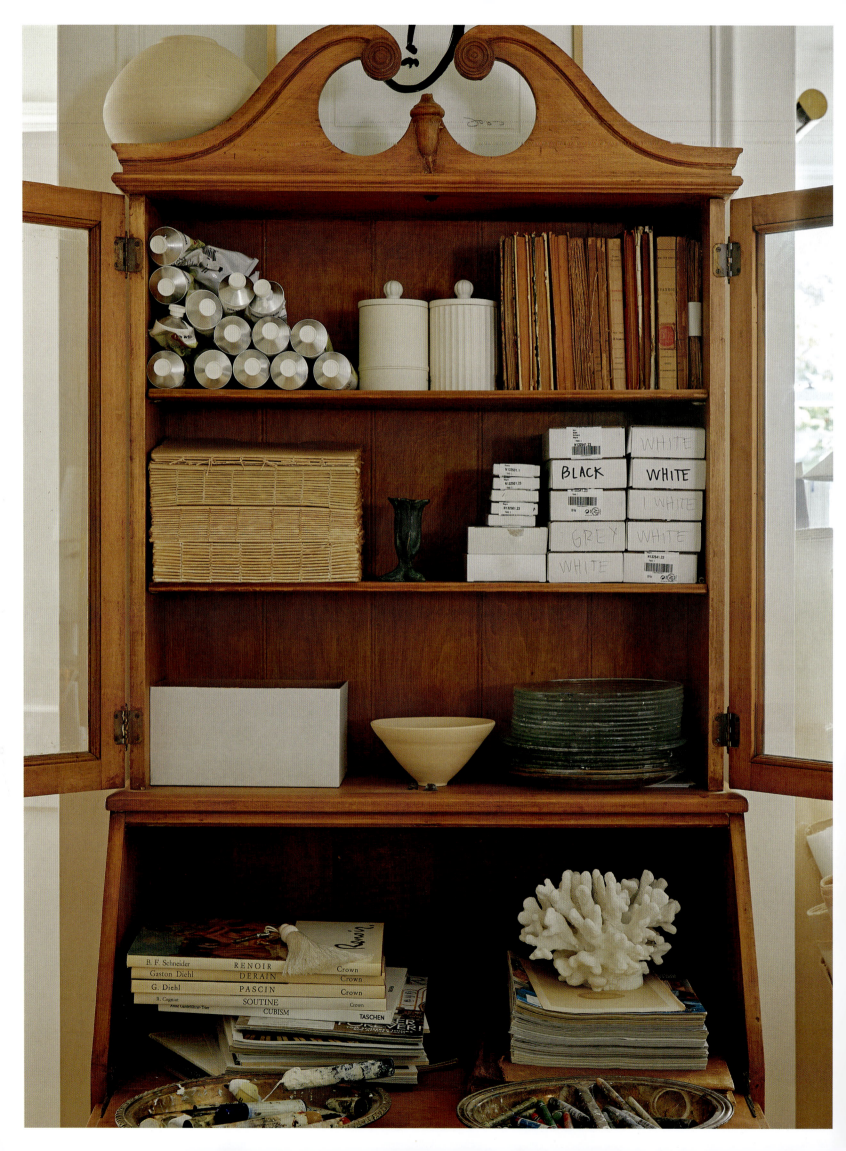

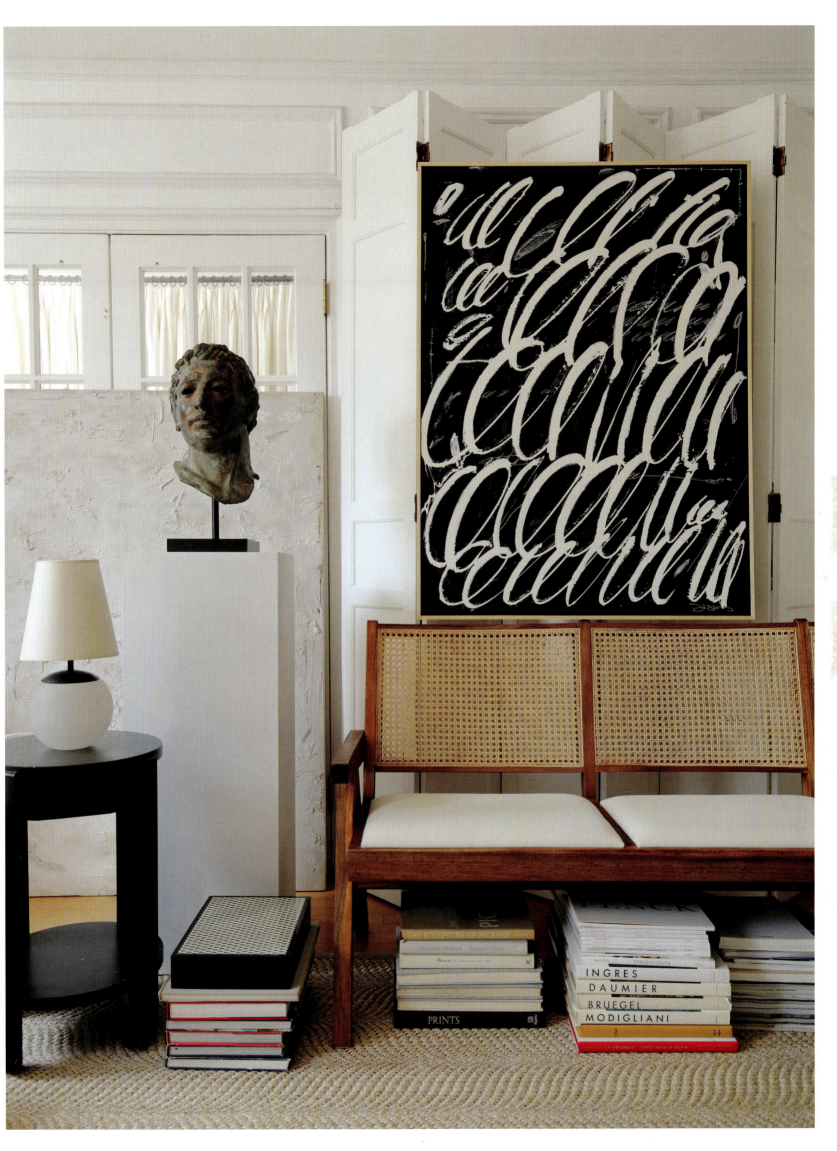

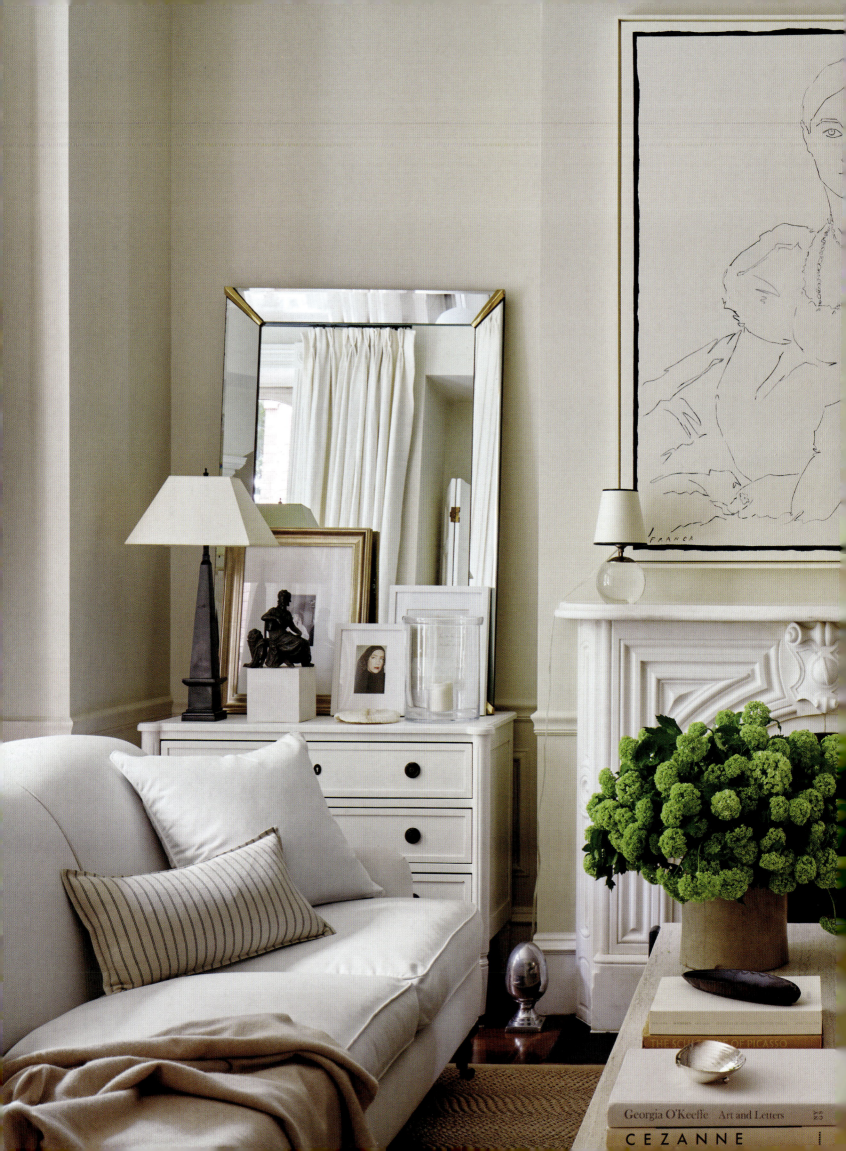

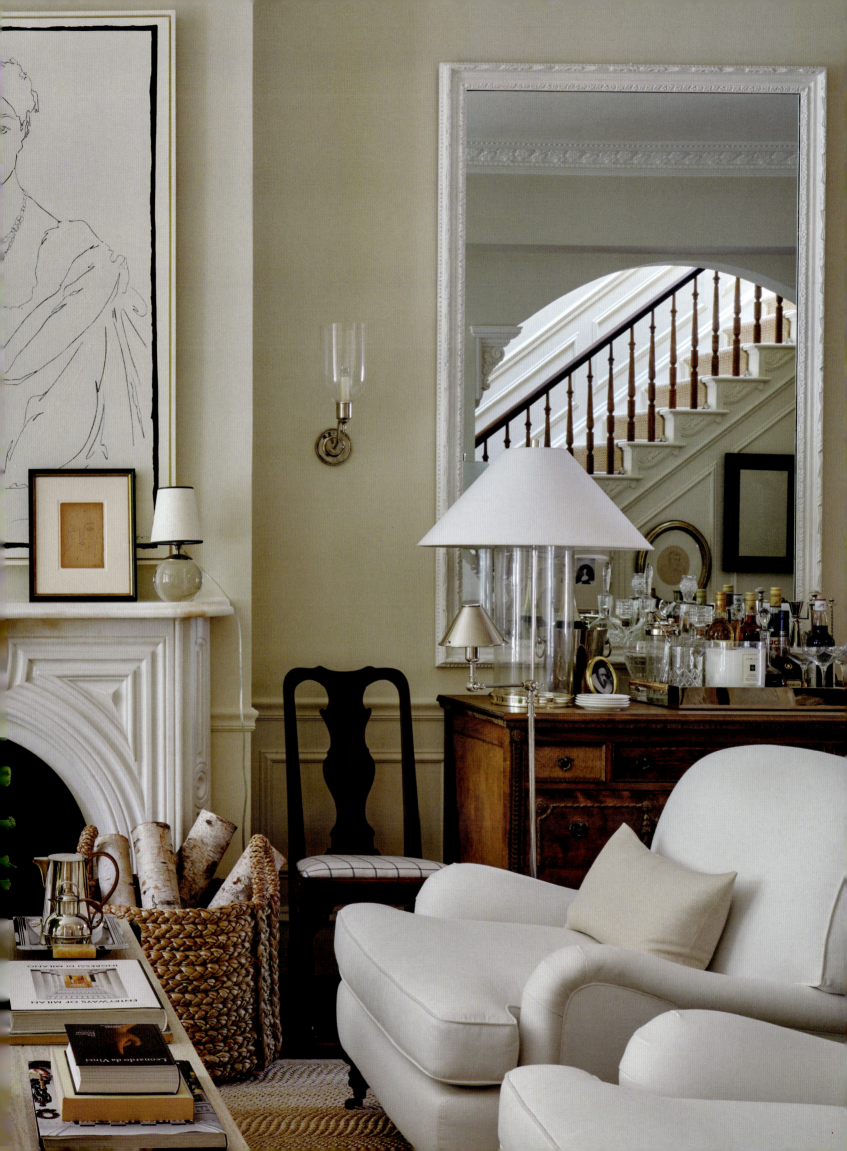

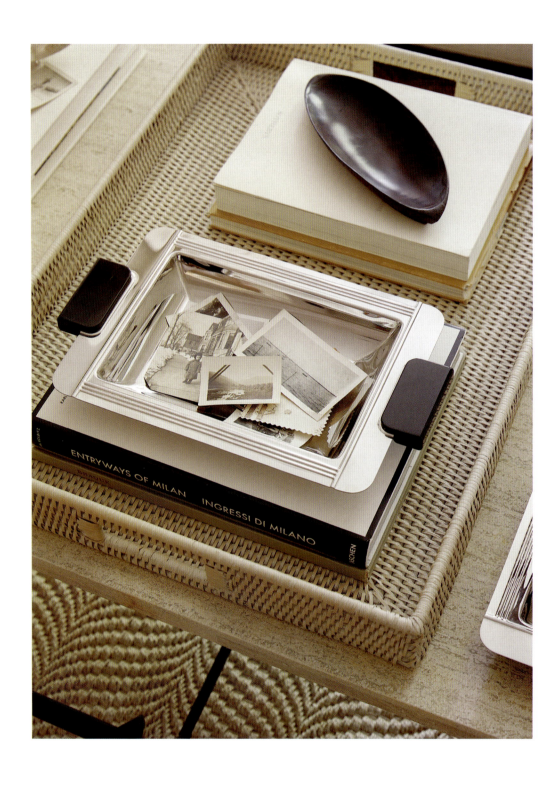

PAGE 78: One of the many cabinets in my D.C. art studio holds supplies and inspiration. Ceramics, coral, and even well-loved pastels and paintbrushes serve a feast of textural variety. PAGE 79: A vignette from my Chicago studio of an abstract (oil, oil pastel, and plaster on canvas) atop a Pierre Jeanneret–style bench with a rattan back. PRECEDING PAGES: The parlor-floor living room in our D.C. townhouse celebrates natural materials. ABOVE: A metal tray layered with vintage photographs nestles in a larger rattan tray and adds interest to a coffee table. OPPOSITE: A woven basket filled with birch logs is truly one of my favorite things—a bounty of rough natural textures.

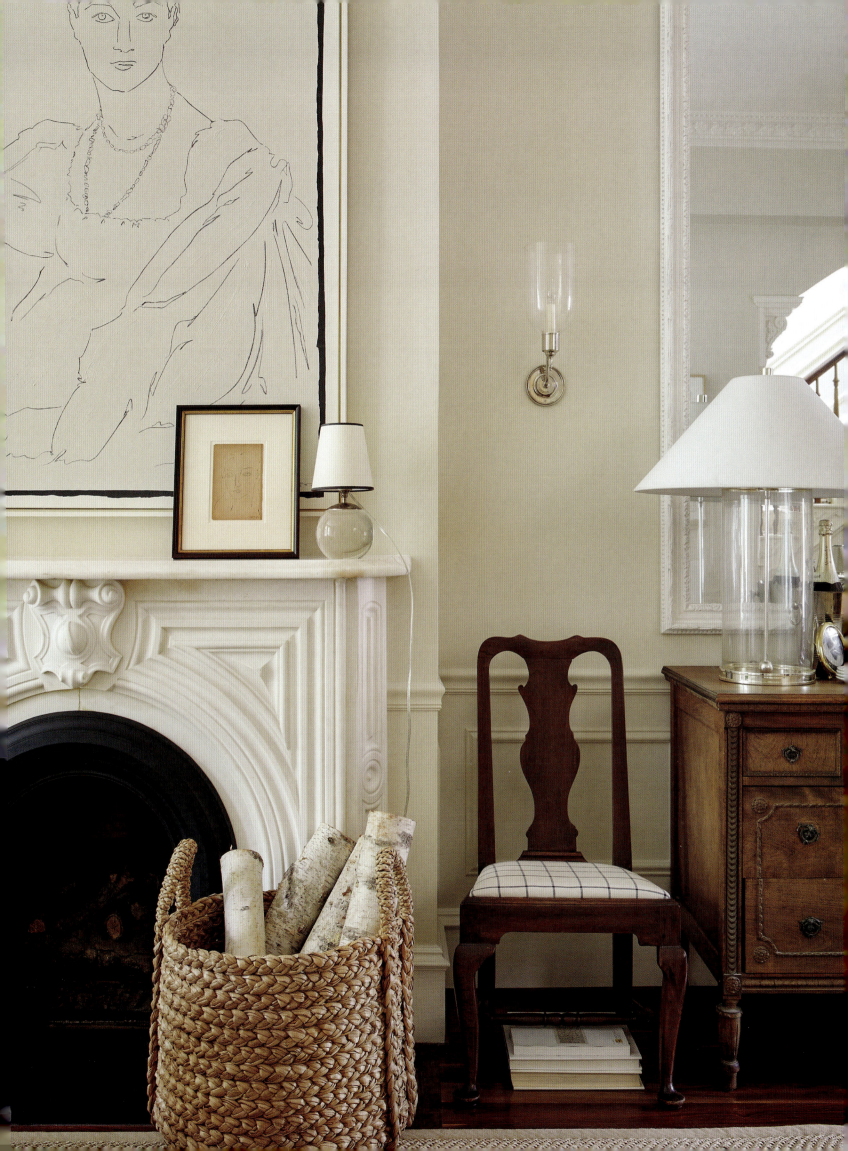

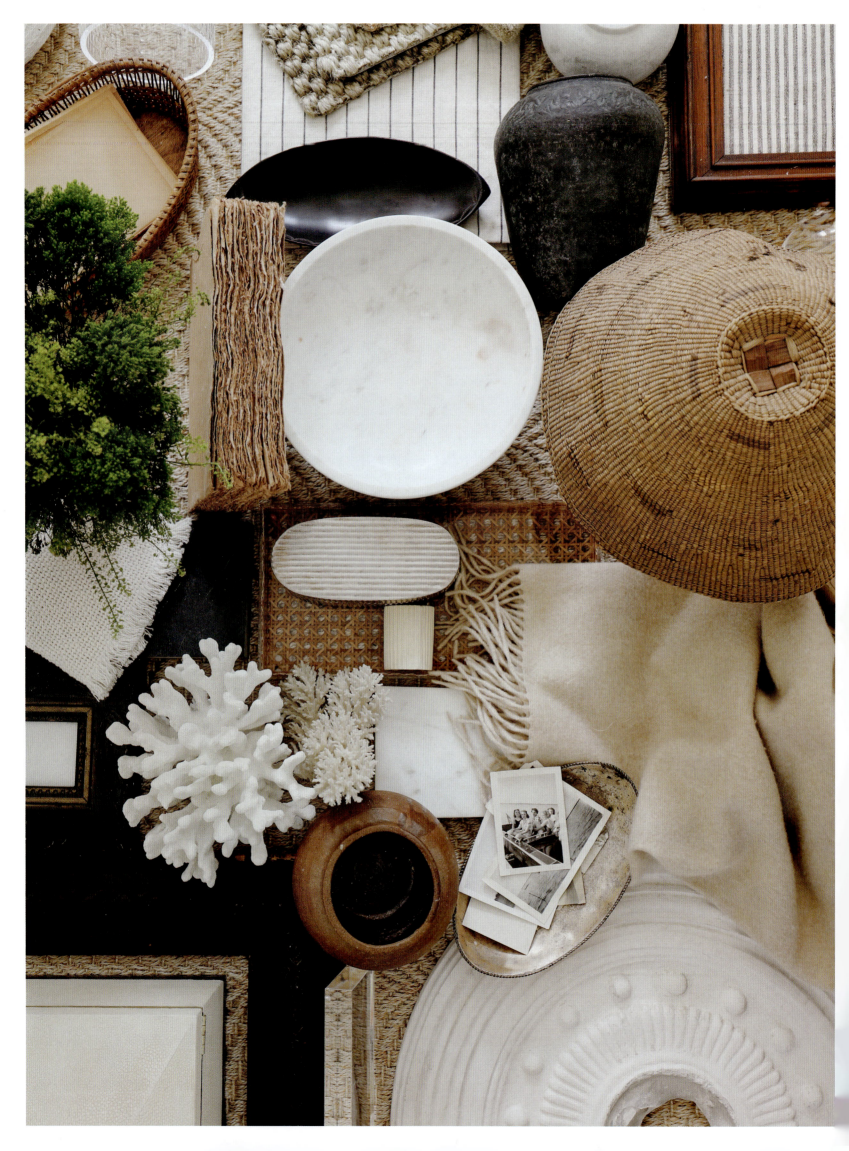

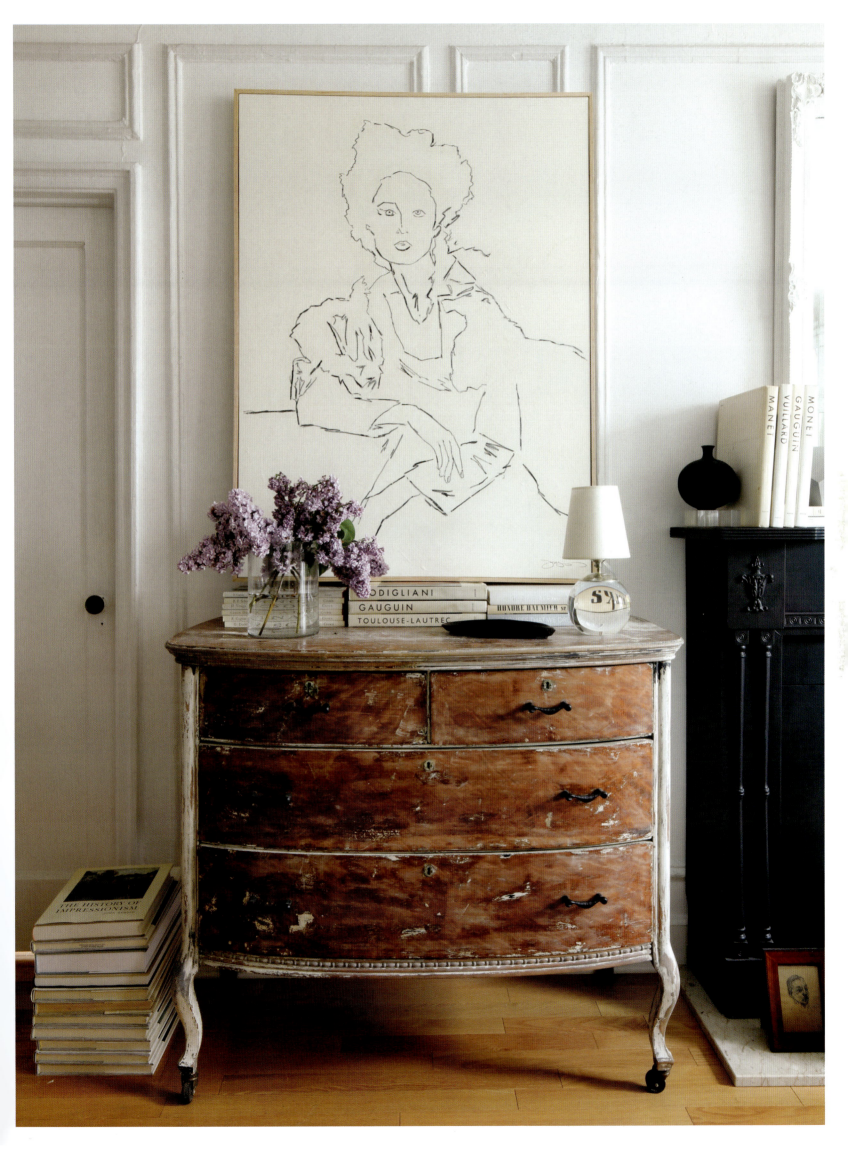

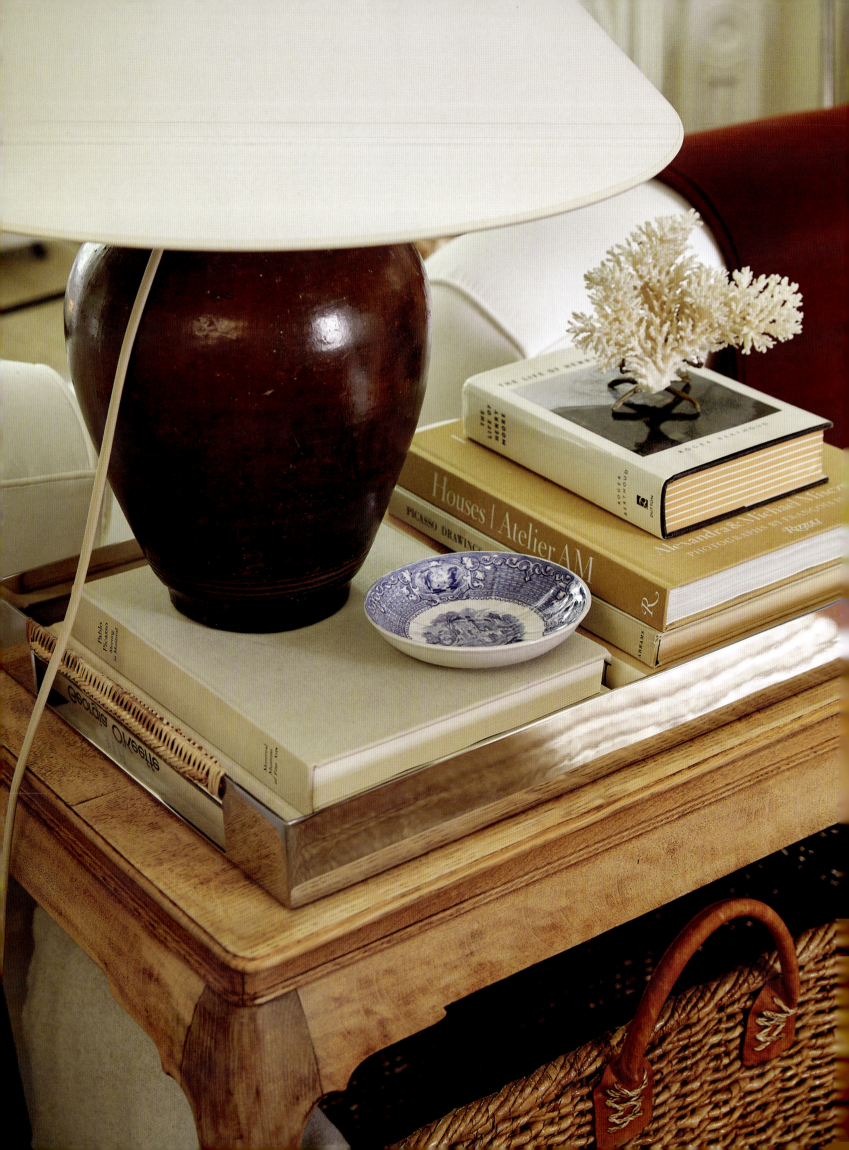

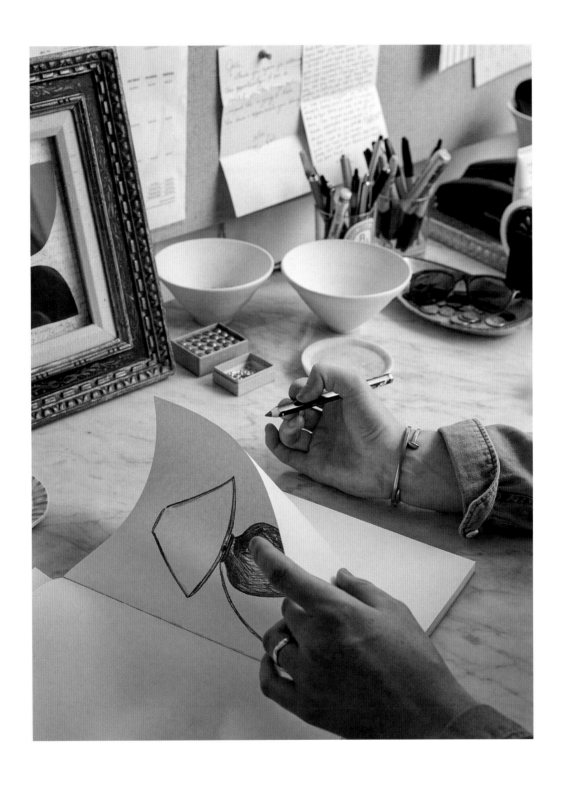

PRECEDING PAGES, FROM LEFT: A mood board displays some of my favorite textural elements. From my *MUSE* series, an ode to classical portraiture: a line drawing of a woman on a base layer of plaster and gesso. A simple motif reliant on texture and line. **OPPOSITE AND ABOVE:** A custom lamp Ignacio and I designed for the townhouse. It's just one of the many pieces we've designed for our homes.

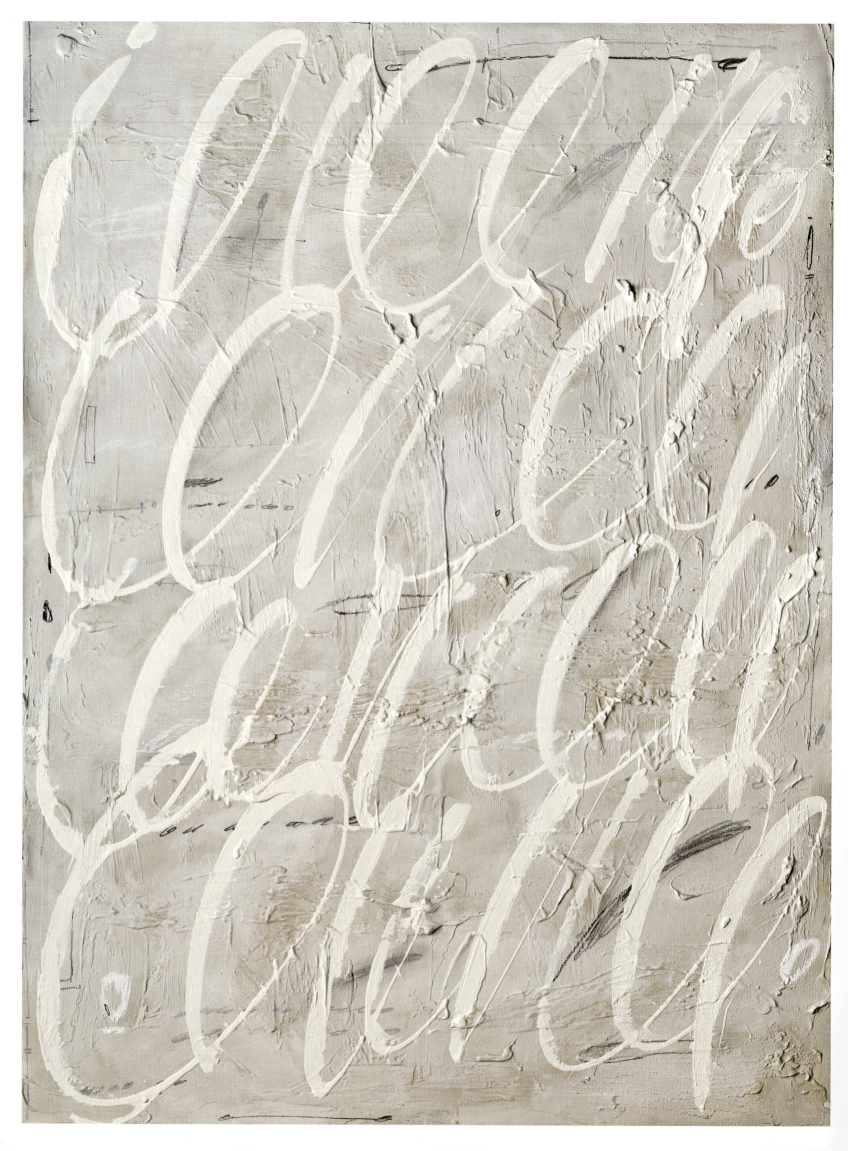

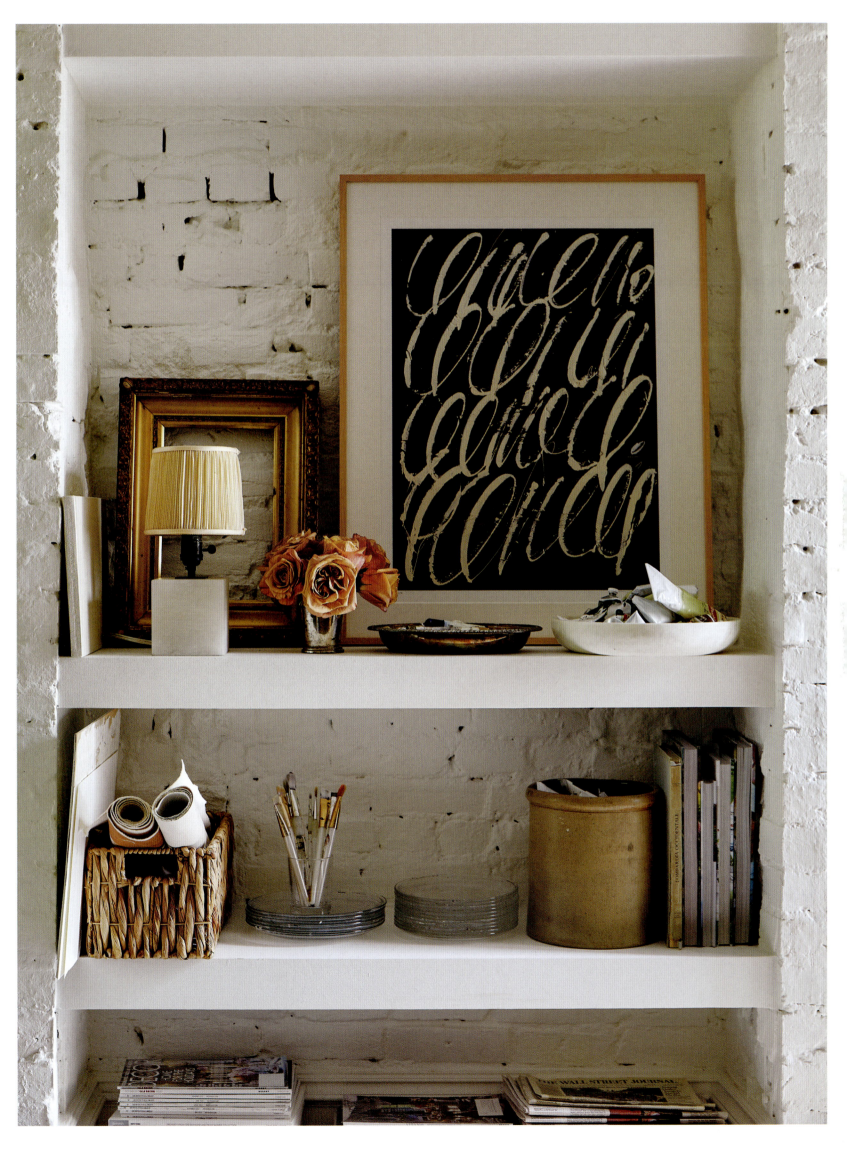

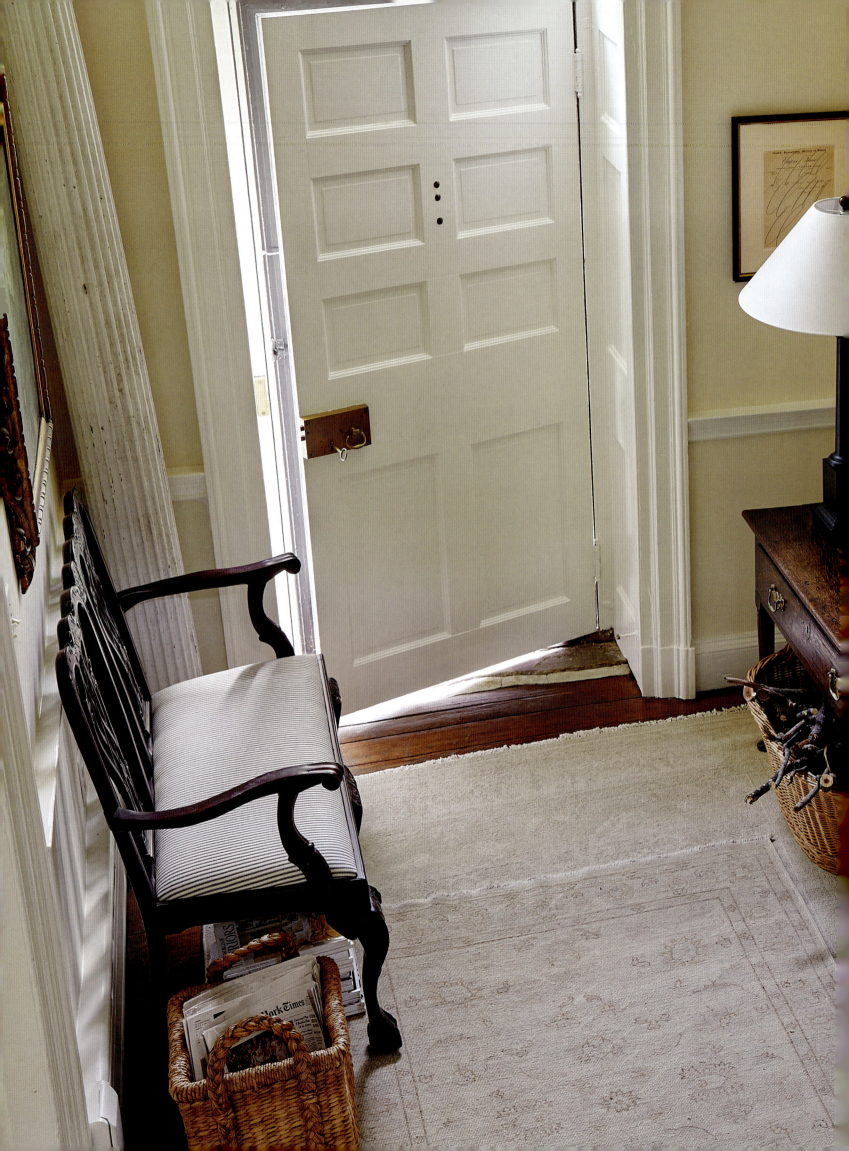

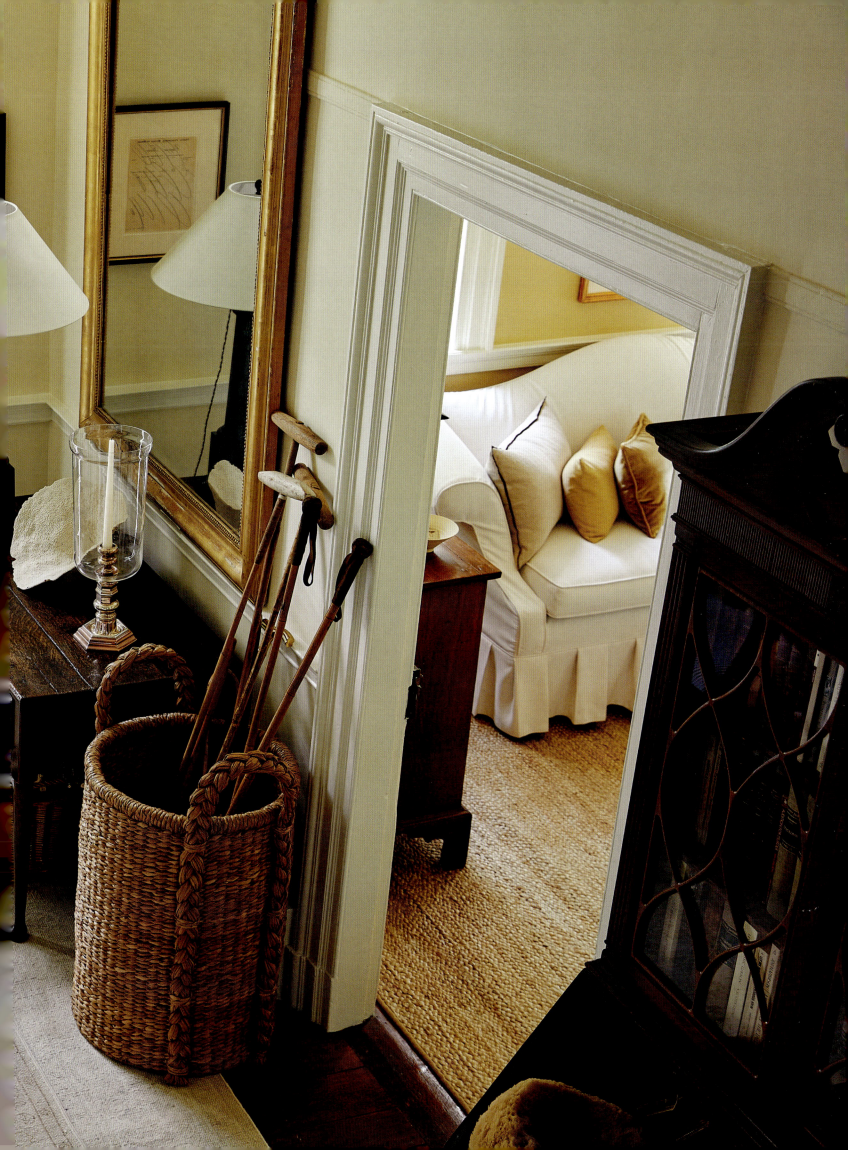

PAGE 88: *Bastille, 1908* mixes oil, acrylic, oil pastel, graphite, and plaster on a 30 by 40–inch canvas. **PAGE 89:** We salvaged the shell of an old fireplace in my D.C. studio and had custom shelves built to fit it, leaving the bricks visible as a textural fillip. **PRECEDING PAGES AND ABOVE:** In the entrance hallway at Sycamore House a large piece of coral, kindling, woven baskets, and polished wood combine to extend a warm welcome to visitors. Bringing in natural items not only lends texture but also smooths the transition between interior and exterior. **OPPOSITE:** A secretary full of books in the entrance hallway at Sycamore House invites browsing, while an antique natural sea sponge begs to be touched.

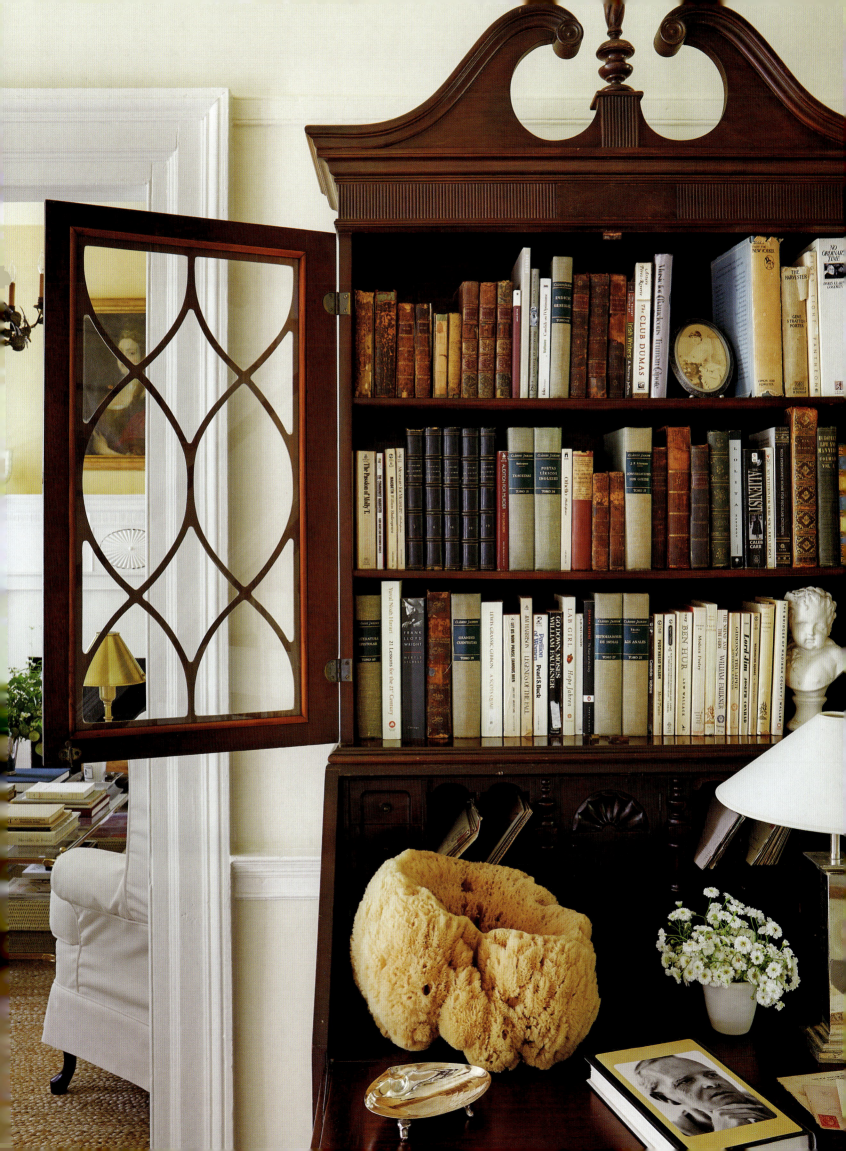

Part of creating a signature style is consistently returning to foundational elements. Returning to those elements is an organic part of the design process, and doing so naturally creates a pattern, which in turn becomes identified with you. A consistent throughline and discipline function as a kind of fingerprint, personal and unique to you.

Texture comes in uncountable forms. I love incorporating wood into a space—the older, the better. Every room needs a little patina. From a demilune to a dining table, wood brings warmth and craftsmanship. Pronounced ridges and grains help give a room soul and character. Glass and crystal are other elements I use frequently. Most people probably would not consider glass a texture—at least, not in the traditional sense—but whether fluted, beveled, or smooth, glass objects contribute sleekness and softness to an interior. Consider the impact of a crystal table lamp, a glass hurricane, or a vase. As part of the give-and-take aspect, glass—especially when transparent—permits other textures to be more prominent. Intertwining these textures ultimately creates a whole bigger than the sum of its parts.

Texture brings a room to life. As in a painting, in a room, textural harmony relies on curating the right mix. But there's a major difference between admiring artwork in a gallery and inhabiting a space—you will actually be touching everything in the room. You'll feel that sisal rug under your feet; your fingers will brush against the cool glass base of a lamp as you switch it on. Don't be afraid to use your sense of touch when shopping for items to decorate a space. (With permission, of course.) Only by experiencing them can you best decide what will transform a space into its best self, and the most accurate reflection of you.

OPPOSITE, CLOCKWISE FROM TOP LEFT: Spiky sea holly contrasts with the softer forms of coral. Natural elements like coral hold their own with framed artwork. A large sea sponge and a small flower arrangement play with texture and size. Orange ranunculus offer a burst of unexpected color on a windowsill.

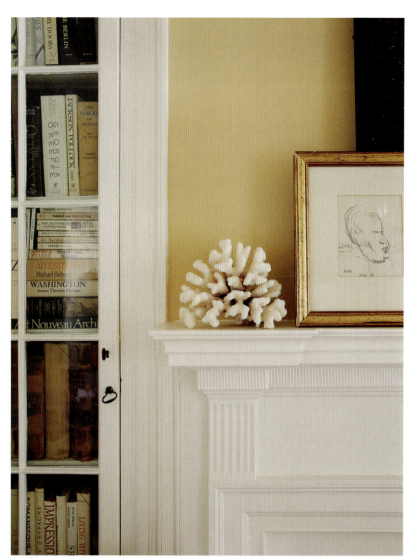

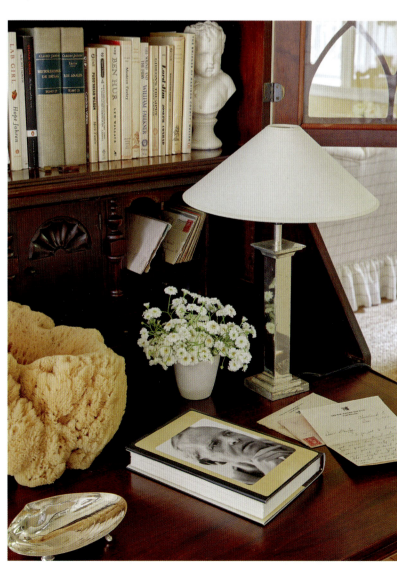

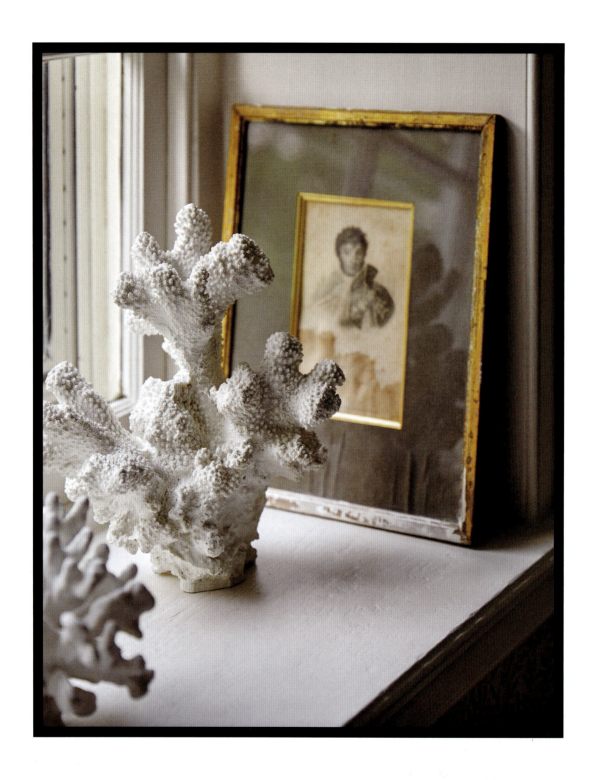

ABOVE: Coral and an antique framed lithograph commune on a windowsill in one of the guest bedrooms. OPPOSITE: Through the looking glass: A nineteenth-century chest sits in the parlor-floor living room at Sycamore House. A French Louis Philippe silver gilt mirror from 1860 serves as a backdrop for a large smoke bush arrangement.

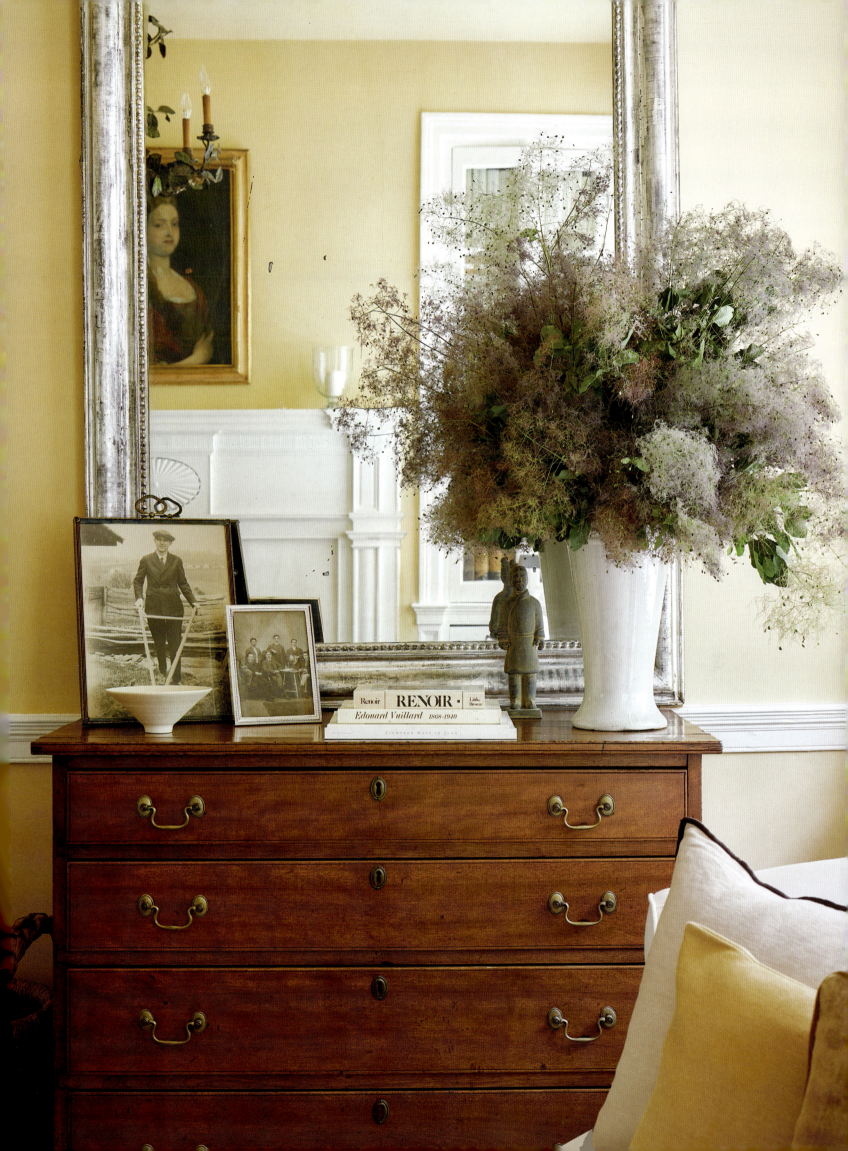

A roomful of perfectly smooth surfaces offers no surprises, and it's not just our fingertips that experience texture. Varying textures are a treat for the eye as well, as they cast shadows and result in a space that reads as personal and unique. At home, I work hard to ensure there's a textural experience everywhere you look — or touch. Stacked wicker baskets and chargers fill the shelves of our kitchen pantry. Neatly folded embroidered and woven tablecloths and napkins are piled high in the dining room cabinets. In my studio, there are chests full of worn, brittle antique documents and books that I use in my work. Utility carts contain cups and trays of dried, crumbly plaster and pastels — remnants from a finished piece. All items and elements chosen intentionally for their varied textural quality.

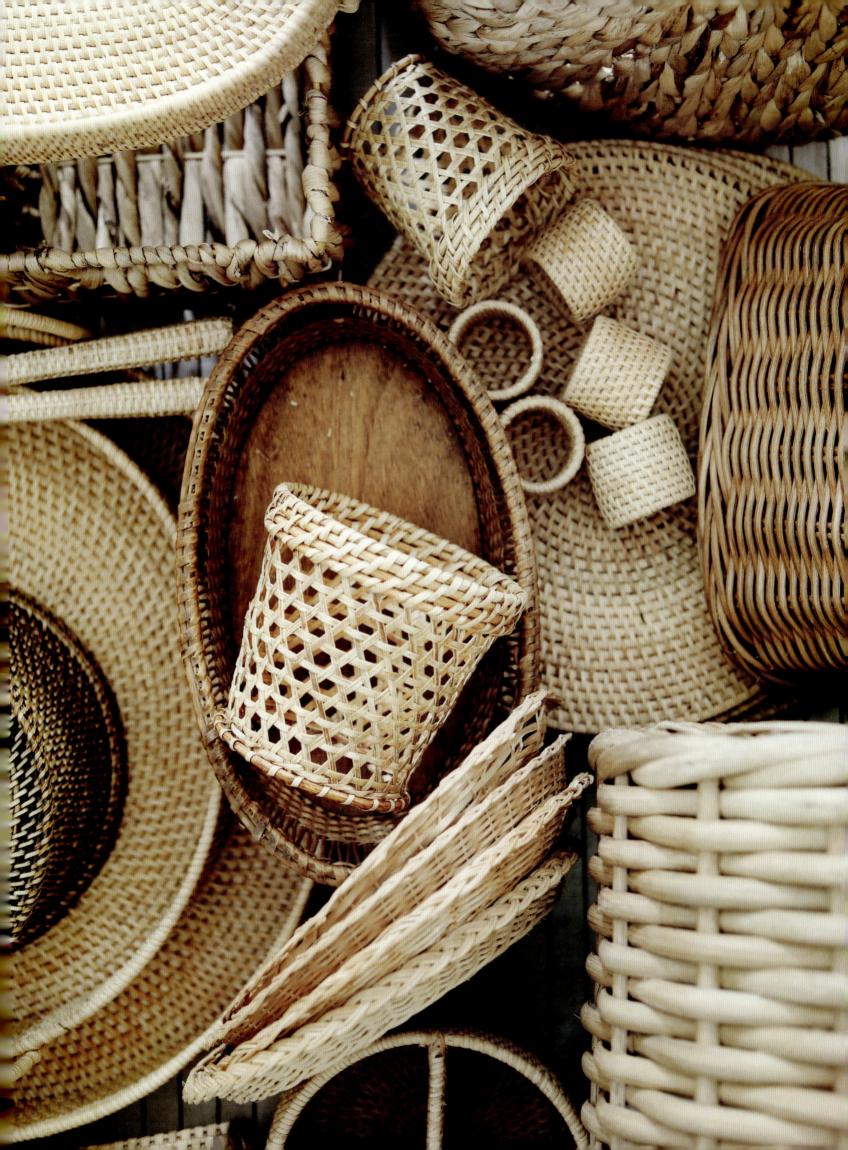

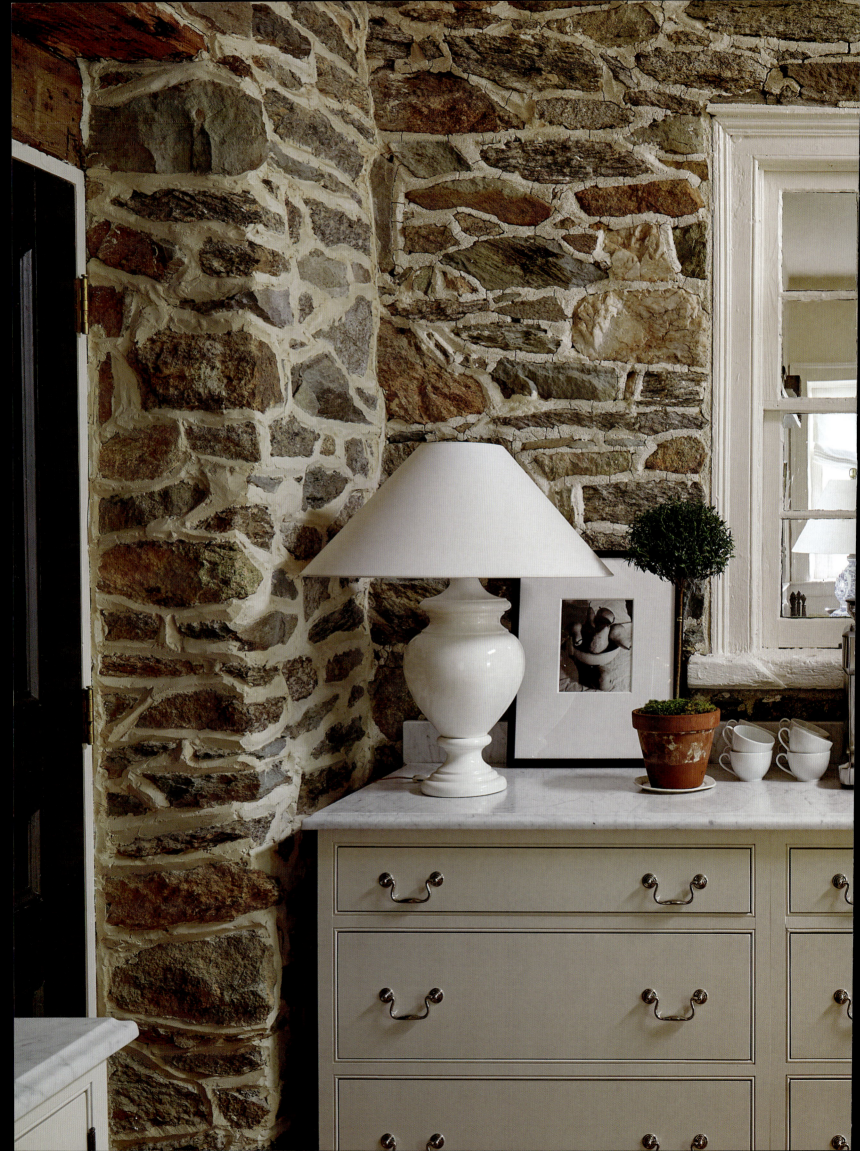

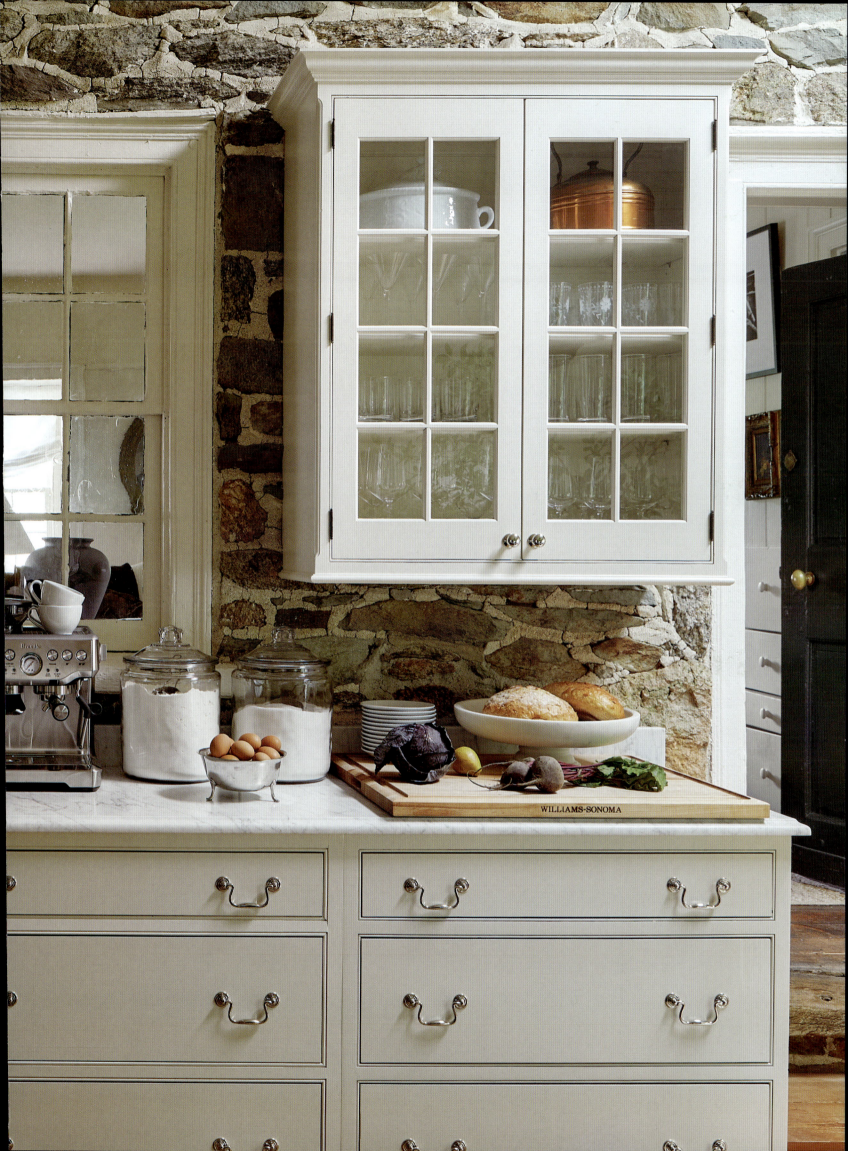

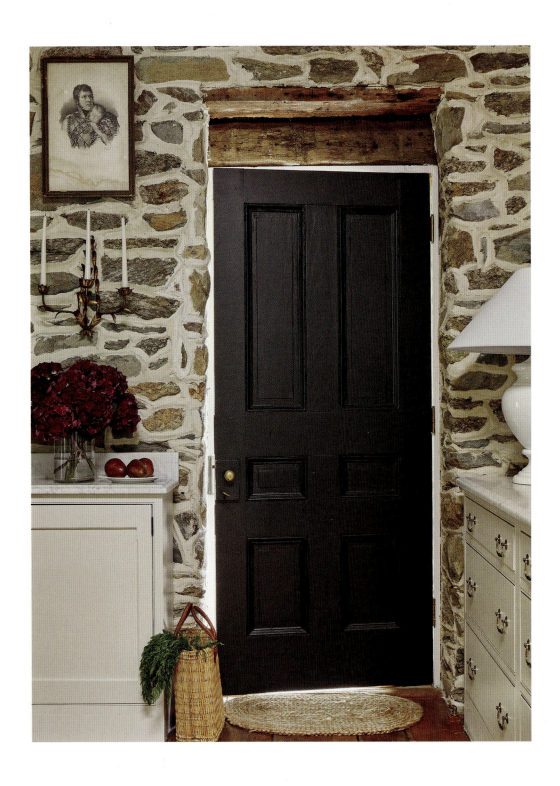

PRECEDING PAGES: The kitchen at Sycamore House was an addition to the original home. The fieldstone walls add a unique textural and natural quality to the room. **ABOVE:** The side entrance to the kitchen. **OPPOSITE:** Open shelves of white dinnerware, silver, and stemware stand aside the original wooden exterior doors and frame from 1780 that lead to the basement and storage area of Sycamore House.

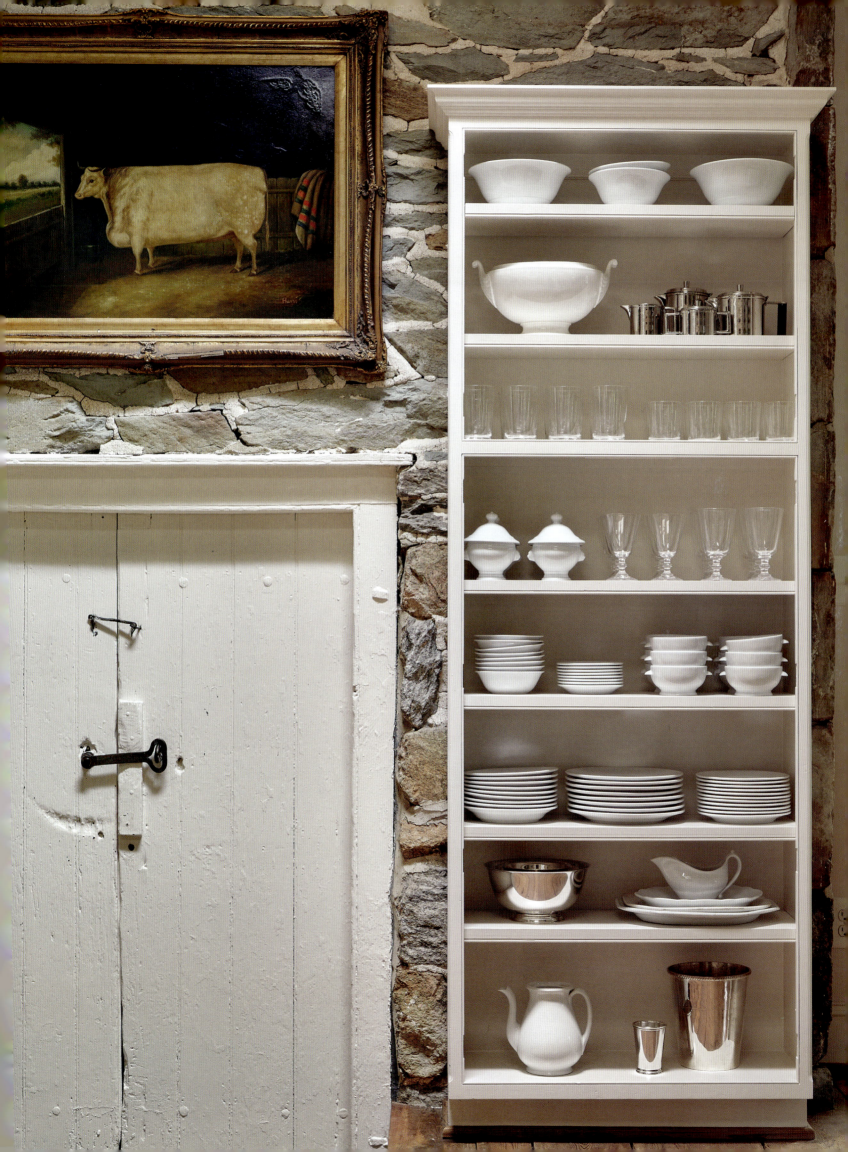

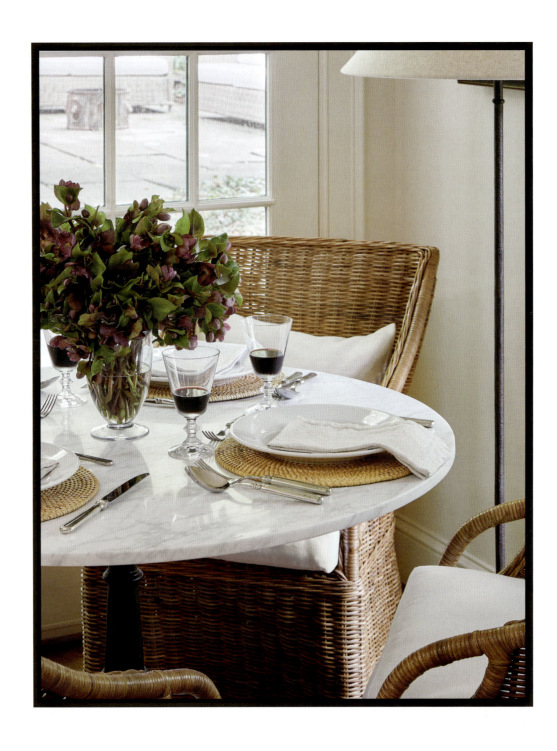

ABOVE AND OPPOSITE: Handwoven rattan chairs contrast with a small, polished marble breakfast table.

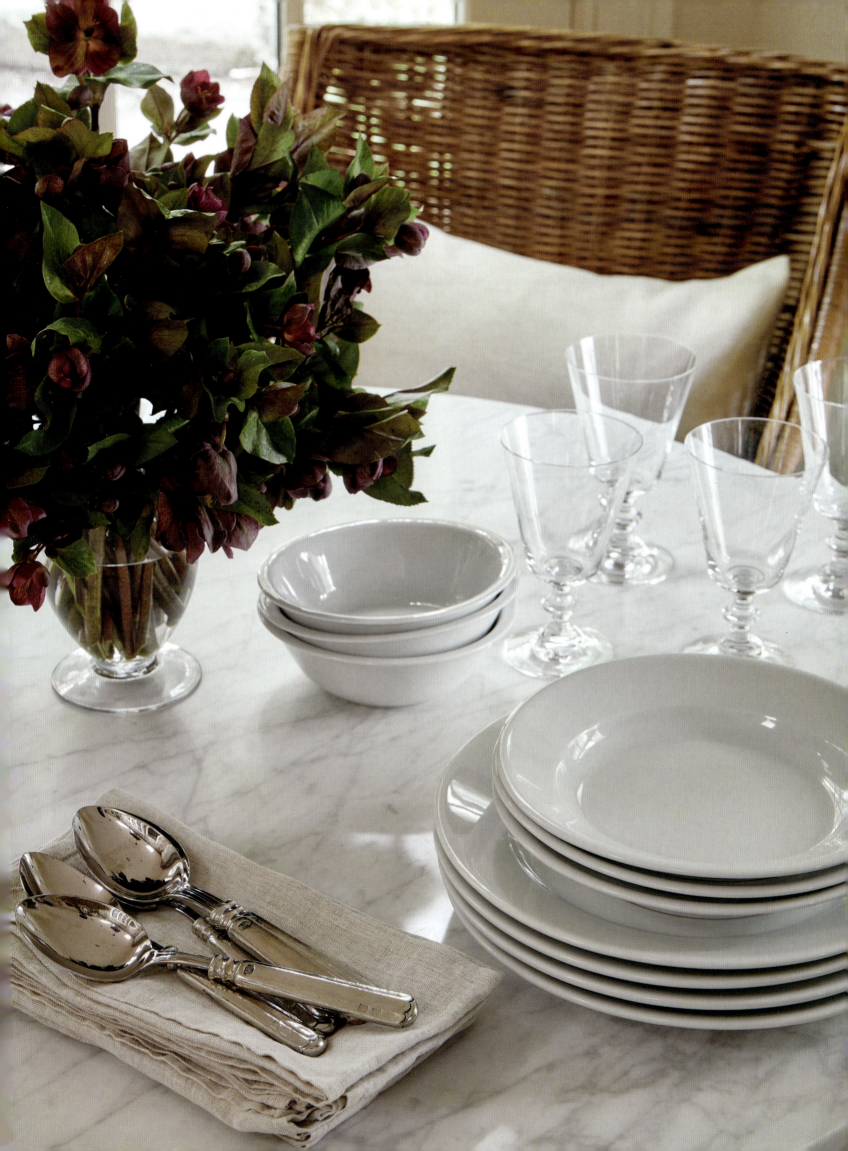

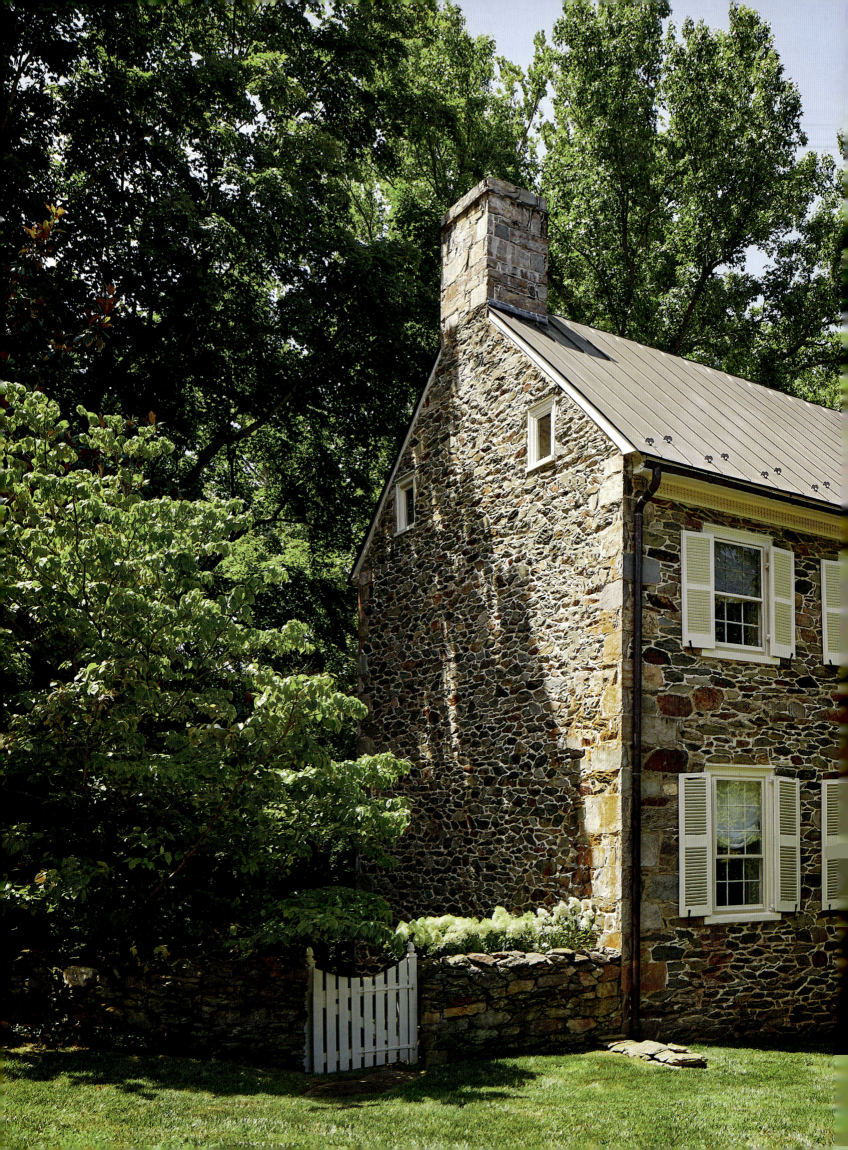

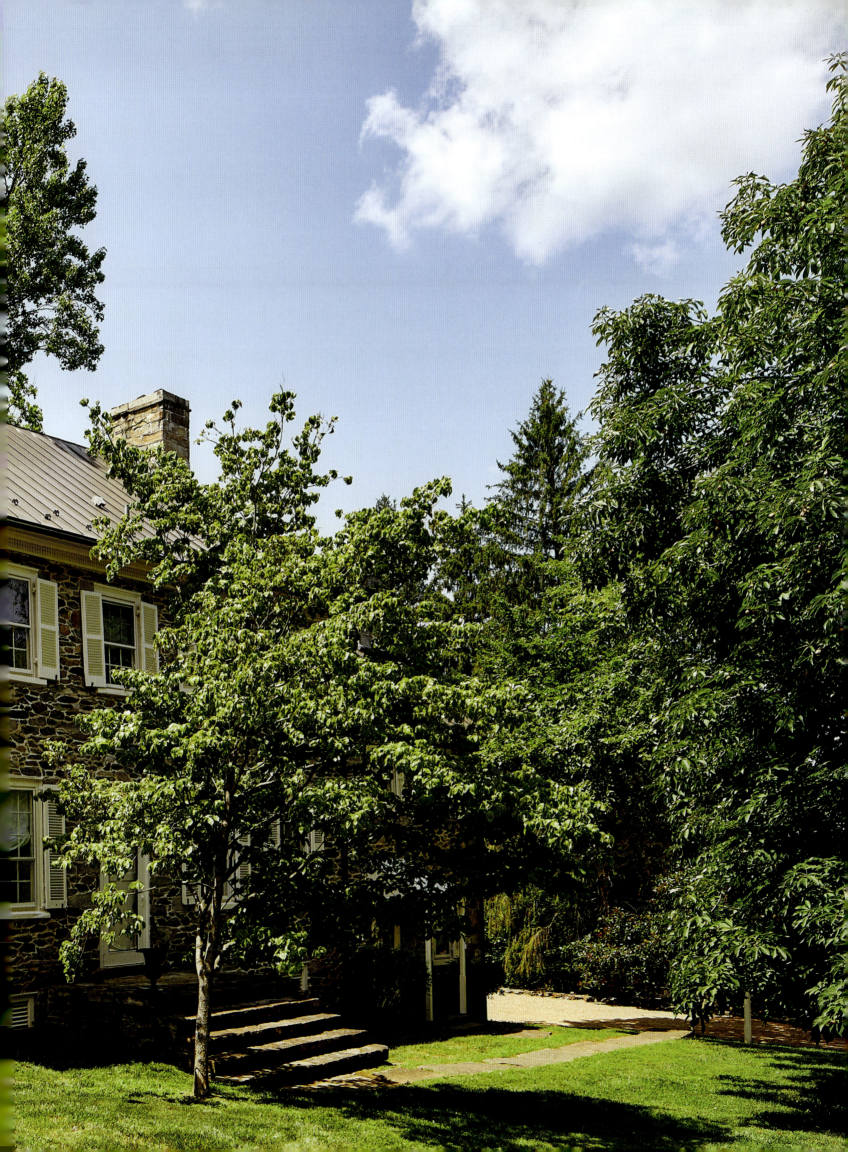

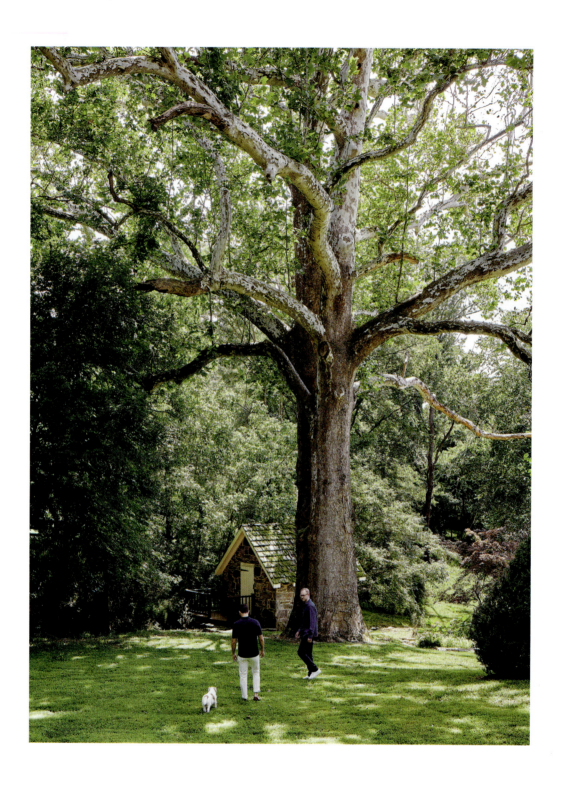

PRECEDING PAGES: The exterior of Sycamore House is a symphony of stonework. **ABOVE:** The large 400-year-old sycamore tree in the backyard inspired our naming of the property. Behind it is an original spring house. These small structures built over streams were often used to store food in the days before refrigeration. **OPPOSITE:** The entrance in the local fieldstone facade is topped by an original, unusually patterned transom window.

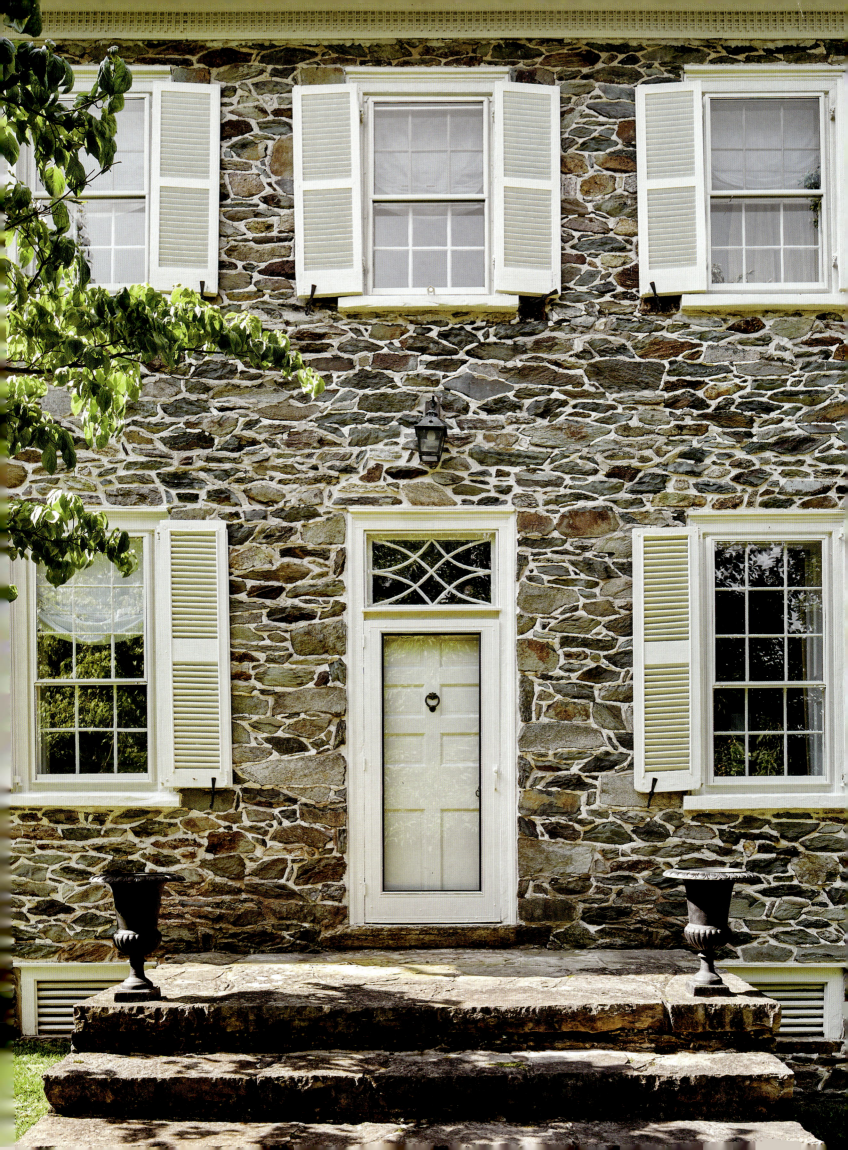

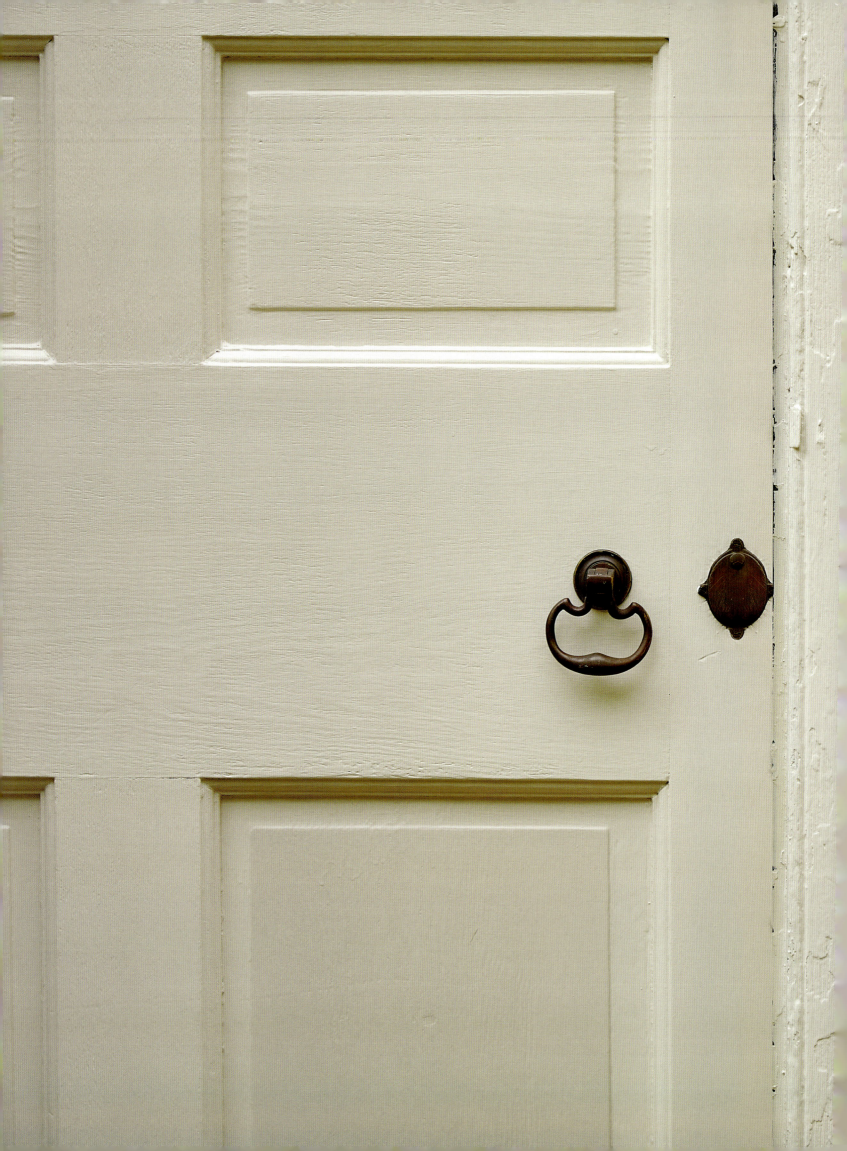

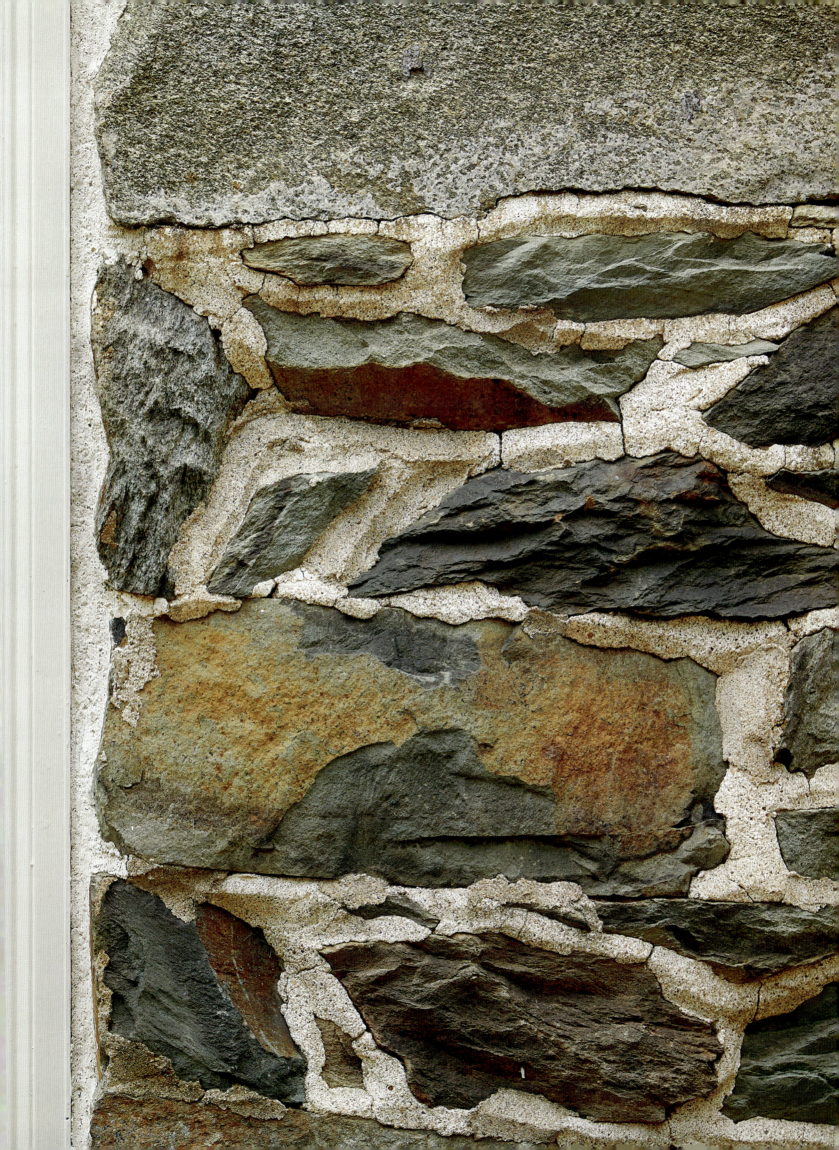

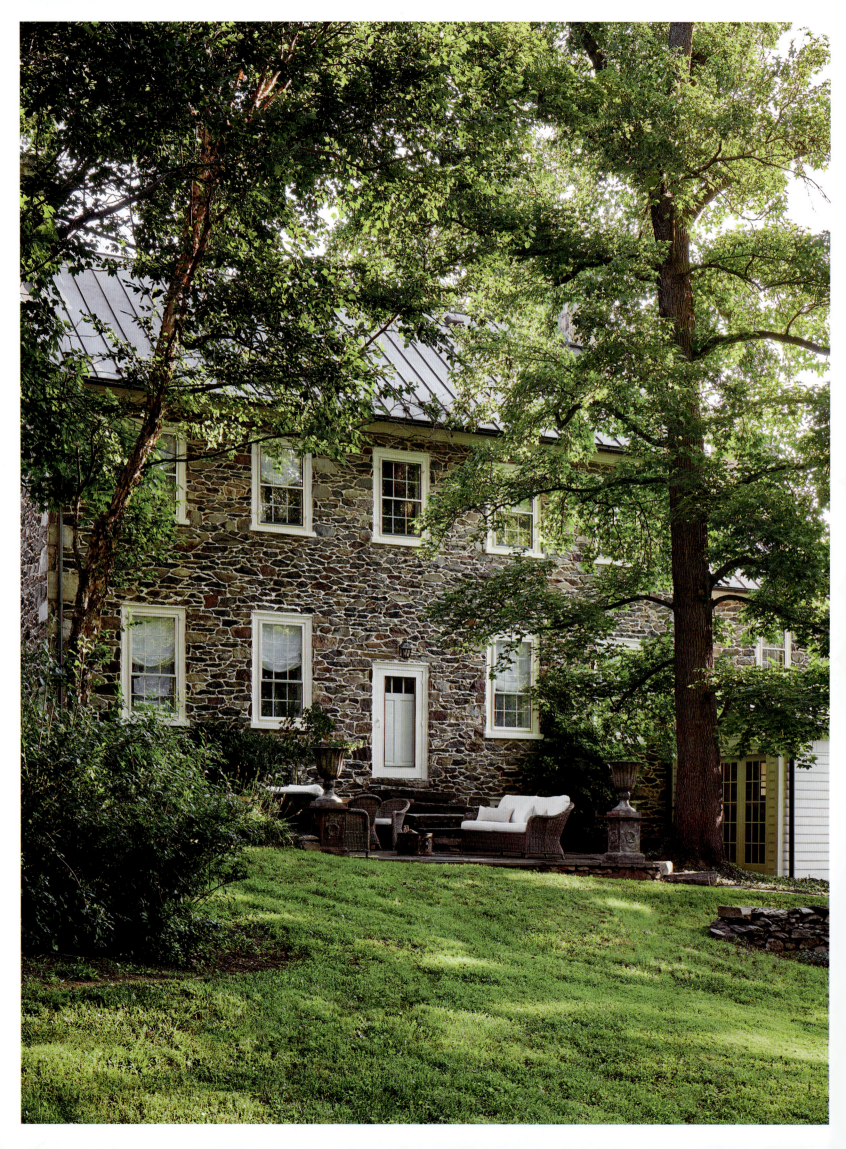

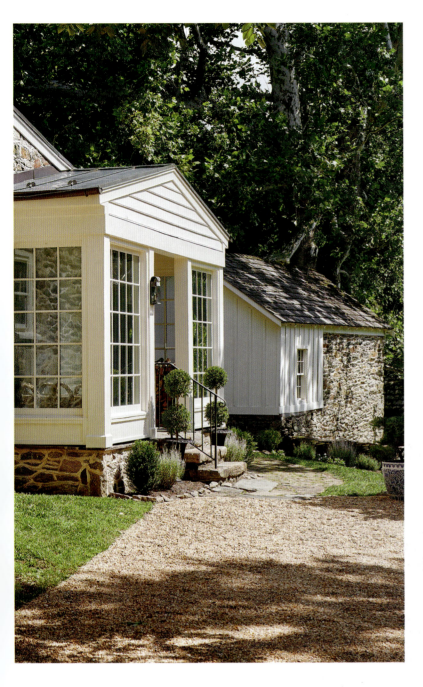
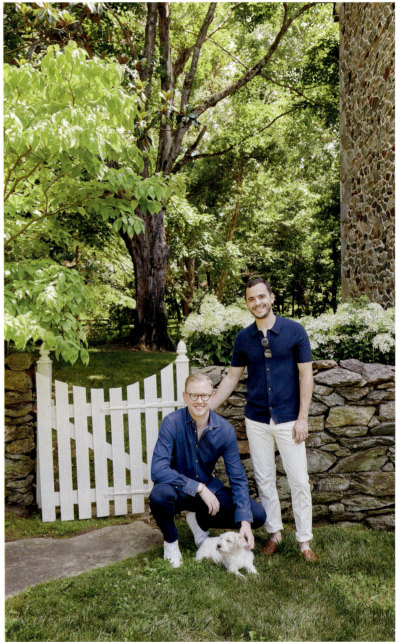

PRECEDING PAGES: The creamy painted door, original rustic hardware, and rough hand-hewn fieldstone are a study in contrasts. OPPOSITE: The rear door of Sycamore House opens onto a patio with plenty of comfortable seating. ABOVE, LEFT: The pea gravel driveway leads to the side porch entrance of the house. ABOVE, RIGHT: Ignacio, Maggie, and me.

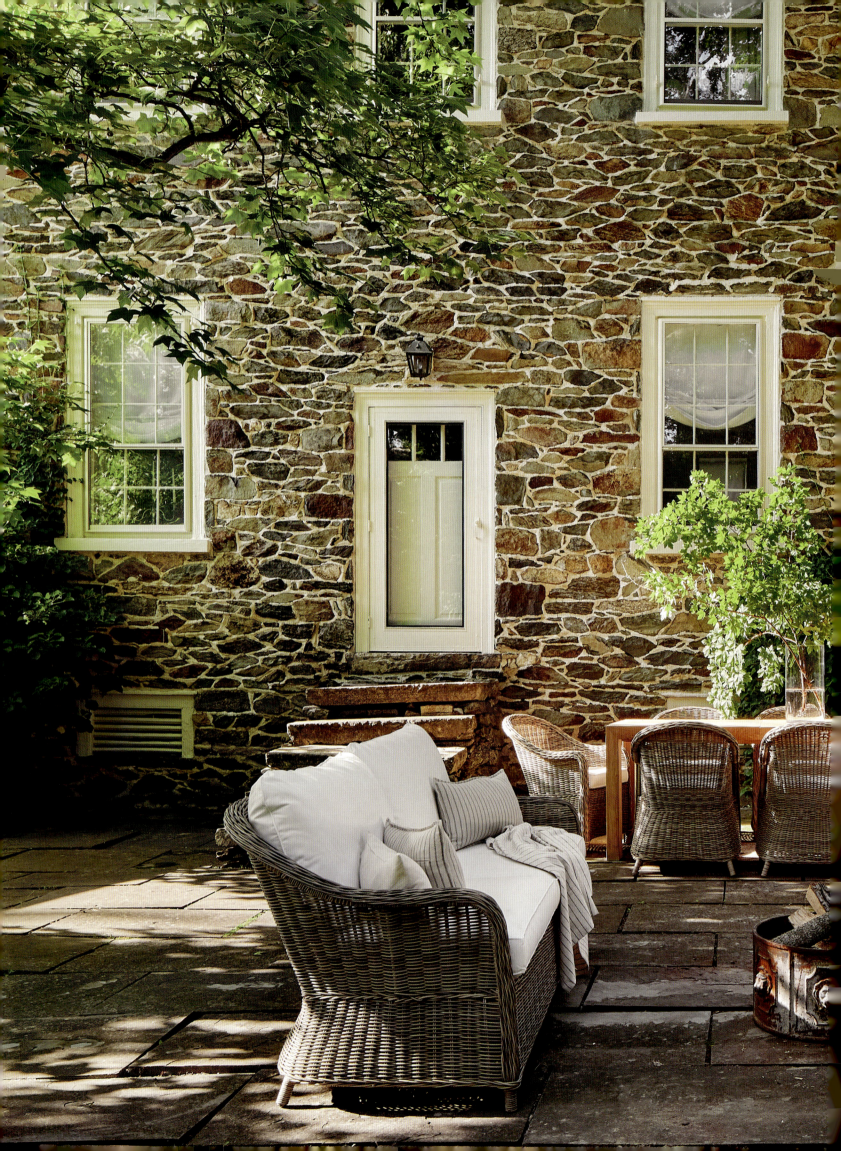

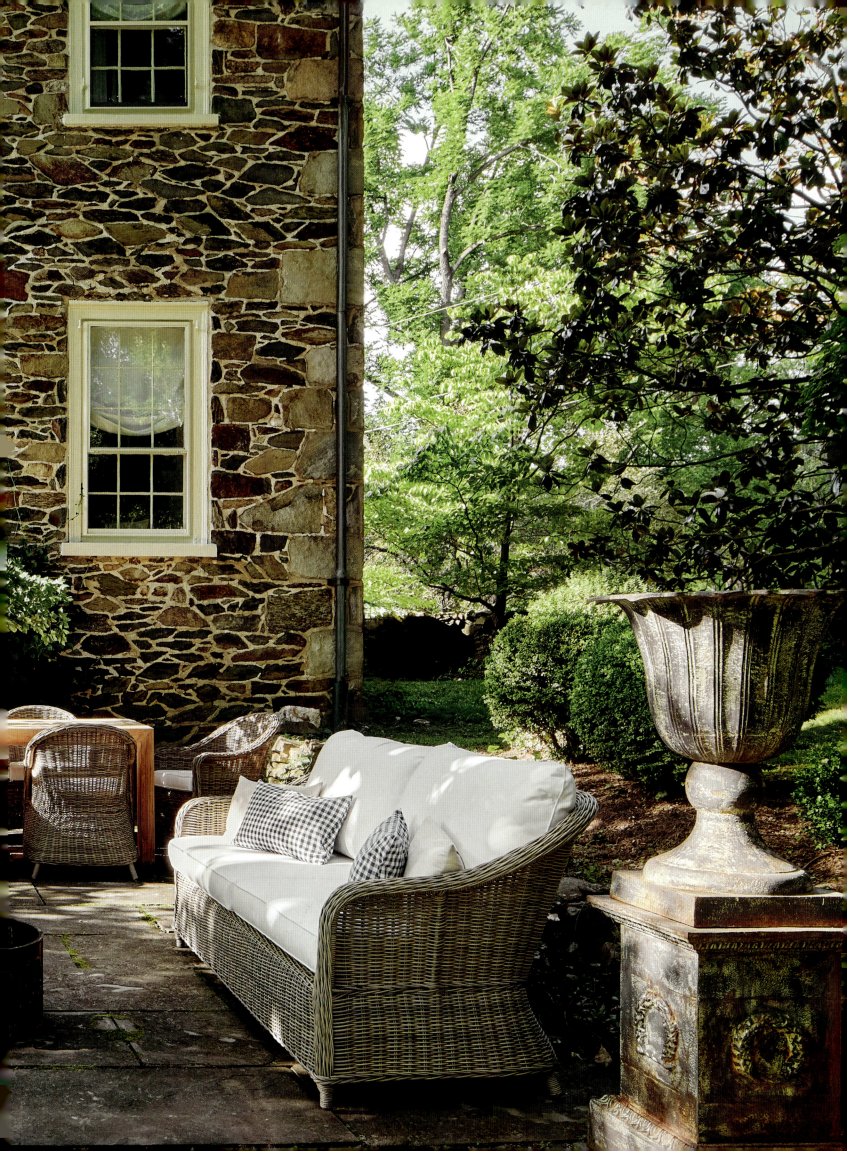

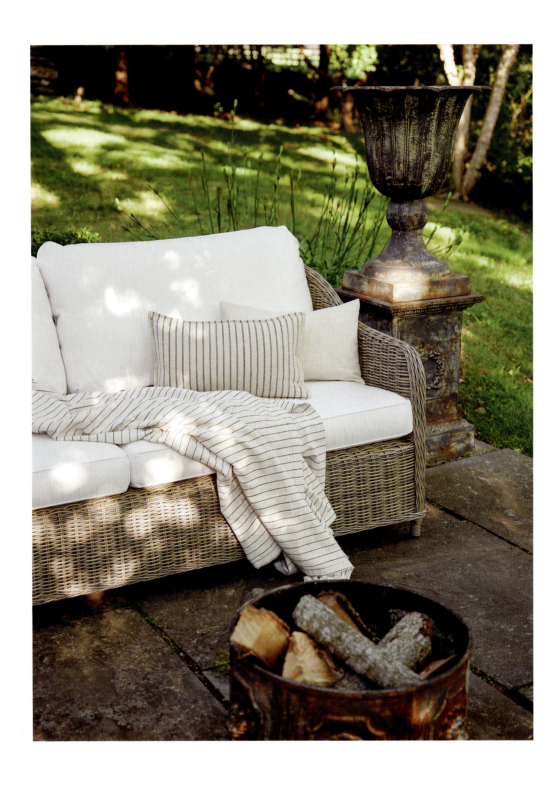

PRECEDING PAGES: On the back patio, wicker sofas and dining chairs blend seamlessly with the house's facade. A large urn on a pedestal makes a statement. **ABOVE:** The firepit makes this space usable for a good portion of the year. **OPPOSITE:** One of the original stone walls and a mix of limelight and puffer fish hydrangeas delineate the backyard.

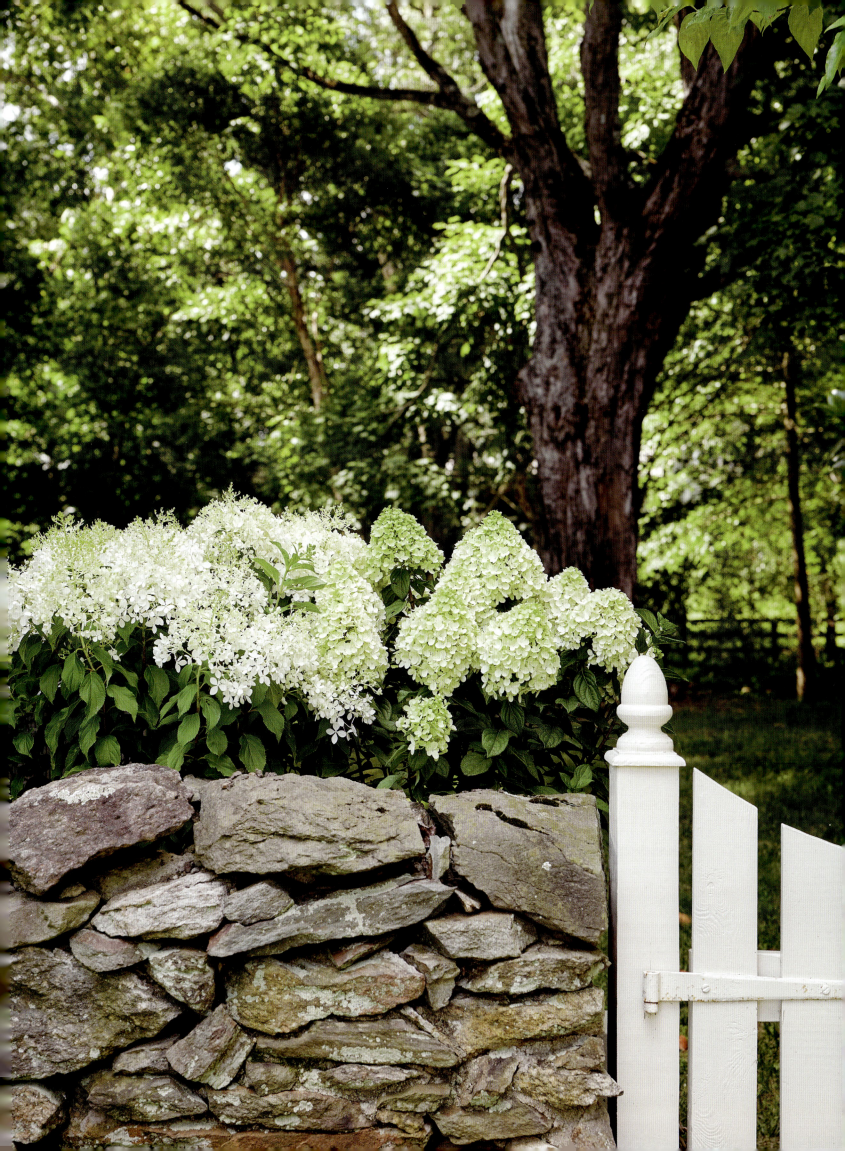

Owning Sycamore House is a dream come true, a manifestation of my childhood admiration for the historic, eighteenth-century stone houses that dotted the Pennsylvania countryside where I grew up. When we purchased the property in the spring of 2022, I was already in love with the home's rich, textural facade, enamored of its craftsmanship, and completely in awe at the thought that each individual stone was gathered and stacked by hand. Built in 1780, Sycamore House is a Federal-style stone farmhouse nestled in a tiny village in Northern Virginia, an area known for historic homes, estates, vineyards, rolling hills, and quaint villages. It is appropriately deemed Virginia's horse and hunt country. Located just one hour and twenty minutes' drive from our townhouse in D.C., the home is our weekend refuge and a place to celebrate and host holidays with family and friends.

Built by Quakers from Bucks County, Pennsylvania, the home is steeped in history. It housed soldiers during the Revolutionary and Civil Wars, and many of its original architectural features—what an architect would call its bones—are still intact. Walking around the property, you can't help but look at and touch the exterior stone. Throughout the day, the sun's warm light against the stone and mortar casts dancing shadows, soothing to the eye. The home is simple and primitive in nature, but it exudes classic elegance—like something from a storybook. It is our little slice of heaven in the countryside. As an artist, this home has become a place where I can dream, create, and welcome others into my world.

OPPOSITE, CLOCKWISE FROM TOP LEFT: The slats of painted shutters contrast with curved hardware. Outdoor planters develop pleasing patina. Paneled rectangles in the front door balance the irregular pattern of the fieldstone. Natural stone offers an infinite variety of colors and textures. **FOLLOWING PAGES**: Firewood stacked by the back door illustrates the impact of ridges and grains.

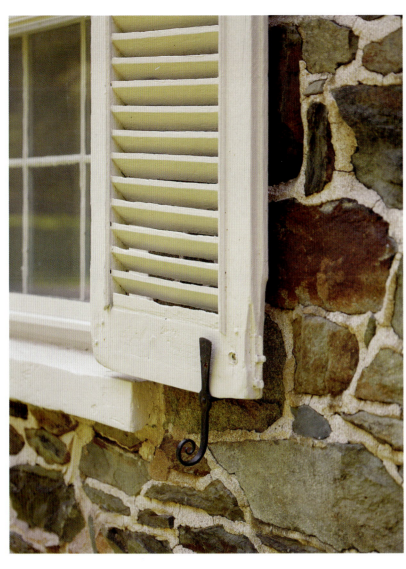
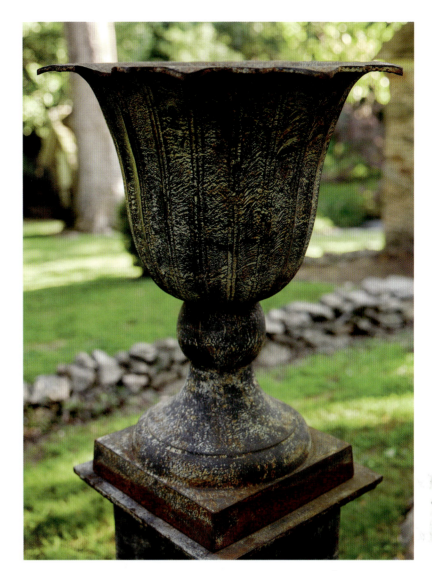
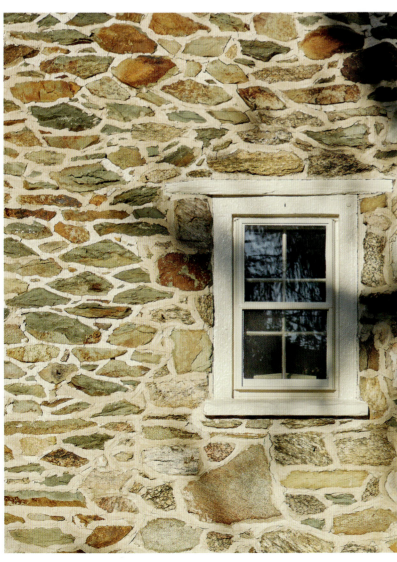
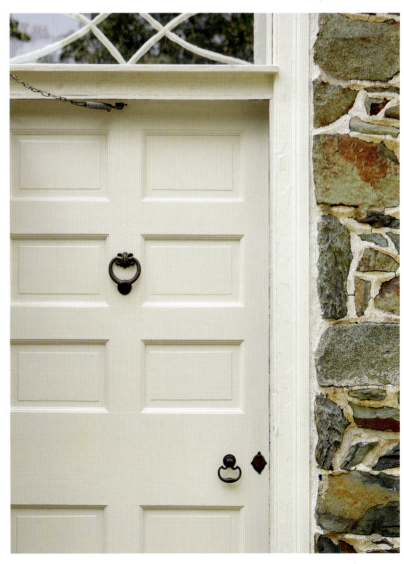

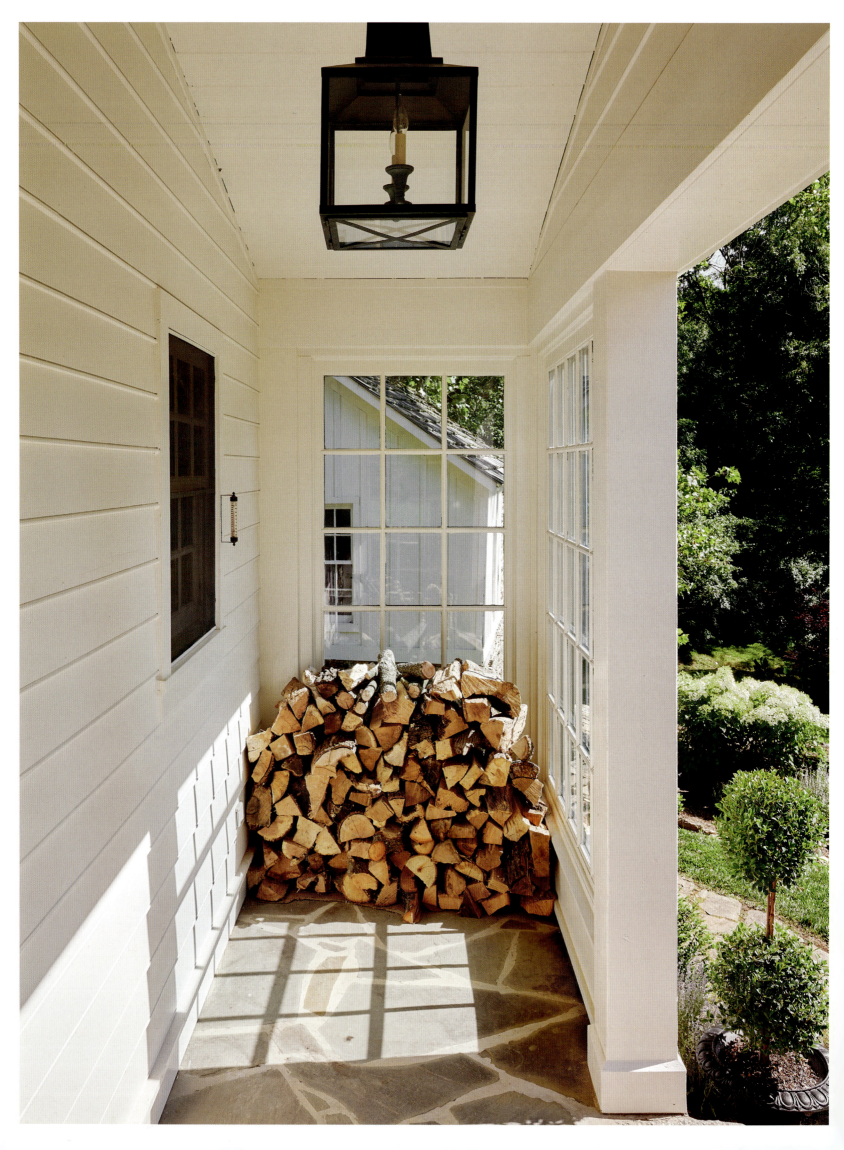

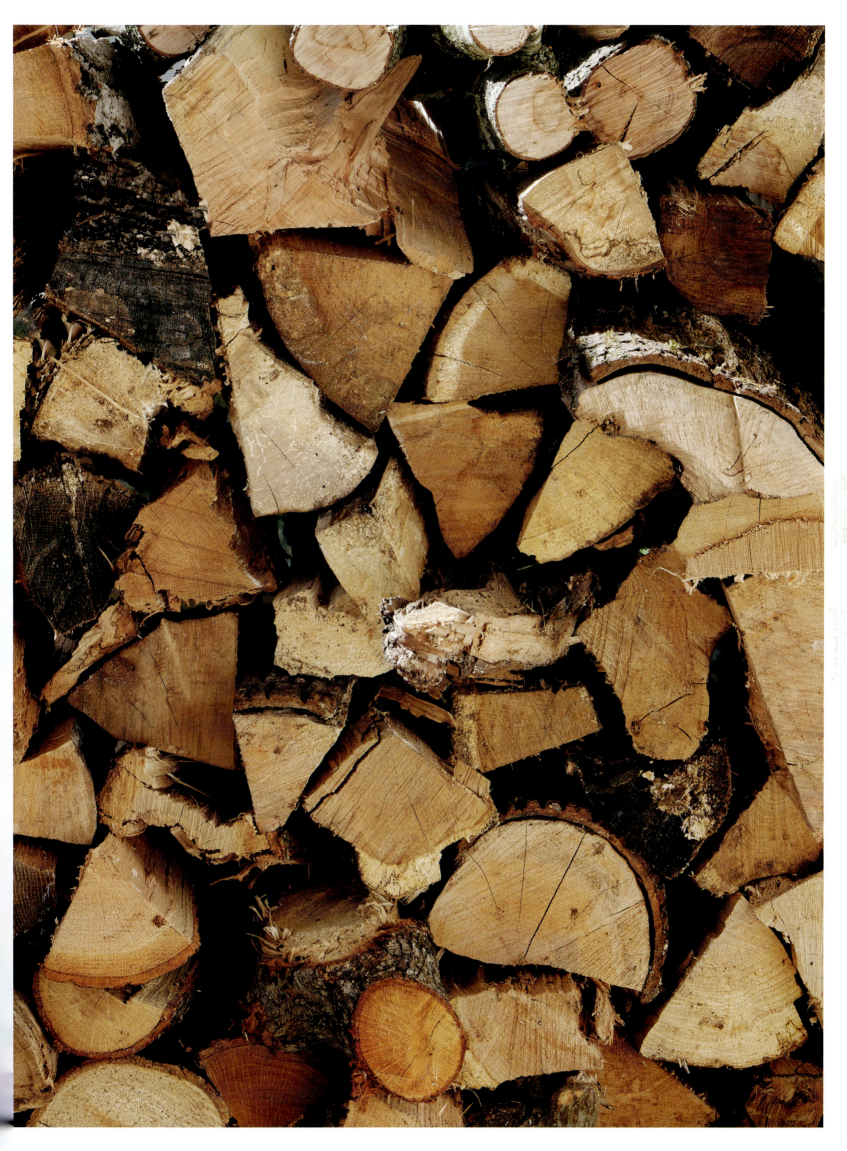

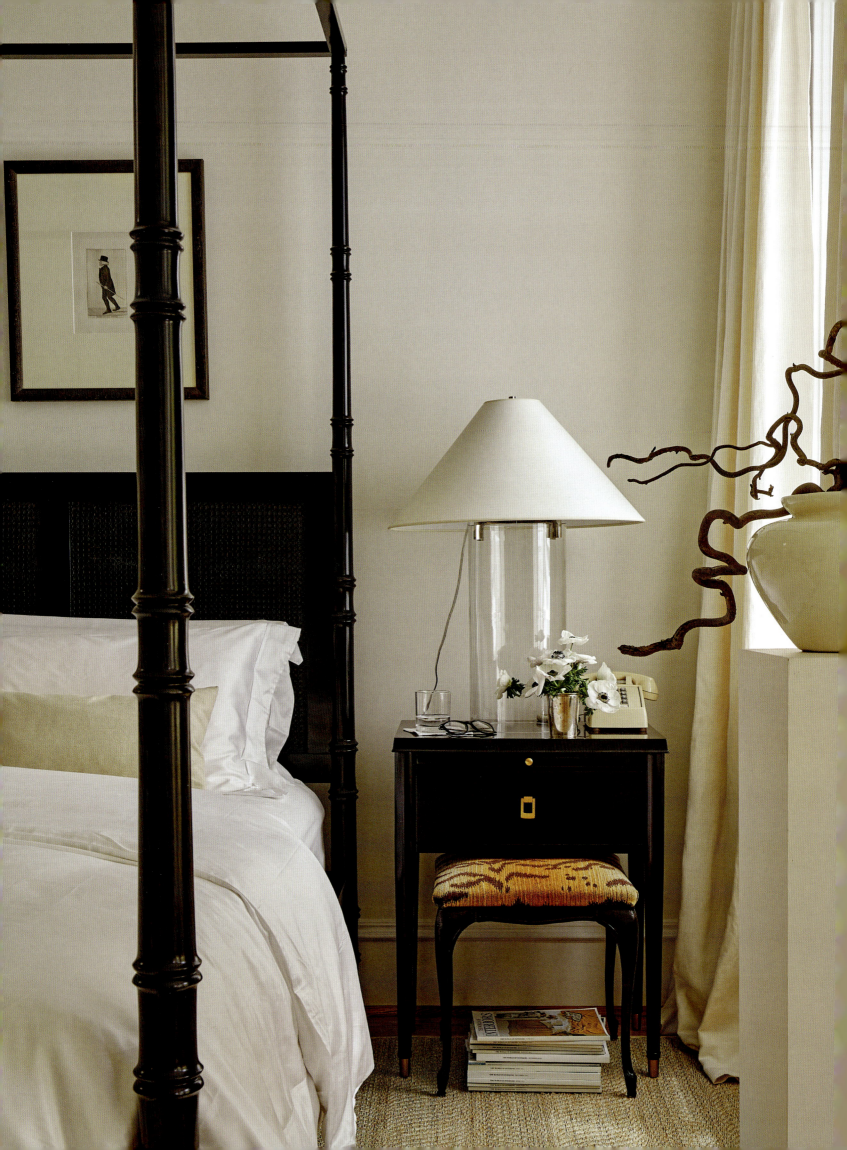

FORM

PALA
Vestibu
F

PL. 48

ÉTATS
e des États
siècle

Deposé

For as long as I can remember, I've been acutely aware of shapes and forms. Indeed, that awareness was a strong motivator that led me to become an artist. When I was young and first studying the great abstract expressionists, I was captivated by their use and manipulation of line and shape. This awakening led me to become hyper-aware of various shapes and forms and how I use them in my work and projects today.

I'm often asked what is most important when grouping and curating pieces for a room. The answer is always the same: form. Whether I'm painting or designing an interior, I consider how forms, lines, and silhouettes interact. Combining them is a juggling act, but one I enjoy. You need some commonality, but also juxtaposition of different shapes in a space. And feeling them click into place is wonderful. The mix entertains the eye—when it works, looking at it is like attending a dance performance.

The shapes and forms I include on a canvas define the overall feeling and mood of a piece. Geometric, angular forms add a sense of structure and tension, while round shapes add fluidity and ease. Some forms bring in visual weight, while others contribute balance and movement. It all depends on their placement and how they coexist with one another.

PRECEDING PAGES: *Vestibule de la Salle des États*, collage work on nineteenth-century architectural plate.
OPPOSITE: Pieces from Alfaro Pottery on our dining room mantel play on shape, form, and scale.

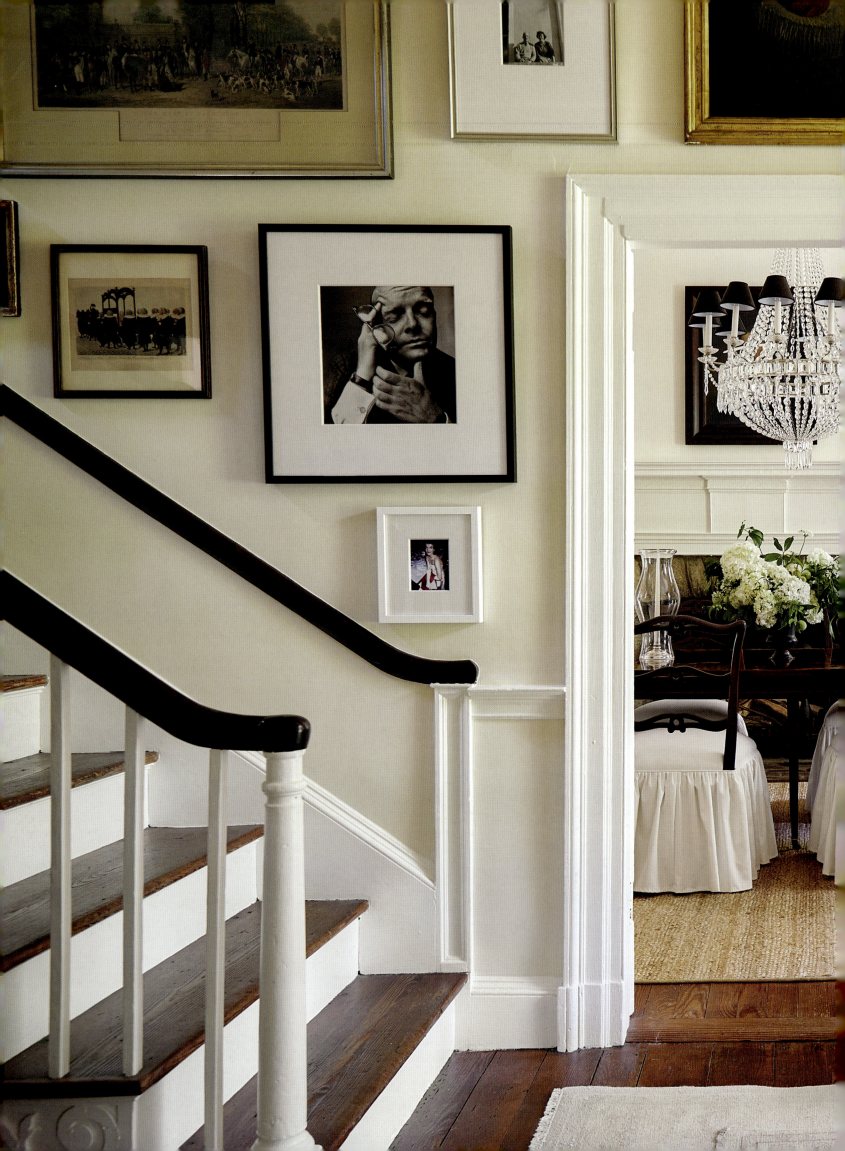

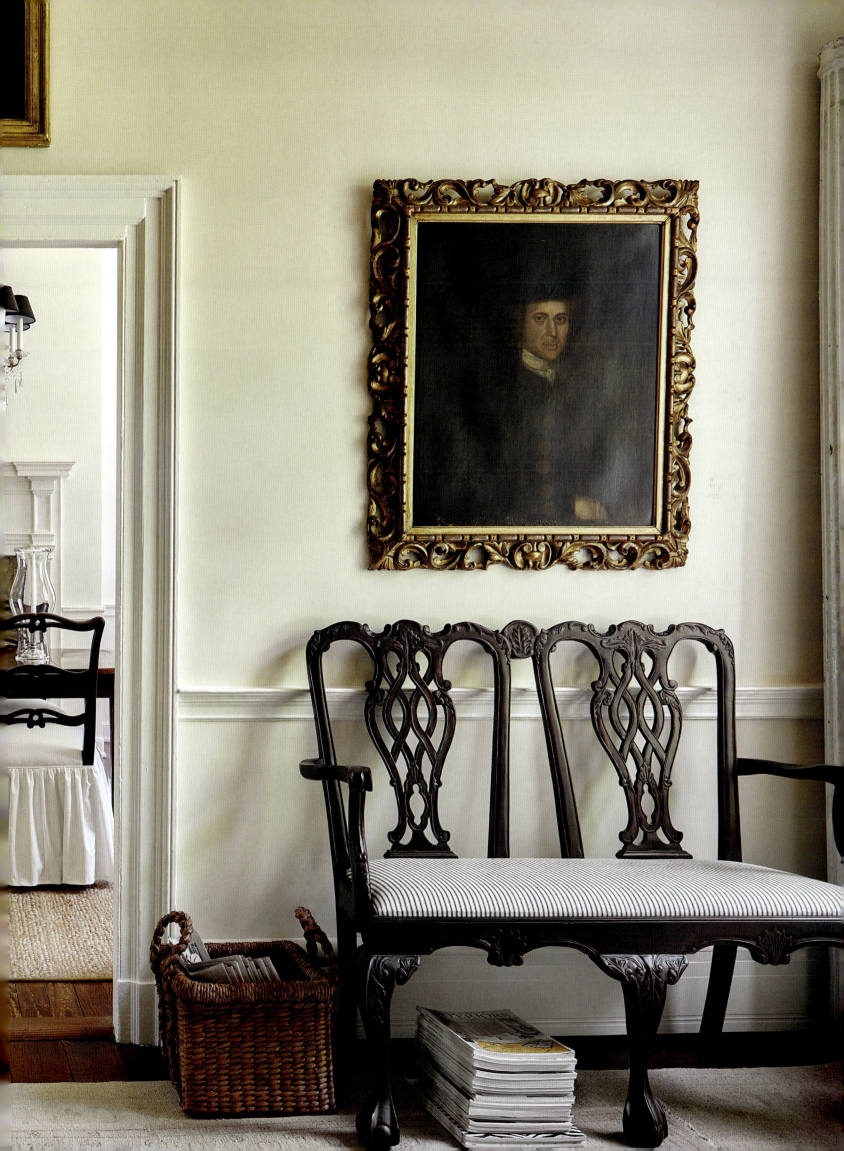

PAGE 128: *École St-François*, collage work on nineteenth-century architectural plate. PAGE 129: In the entrance to our D.C. townhouse, round forms contrast with straight lines. PRECEDING PAGES: The main entrance at Sycamore House and the adjoining formal dining room are a great example of line, form, and contrast at work. ABOVE: Mixed media abstract on an antique book page featuring pastel and graphite. OPPOSITE: I filled the (non-working) fireplace in my Chicago apartment with books in a geometric arrangement, then broke the pattern with a small bust. On top of the mantel sits a framed abstract painting I created titled *Rue de l'Annonciation*.

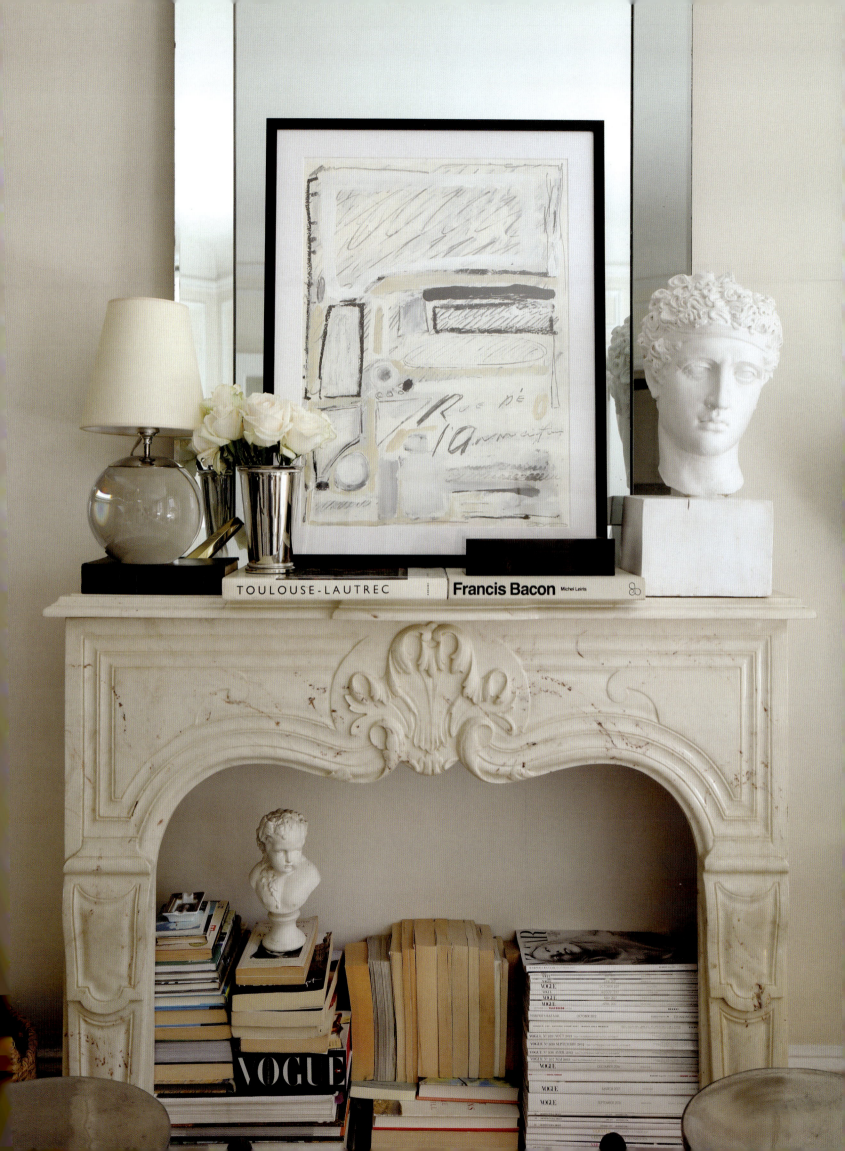

A chair isn't just a chair. Its form, design, and body—for example, the curvature of the legs or the shape of the arms—make it unique. The chairs you choose can have a powerful impact on a room.

At Sycamore House, our country property in Virginia, the expansive and airy dining room sits on the main floor. I designed it to feel elegant and restrained. Refined, but not stuffy, in contrast to the formal traditions that surely once prevailed, as evidenced by the large fireplace, built-in cupboards, and butler's pantry to the side that date to the eighteenth century. A small, primitive staircase leads to the summer kitchen just below.

The last items I sourced for the dining room were the chairs. We visited countless auctions, scoured the internet, and even took a sourcing trip throughout the Northeast from D.C. to Connecticut in search of the perfect set. I sought pieces that would add contrast to the space but had an interesting form as well. Since the room's palette is pared down, they needed to be intricate enough to hold their own while not feeling out of place in a country setting—a tall order. We tried four different sets, and then we finally settled on the perfect Chippendale ladderback chairs. Their delicate form was suited to the space. To soften them, I designed custom ruffled skirts that add romance and contrast with the dark lines of the backs.

OPPOSITE: An ornate vintage gilded frame, the backrest of a Chippendale bench, and a salvaged column sourced from Chicago contribute intricate, delicate forms to a hallway vignette.

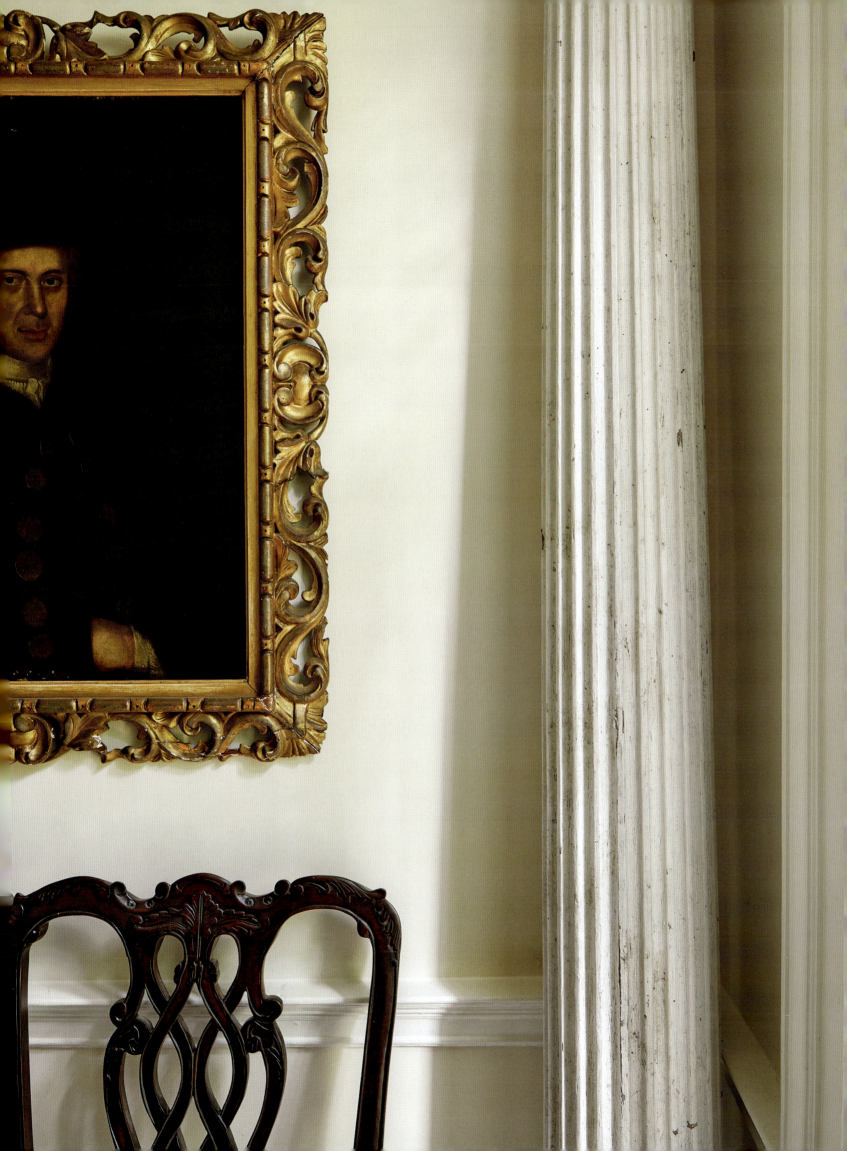

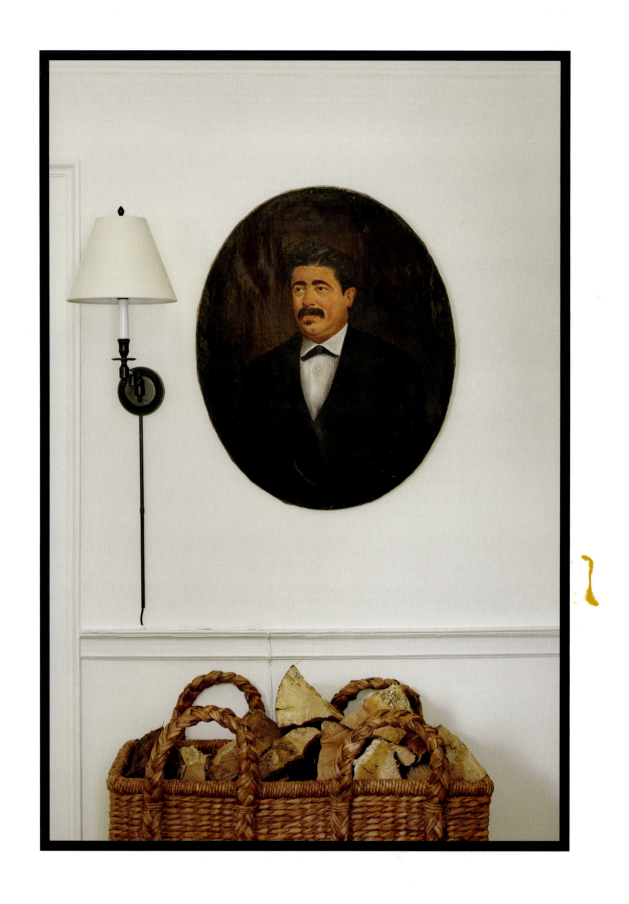

ABOVE AND OPPOSITE: Portraits from different periods and in various shapes and sizes fill the walls of the dining room at Sycamore House.

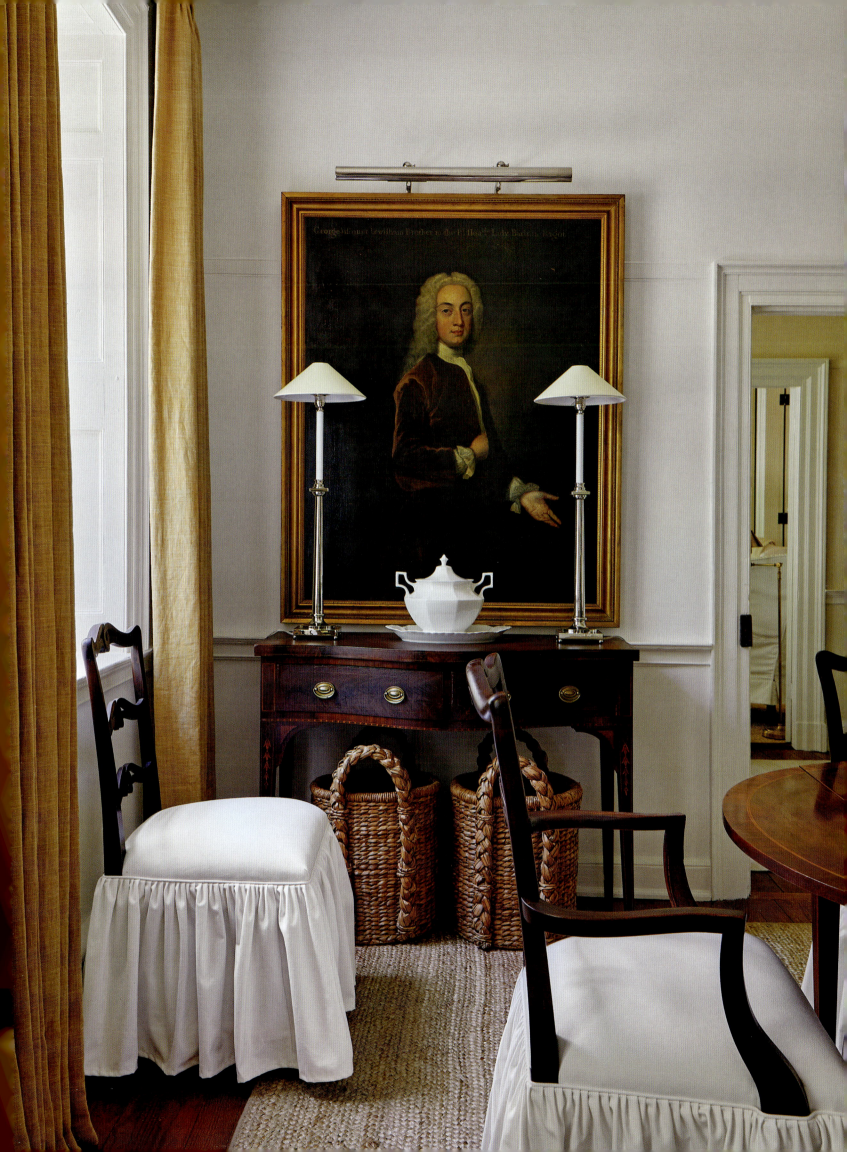

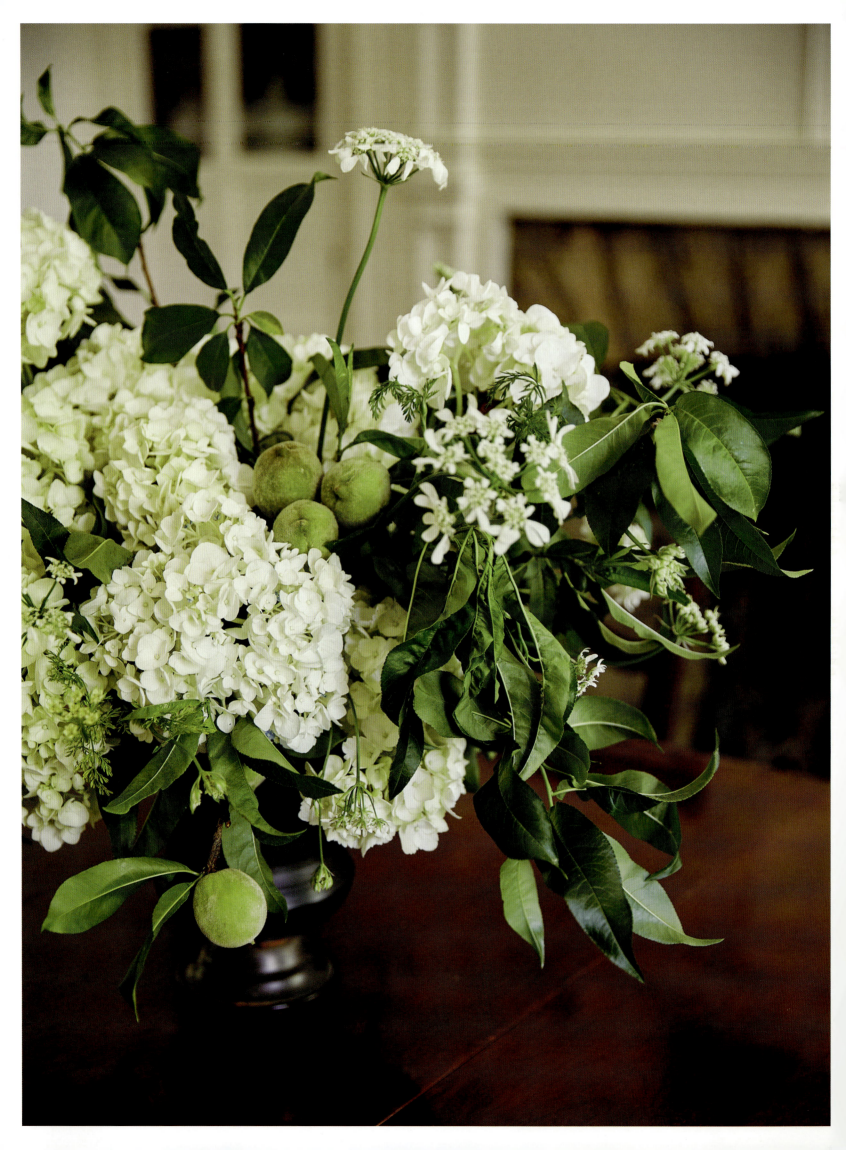

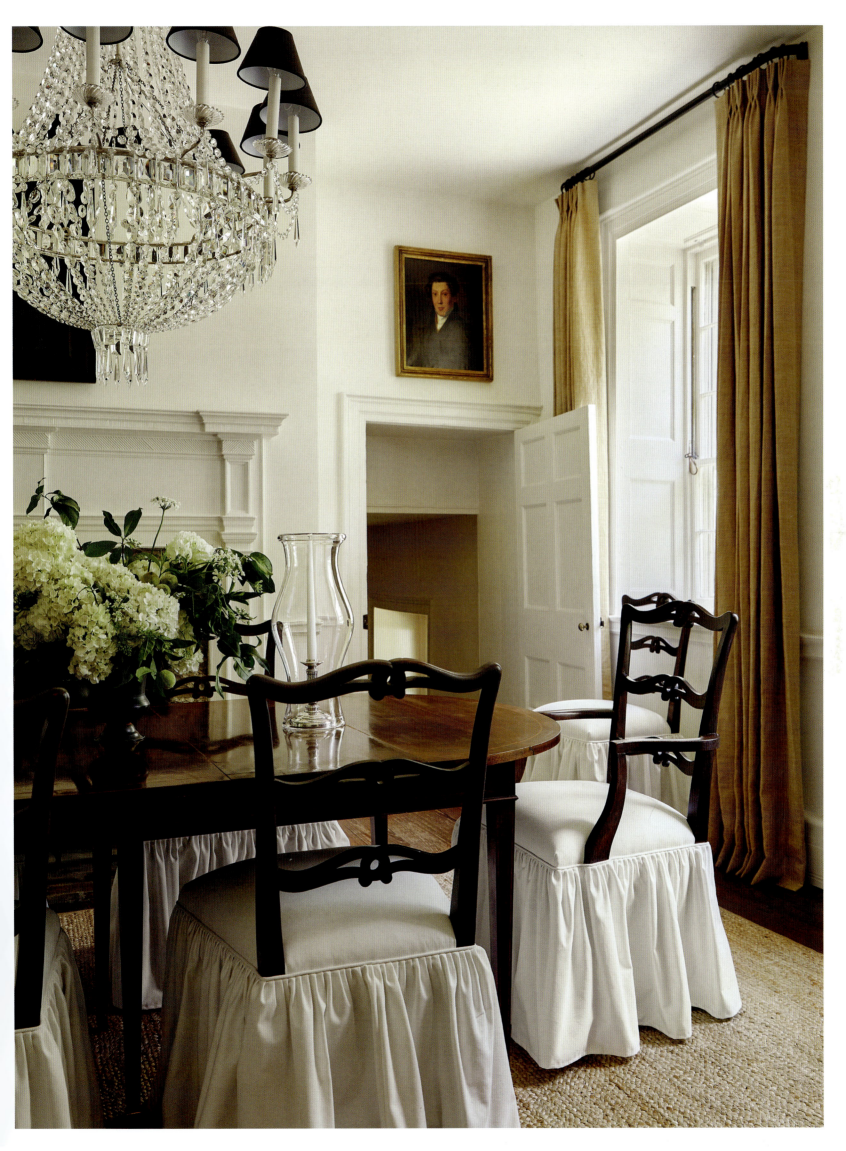

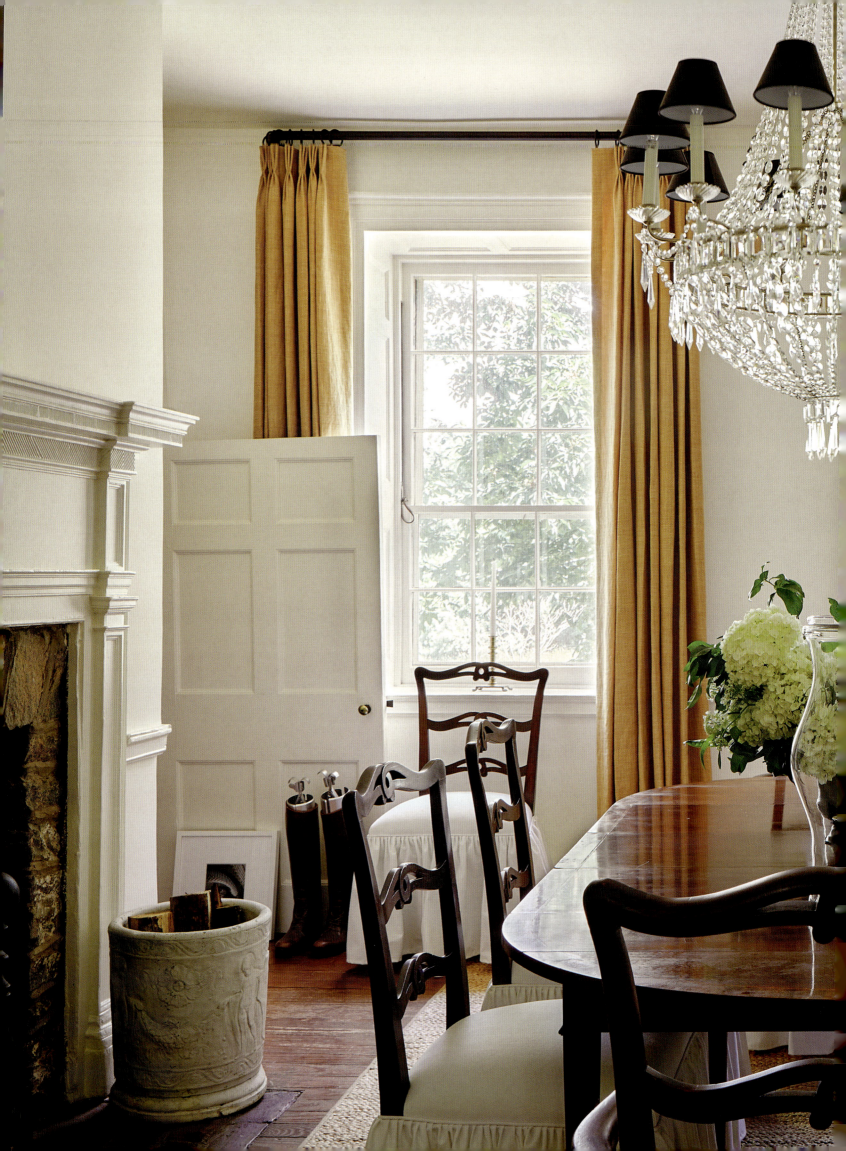

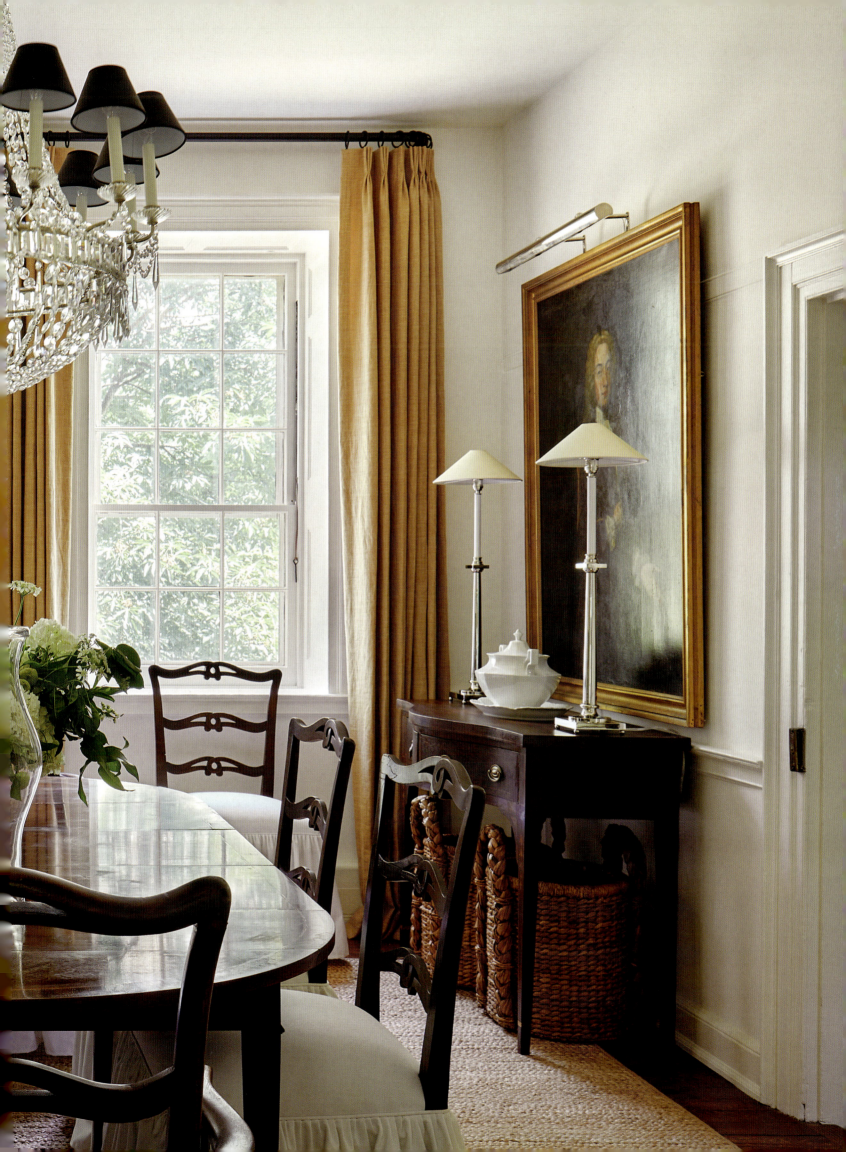

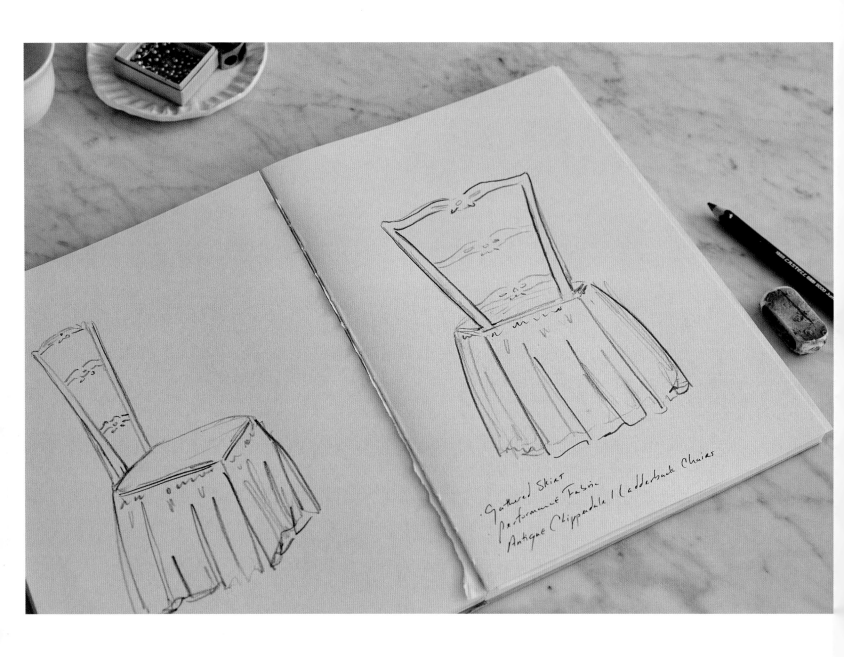

PAGES 138 AND 139: An arrangement of summer blooms consisting of hydrangea, white lace, and branches from a peach tree graces the dining room. PRECEDING PAGES: I chose a pared-back palette for the dining room at Sycamore House to allow the contrasting forms of antique Chippendale chairs with curved ladderbacks and a Swedish Empire chandelier with crisp conical black shades to take center stage. ABOVE AND OPPOSITE: The custom upholstery I designed for the dining room chairs includes flowy gathered skirts that juxtapose against the chairs' dark back posts and rails.

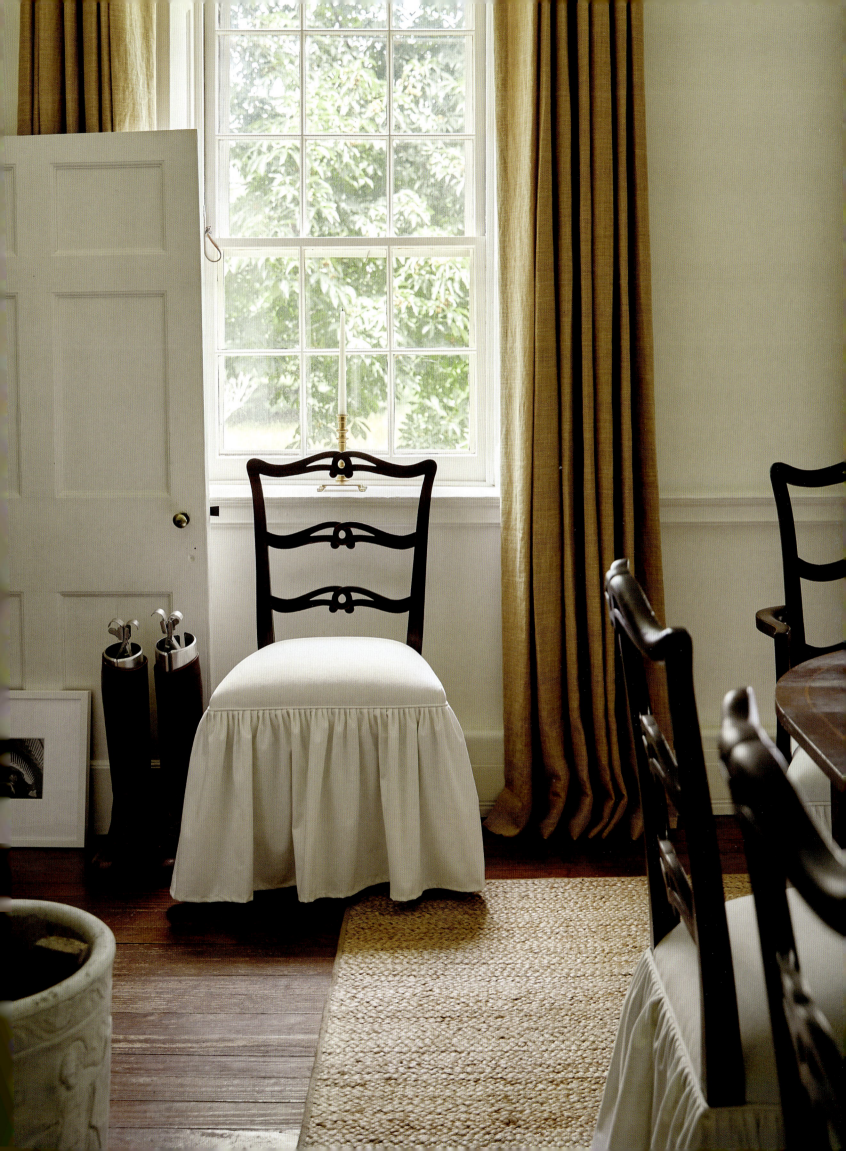

I love thin lines, and I've always been drawn to fragility. From the slender frame of a Chippendale sofa to the dainty silhouette of a taper candle, fine lines evoke both elegance and tenderness. Pieces with slender, delicate profiles calm the eye.

One of the best ways to accentuate delicate lines is by utilizing contrast. The primary bedroom in our townhouse in Washington, D.C., is a perfect example. I remember the first time I walked into the space when we toured the property during the summer of 2020. It's a large, L-shaped room with beautiful tall windows that look onto a tree-lined street just east of the Capitol Building. I immediately fell in love with the view and the light pouring in from the south-facing windows. The trees draw the eye in every season—in spring the blossoming buds beckon, and in winter the bare sculptural branches lend a sense of drama.

At first, I was intimidated by the room's size. Our previous bedrooms in Chicago, New York, and Milan had been much smaller and more intimate. I wanted to fill the space physically and visually, but at the same time I didn't want to clutter it with too many pieces. I painted the room a warm, creamy off-white to maintain an open and breathable environment. To add interest, I planned to incorporate height and contrasting lines to fill some of the negative space. A canopy bed was the solution.

OPPOSITE: A signature of my early work: slashed portraiture. The focal point of the painting shifts away from the eyes, allowing the viewer to take in other elements. Slashing also gives the piece tension.

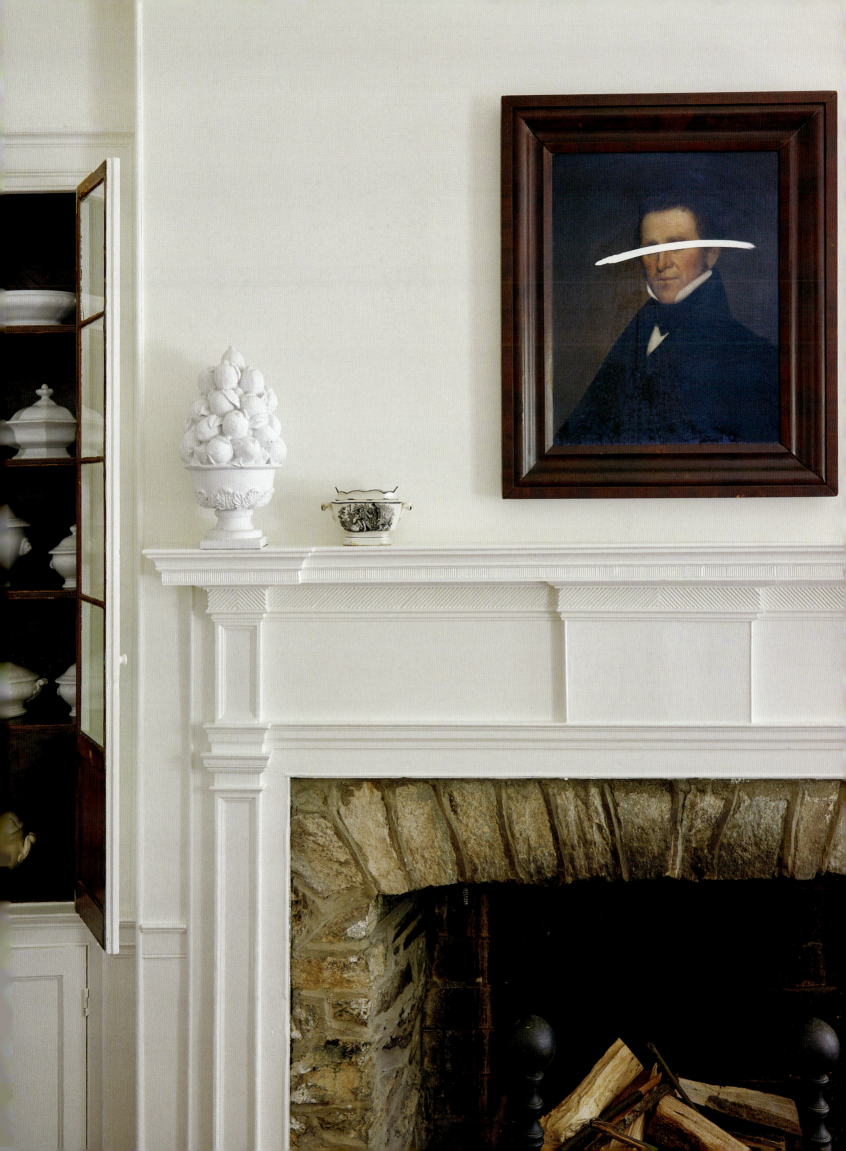

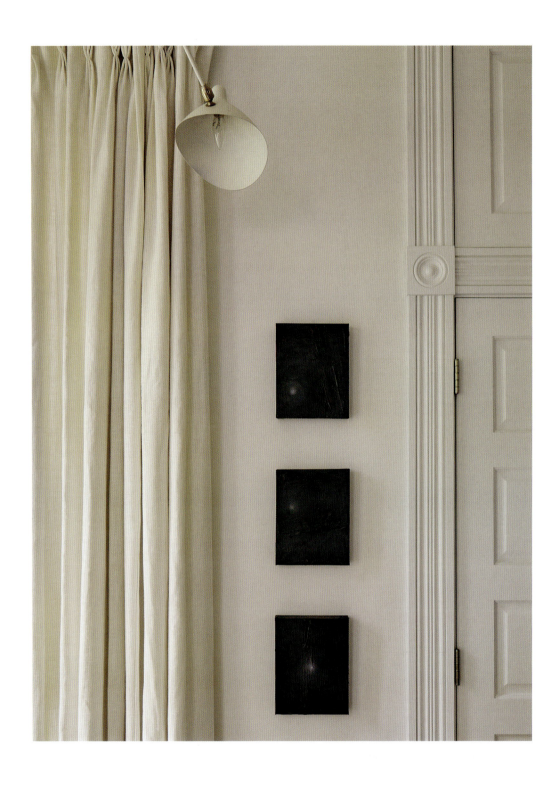

ABOVE: A series of three abstracts that I created hang in the primary bedroom at the townhouse—an example of contrast, form, and movement. OPPOSITE: One of the original built-in cabinets in the dining room at Sycamore House showcases tureens in various shapes and sizes that I've collected over the years.

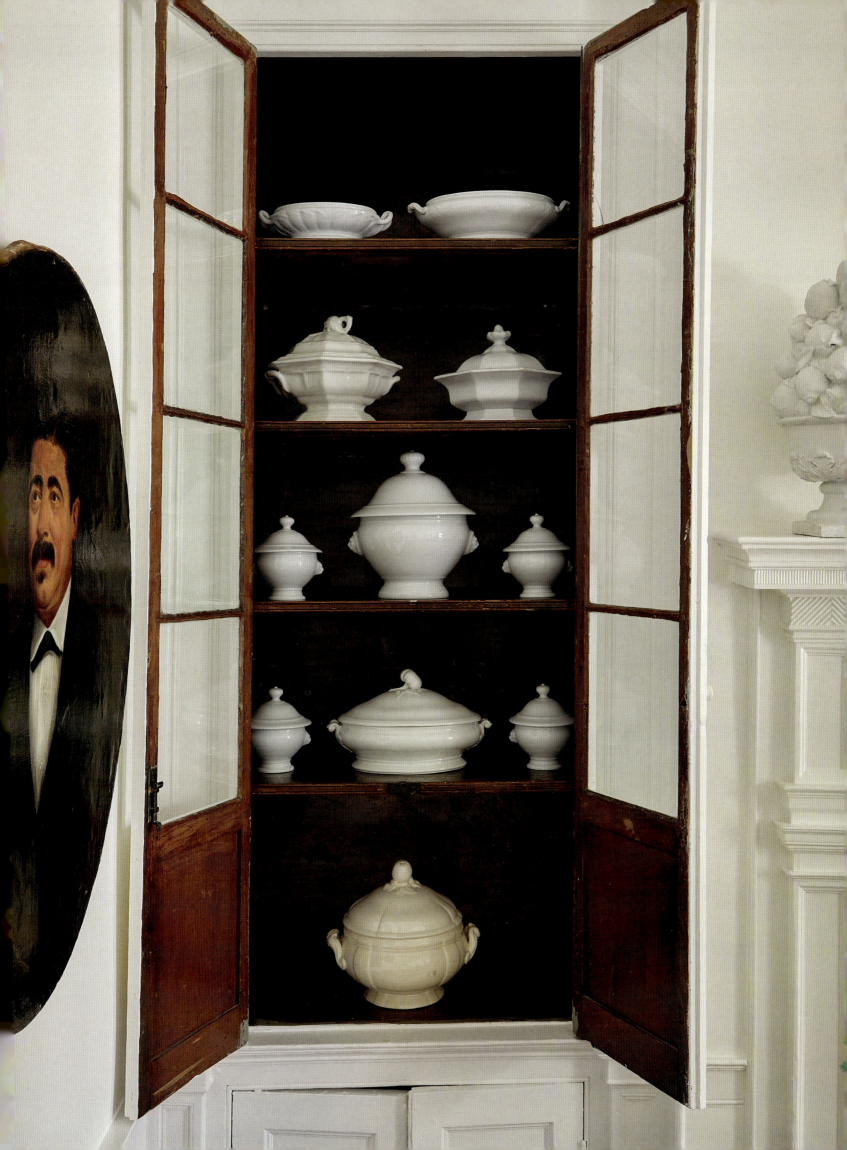

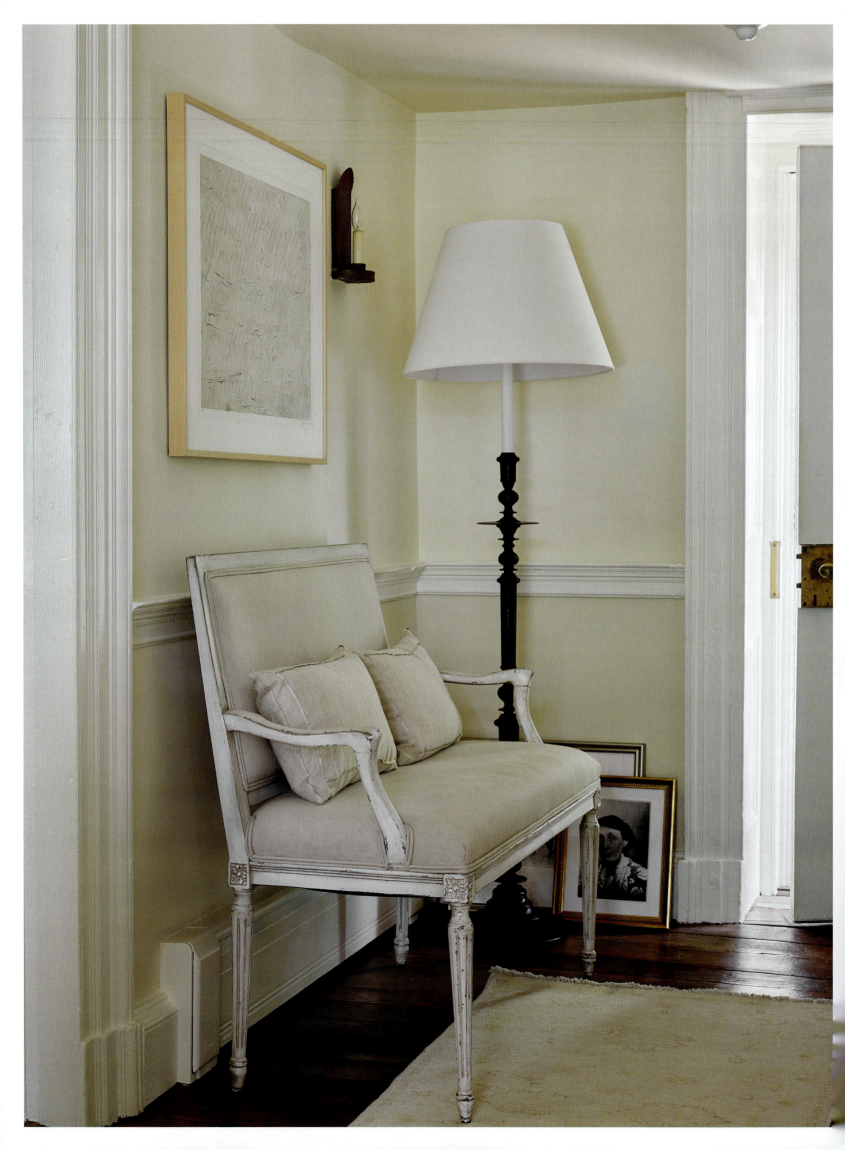

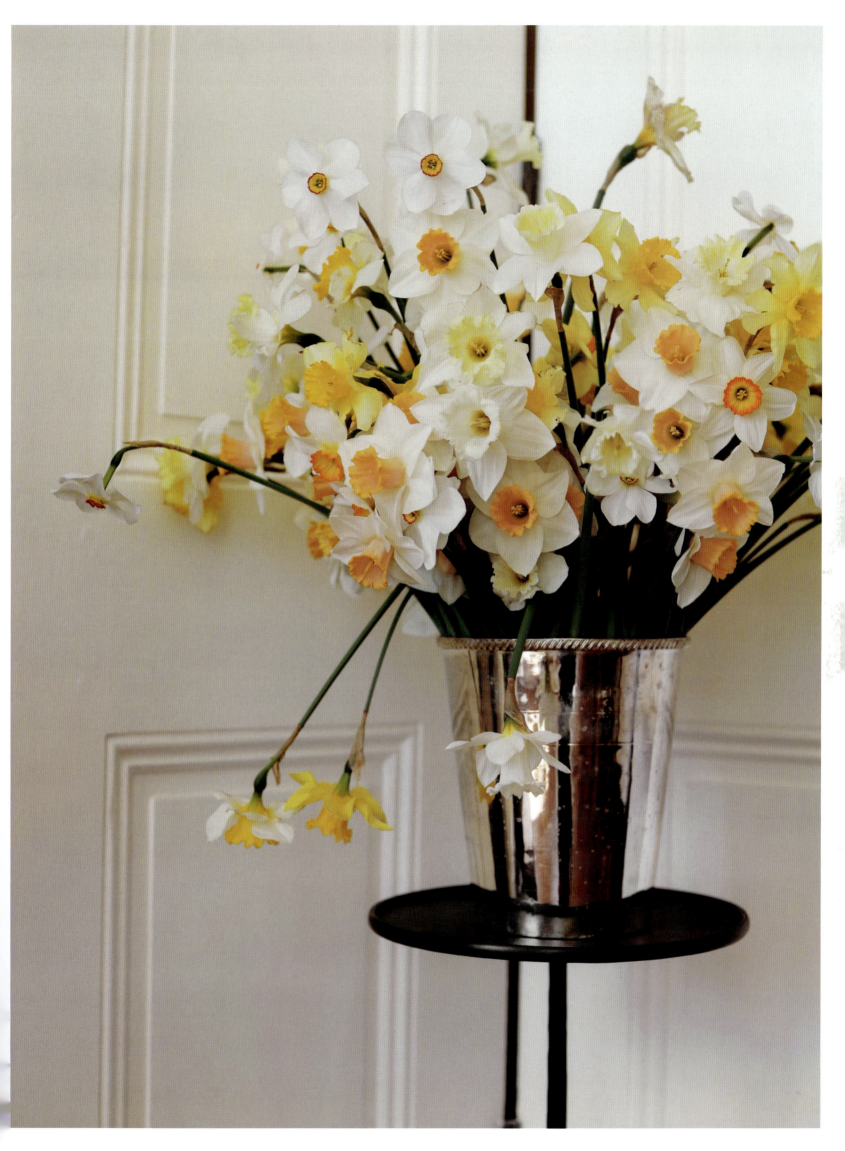

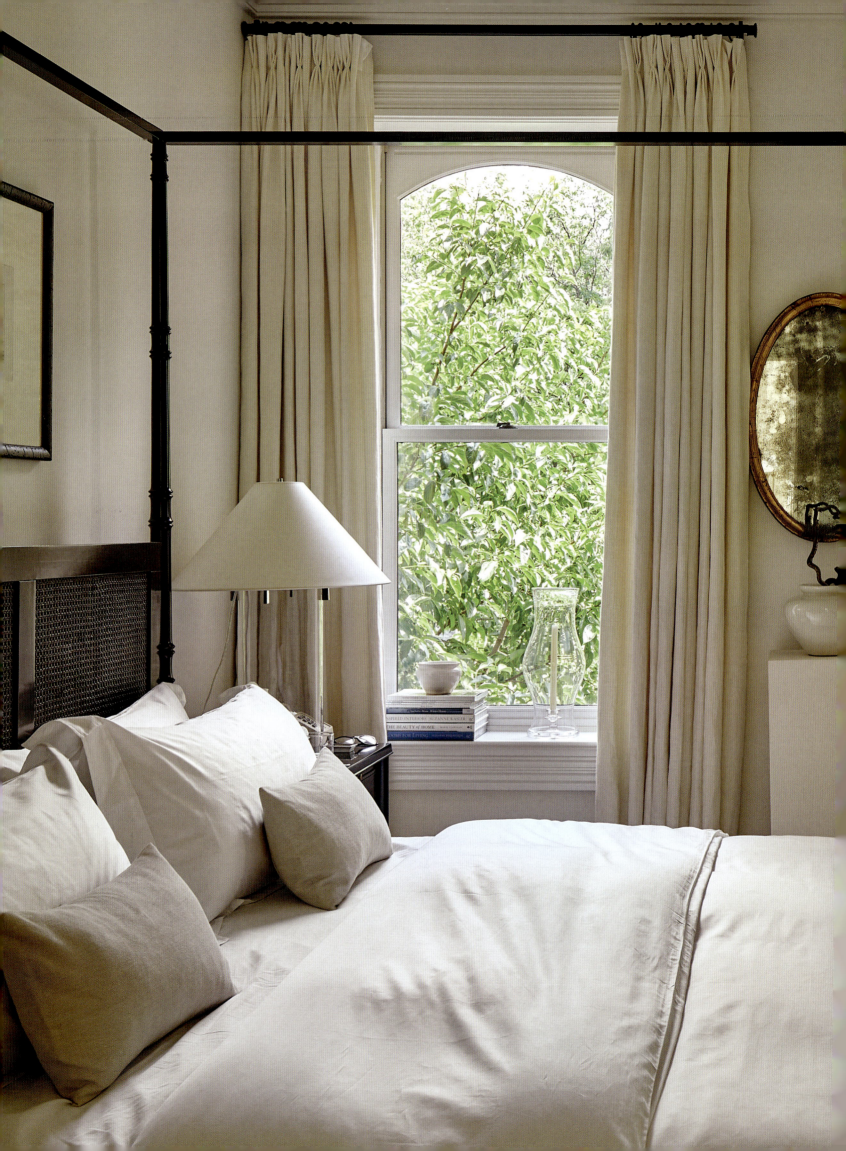

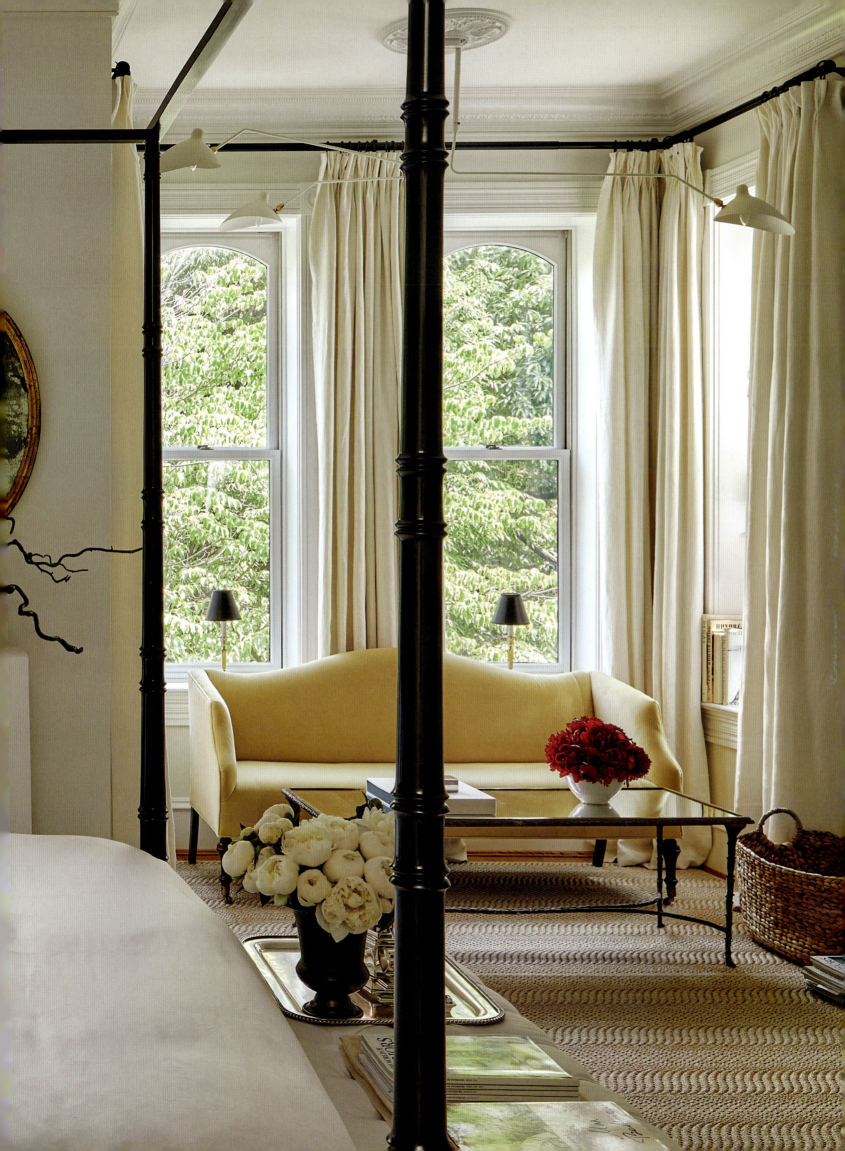

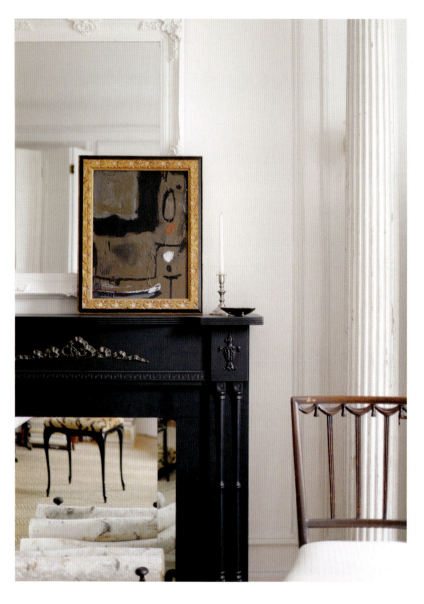
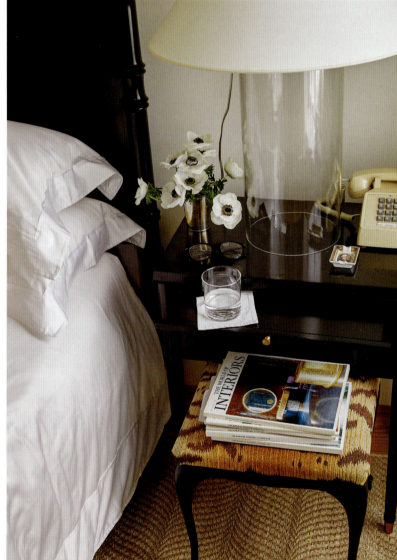

PAGE 148: A quiet hallway moment at Sycamore House. **PAGE 149**: A bouquet of bell-shaped daffodils freshly cut from the garden rests in a vintage silver champagne bucket. **PRECEDING PAGES**: The primary bedroom at the townhouse needed strong forms to define the large space. **ABOVE, LEFT**: Straight lines, including a fluted column, in my Chicago studio. **ABOVE, RIGHT**: A cylindrical glass lamp adds form but doesn't block the dark bedside table from view. **OPPOSITE**: The primary bedroom's four-poster bed with carved bamboo details structures the room visually and guides the eye.

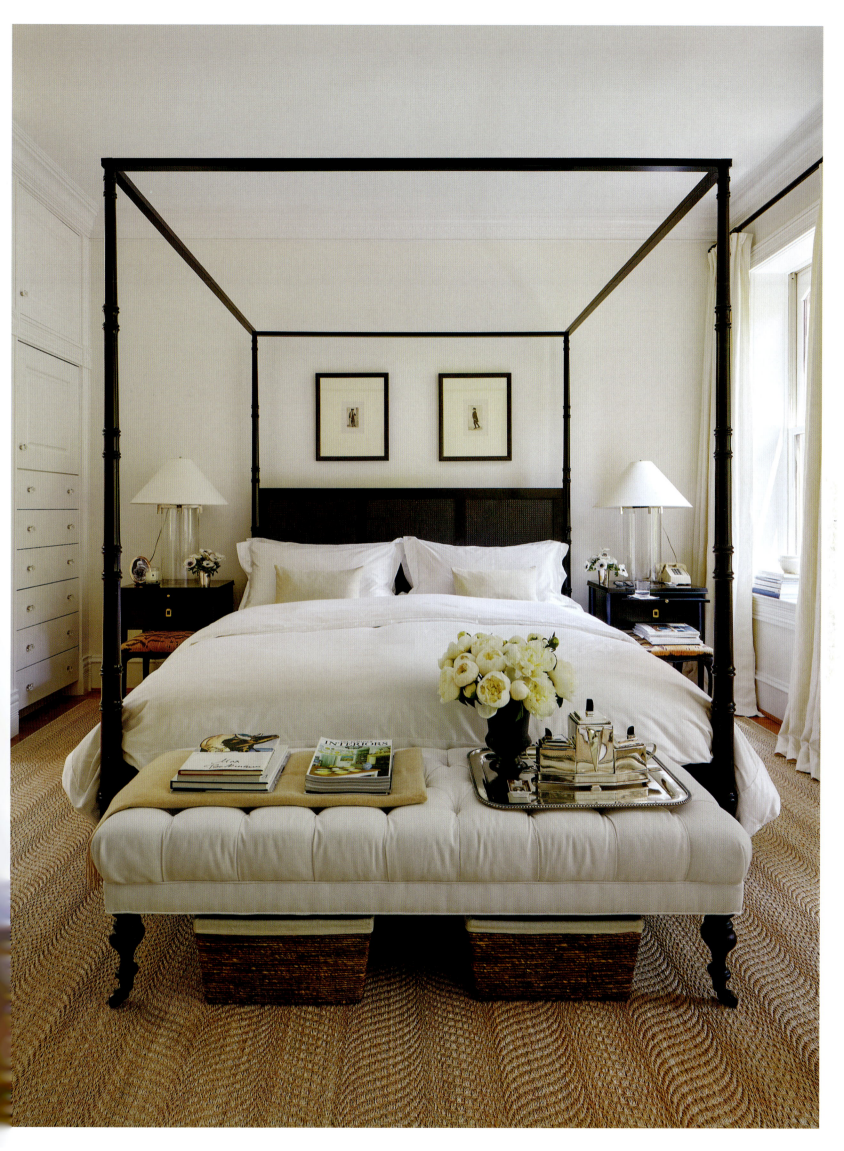

A canopy bed offers a strong shape that can define a bedroom. I fell in love with the bed frame in our primary bedroom for this exact reason. Its silhouette is simple yet intricate: striking ebony posts with carved bamboo details. It demands attention. The stark contrast of the thin, black posts against the off-white walls encourages visual movement. Without it, the bedroom would feel empty, with no impetus for the eye to move and travel. The delicacy of the bed adds elegance without overpowering the room's serene palette.

Various shapes and thin lines can be found all around this room. I intentionally sourced and curated pieces of furniture and accents whose form and shape were different from one another. An oval, gilded, oxidized mirror from the late nineteenth century sits just above a simple white pedestal holding a round, lebes-style vase containing dry, contorted branches. Beside the bed are tall, cylindrical glass lamps with triangular Empire-style shades. The reading nook has a rectangular table with ornate, thin, delicate legs and a mirrored top. I created the nearby series of three small black rectangular abstracts to tie back to the contrast and shape of the canopy bed. All forms subtly add harmony to the space by being juxtaposed with one another, creating the perfect amount of interest and sense of ease.

OPPOSITE, CLOCKWISE FROM TOP LEFT: The townhouse stairs are sinuous. The curved arm of a sofa contrasts with the folds in the drapes. Dark contorted branches stand out against a lebes-style vase. Shapes are reflected in a mirrored coffee table.
FOLLOWING PAGES: I instantly fell in love with the delicate, fragile lines of a small antique desk, originally from the Ritz Paris, that sits in the bay window on the townhouse's parlor floor.

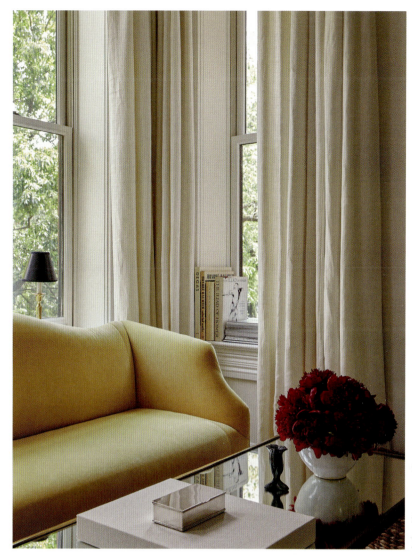
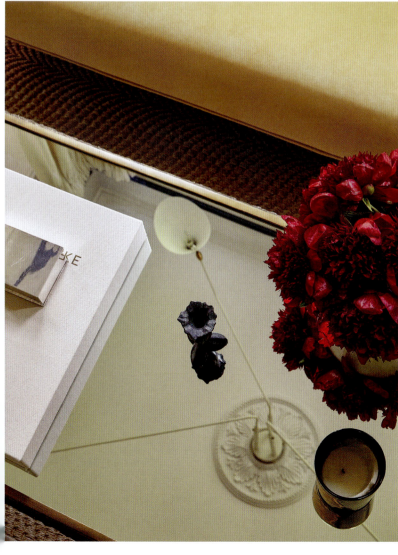
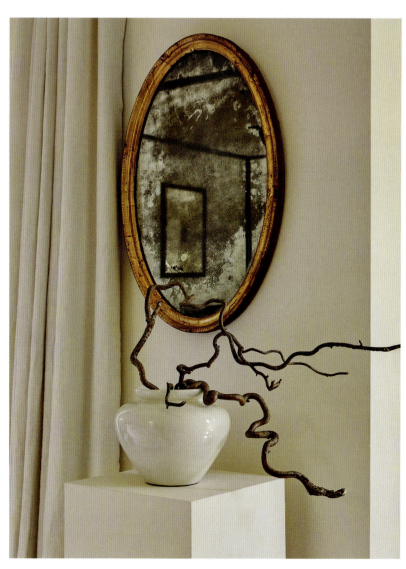

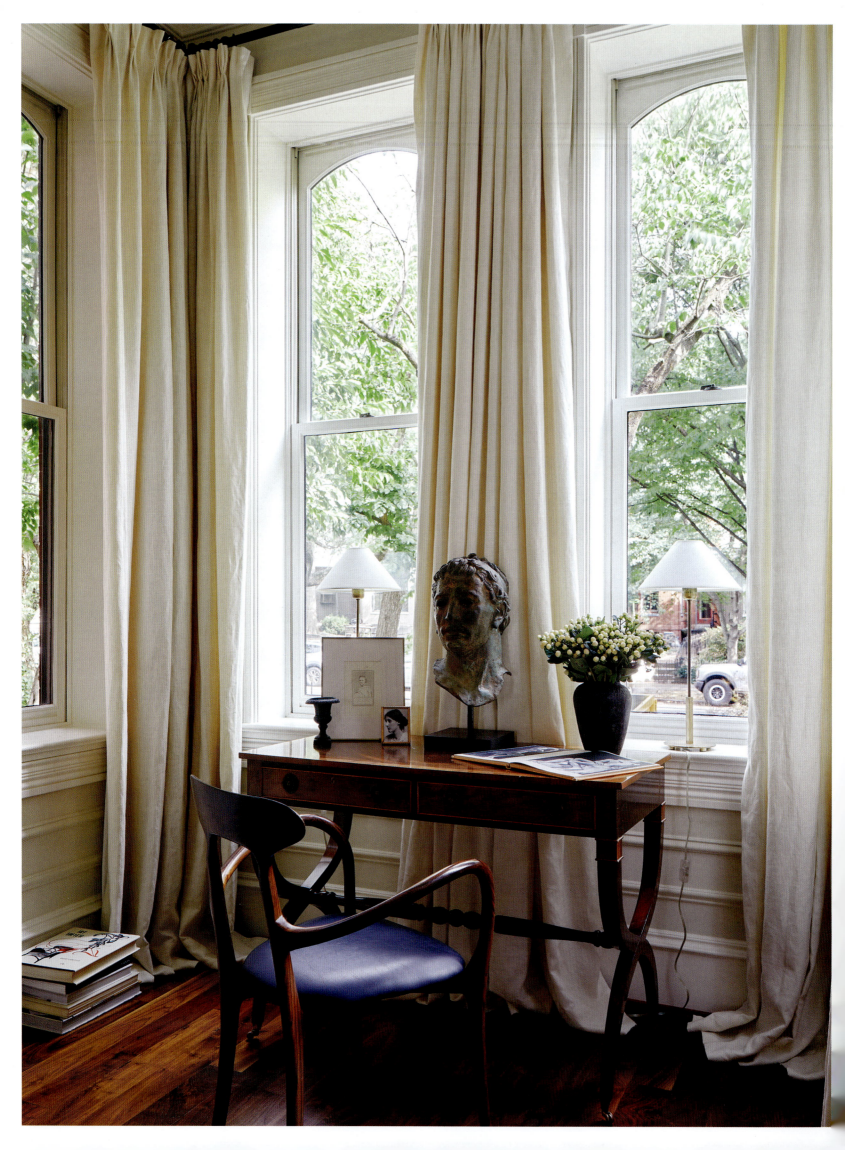

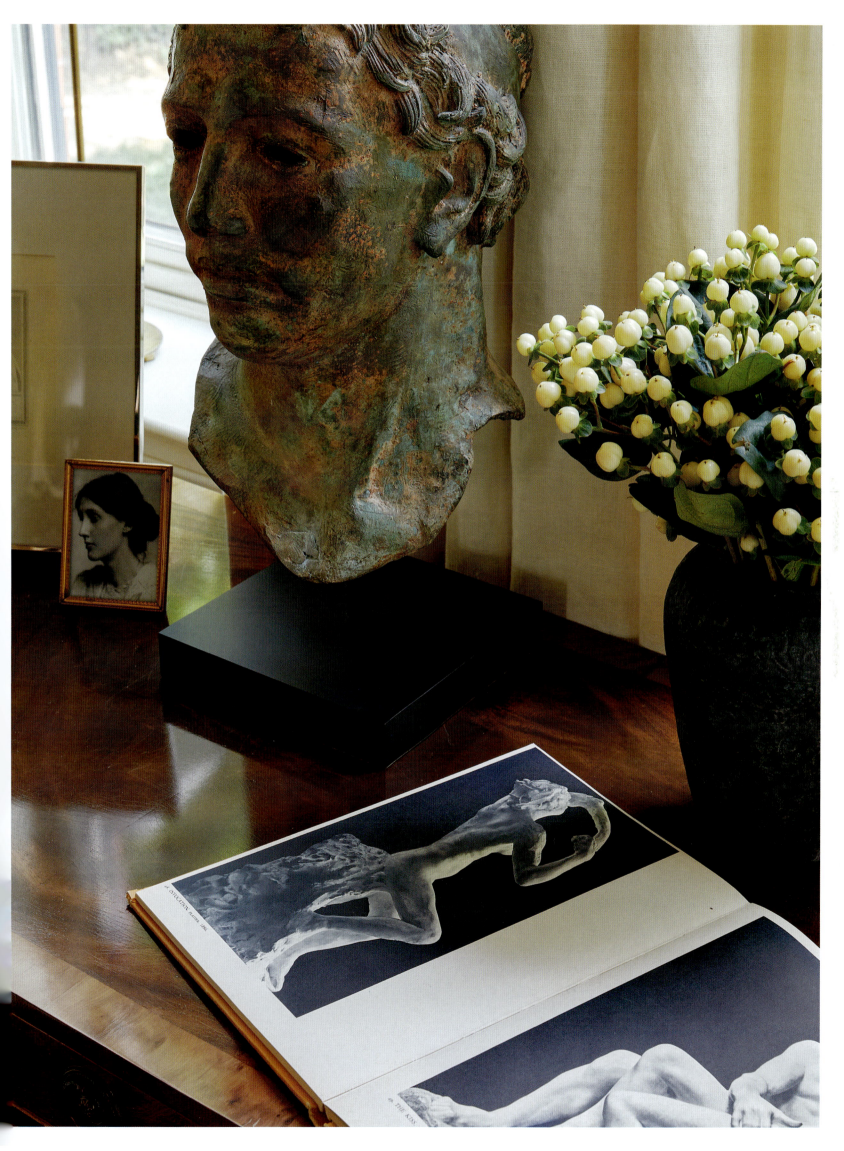

I grew up behind an auction house. My parents were collectors, and antiques — items with a tangible sense of history and craftsmanship — filled our home. I developed a deep love for both the art of the hunt and the pieces themselves. Their structure, form, and subtle imperfections were testament to time and use. I remember falling in love with and noting the delicate lines of Queen Anne–style furniture throughout my childhood home. Today, Ignacio and I often spend our weekends antiquing. This can be as casual as a Saturday spent traveling around Middleburg, Virginia, and the rest of Loudoun County or a quick stop in Georgetown. We also plan longer trips to some of our favorite towns in Bucks County, Pennsylvania, and Litchfield County, Connecticut. Our home is filled with pieces we picked up during these excursions. Each of these mementos and conversation pieces reminds me of a certain period in my life. Everything tells a story in our home.

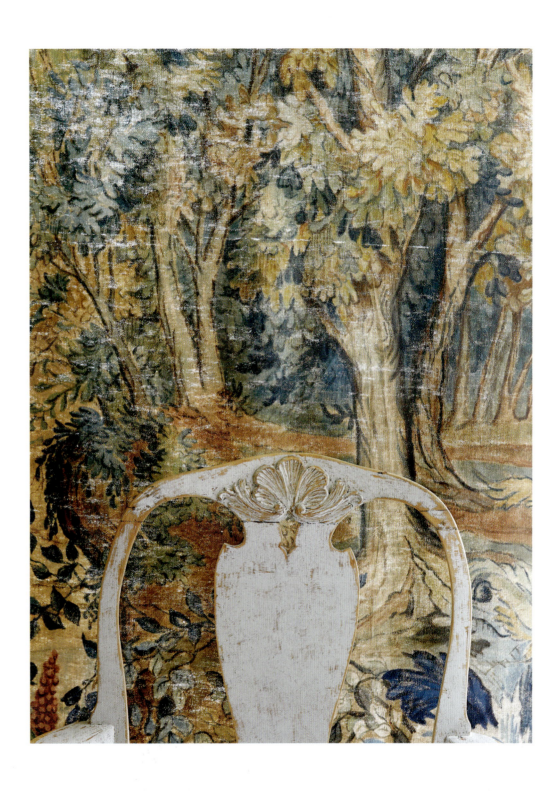

OPPOSITE: Even at the very start, when I'm sourcing and antiquing in some of my favorite shops, I'm already acutely aware of the forms I'll incorporate into my projects and homes.
ABOVE: An eighteenth-century Swedish Gustavian armchair sits in front of an antique tapestry.

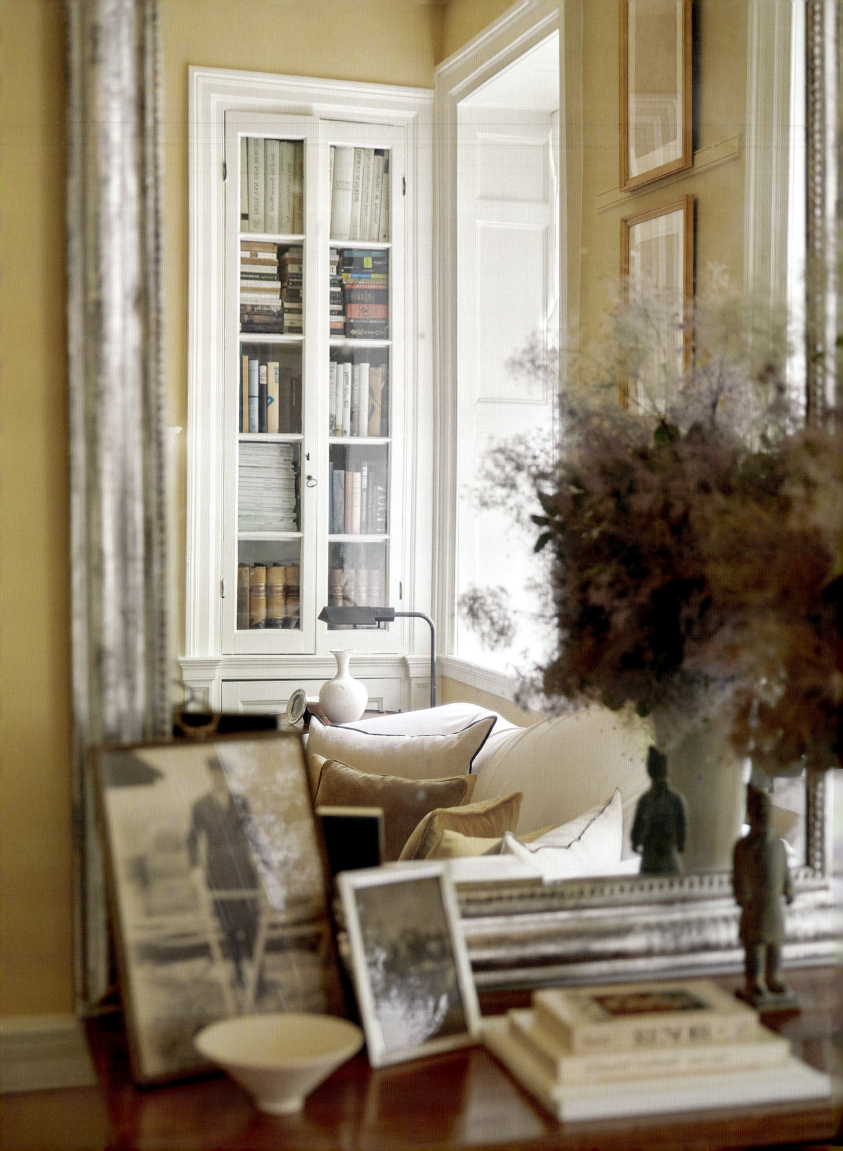

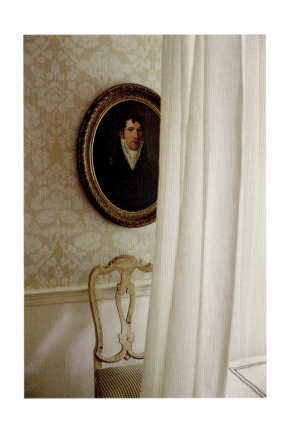

LAYERS

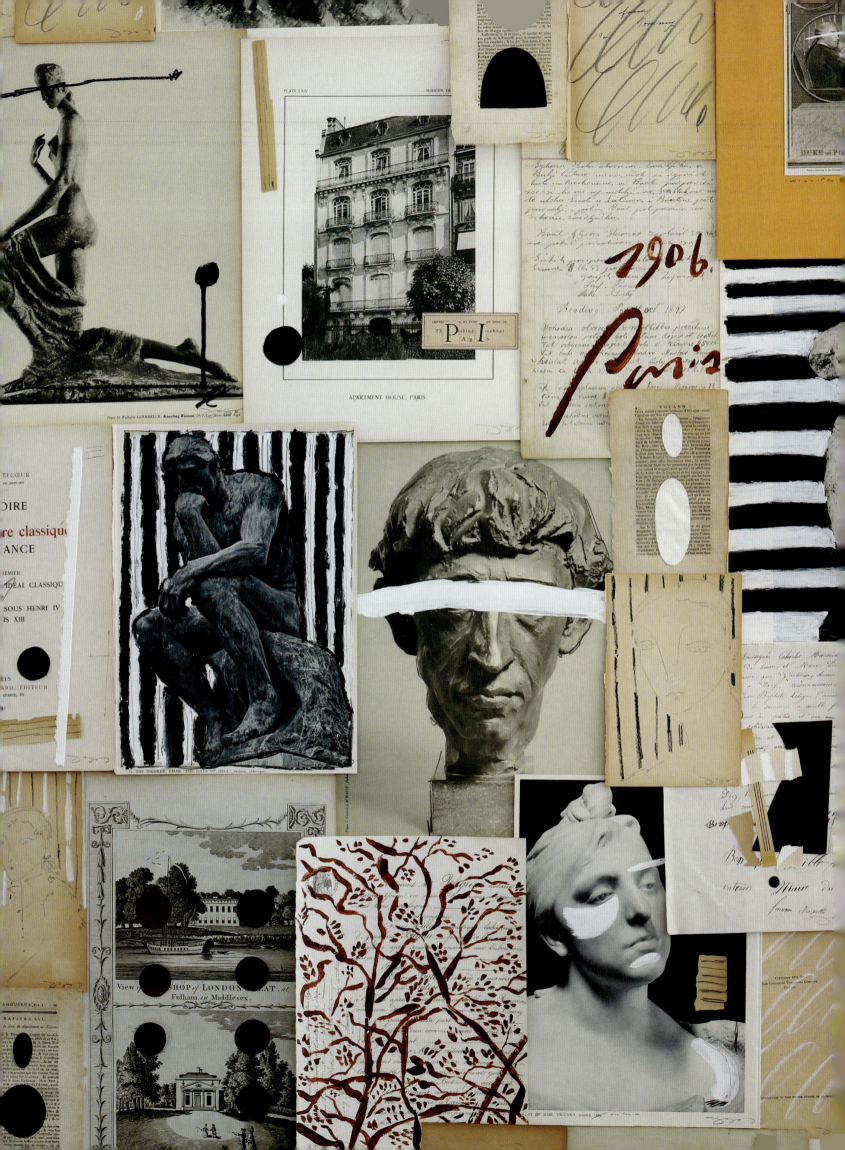

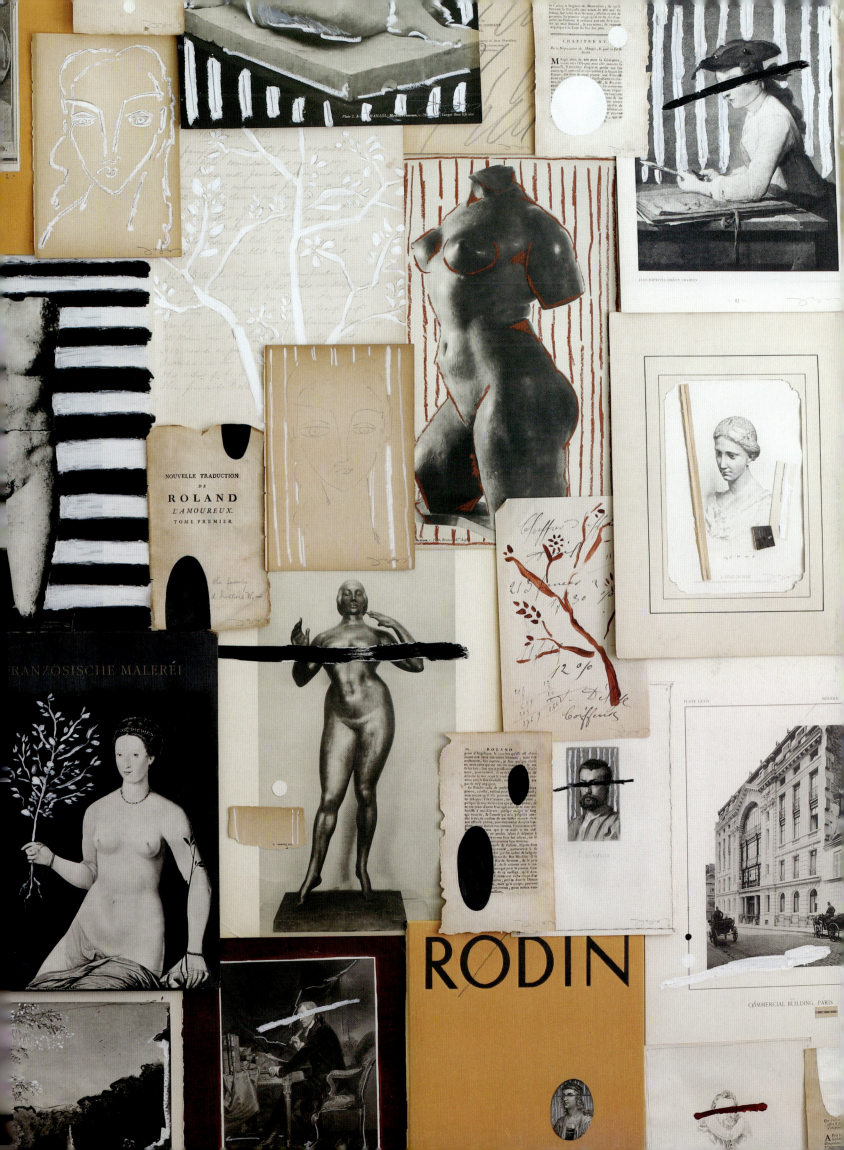

I'm naturally drawn to a sense of depth and dimension in almost everything. Layers foster intricacy and complexity. This can apply to artwork, interiors, and even how we dress.

I started painting when I was eleven years old. My parents built my first studio in a small corner of the basement of my childhood home. It became my refuge, a place I escaped to after school and where I got completely lost creating anything I wanted. At that same time, I began collecting books about various styles of art and the masters whose works I was drawn to. In my studio, I would analyze the images in those books, dissecting the artists' techniques, colors, and elements.

My first loves were the Impressionists, with their ability to layer paint on a canvas to a point where the artwork itself became three-dimensional. Large swaths of paint billowed off the foregrounds of their works, mimicking crashing waves or rolling clouds. My older cousin Michelle, who was an artist herself, taught me to layer colors onto the canvas liberally, naturally applying depth to the composition with palette knives. During my high school years, I fell in love with cubism and pop art. I learned that my work did not have to be limited to paint on a canvas. I explored a mixed-media approach by incorporating everything and anything that I could get my hands on and layering it on the canvas. Old newspapers, linen, string, wire mesh, even old, rusted nails that I found in my dad's red toolbox. If it could be glued and painted, it was fair game.

PRECEDING PAGES: A collage of pieces from *Bibliothèque*, a series I started in 2018 that consists of abstracts and drawings on antique French, Italian, English, and early American documents and book pages from the seventeenth through the twentieth centuries. **OPPOSITE:** A layered scene from my Chicago studio featuring a large folding screen, a marble desk for drawing, and artwork and books I often reference for inspiration.

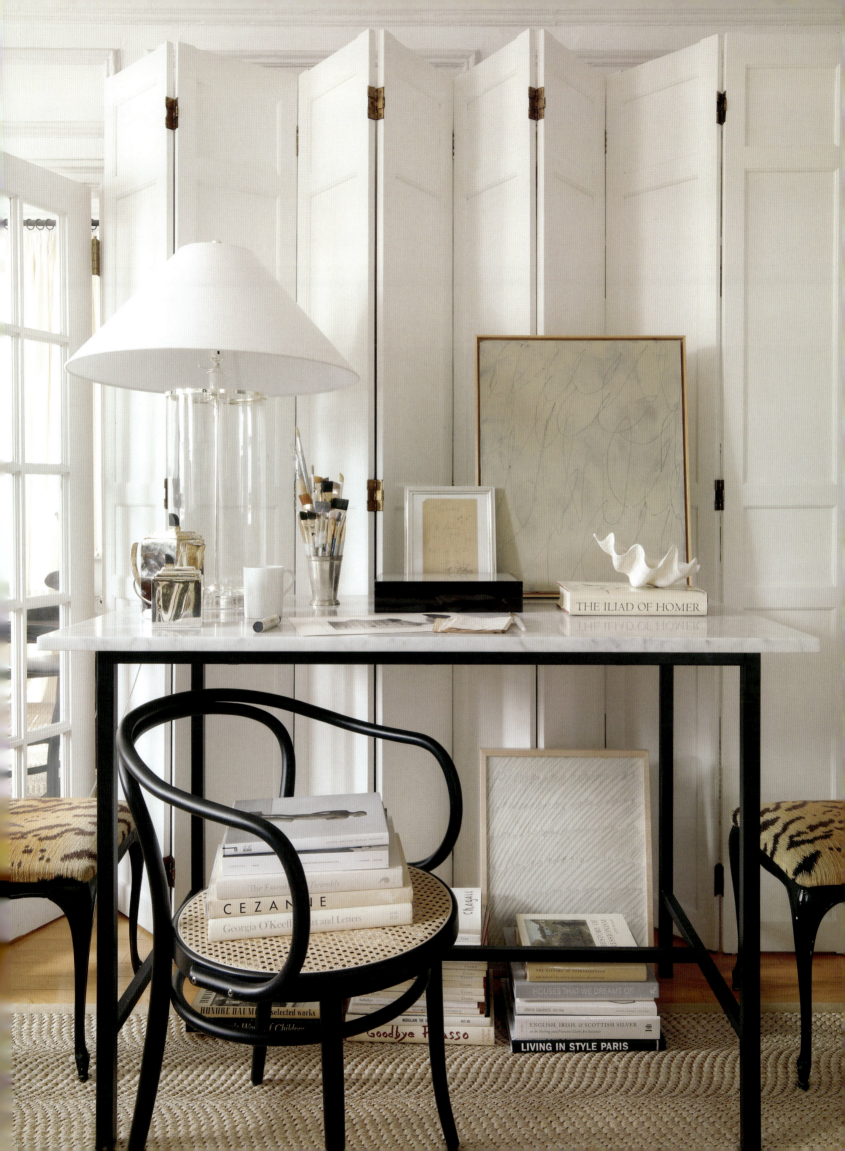

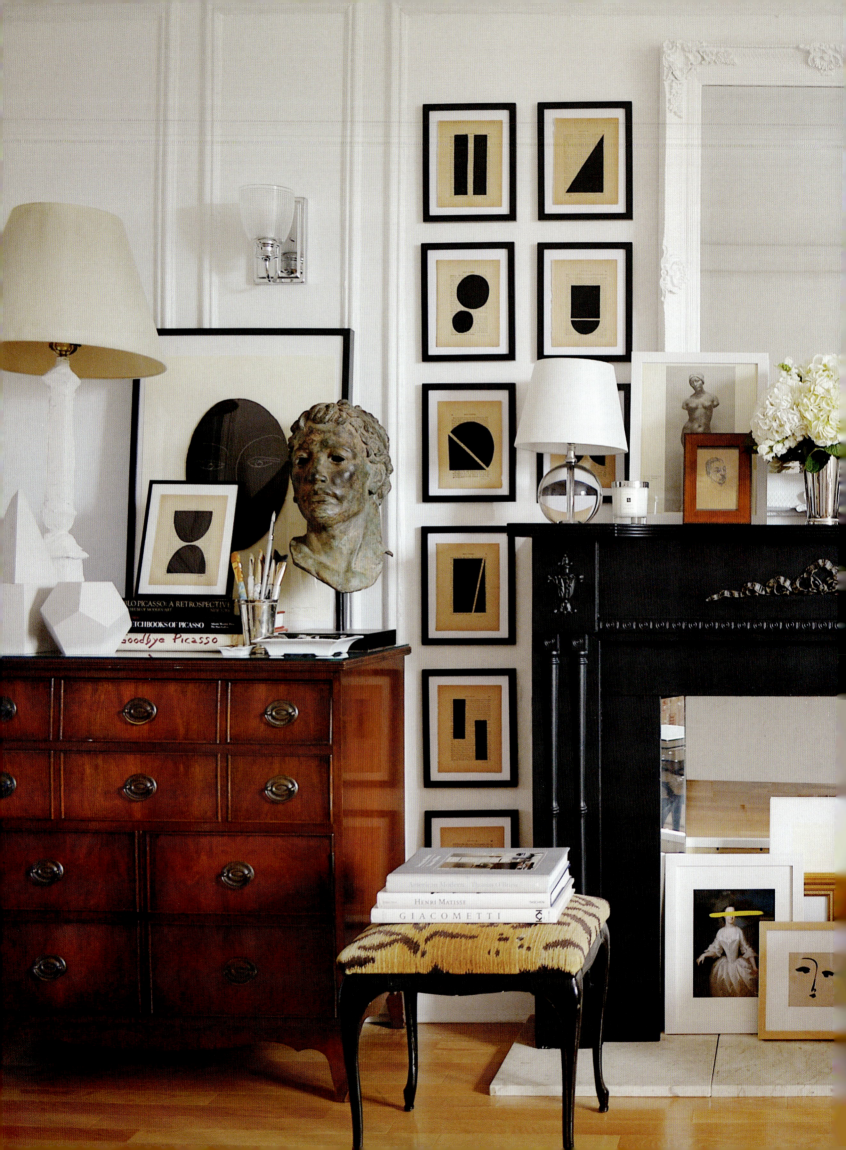

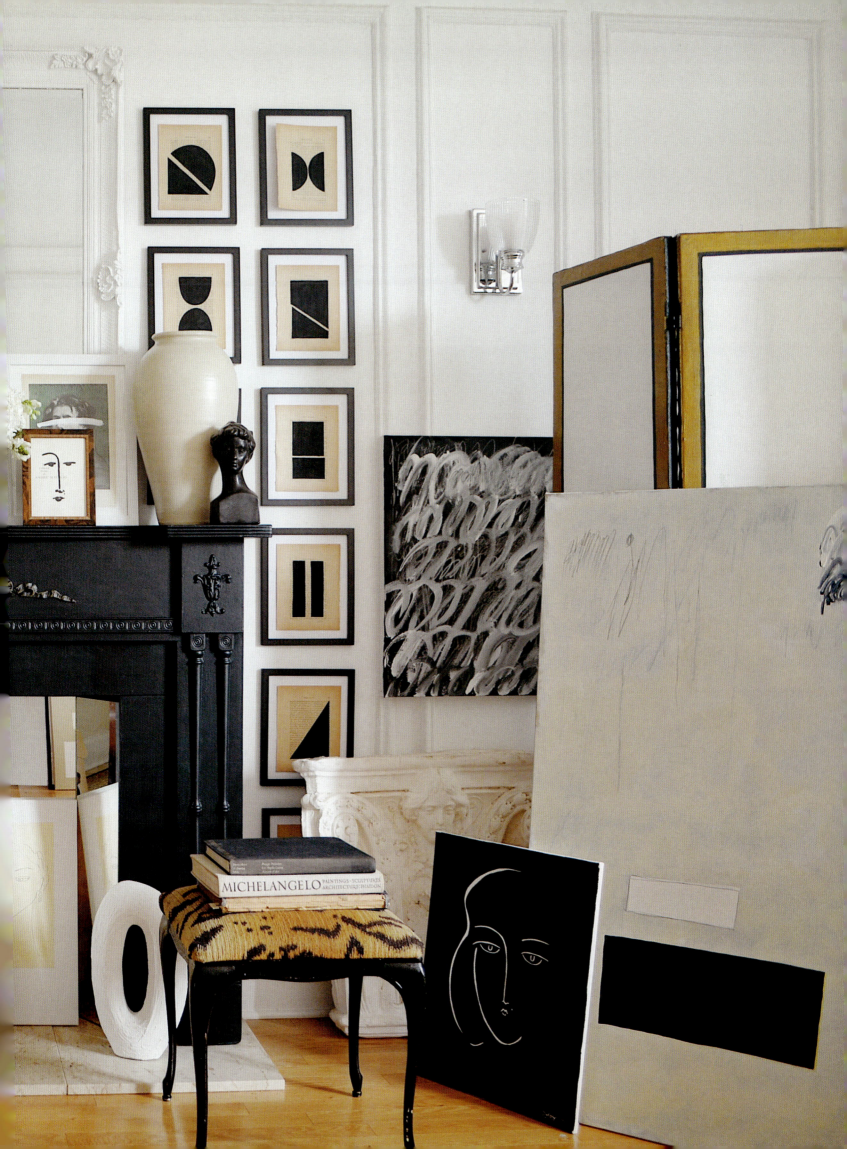

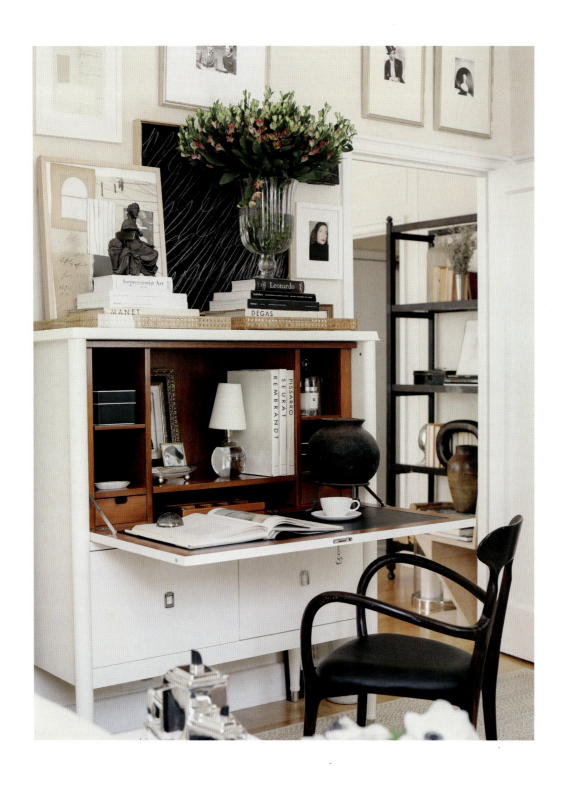

PRECEDING PAGES: A vignette from my Chicago studio featuring a faux mantel with a mirror insert, flanked by framed pieces from my *Géométrique* series of paintings on antique book pages.
ABOVE AND OPPOSITE: The secretary desk in the primary bedroom of our Chicago apartment is both practical and fun to style and layer with artwork and books.

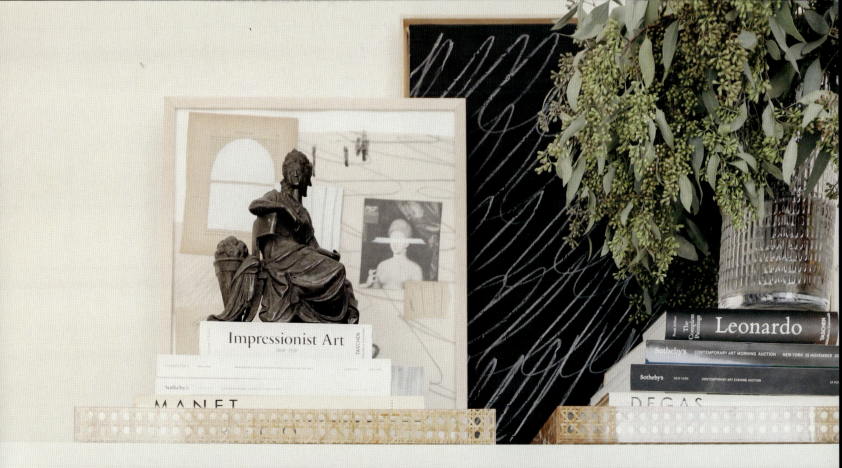
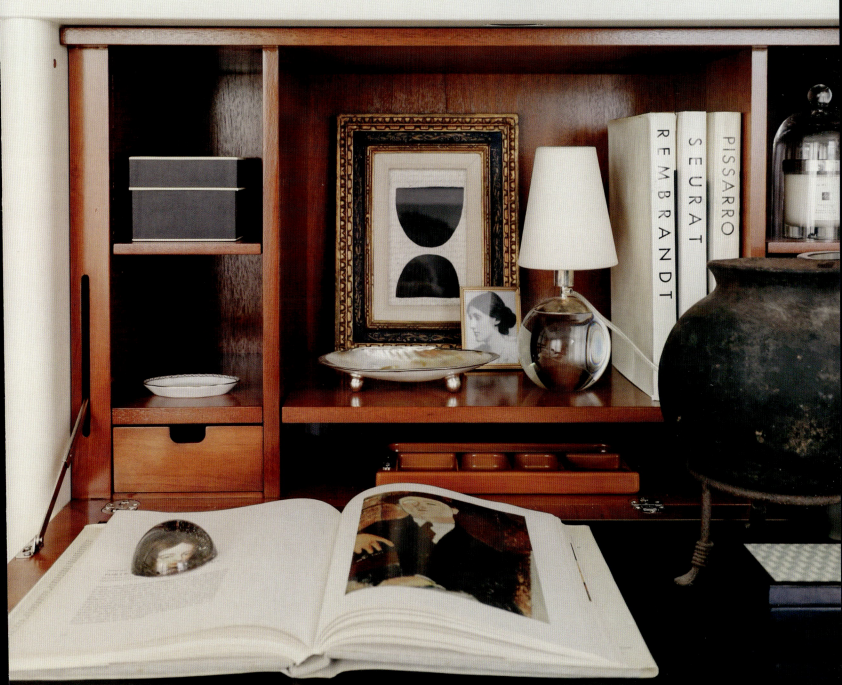

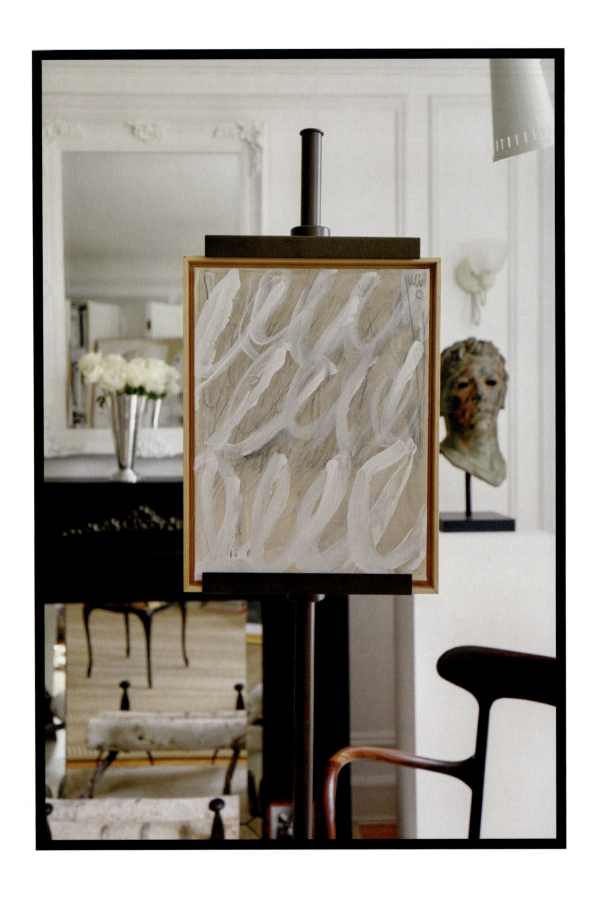

ABOVE: A small abstract painting of mine made by layering oil, oil pastel, graphite, and plaster on canvas sits in the salon of my Chicago art studio. OPPOSITE: The living room of our Chicago apartment with a faux mantel I installed, then filled with books and magazines.

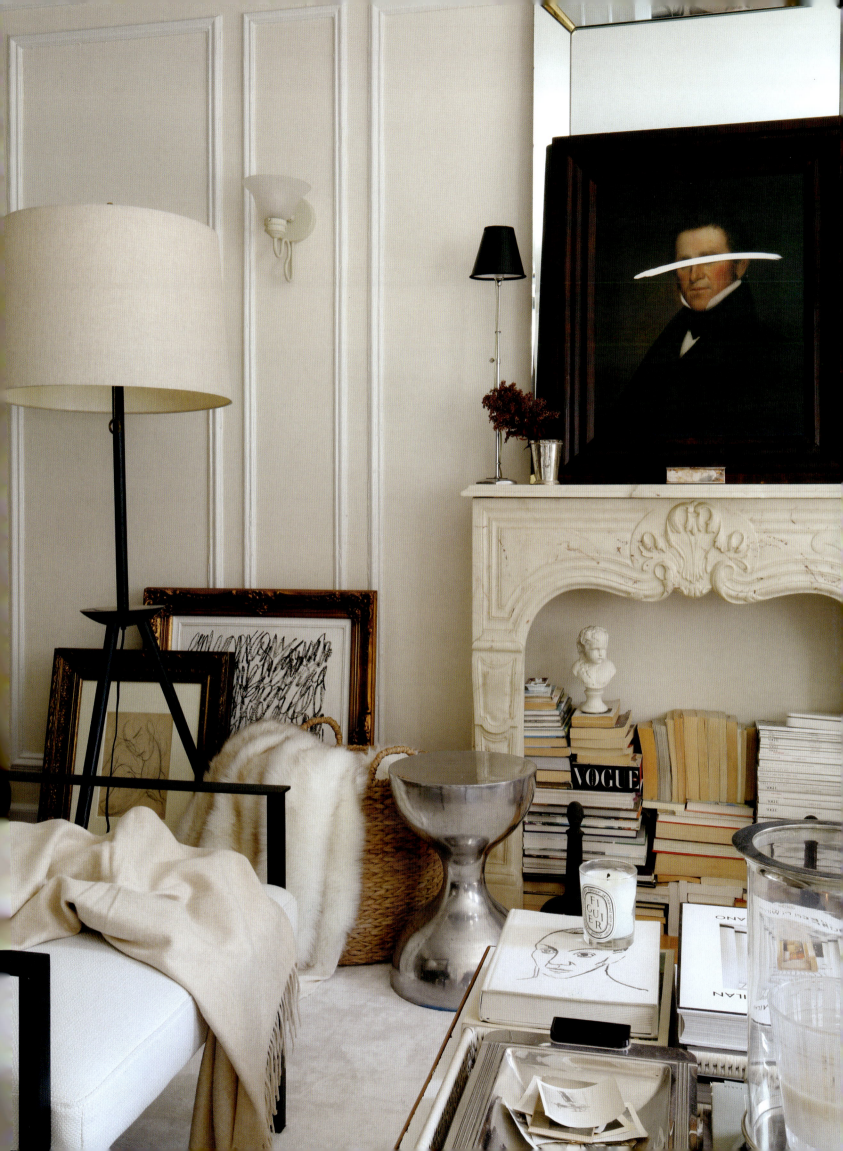

Just as I use layering in my artwork, I love creating a layered interior. Whether I'm in my studio or home, I want to be in an environment that feels collected and where I am surrounded by objects that I love. Friends and clients who visit one of my studios often tell me that my workspace feels like an extension of my home. Artwork leaning against dressers, stacks of books under furniture—these add up to a utilitarian space that still manages to feel warm and inviting. Even the various supplies I have, like paints, pastels, brushes, and pencils, are all grouped and placed in silver trays and baskets. Stacked, organized, and layered throughout the studio.

An important part of layering an interior is creating vignettes. Establishing intimate areas that visually pull you in and frame an individual moment within a room is a fundamental part of my process when I'm styling a project. Every nook and corner can have its own unique moment, as long as it stays cohesive with the rest of the room. I love to place an antique dresser or secretary—something substantial that can act as a focal point without being too weighty—in a small, unassuming area beside a sofa or a chair, and then layer in leaning artwork, a mirror, books, and a lamp. This creates interest in a place that might otherwise have been overlooked and deemed insignificant. I've created similar vignettes in both of our own living rooms. A room should have numerous focal points so that there is always something to catch the eye, no matter where you're positioned. These visual snapshots keep a space feeling dynamic.

OPPOSITE, CLOCKWISE FROM TOP LEFT: Artwork and books are made for layering and marry well with natural elements. To layer successfully, think outside the box—like hanging artwork on something other than a flat wall. Books, too, can be displayed in myriad ways, including in stacks on the floor. Transparent surfaces make layering simple.

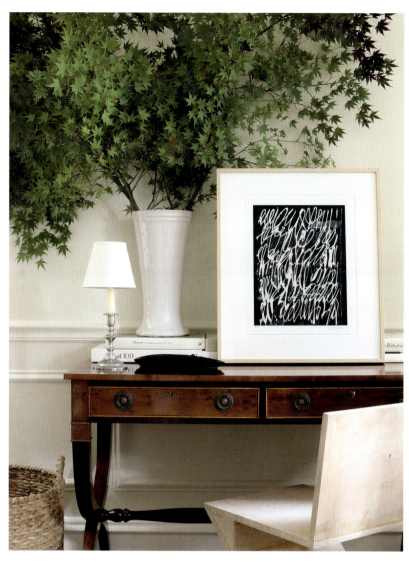
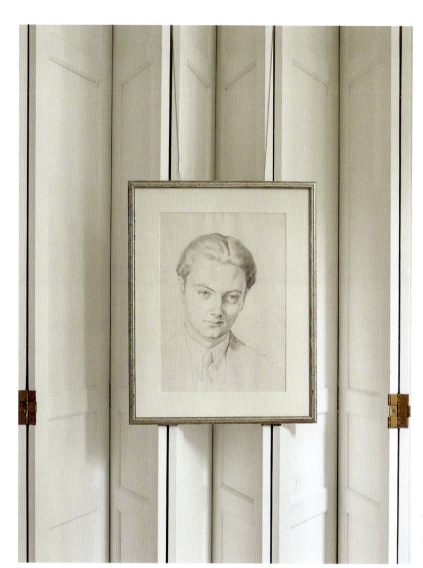

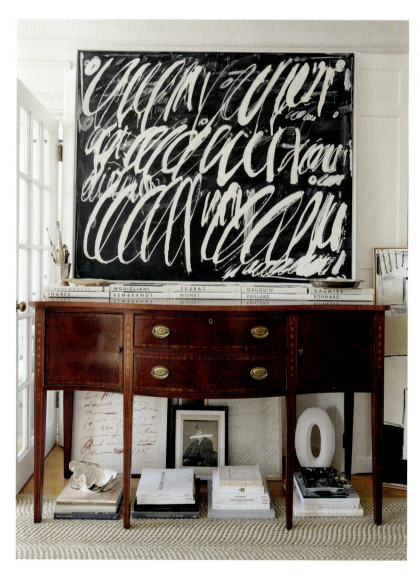

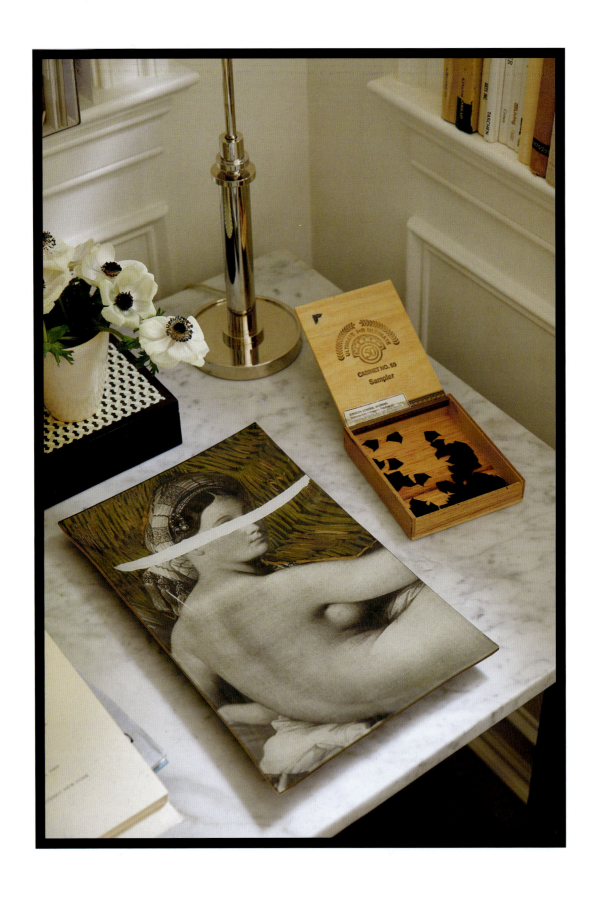

ABOVE: A decoupage platter featuring a piece from my *Bibliothèque* collection. OPPOSITE: A vignette in my Chicago art studio features two of my abstracts hung on a pair of French doors—an unusual backdrop.

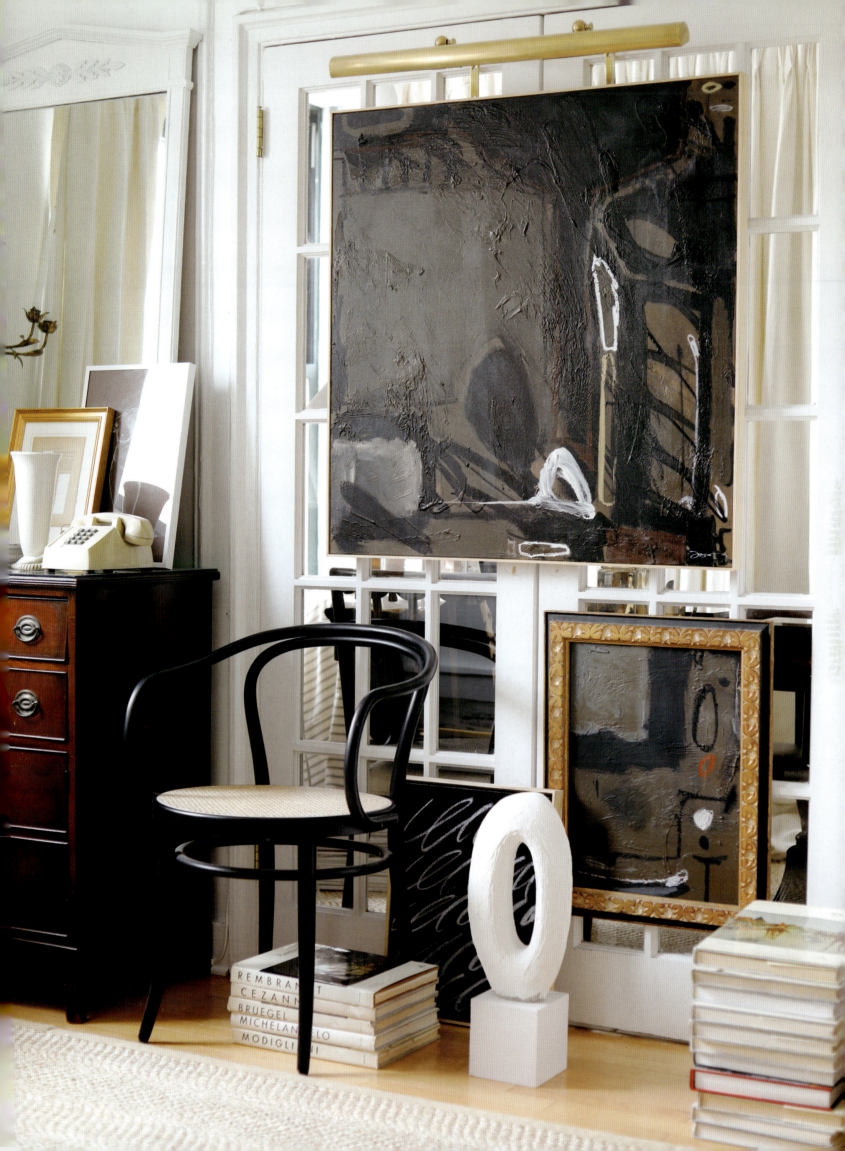

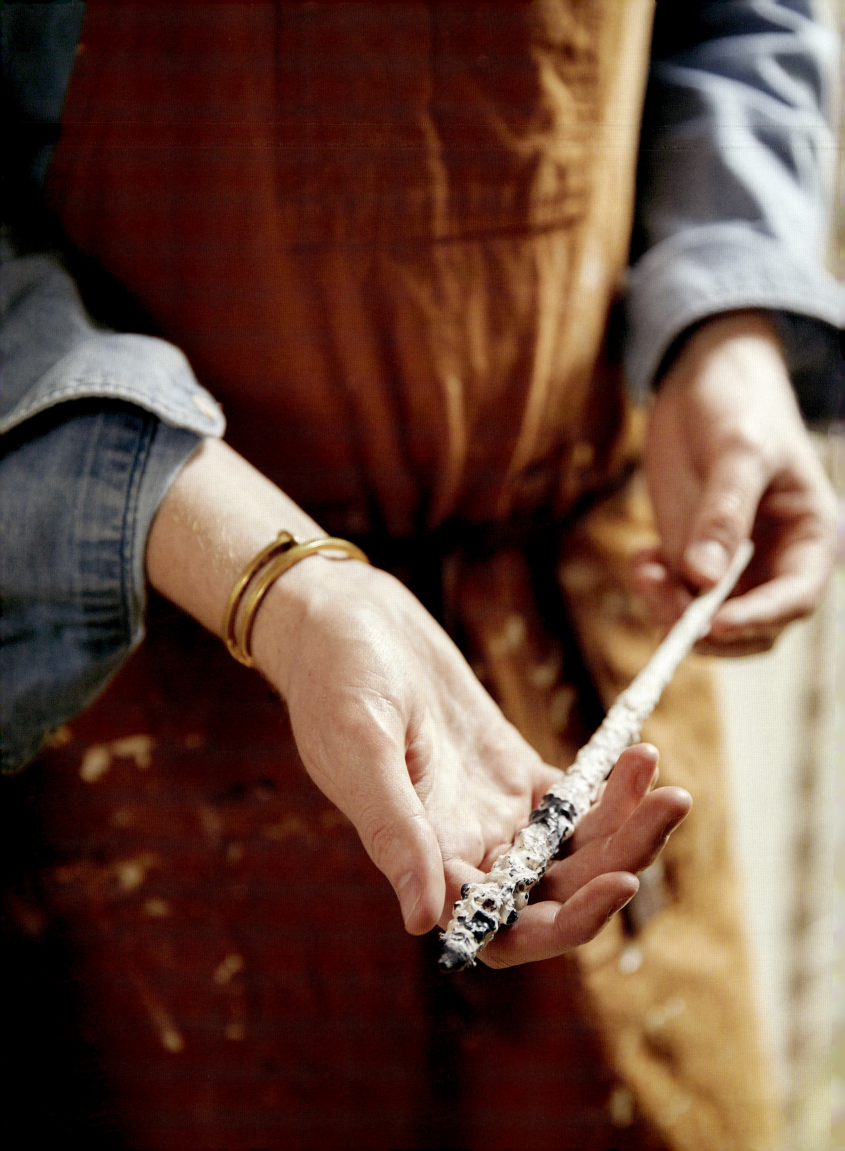

I'm the type of person who loves the foxing of an antique mirror, the rusted patina on wrought iron, cloudy tarnish on polished nickel, or the scratches and markings of an old wooden floor. There's beauty in the imperfect. One such well-worn treasure is a paintbrush I have had since high school. It has thick, bumpy layers of paint on it. Some have told me to toss it; others have told me to frame it. The layers of paint on this brush recount the artistic journey of my life.

From high school projects to large-scale commissions for noteworthy and famous clients, it's been used on thousands of pieces, and there's a little bit of every painting I've done on this little brush of mine. It sticks out like a sore thumb among the clean brushes in the studio, but with its layers it holds more meaning than anything else in the room.

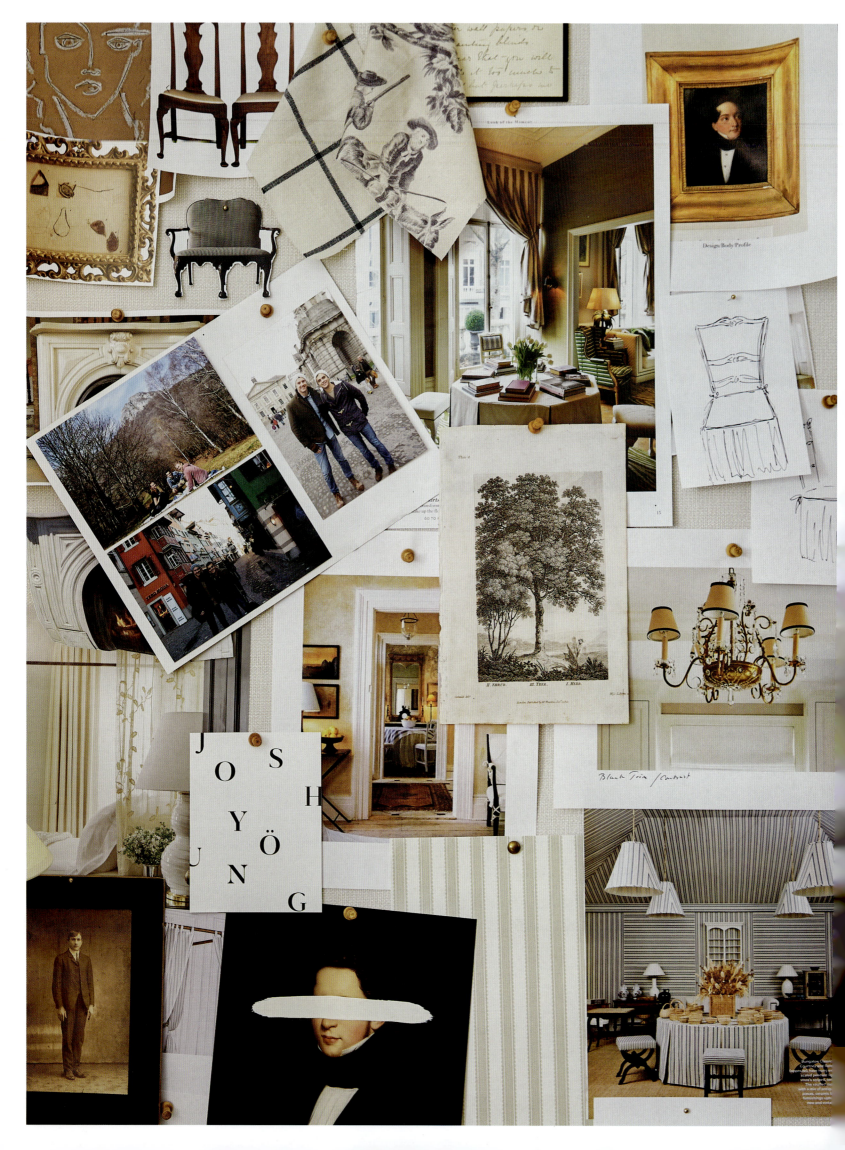

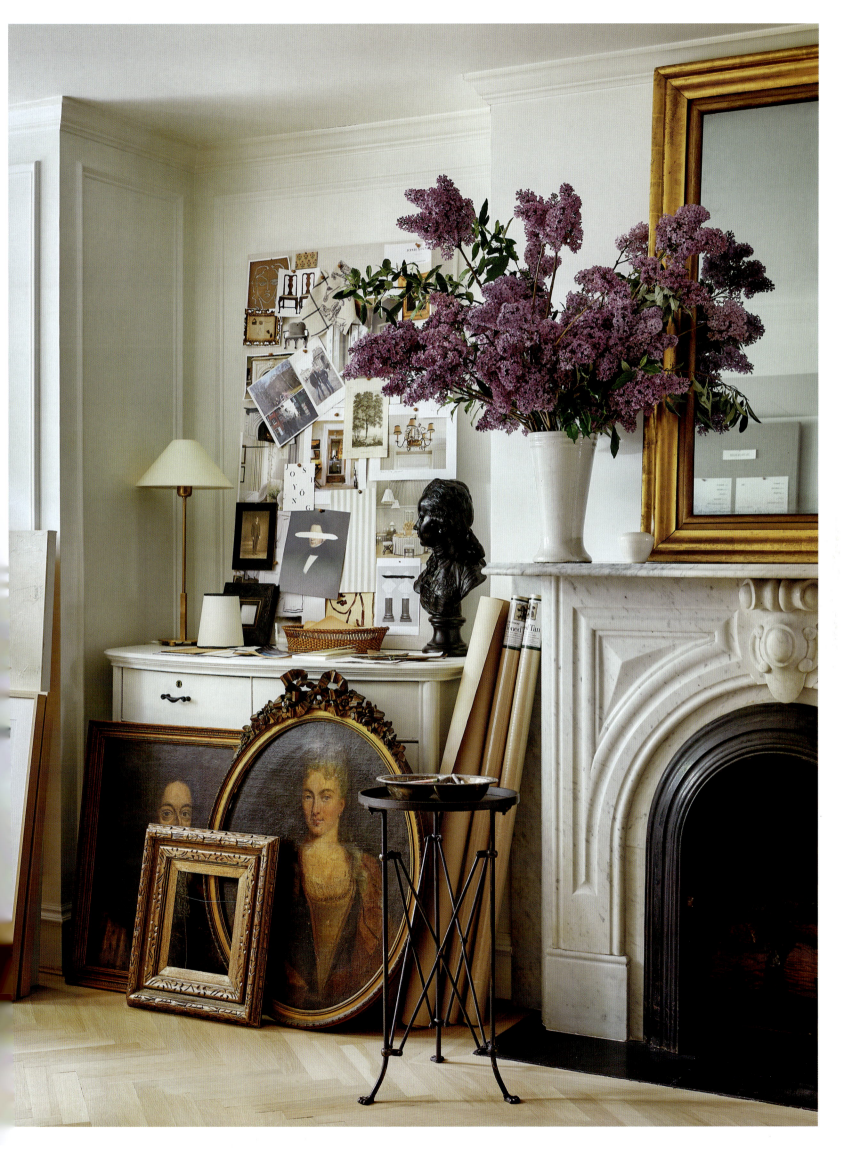

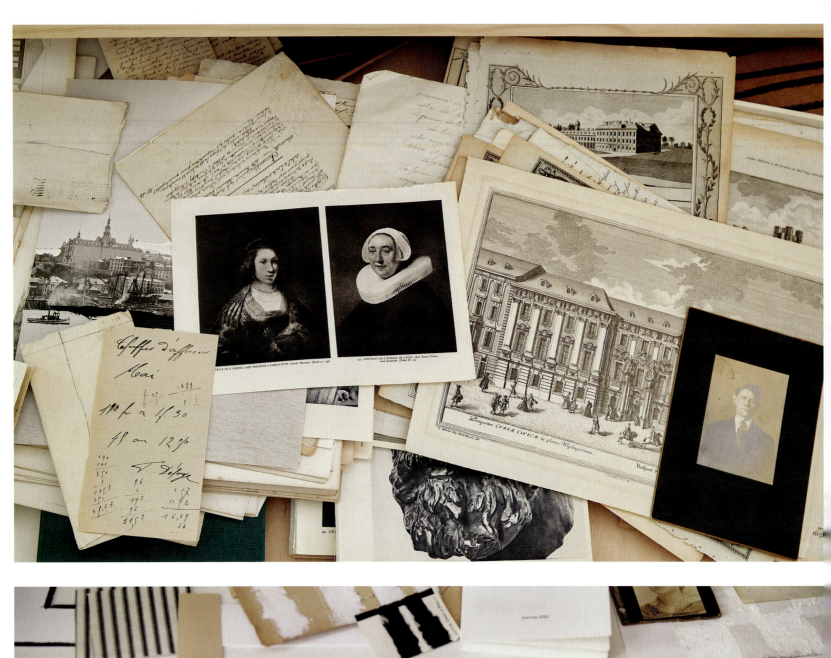

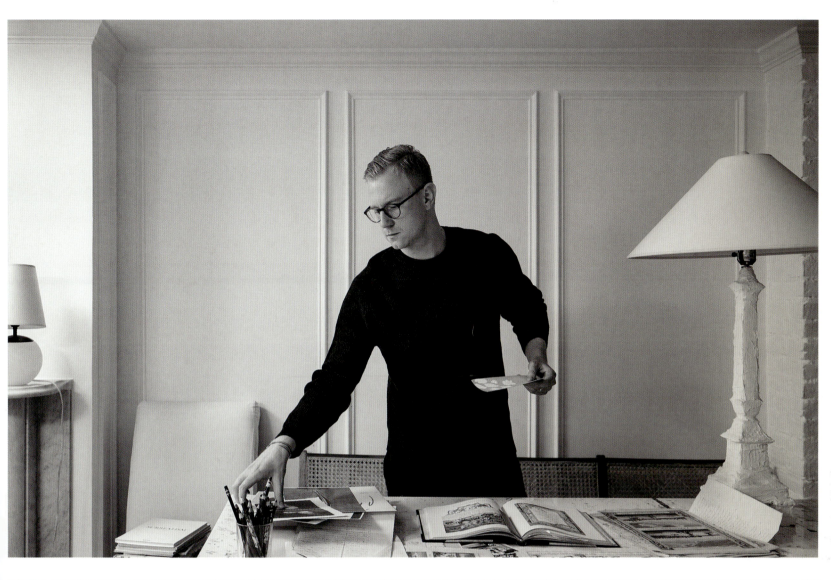
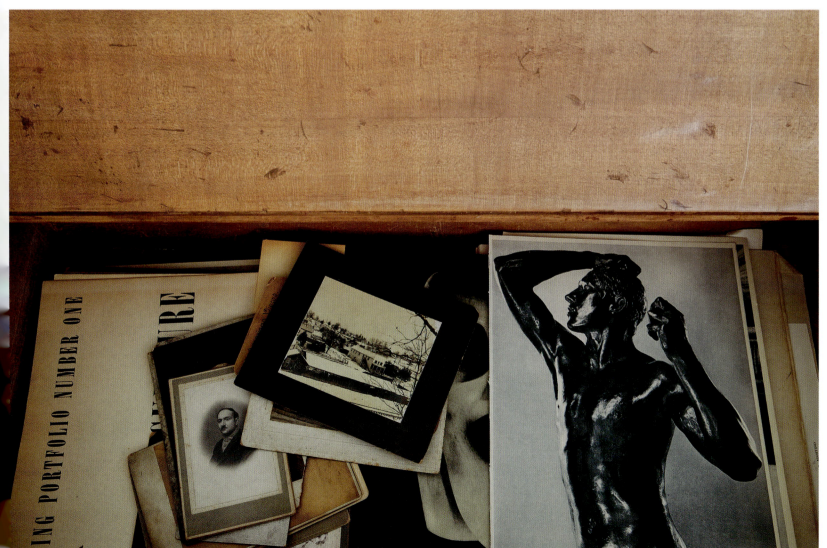

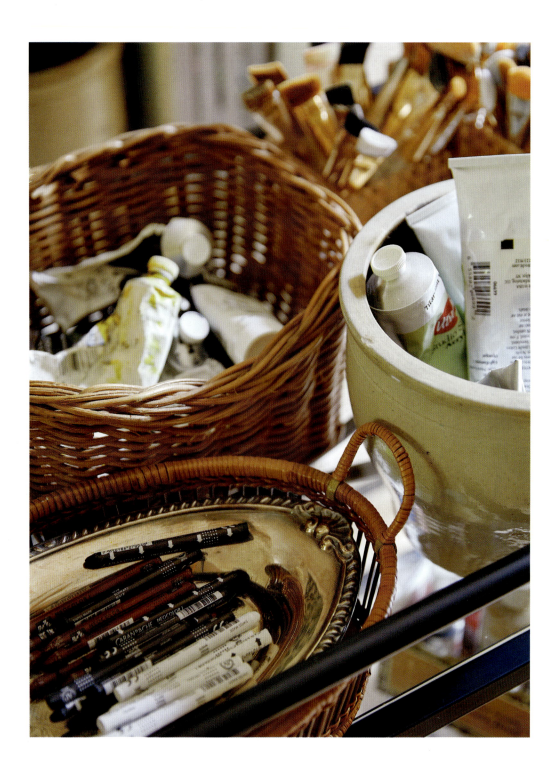

PAGE 180: In my D.C. art studio, one of the many mood and reference boards that I use for personal and design projects. **PAGE 181:** An empty frame adds depth without obscuring the items behind it. **PRECEDING PAGES:** In the studio, sorting and sifting through antique documents and materials for an upcoming collection. Many are sourced on my travels and from my vendors around the world. **ABOVE AND OPPOSITE:** Layers and vignettes need not be purely decorative—useful objects can also embellish. Art materials stored in my studio form displays.

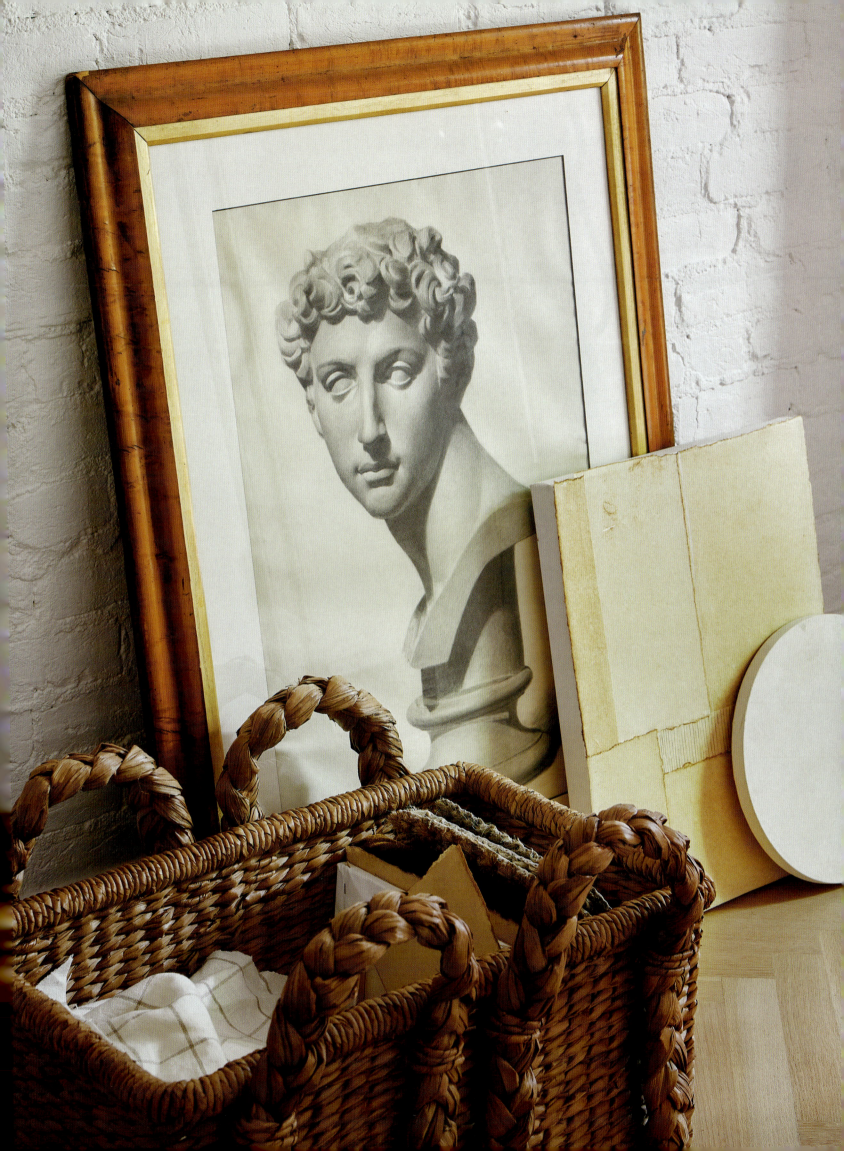

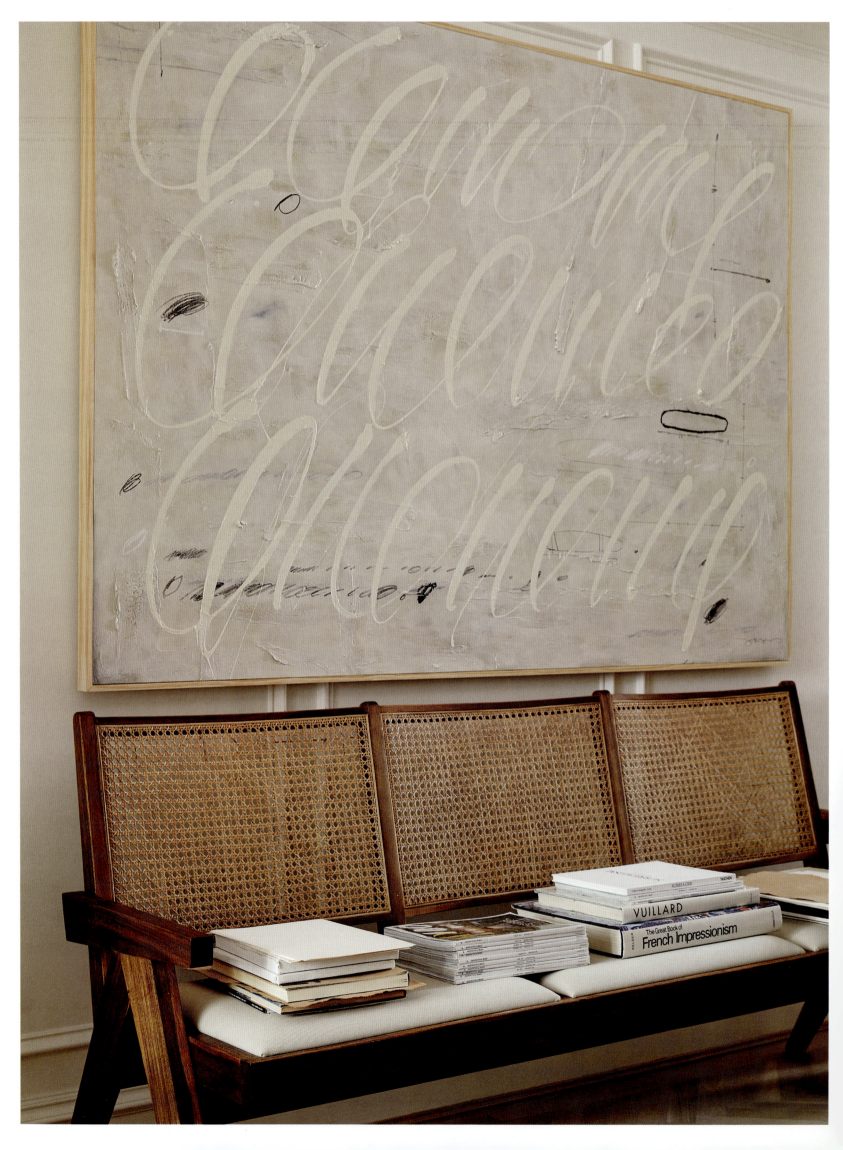

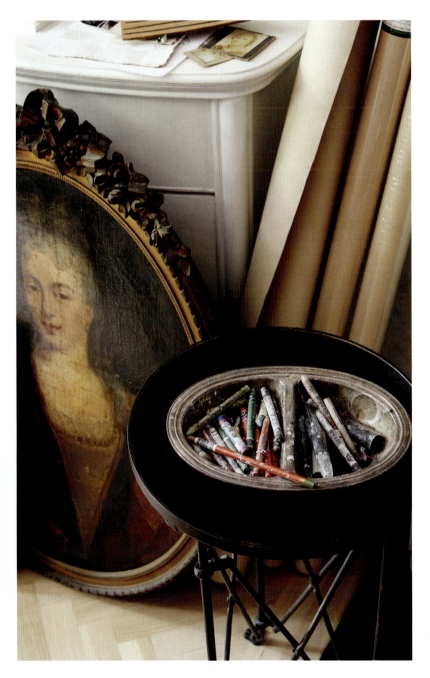

OPPOSITE: A client commission titled *Corso Venezia, 1933* (oil, oil pastel, graphite, plaster, and gesso on canvas) hangs in the studio. **ABOVE, LEFT**: A tray of pastels and pencils rests on an antique iron side table. **ABOVE, RIGHT**: Rolls of loose canvas wait to be used for commission work.

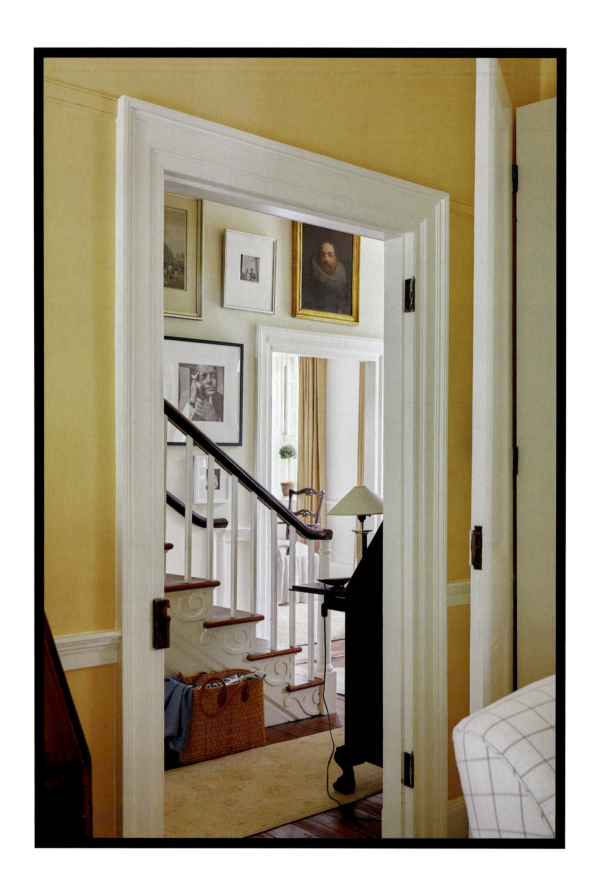

ABOVE: A peek from the parlor-floor reading room at Sycamore House into the main hallway and dining room creates visual layers: the walls, the stairs, the artwork, the drapes. All the elements cohere into a seamless whole.
OPPOSITE: The reading room at Sycamore House features a custom English roll-arm sofa I designed with a gathered skirt in a neutral windowpane patterned fabric. An antique glass bell jar lantern adorns the ceiling, and two wingback armchairs with custom black piping flank the fireplace.

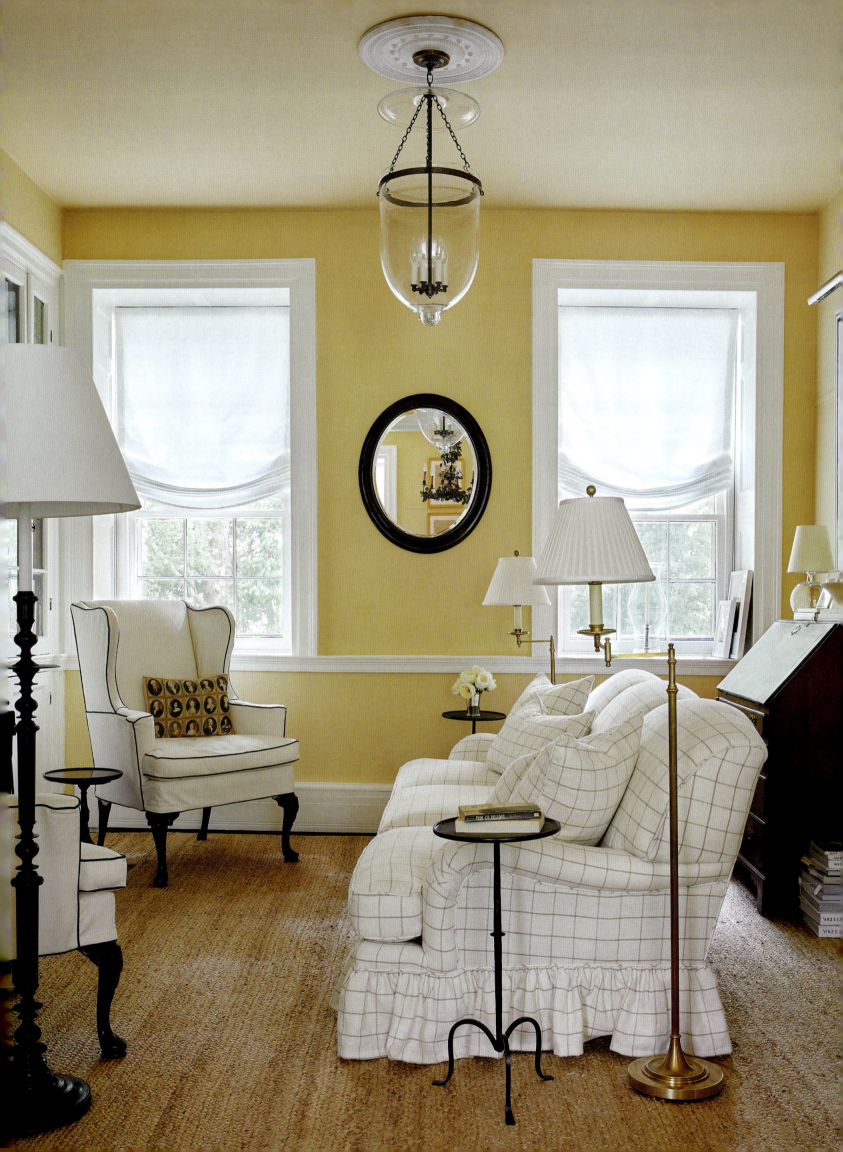

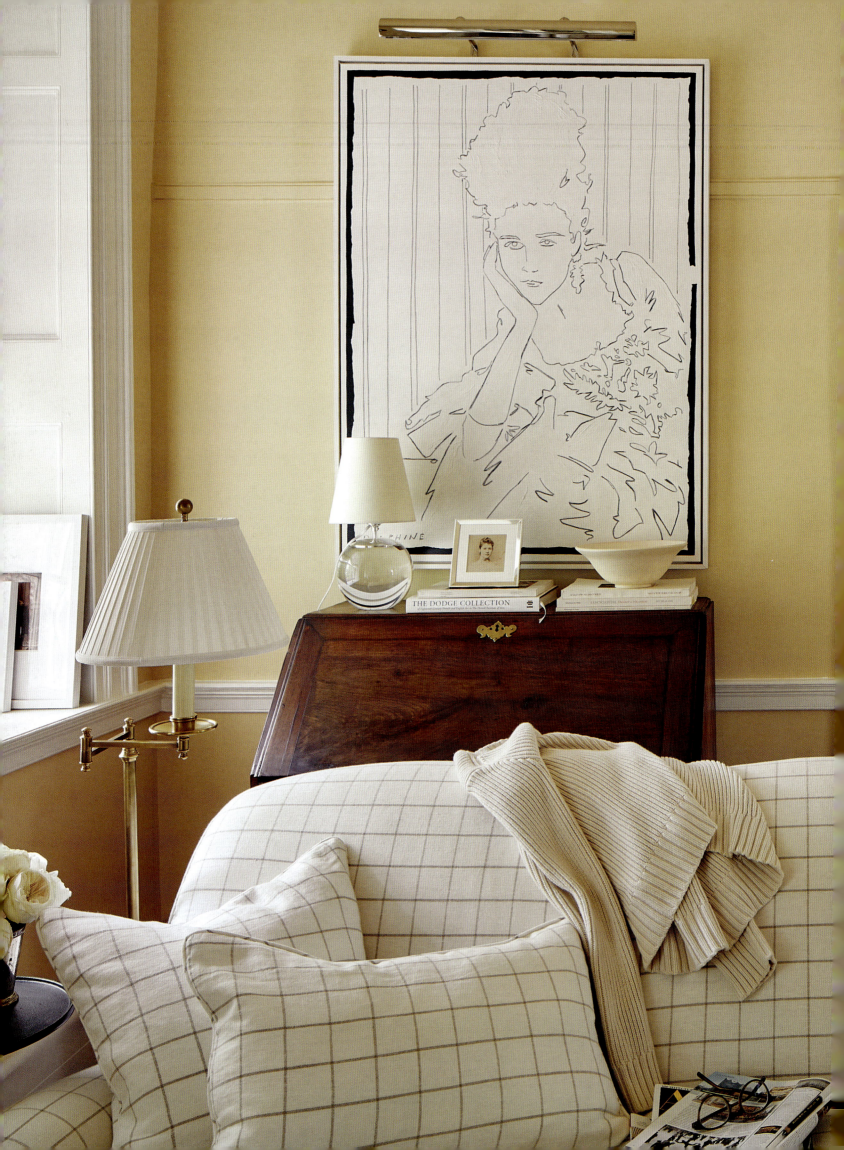

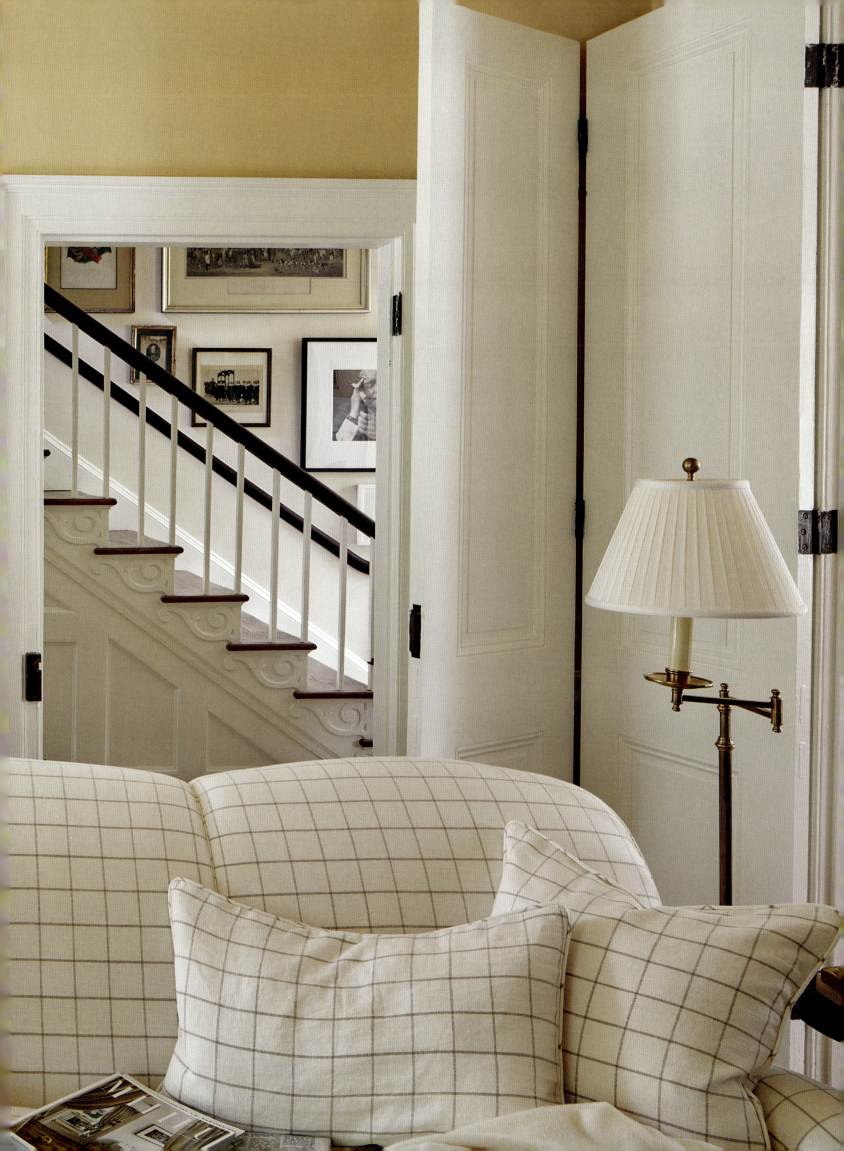

PRECEDING PAGES: Arguably my favorite space at Sycamore House, the reading room is an oasis where I curl up to read my magazines, catch up on emails, or relax by the fireplace on cold winter nights. **ABOVE:** The peaceful reading room is layered—naturally—with my favorite novels and art and design books for my guests and me to enjoy. **OPPOSITE:** On top of the fireplace is a large portrait we purchased during a sourcing trip in Hudson, New York.

192 LAYERS

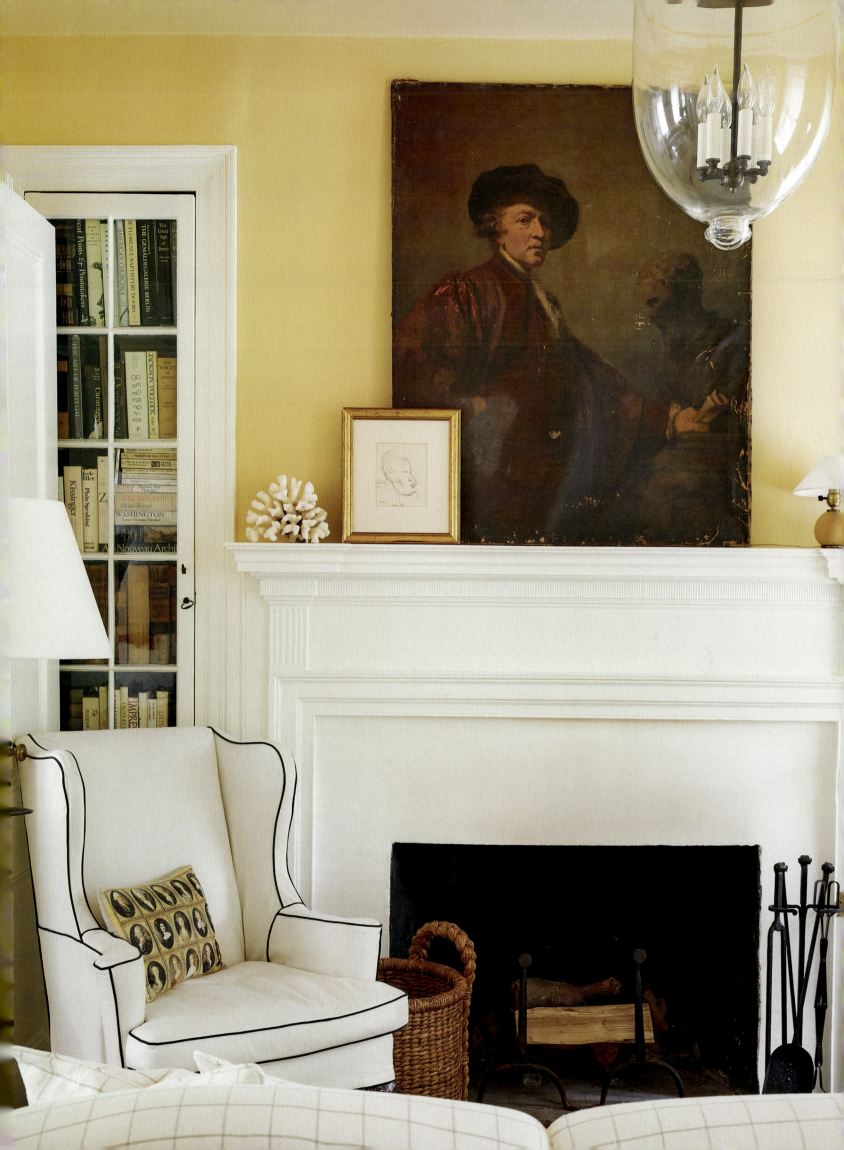

Books are the perfect objects for layering and styling. Books add warmth and character to a room, and collecting them over time is fun and rewarding. I've built up quite a personal collection of my own, and my books really are prized possessions. When styling, I have a firm rule that I only incorporate books that I have read or plan to read—they're never just props. To my mind, a beautiful and complete room always incorporates good art, good lighting, good antiques, and good books.

In almost every room in my home, and in almost every vignette within it, you will find a pile of books—stacked on tables, layered under commodes, or placed on windowsills. Shelves filled to the brim with books. Some old, some new. Some lined up vertically, others stacked horizontally. Books that are carefully selected and curated not only showcase interests, but hopefully are also intriguing to guests. You can't judge a book by its cover, but books can certainly tell you a lot about their owner.

Another way to add layers is through the use of mirrors. Aptly known as looking glasses, mirrors draw the eye into a different perspective of a room, inserting a magical layer in any space. I've always had an affinity for antique mirrors. Over the years I've situated them on top of dressers and commodes, on mantels, and even inside nonfunctioning fireplaces, as in in my former art studio in Chicago. Try placing mirrors in areas that catch your eye as you move from one room to another. Mirrors can expand a narrow hallway, or add depth to an uninteresting, flat wall.

OPPOSITE, CLOCKWISE FROM TOP LEFT: A quiet moment with warm summer light pouring into the reading room. Ignacio and I purchased this accent pillow with a portraiture pattern in Milan when we were students. *Josephine*, from my *MUSE* series, hangs above an antique secretary. We filled a drawer with bayonets and spoons found under a staircase at Sycamore House during a renovation—the items date back to the Revolutionary War and the War of 1812.

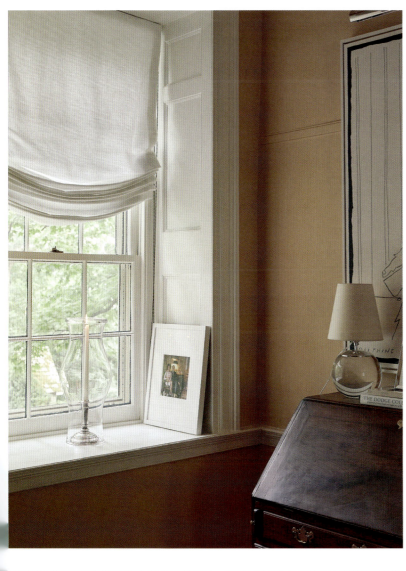
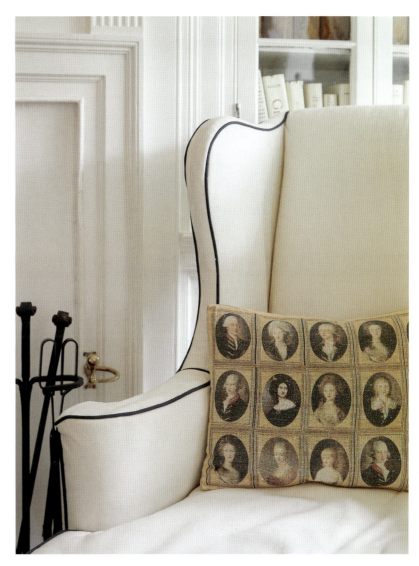
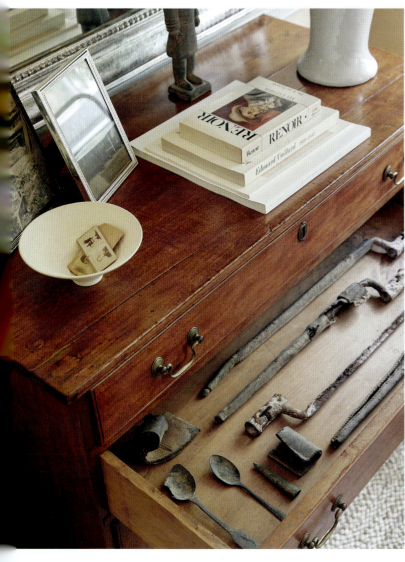
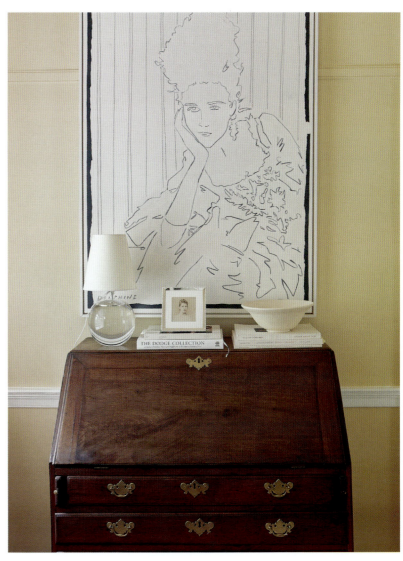

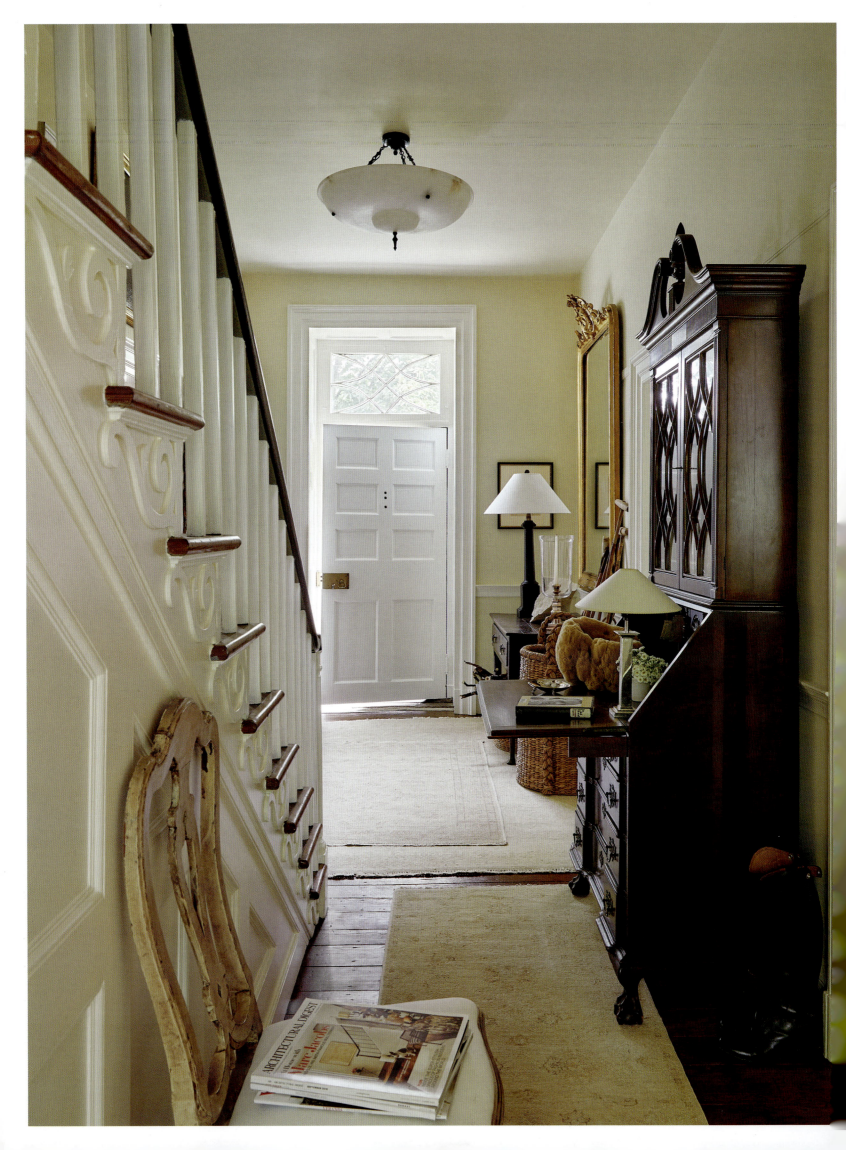

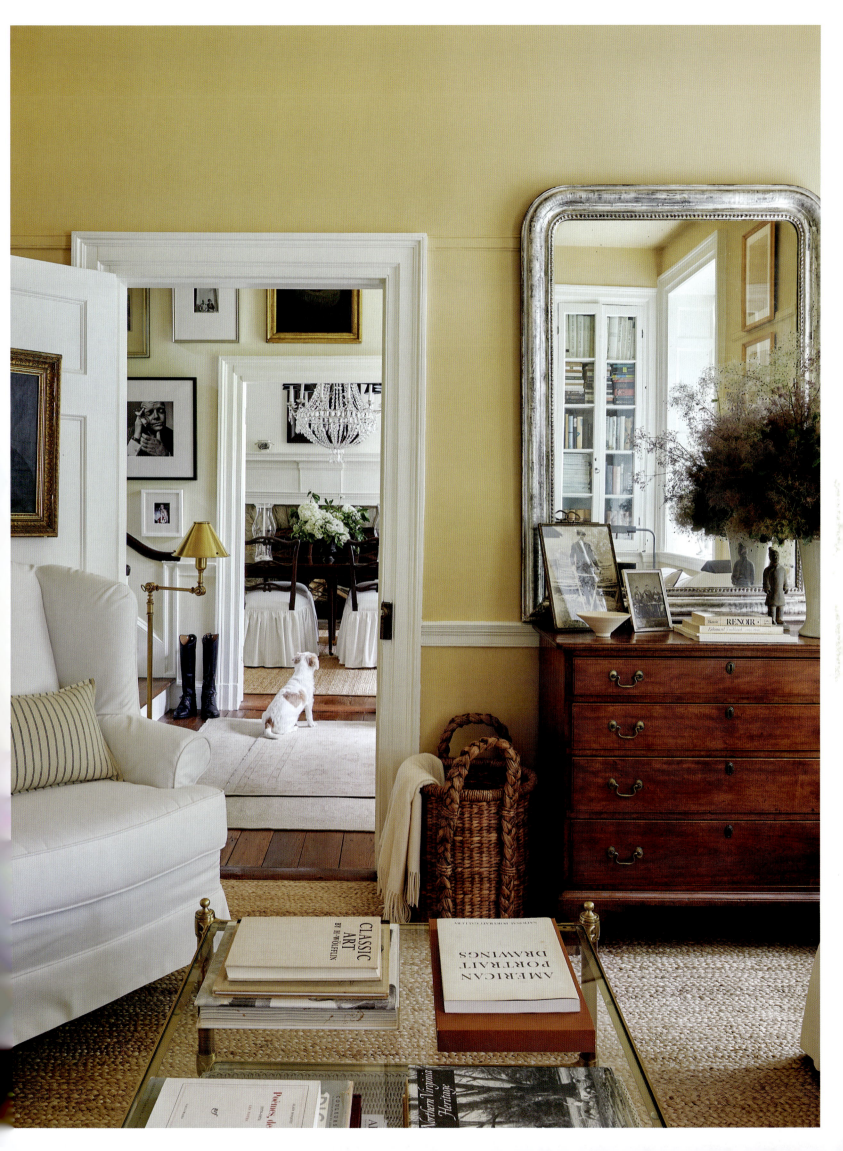

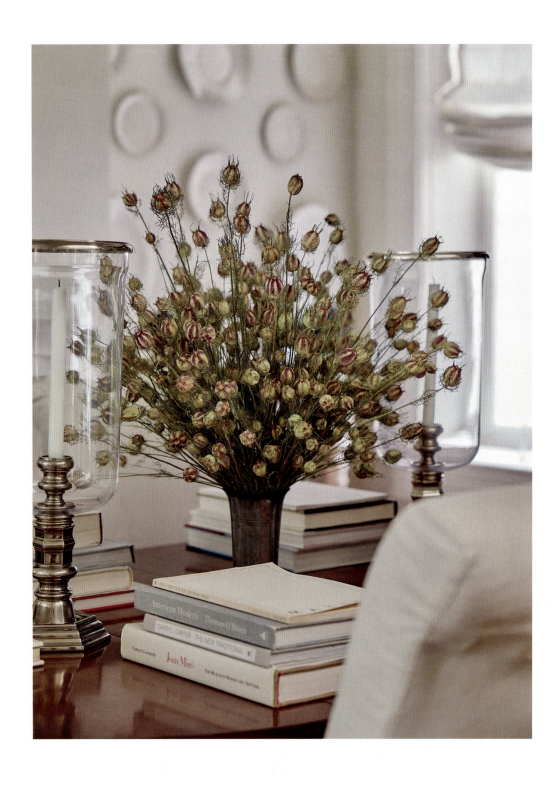

PRECEDING PAGES, FROM LEFT: The view from the back door of Sycamore House toward the main entrance reveals many layers, including overlapping rugs and light fixtures at various heights. Our dog, Maggie, stands guard at the door to the dining room. **ABOVE:** An arrangement of dried nigella pods, stacks of books, and antique glass hurricanes warm up the dining room table at the townhouse. **OPPOSITE:** In the dining room, northern light showcases the beautiful details of the nineteenth-century Italianate statuary marble mantel. Layered need not mean busy—here, negative space is an important element.

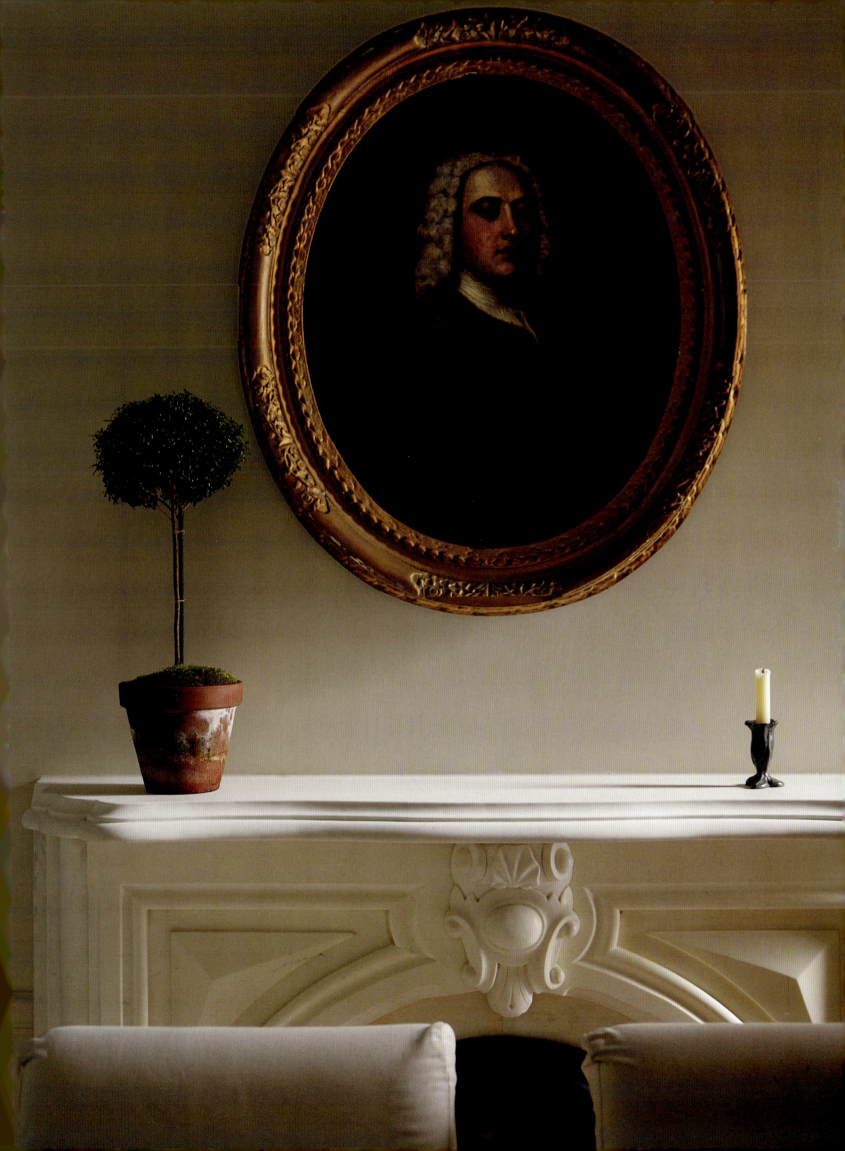

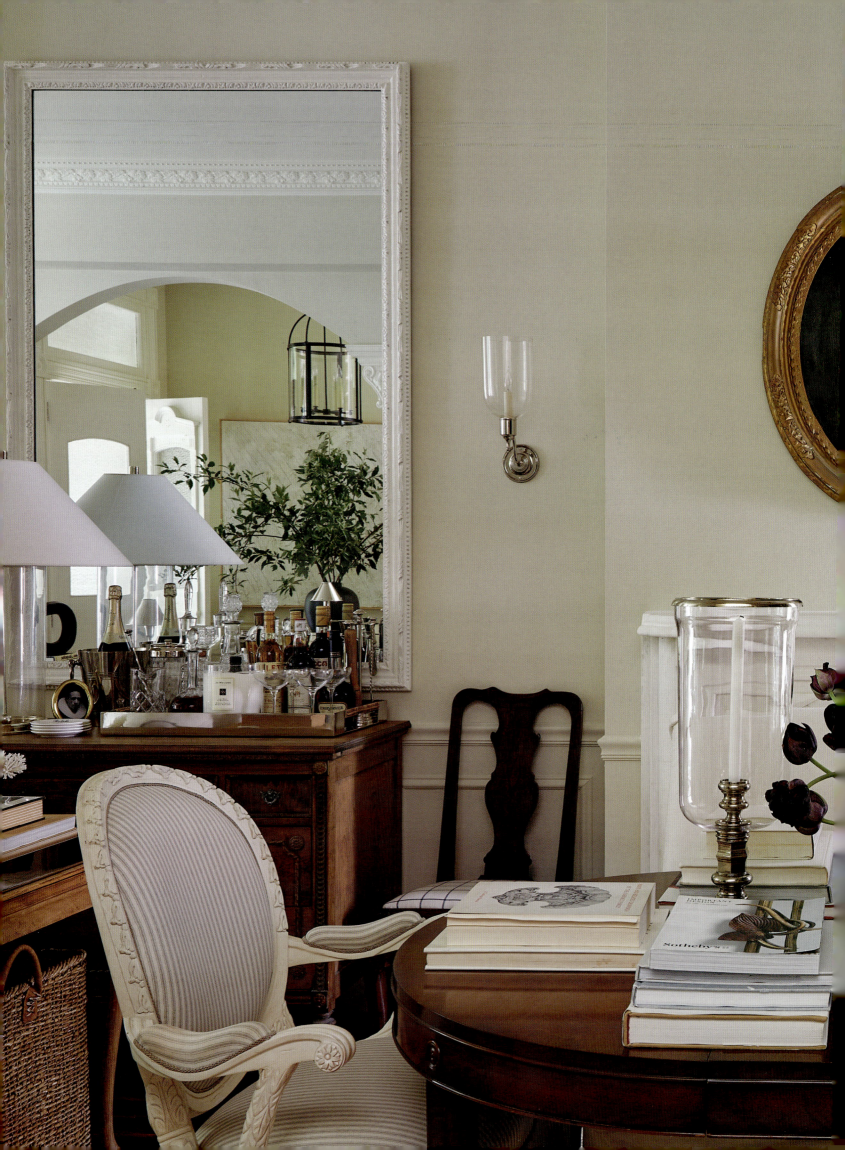

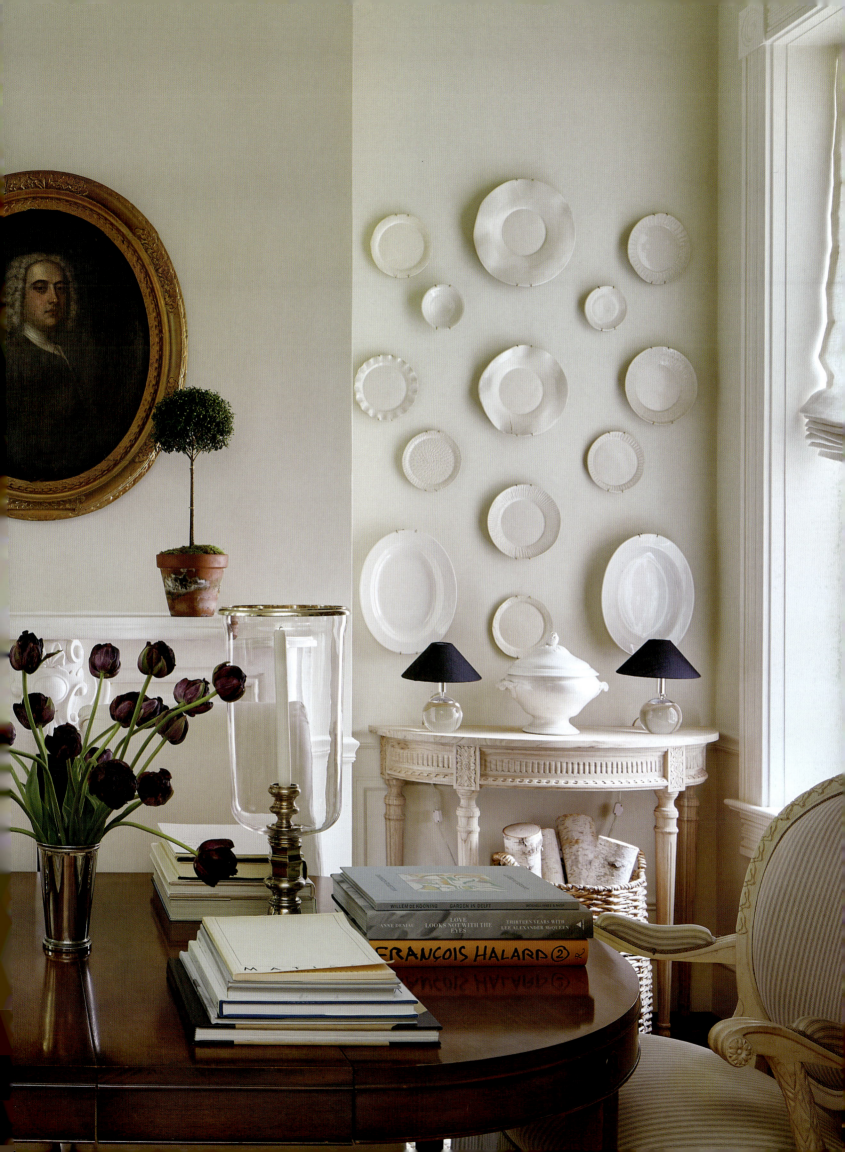

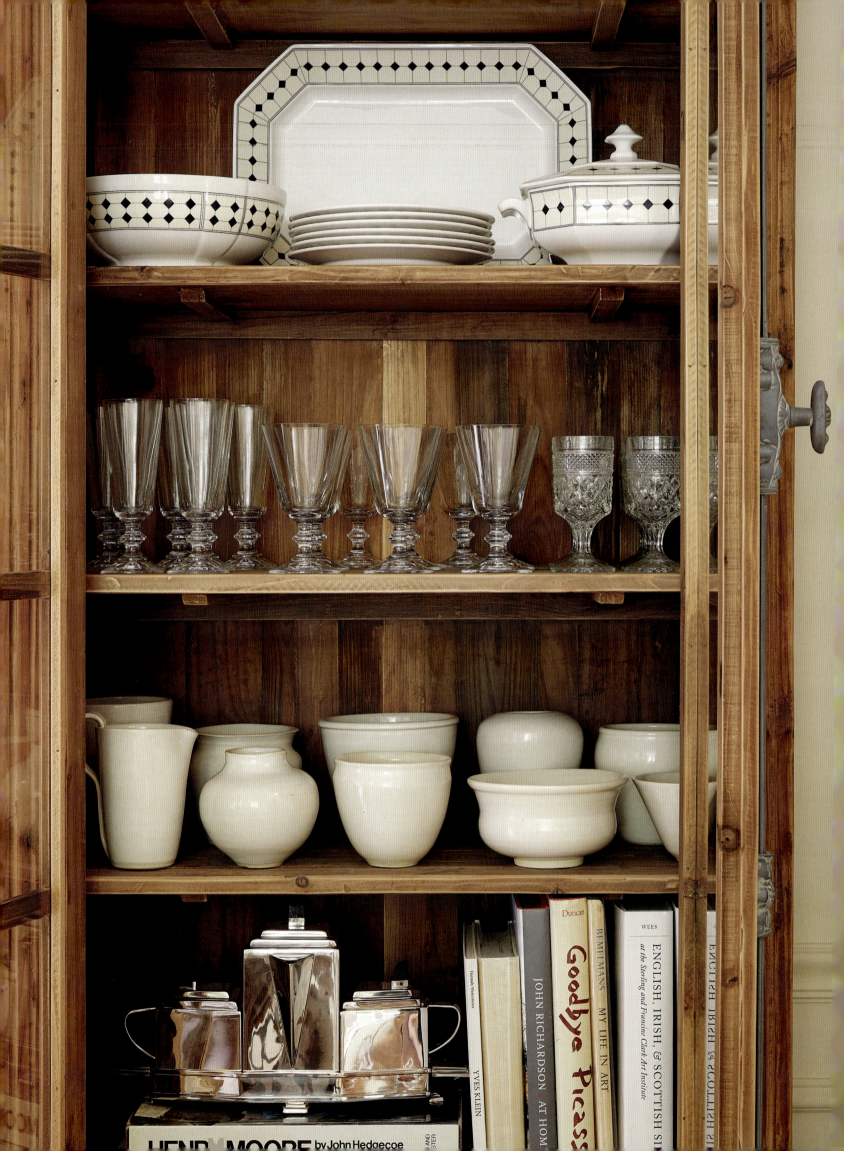

A beautifully layered home is a home that feels collected and carefully put together over time. Collecting is an artform. The pieces I collect and the objects I choose to display weave a tale of my interests and passions. Their placements and marriages with other items help form the layers of my home. There's nothing that feels more immediately intimate than walking into a collected home. Keepsakes and found treasures intentionally displayed and layered stand as a testament to time and an individual's decorative evolution. A curated environment is the antithesis of sterility. When we have guests at the townhouse or Sycamore House, I love to watch them explore. Whether they venture room to room observing all of the details or scan a space with their eyes while seated in one of our living rooms or dining rooms, I find great joy in witnessing them and knowing that I have created an environment that is fun for others to experience. Every object tells a story and holds meaning or a memory.

One thing I love about being a collector is the way that over time my collections have made clear what draws me aesthetically: a true mix of classical and modern elements that are playful and refined. After years of collecting furniture, decorative accents, and artwork, I can see an obvious stylistic throughline in the mix of art deco, Swedish Gustavian, and early American objects found in our homes. All the pieces exude a feeling of refined simplicity and overall sense of fragility in their form, including a collection of classical portraiture, vintage lighting, antique textiles, and unique pottery and ceramics.

A home's layers give it character and depth. Layering any space should be about intention, curation, and a true display of your interests and passions. It's an organic process that evolves and is one that should be explored without limits or restrictions.

PRECEDING PAGES: The dining room in our D.C. townhouse is a testament to my love of layering.
OPPOSITE: Inside the china cabinet in our dining room, French patterned dinnerware, wine goblets, pieces from Alfaro Pottery, and a vintage art deco tea service are stacked in distinct strata.

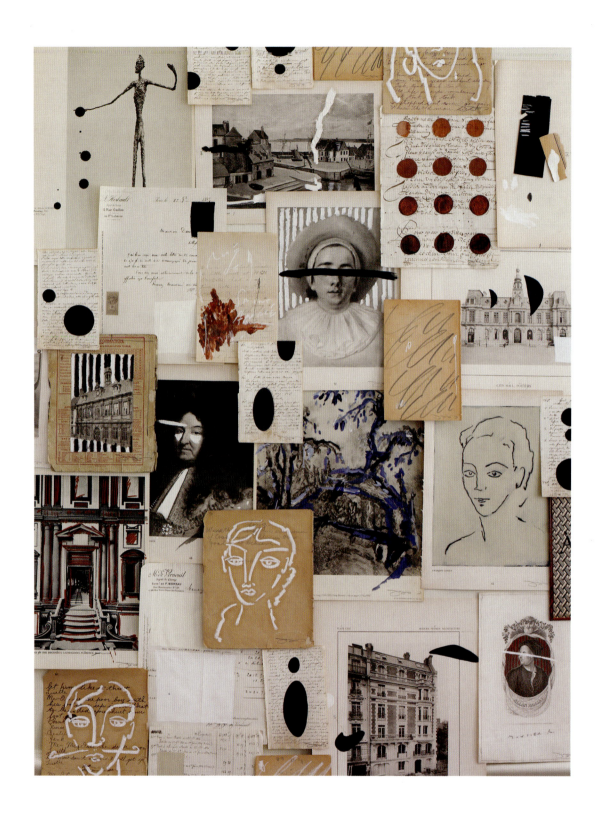

ABOVE: A collage from my *Bibliothèque* series. OPPOSITE: Antique glass decanters and goblets sit atop a vintage dresser in the butler's pantry at Sycamore House with vintage French wired buffet lamps. A mirror, like this art deco example from the 1920s, instantly adds dimension to a room through reflection. FOLLOWING PAGES: A guest bedroom at Sycamore House features a king-sized canopy bed. Repeating the same motif in different areas—like using the pattern of this traditional damask wallpaper on lampshades—creates depth. PAGE 208: Bookshelves filled with some of my favorite novels for guests to read while visiting. PAGE 209: An eighteenth-century chest of drawers and one of a pair of antique Swedish Gustavian side chairs with neutral striped upholstery.

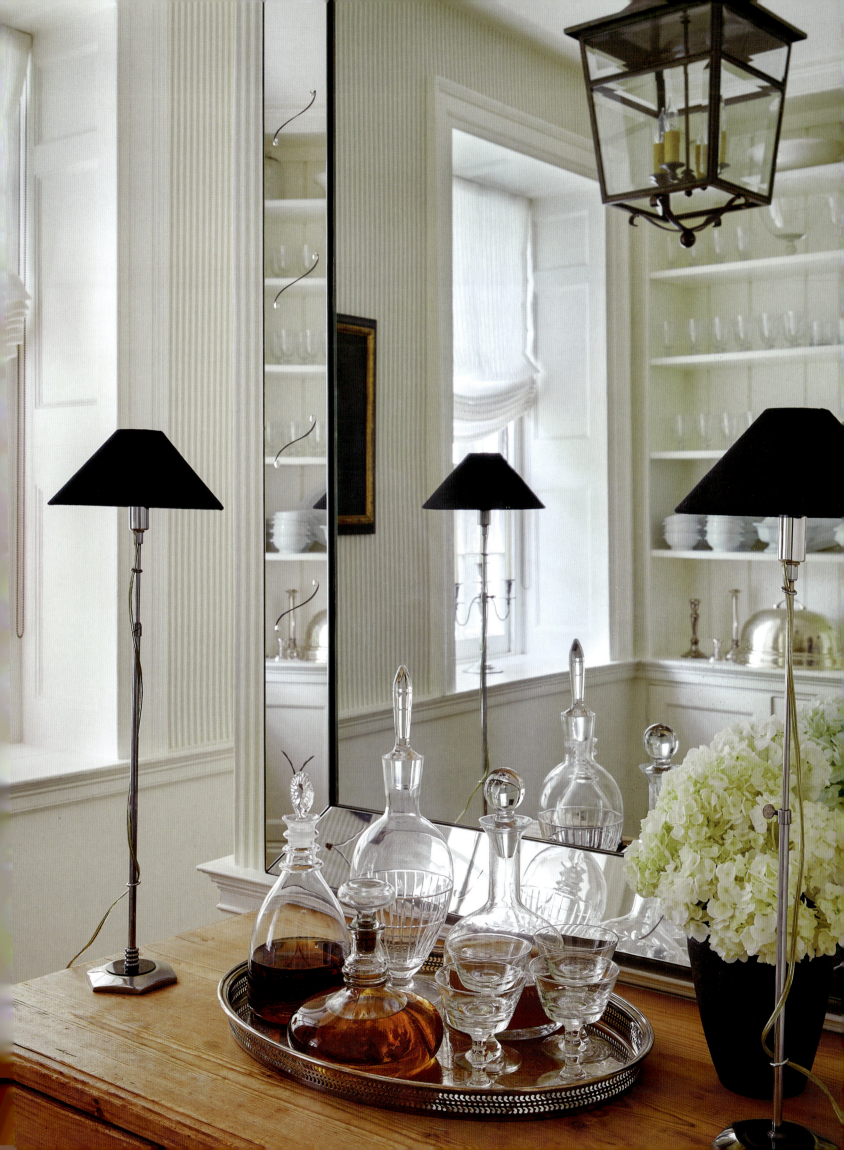

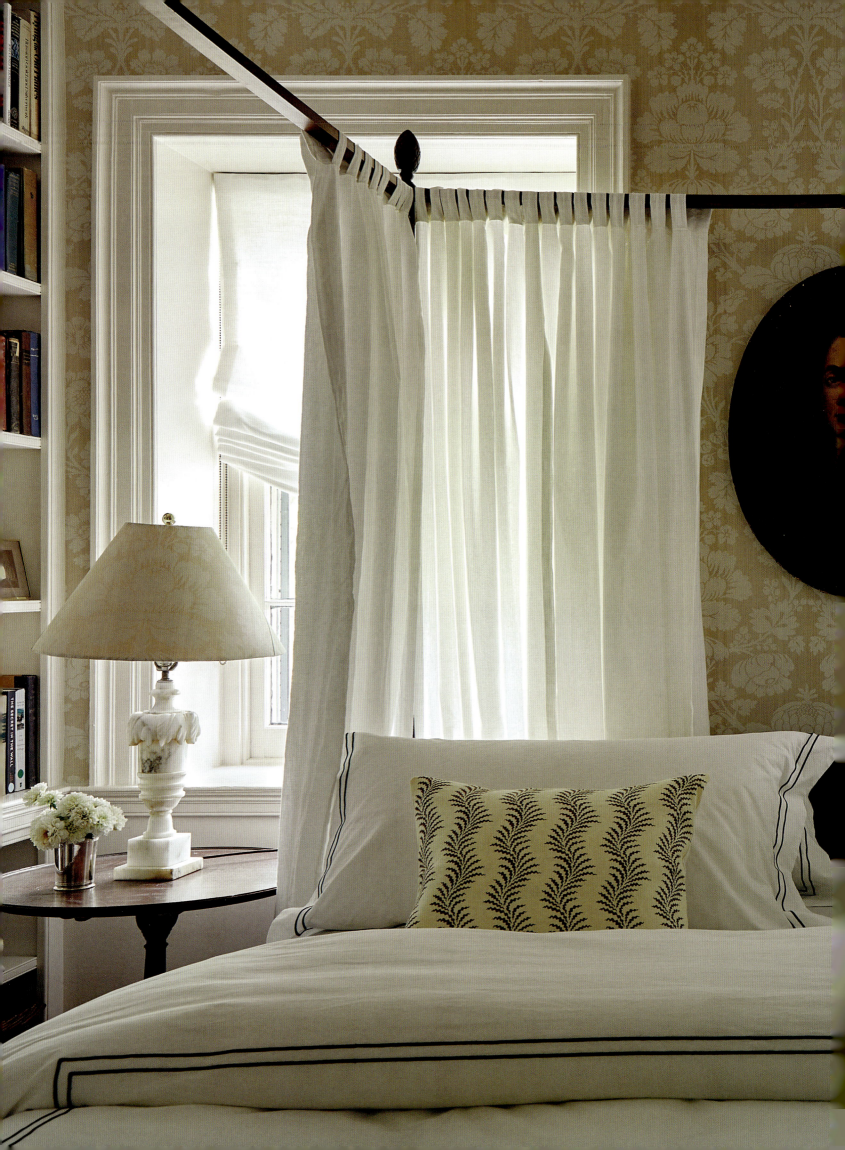

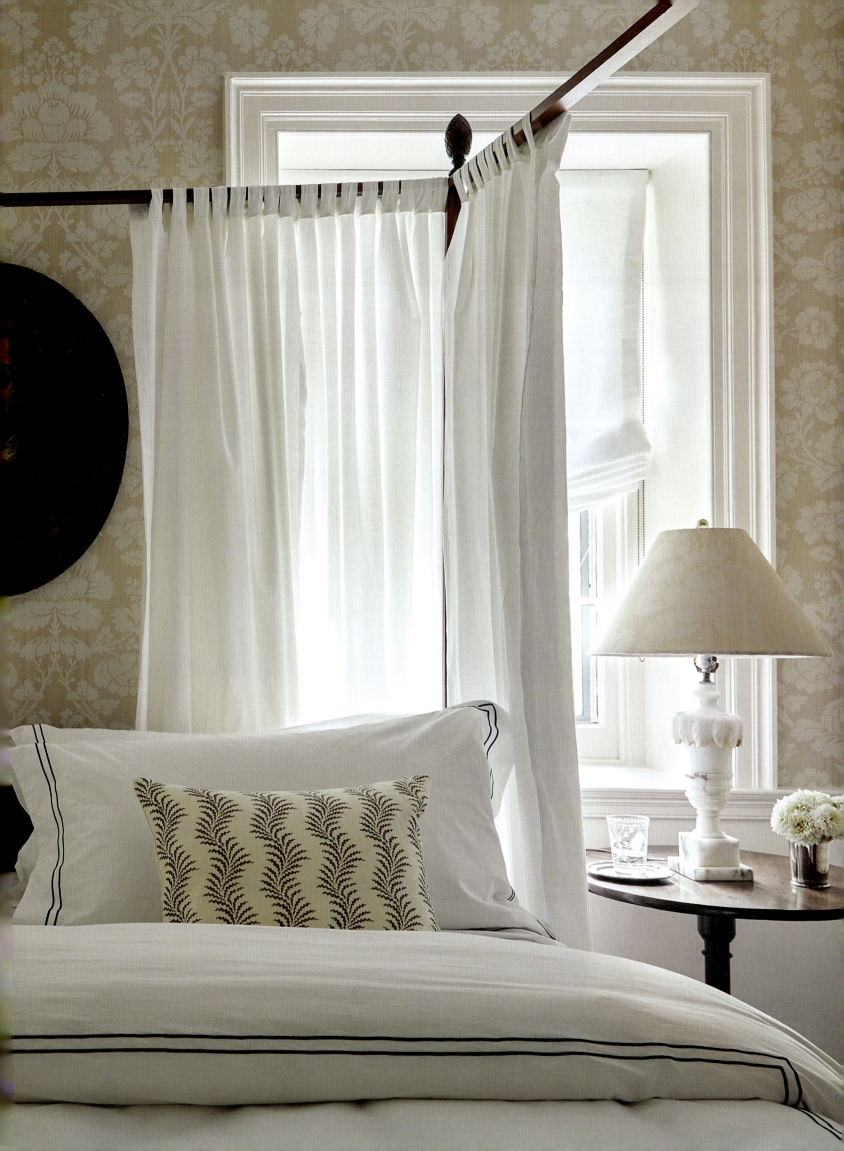

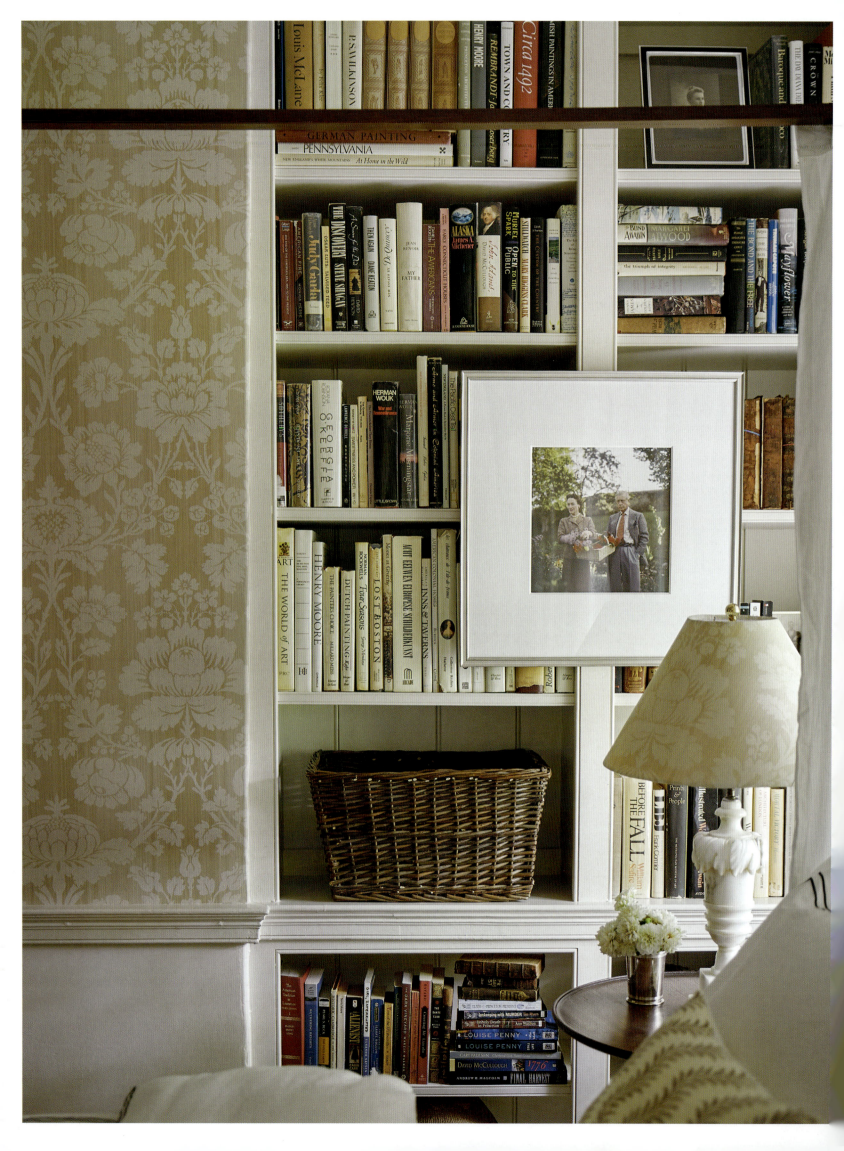

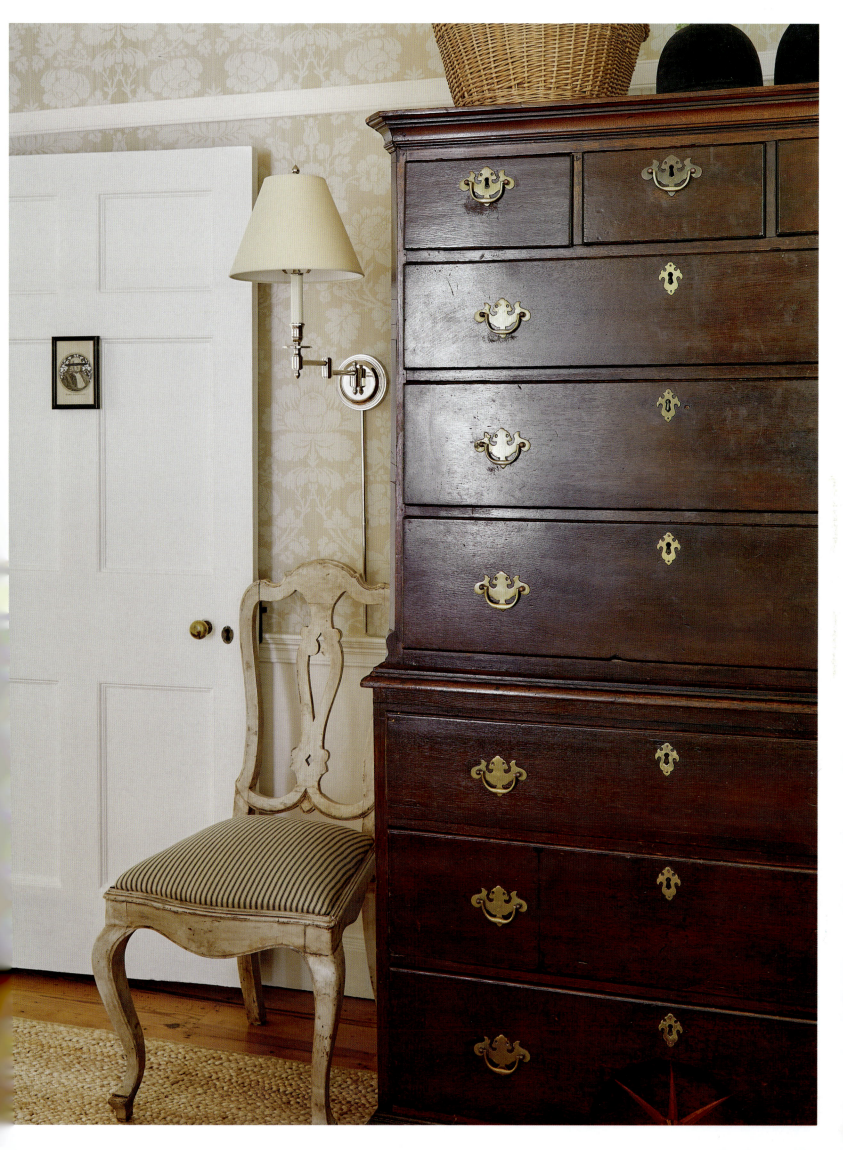

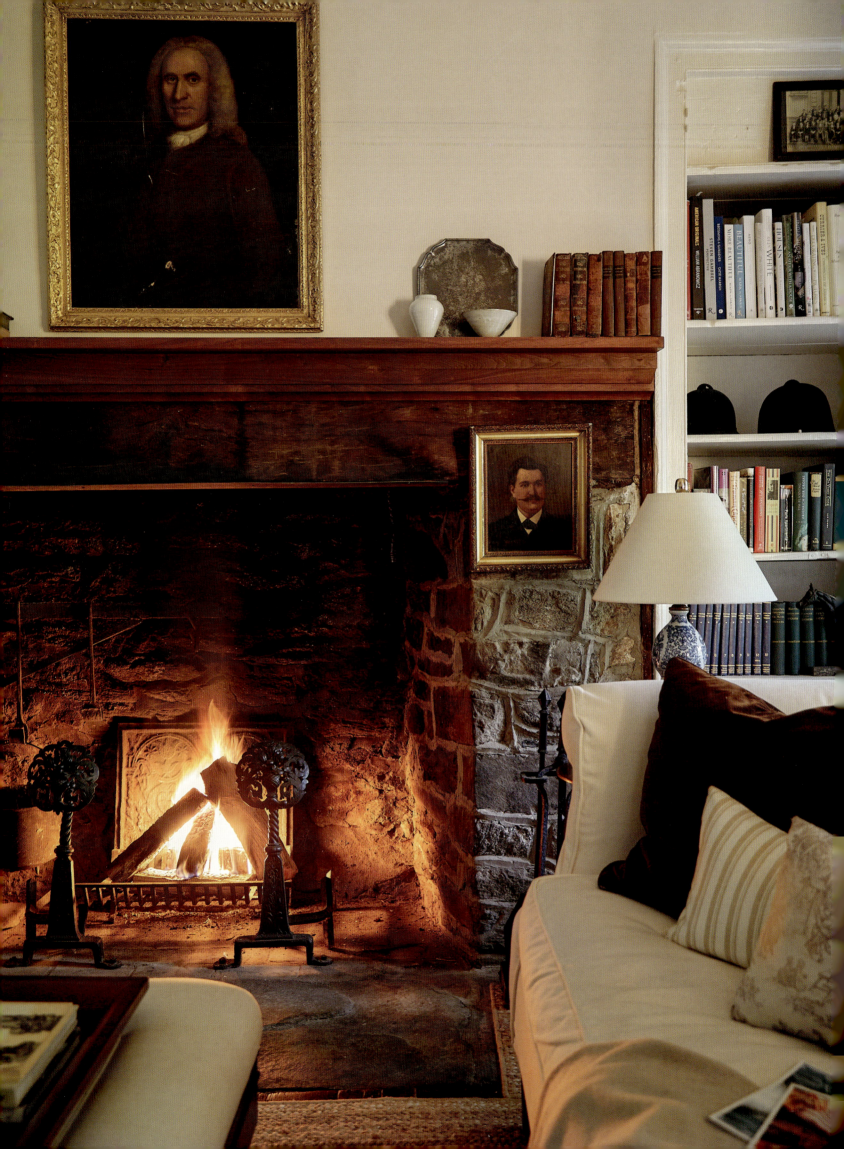

NOSTALGIA

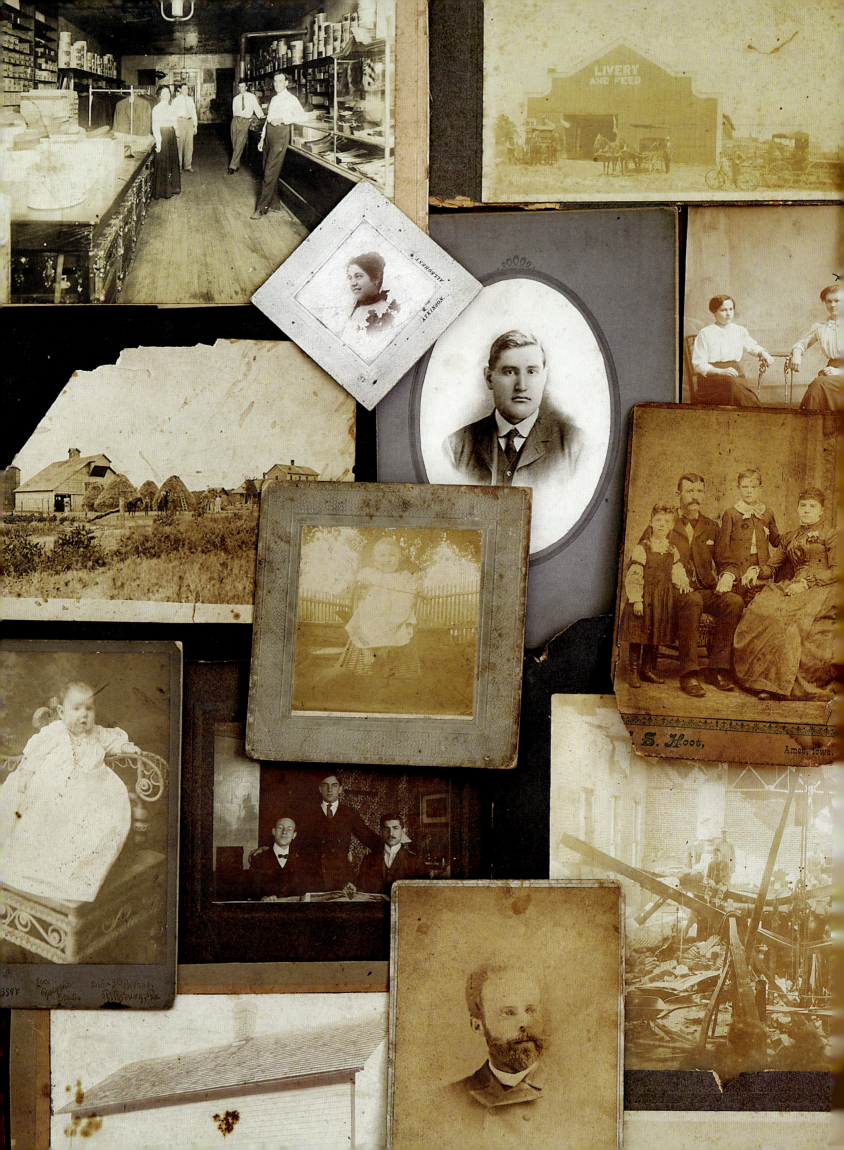

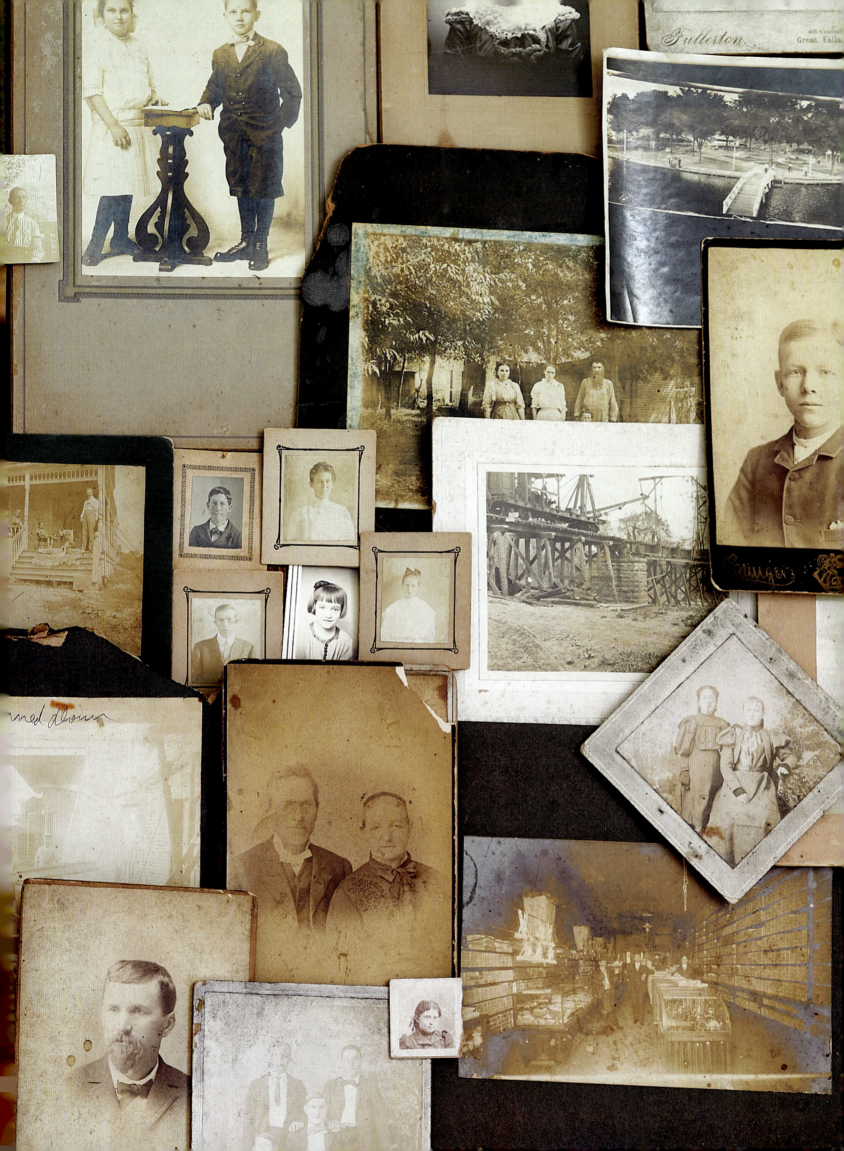

For me, nostalgia is about cultivating a sense of warmth and comfort. A respite that allows space to dream. Escapism from the day-to-day. It's walking into a room and being surrounded by objects or things that hold sentimentality and significance. Evoking a feeling of history while still being rooted in the present.

In the seventeenth century, nostalgia was often linked to depression and melancholia. For some, that could very well be the case, but I like to think of nostalgia as less about fixating on what was and more about romanticizing a feeling of what may have been. Pulling and referencing elements from the past that we find enjoyable and satisfying. Going beyond just the aesthetically pleasing and creating a world with depth and meaning.

I've always been observant of my surroundings. Even when I was a child, family and friends would remark on my ability to recall an experience or a place in great detail. Extremely in tune with my senses and aware of the influence they have on my overall mood and creativity, I'm also the type of person who feels their way through life. Songs, a fragrance, a film, or a place immediately connect me to specific memories. I tend to link a certain amount of sentimentality to people, places, and things, and I look to have that nostalgia translated and represented in both my artwork and my interiors.

PRECEDING PAGES: Vintage photographs I've collected over the years throughout my travels. Direct portals to the past, they evoke so much emotion. **OPPOSITE:** The gallery wall in our D.C. townhouse displays a mix of my abstract work, black-and-white photography, antique engravings, drawings, portraiture, and vintage mirrors.

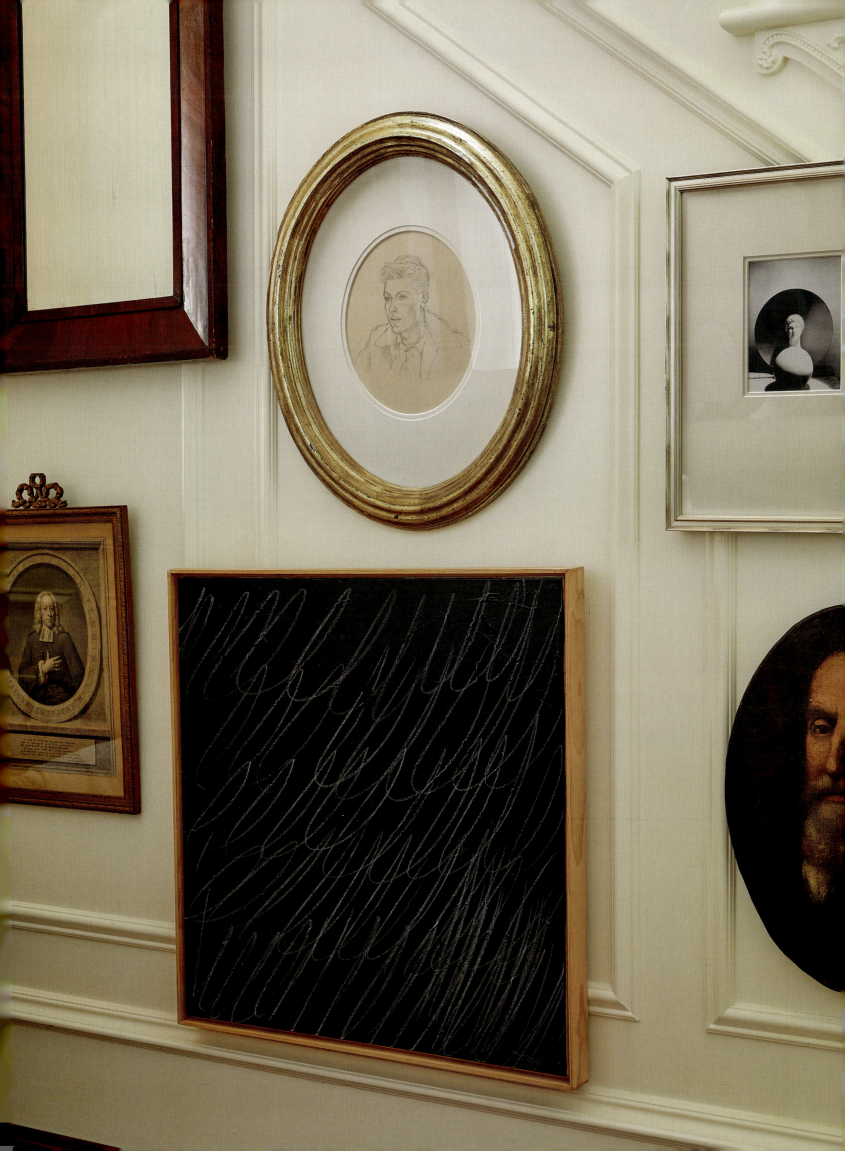

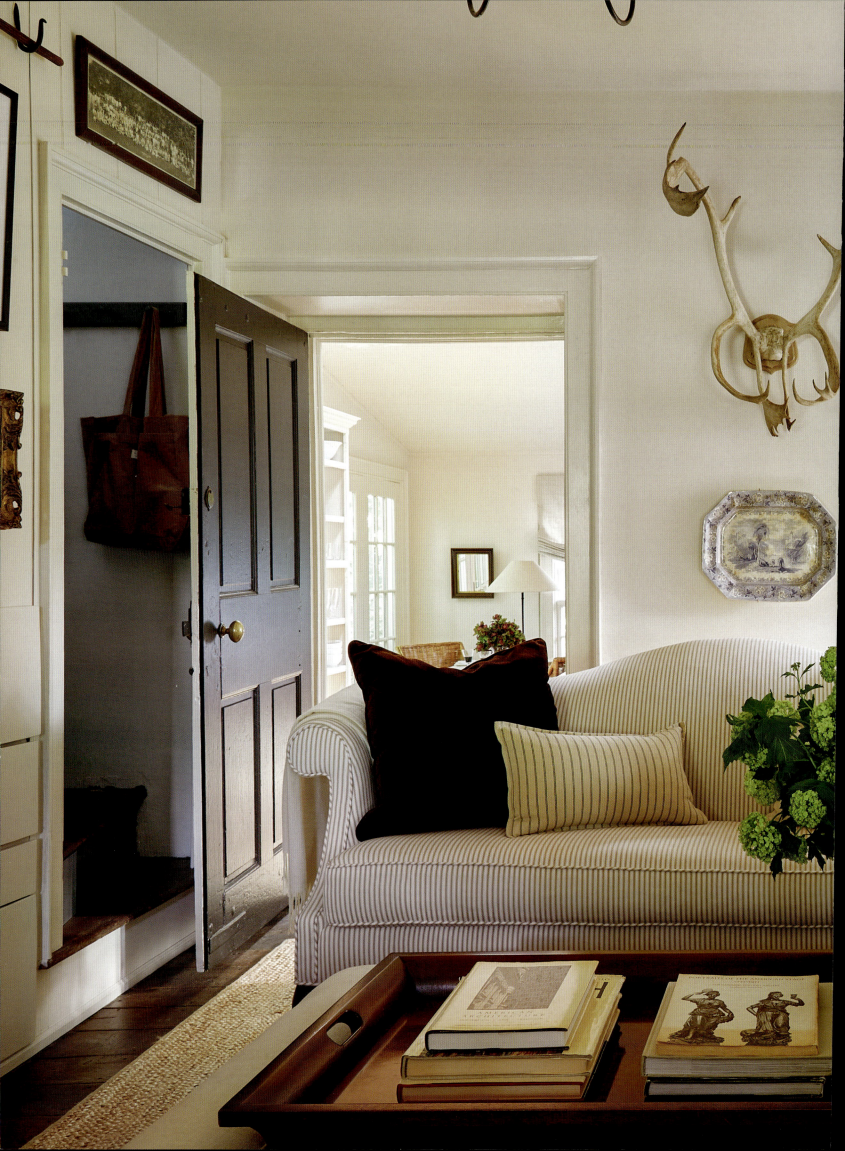

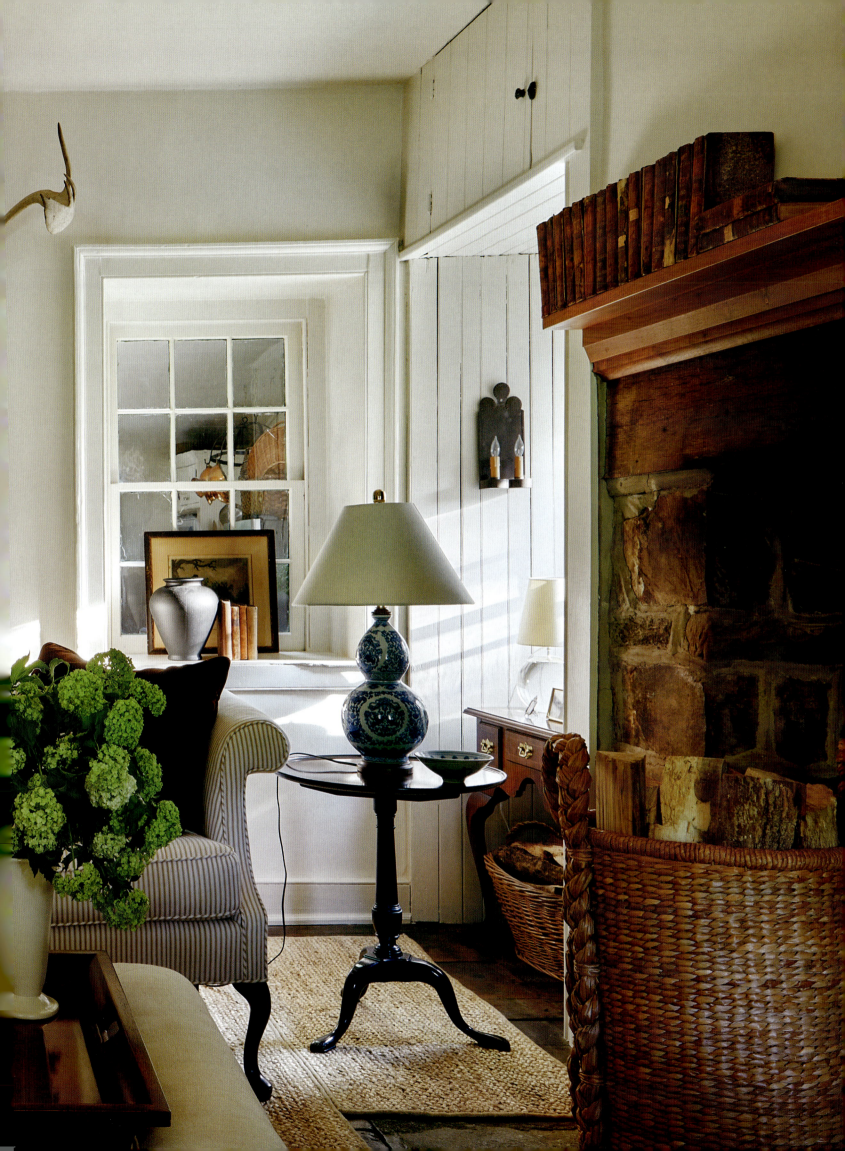

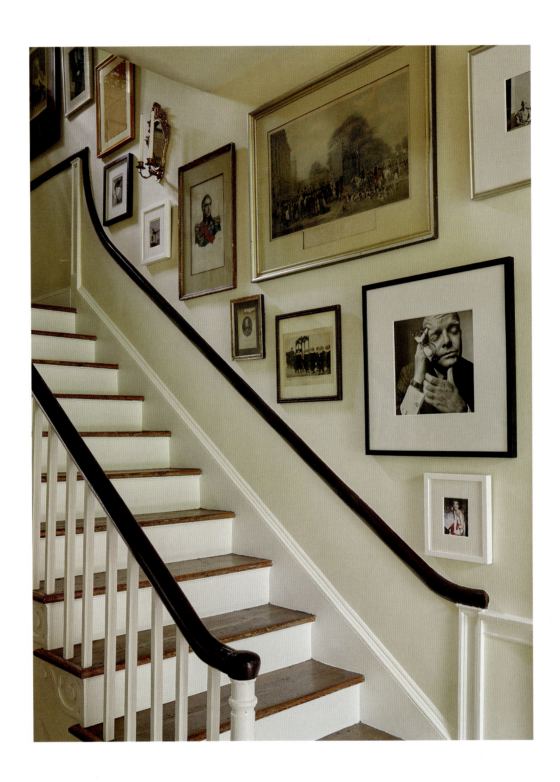

PRECEDING PAGES: The summer room at Sycamore House, the original kitchen from 1780, is now a casual living room and retreat—a place to watch television or enjoy a cup of coffee first thing in the morning. **ABOVE:** The gallery wall at Sycamore House wraps around the first- and second-floor staircase. The walls are lined with photographs of notable individuals I've always found fascinating, like Truman Capote, Julia Child, Jacqueline Kennedy, Princess Diana, and Wallis Simpson. **OPPOSITE:** A side table in the summer room holds framed black-and-white images and photographs, lending a sense of heritage and warmth.

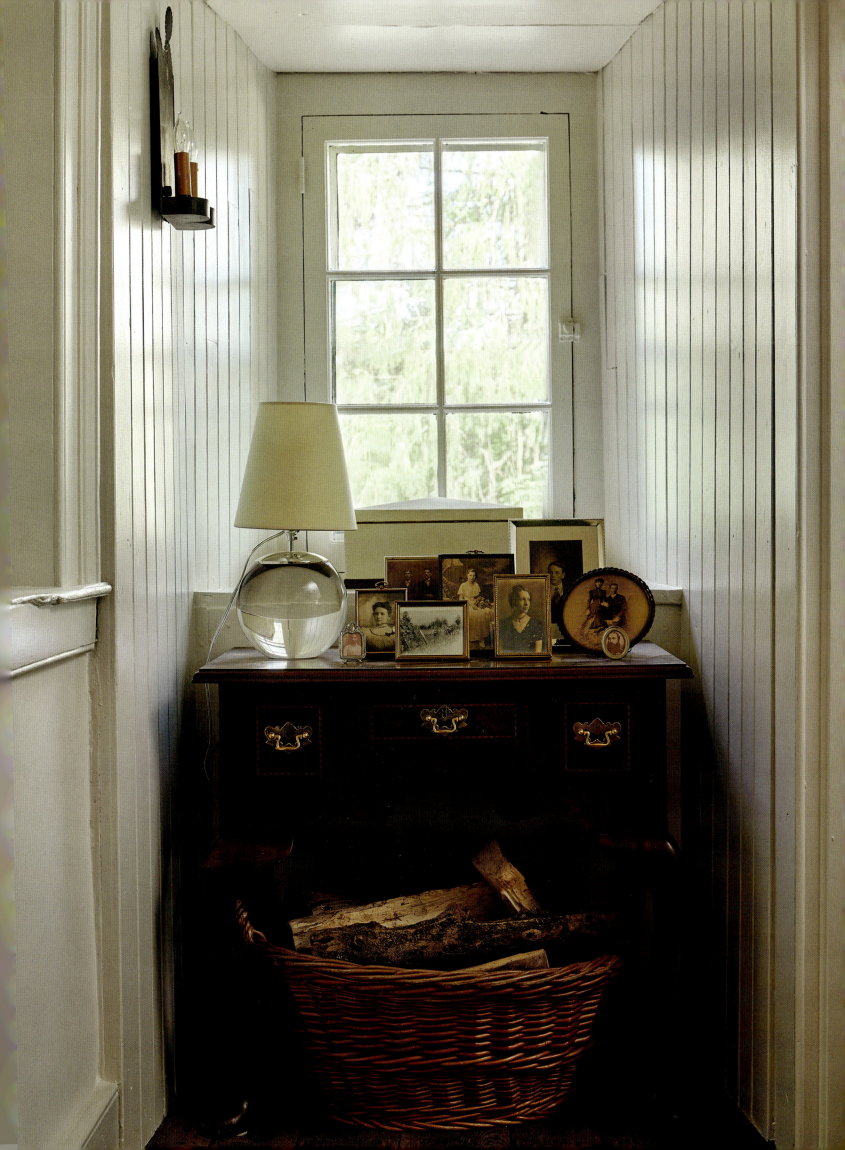

Growing up, I was obsessed with the glamour and elegance of notable society figures, like Truman Capote and Wallis Simpson. I would study them intensely—the way they dressed, the way they talked, their fabulously decorated homes, the lavish parties they threw. I would often draw and sketch them late at night in my childhood bedroom. Strange and peculiar individuals for a thirteen-year-old boy to idolize, but I was completely enamored. Photographs of individuals like them can be seen scattered throughout the townhouse and Sycamore House.

I remember going on historic home tours with my parents and friends and seeing walls filled with old portraiture. I was completely fascinated. I found these paintings to be mystical and haunting. I felt I was staring history in the eye, quite literally.

This passion for portraiture influenced my early work with portrait art. During my years in Milan, I would paint on top of portraits, often inexpensive reprints I had found in books or on canvas at the Mercatone dell'Antiquariato sul Naviglio Grande, Milan's famous outdoor antique market. I would alter these historic and refined images with quick, colorful outlines or more playful, eye-catching background colors, modernizing them. I added slashes across their eyes to shift the focal points of their gazes, adding in tension and intrigue and giving these otherwise forgotten individuals from the past new life. These works and this series of mine went on to garner a lot of attention and remain a large part of my work and collections to this day.

OPPOSITE: To elevate the television, often an eyesore, we added a custom frame around the television and surrounded it with a collection of antique blue-and-white china. A small staircase on the left leads into the formal dining room.

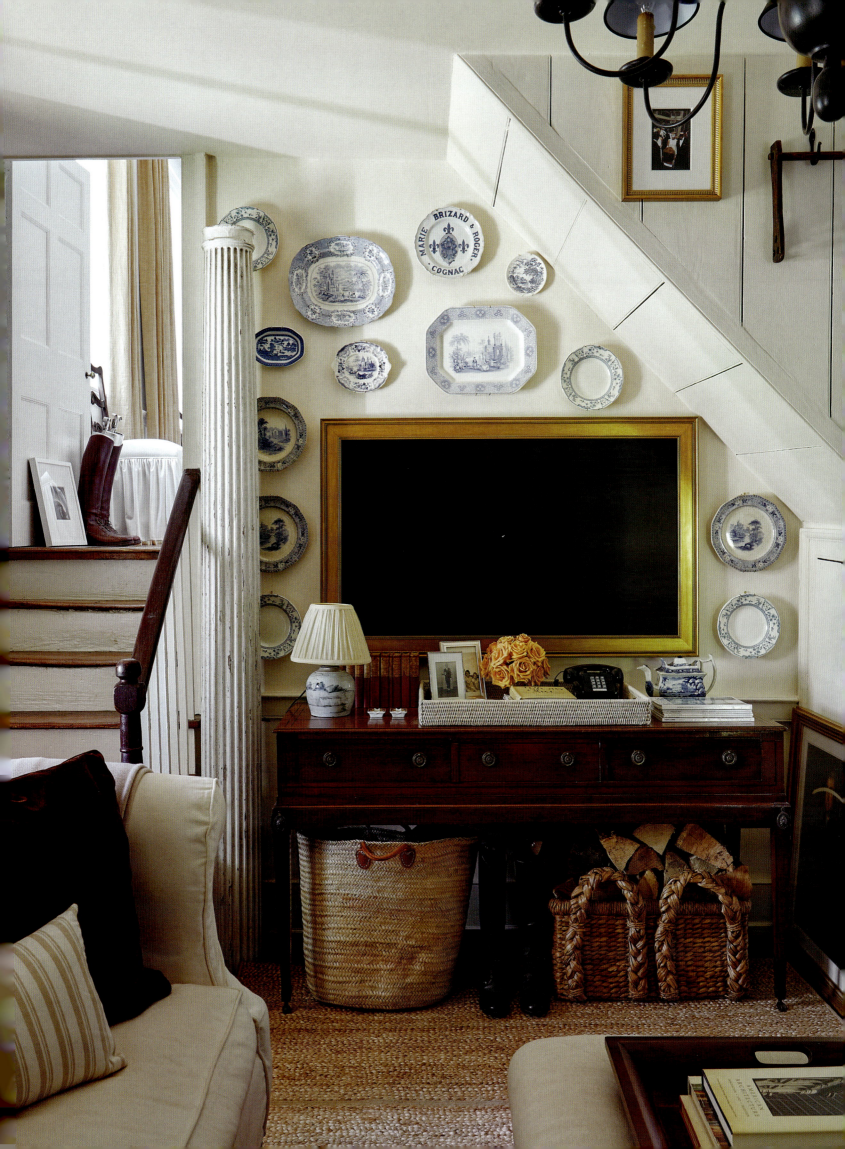

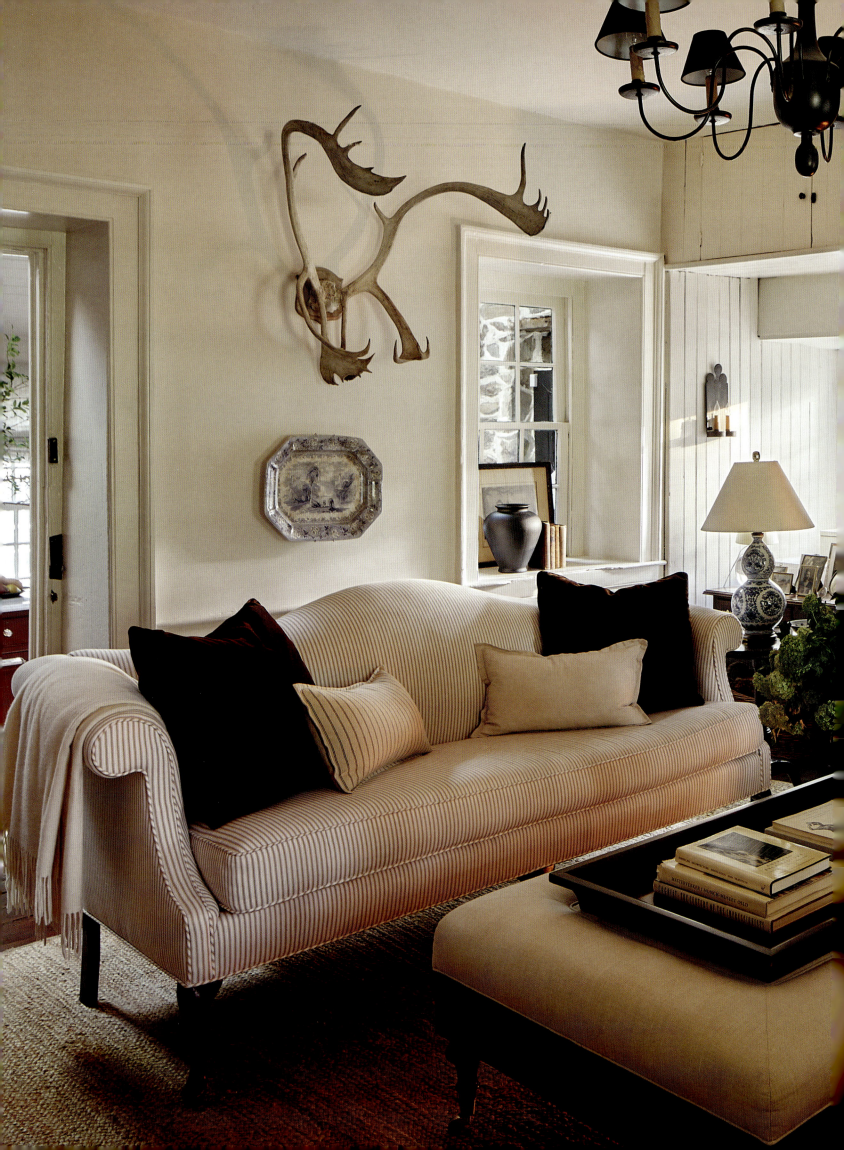

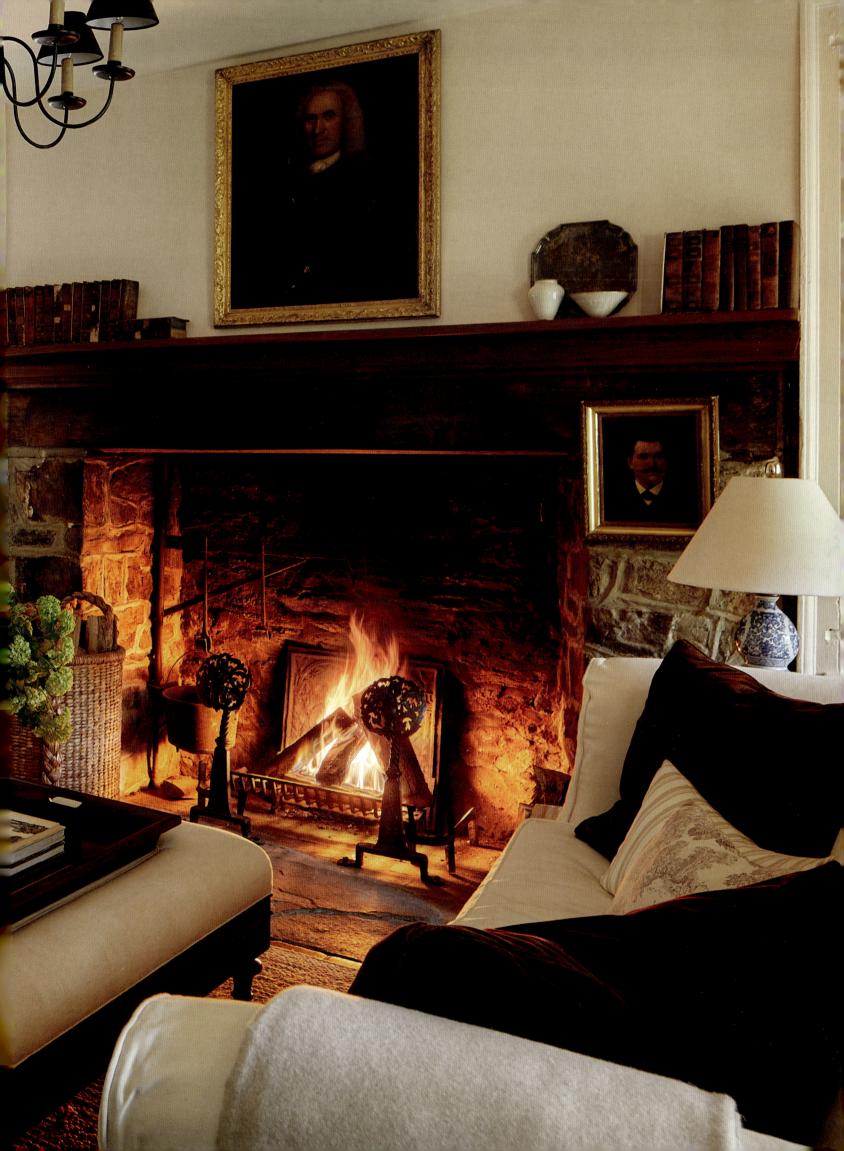

I love creating a mood in my home. From the moment guests enter, I want them to be transported and instantly feel at ease. I'm always acutely aware of the fragrances I have burning and the placement of lighting fixtures, and I use dimmers to adjust the light level and foster stillness or intimacy. When I'm entertaining, I create a custom playlist to set the mood. I want the experience to satisfy all the senses and be memorable for others. I aim for a mood of romance that has a dreamlike quality.

I like to conjure up a feeling of nostalgia by utilizing classic details throughout my home. From old black-and-white photographs to vintage textiles and rugs, there's an intentional historic quality that gives the impression that the rooms in my home are older than they are—not dated or tired, but exuding a sense of heritage: timeless and traditional.

I think too often we treat our homes like showrooms, precious and fixed: beautiful to look at but impractical to live and relax in. I'm a firm believer that you can have nice things, and a well-appointed space, while still being able to enjoy them practically. Nostalgia and comfort go hand-in-hand. When I'm at home, I need to know I can fully relax and that things aren't too precious to live with. All our white upholstery is performance fabric, and I'm always buying things in sets or pairs in case of accidents. If I'm relaxed, others in my home will be, too.

PRECEDING PAGES: Although we call this space the summer room, it is especially cozy on a crisp fall day when the dramatic, oversized fireplace blazes with a roaring fire. The smell of firewood instantly transports me to my childhood. **OPPOSITE, CLOCKWISE FROM TOP LEFT:** A wicker tray holds framed photographs of my mother and her five sisters as children and my late grandfather in his teenage years. Antique English riding hats accessorize a library made from the cabinets of the original 1780 kitchen. A large wooden tray sits on top of an oversized ottoman that is used as a coffee table and occasional footrest. Pillows in different patterns and materials fill a slipcovered Chippendale sofa.

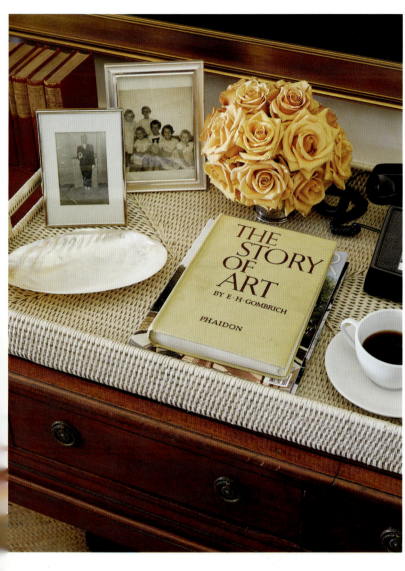
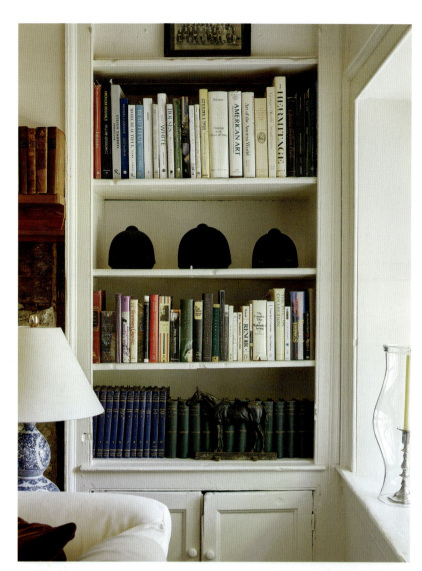
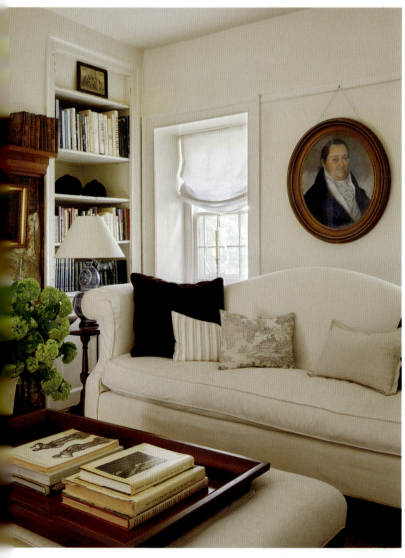
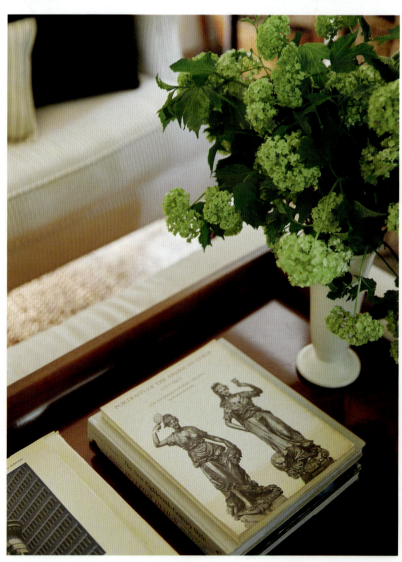

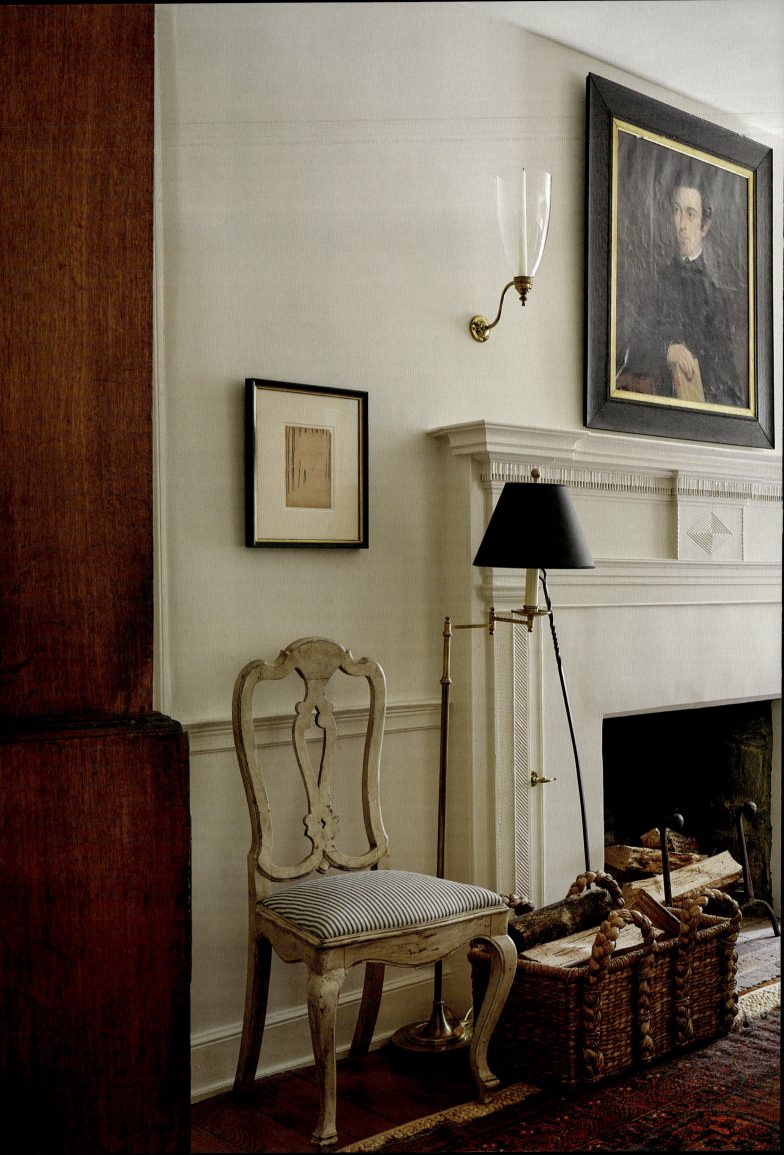

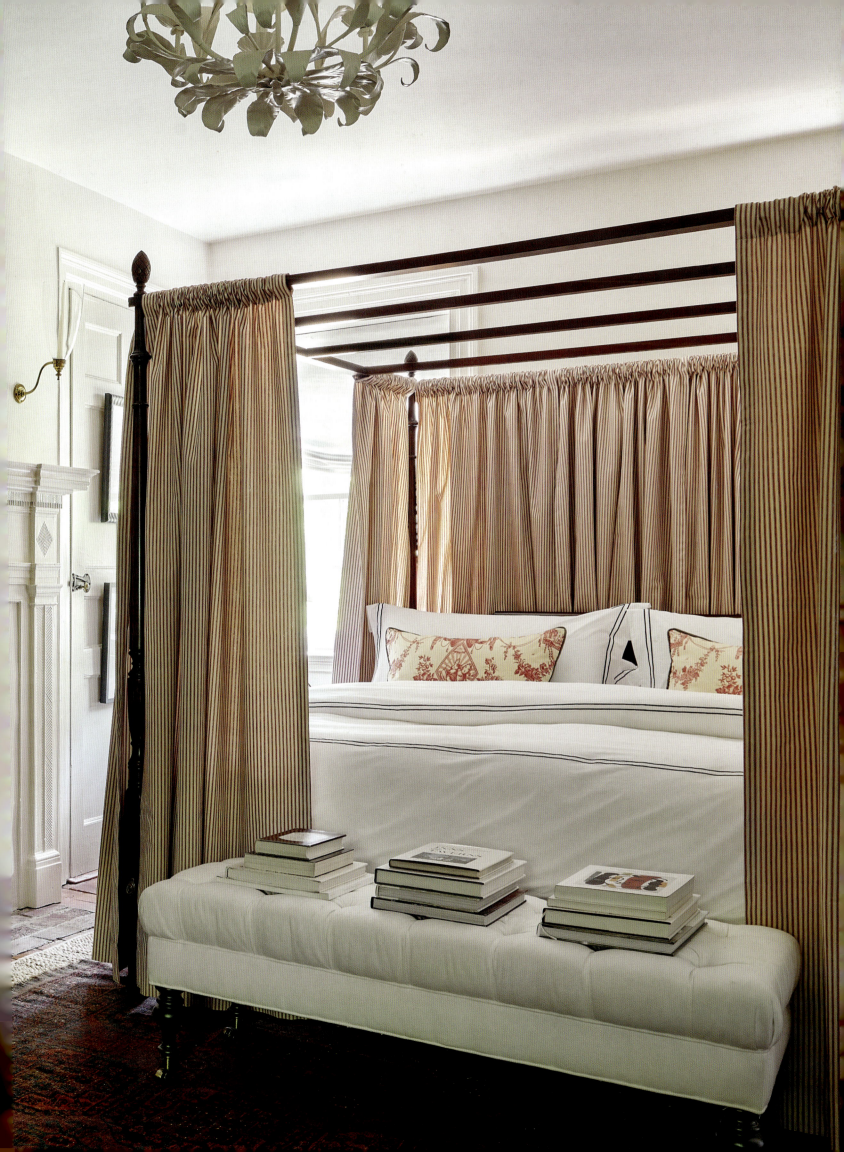

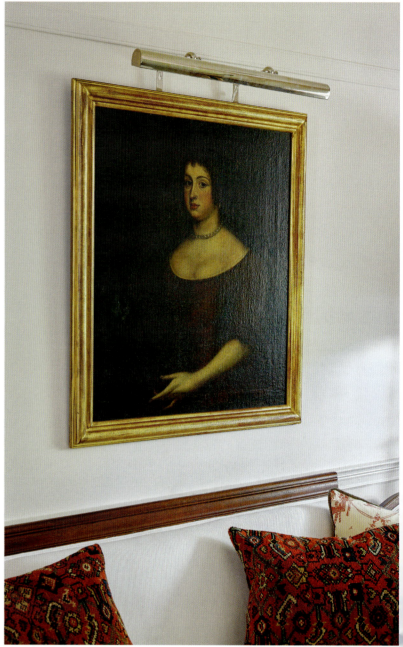

PRECEDING PAGES: In the primary bedroom at Sycamore House, the bed curtains nod to the room's past.
ABOVE AND OPPOSITE: Vintage textiles, including Persian and Turkish rugs and pillows, fill the room with warmth.
FOLLOWING PAGES: Layering vintage rugs throughout Sycamore House gives the rooms a sense of history.

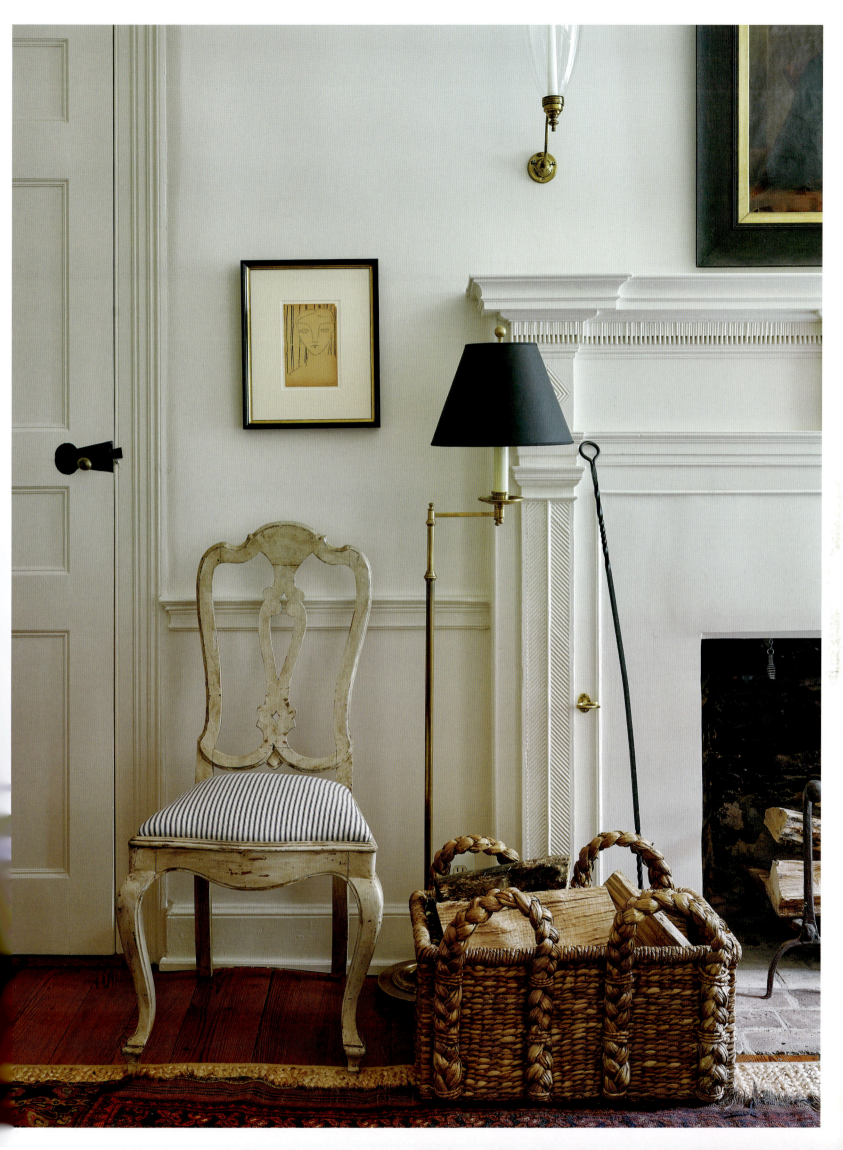

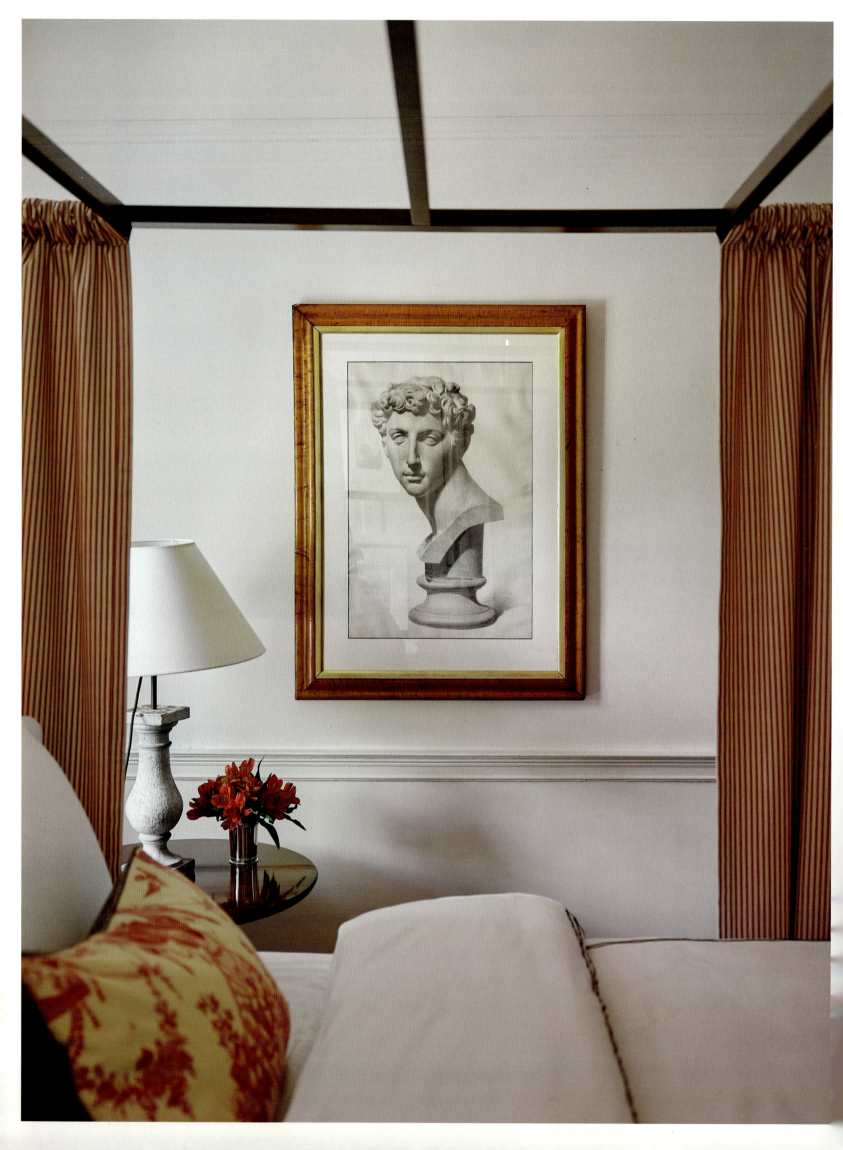

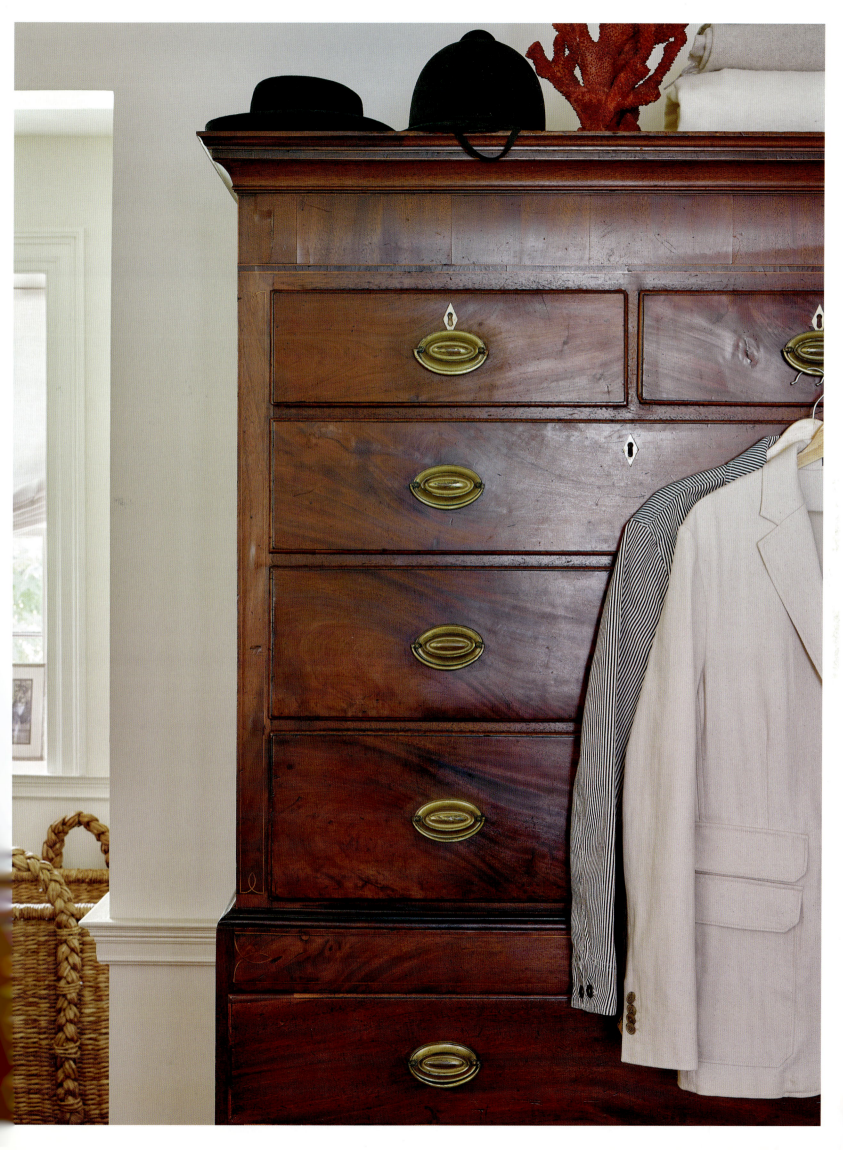

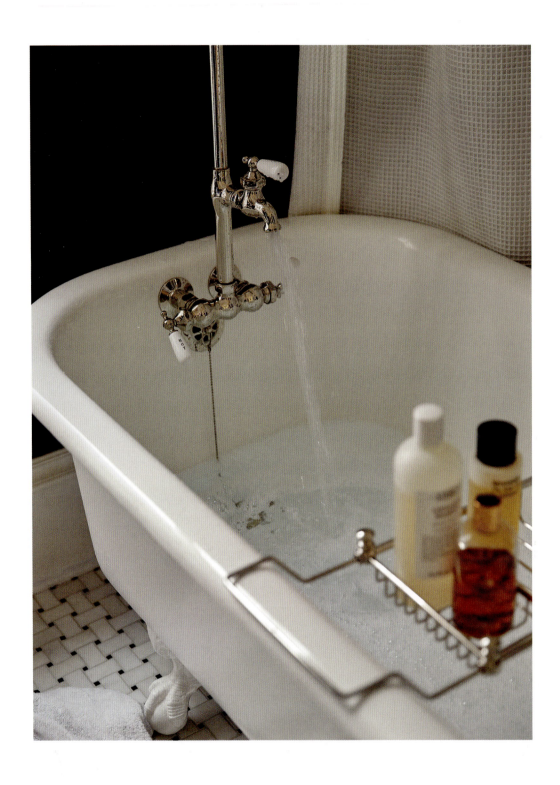

PREVIOUS PAGES, FROM LEFT: In the primary bedroom, an antique drawing of a bust seems as if it has always hung here. Jackets hanging from a nineteenth-century highboy add a lived-in feel. Atop the highboy rest traditional riding hats, a nod to the region's history. **ABOVE:** In the guest bathroom at our D.C. townhouse, we kept the original clawfoot bathtub. **OPPOSITE:** Off-black cabinetry, a soapstone counter, and cream-colored walls combine to create a timeless feel.

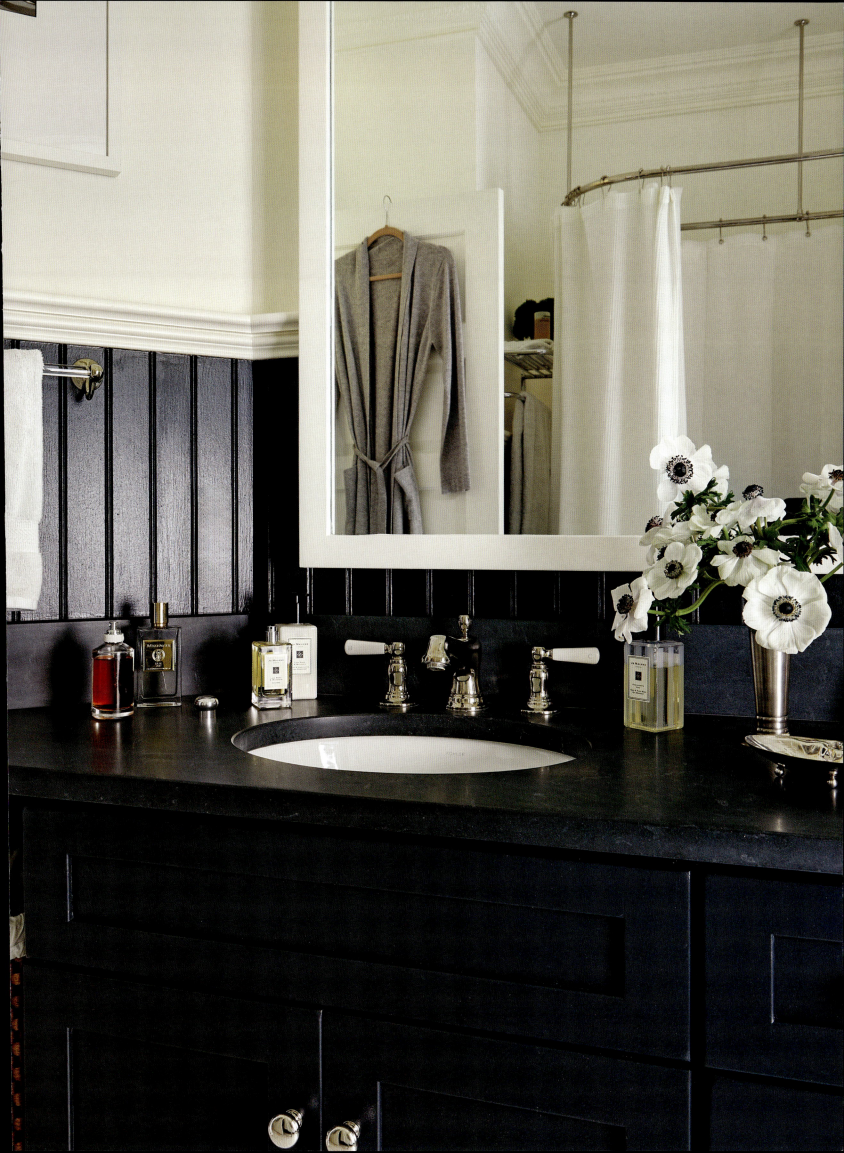

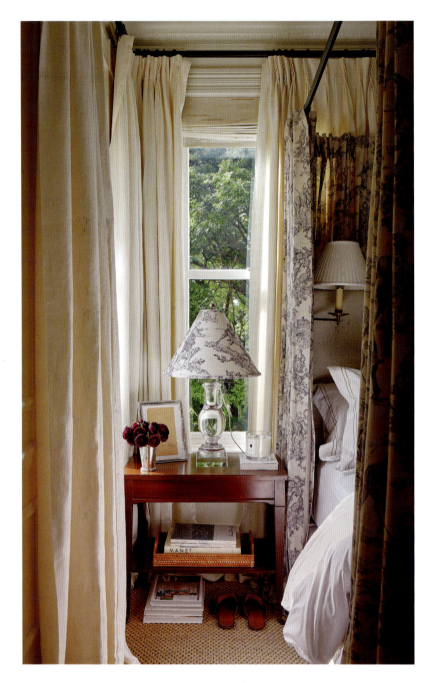
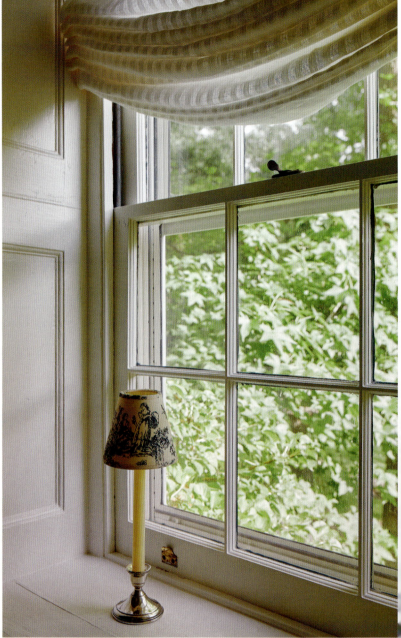

ABOVE AND OPPOSITE: I wanted the guest bedroom at our D.C. townhouse to feel romantic and dreamlike. French toile fabric hangs from the king-size canopy bed with matching lampshades on either side.

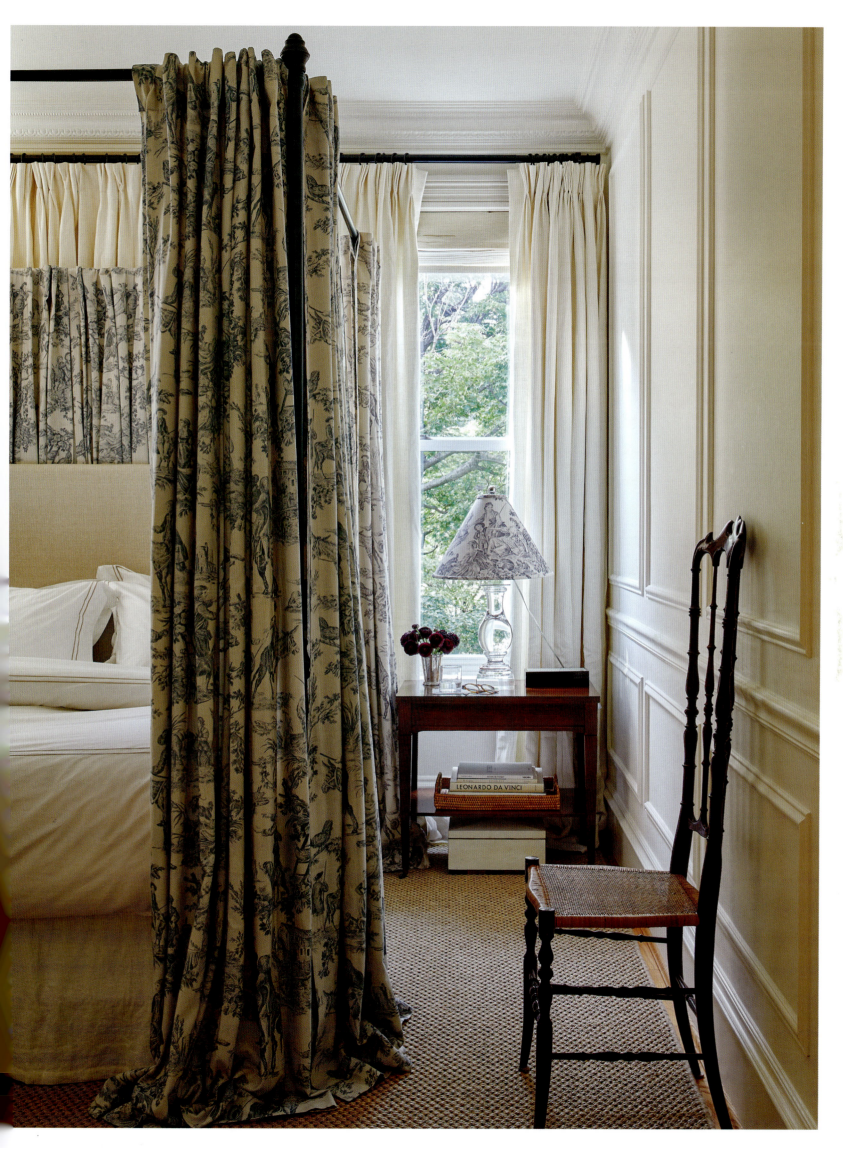

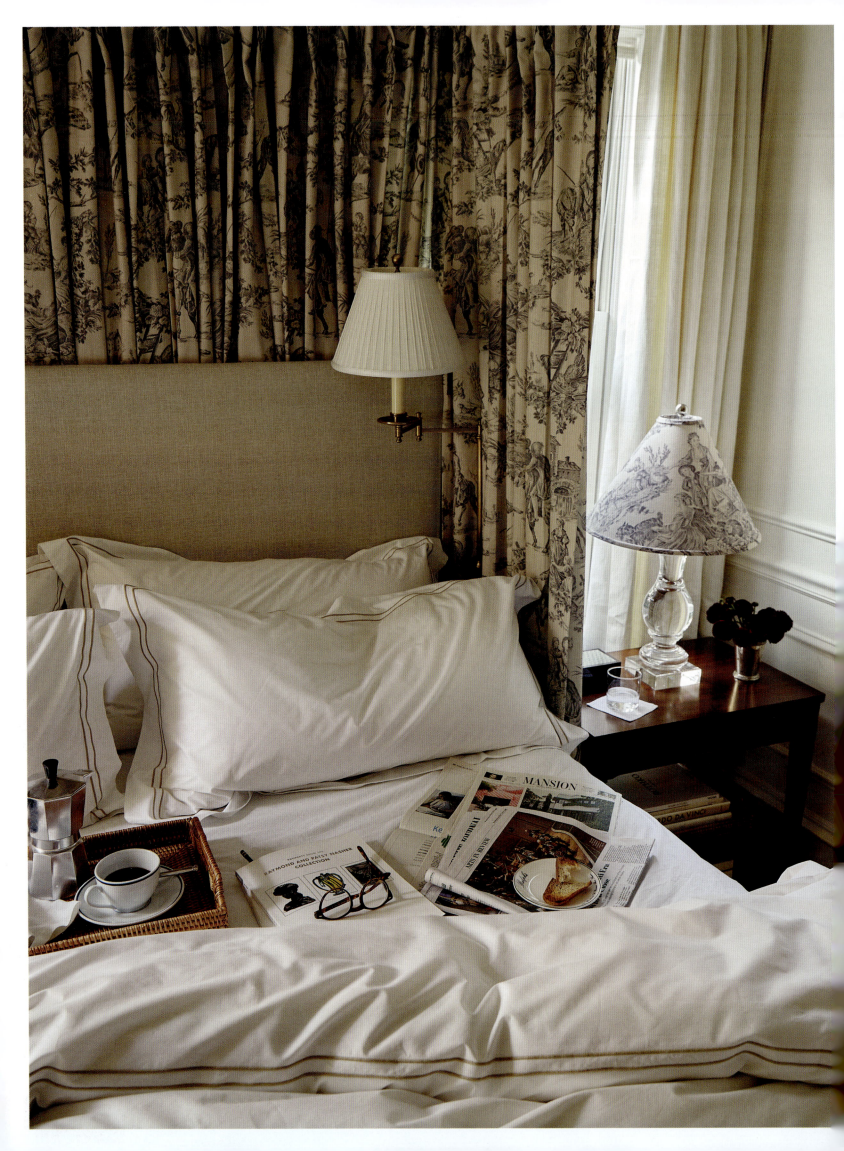

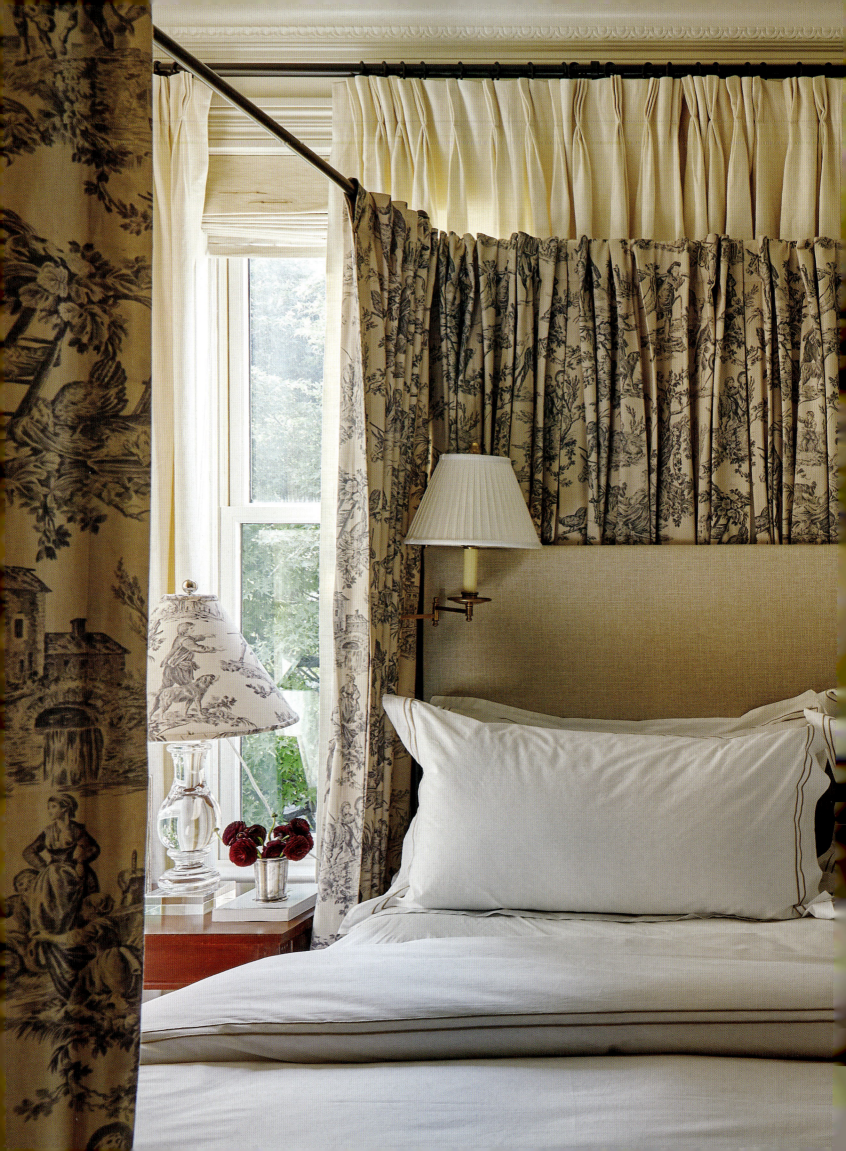

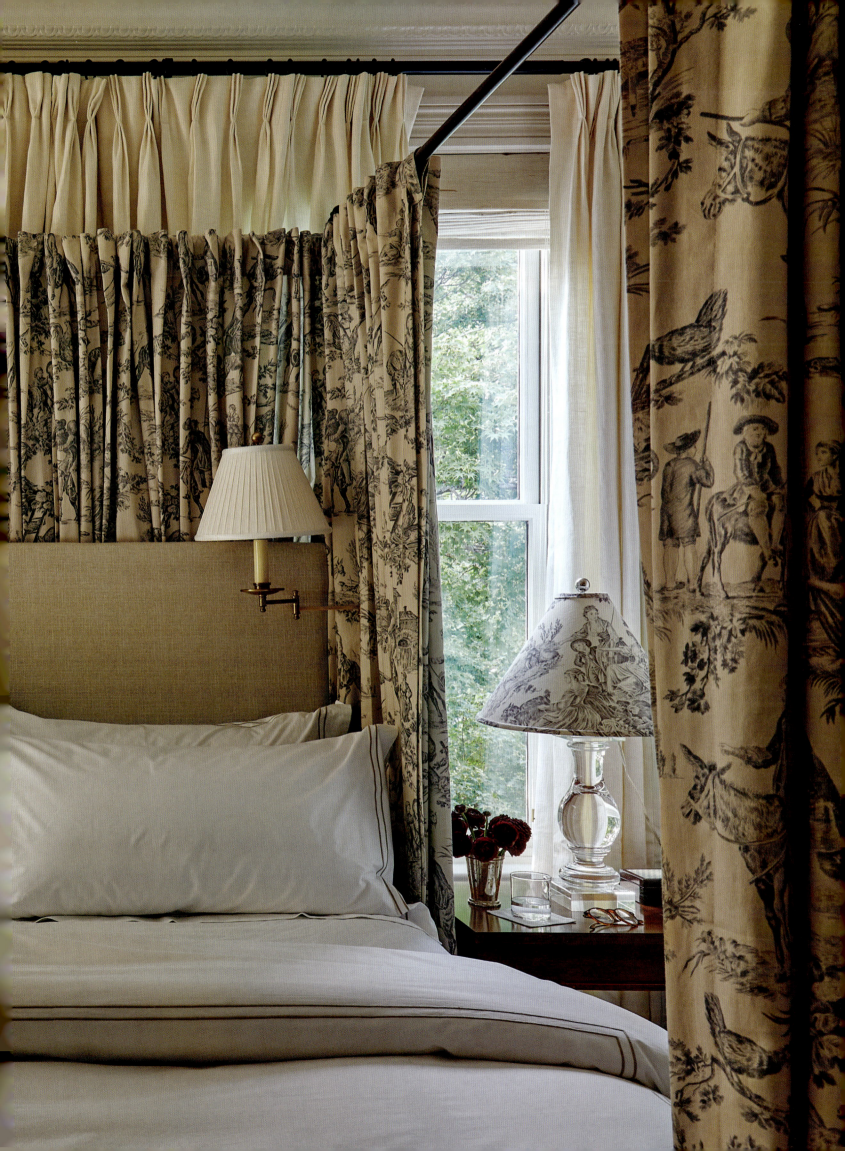

I've divided up much of my life into mental chapters: my early years in Pennsylvania, my teenage years in North Carolina, my early twenties in Milan, and my later time in New York and Chicago. Now in my thirties in Washington, D.C., I realize how the different places I've lived and the experiences I've had there remain with me today, informing my artistic and stylistic senses.

Growing up in the northeast, I loved the changing seasons, and autumn has always been my favorite. The warm scents of clove and burning firewood still transport me to my younger years. When I was ten, films like *Sleepy Hollow* by Tim Burton made me fall in love with neutrals and the mystic side of early Americana. In Pennsylvania, the months of September through November are a visual treat of rolling hills with vibrant foliage. Physical and tangible reminders of the past are scattered throughout that evocative landscape: historic homes of local fieldstone, eighteenth-century churches, graveyards, Quaker meetinghouses, and old schools. Autumn is also a time to gather and create memories around the table.

Growing up in a town with a large Italian-American population and having lived in Italy, nothing is more traditional and nostalgic than Sunday dinner. I make a habit of setting aside time for it, and after a long week in the studio, there's nothing I look forward to more. It can be a meal for a large group of people or an informal, casual one for just Ignacio and me. The key is to make time for at least one meal, one evening, to slow down and share an experience with one another before the start of a hectic week, creating memories in the moment that will one day become and feel nostalgic.

PAGE 238: Swinging floor lamps on either side of the bed encourage guests to nestle in a little longer to read the morning paper, catch up on emails, and feel at ease while visiting our home. Breakfast in bed is highly encouraged. PAGE 239: The toile fabric has an elegiac pattern. PRECEDING PAGES: Layers of fabric create a soft, relaxing environment that gives the room an old-world look and feel. OPPOSITE: Vintage copper—polished to a shine—hangs in the kitchen at Sycamore House. We designed the custom cabinetry and added timeless swan-neck bail pulls and antique hardware.

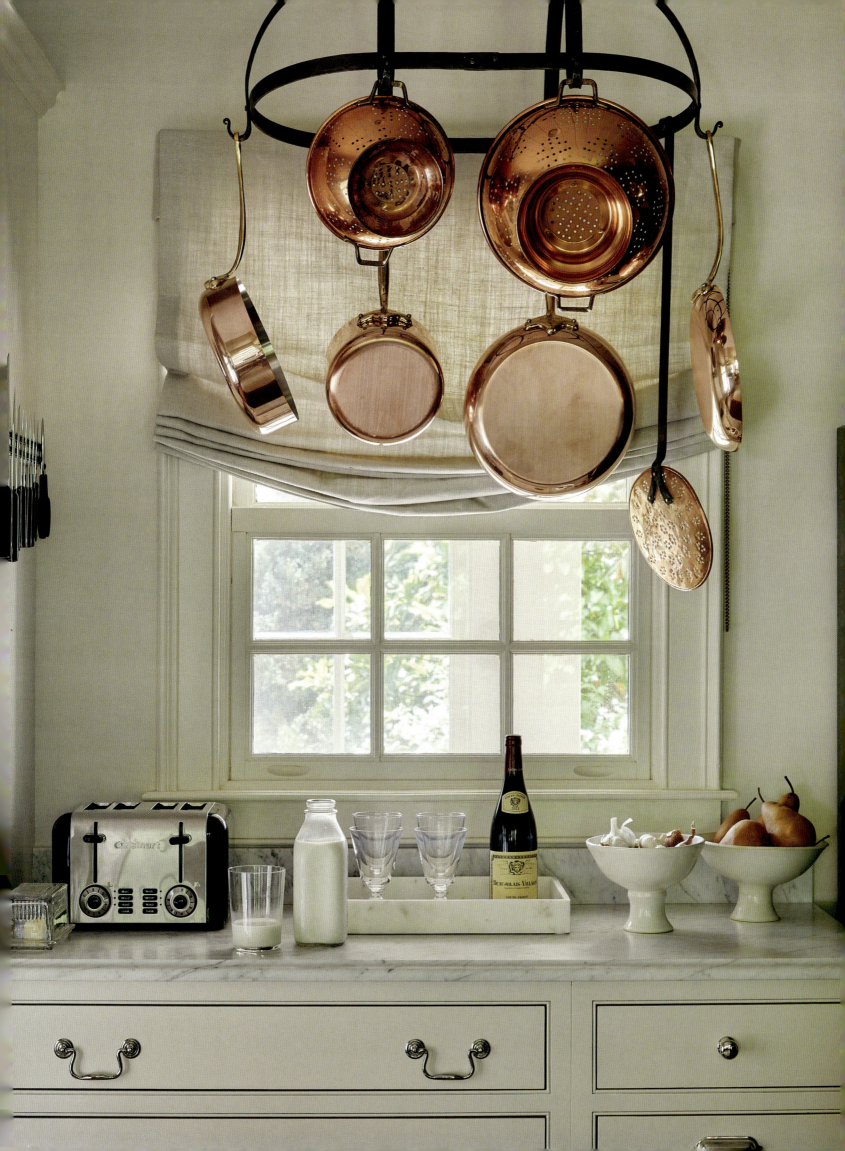

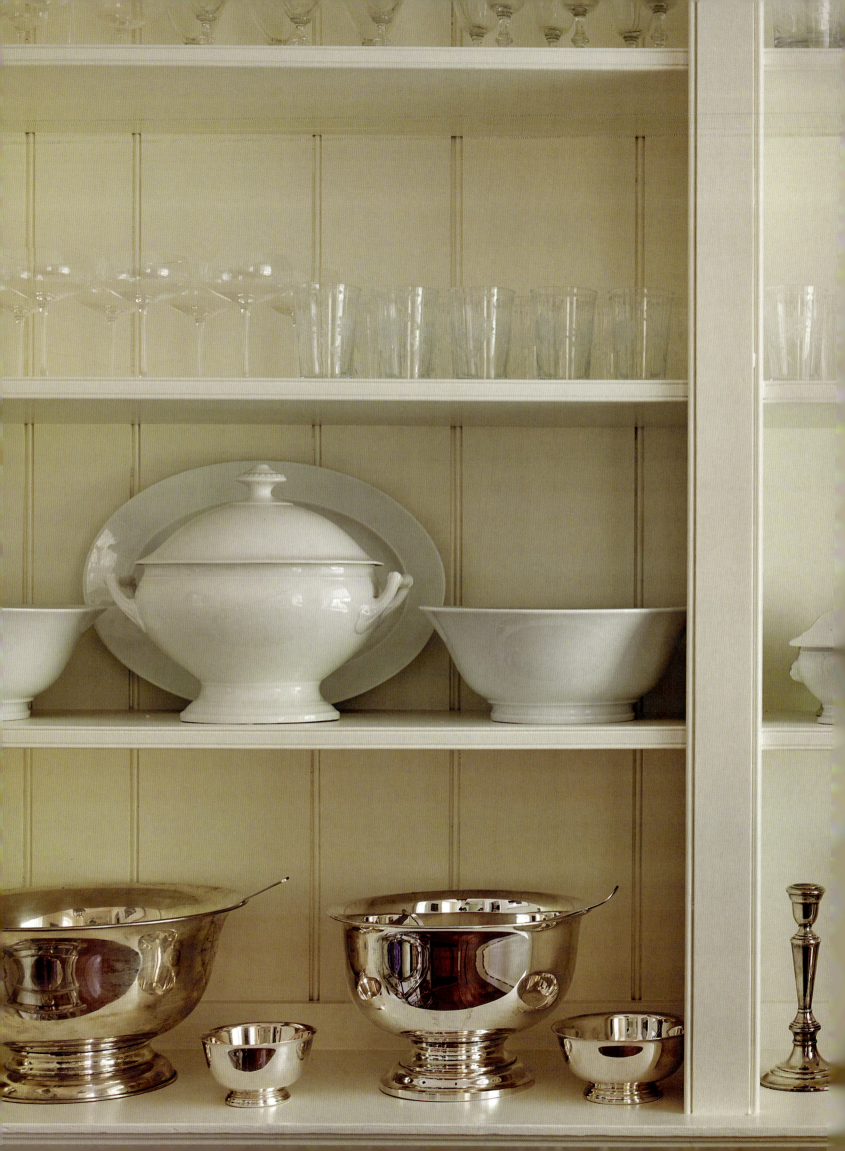

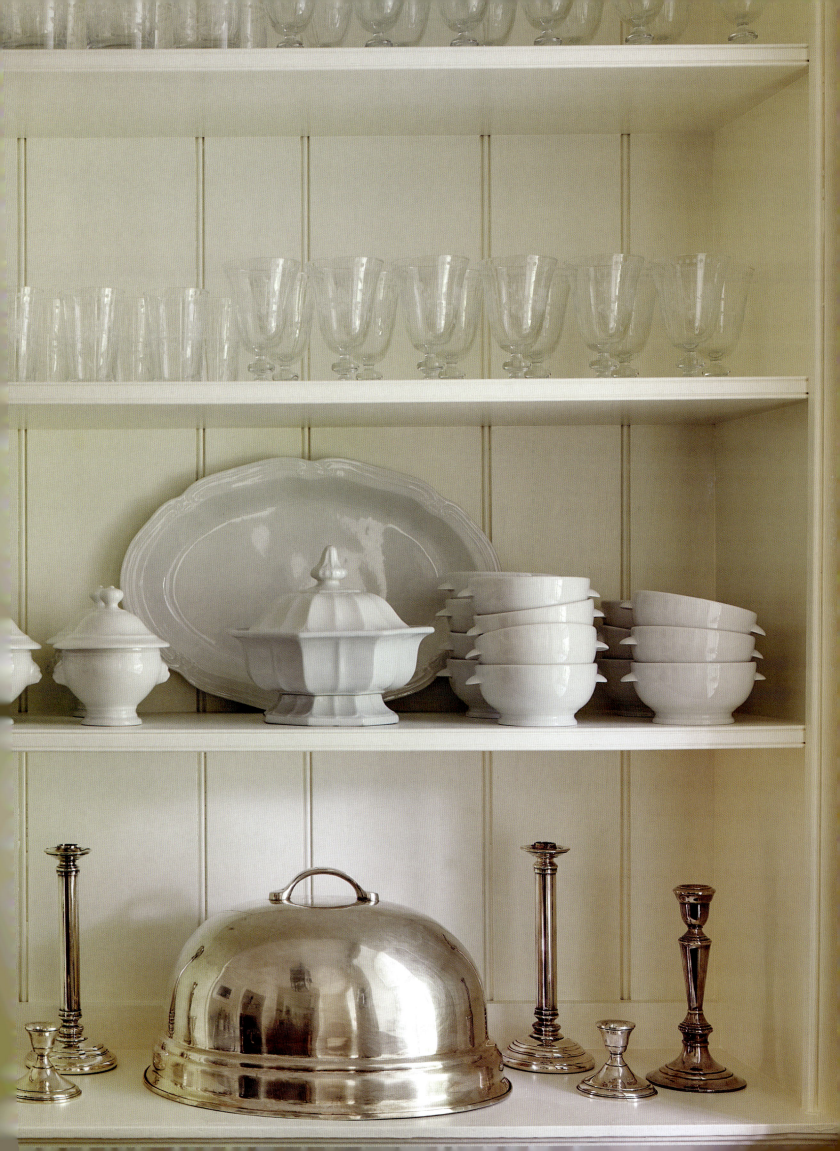

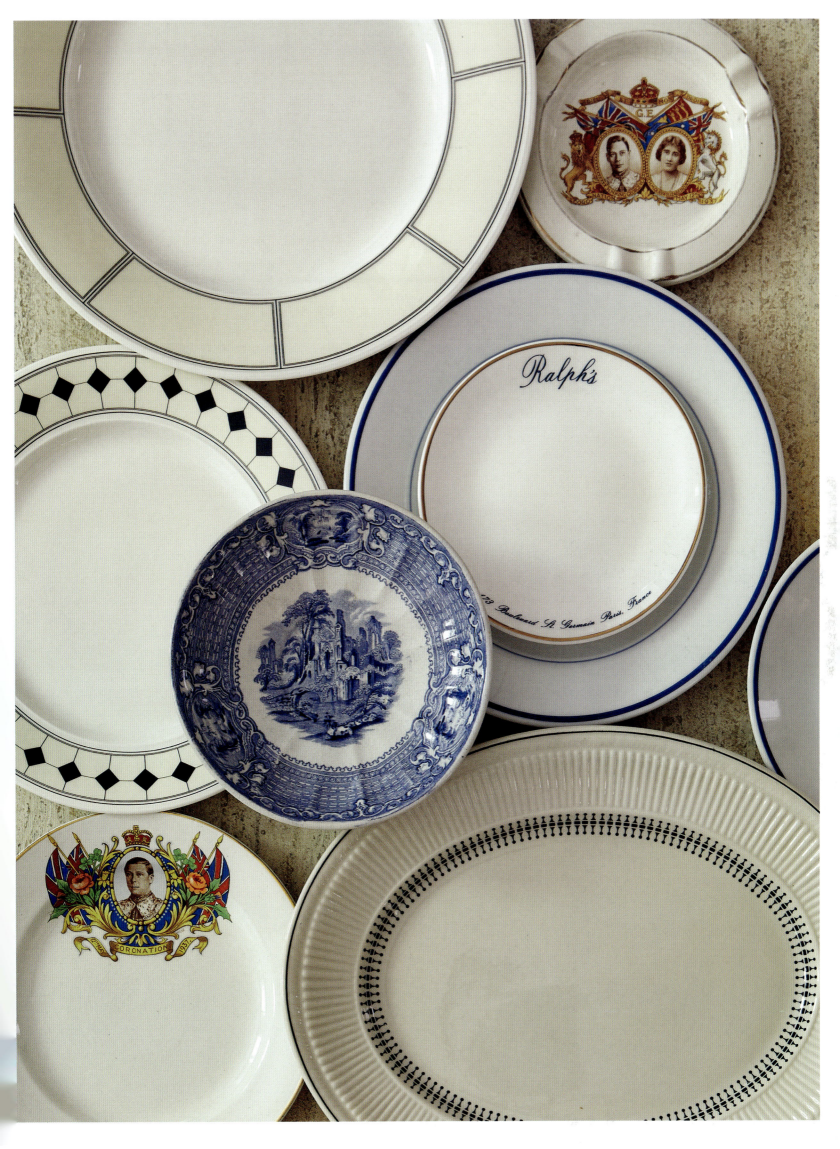

Early Sunday morning, the aroma of sautéed onions, carrots, and celery fills the air. Over the years, Ignacio's ragù alla Bolognese has become a staple in our home. The minute I smell it cooking, I'm transported back to our university days in Milan, where we met and lived together. During the winter months I love waking up just as the sun begins to rise to start a cozy fire at Sycamore House. Afterward, I often join Ignacio in the kitchen to prepare for that night's meal and reflect on the past week. I like to pull out old china and dinnerware that I've collected for the table. There's something magical about sharing a meal with the people you love. It allows you time to create new traditions, and I don't think I'm alone in saying that some of my happiest memories have been made around the table.

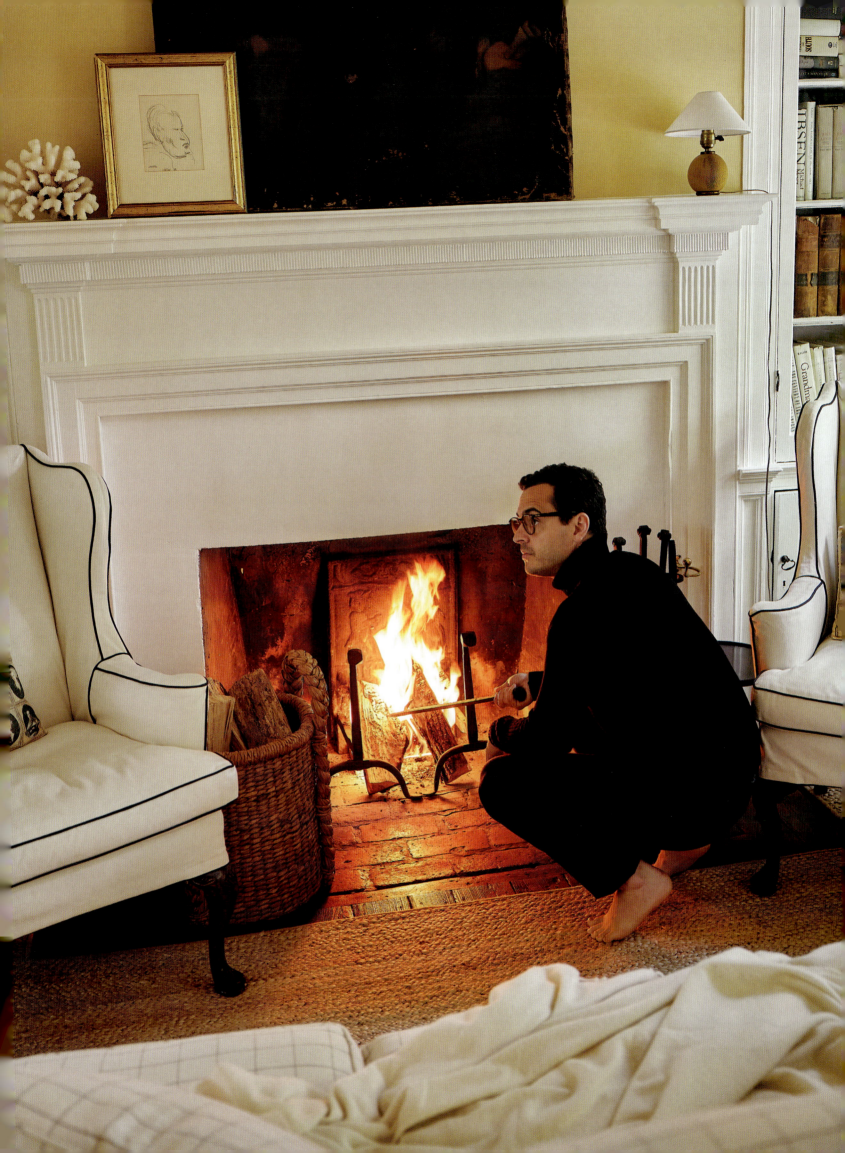

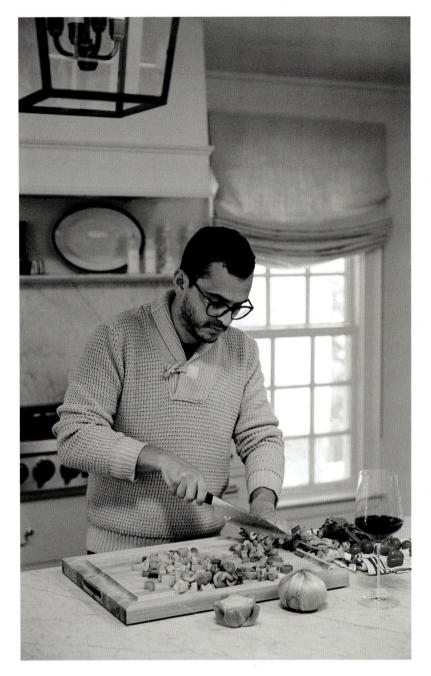
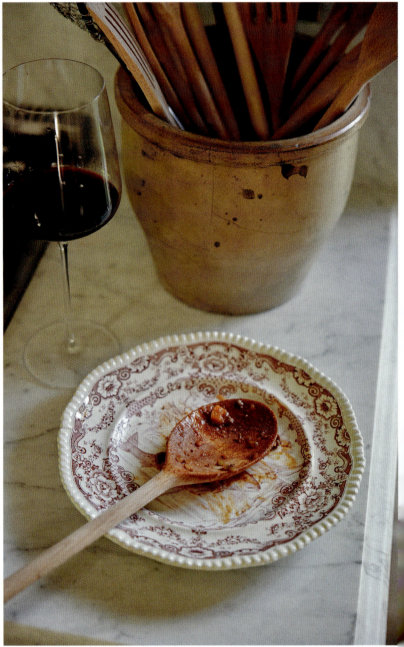

PAGES 244–45: Sycamore House has wonderful old-house details, including a butler's pantry I have filled with vintage silver, stemware, tureens, and platters. PAGES 246 AND 247: On my travels, I collect antique plates, platters, saucers, and ashtrays. Each piece reminds me of an earlier time or a place I've visited. ABOVE, LEFT: Ignacio prepares his famous Bolognese on a cold winter day. ABOVE, RIGHT: A vintage dish does double duty as a spoon rest. OPPOSITE: Every occasion, like entertaining friends at a casual lunch, creates new memories—fodder for future nostalgia.

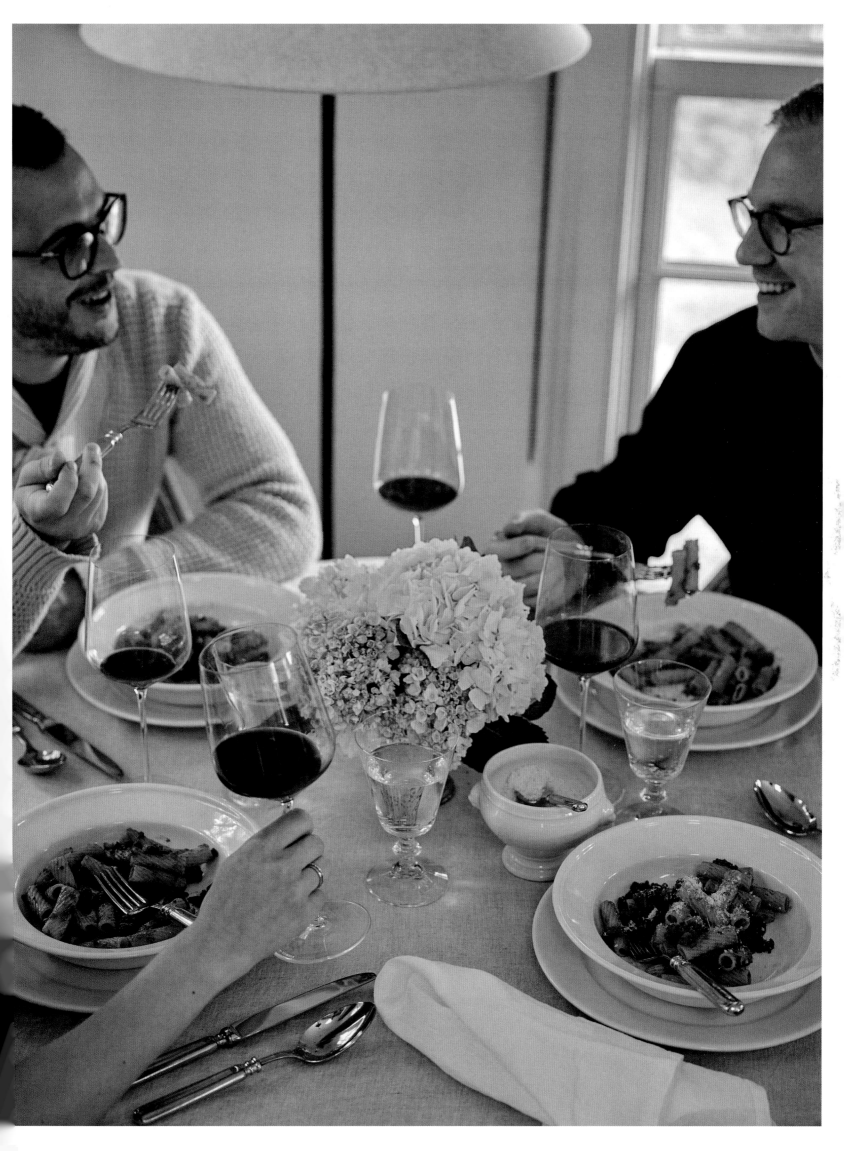

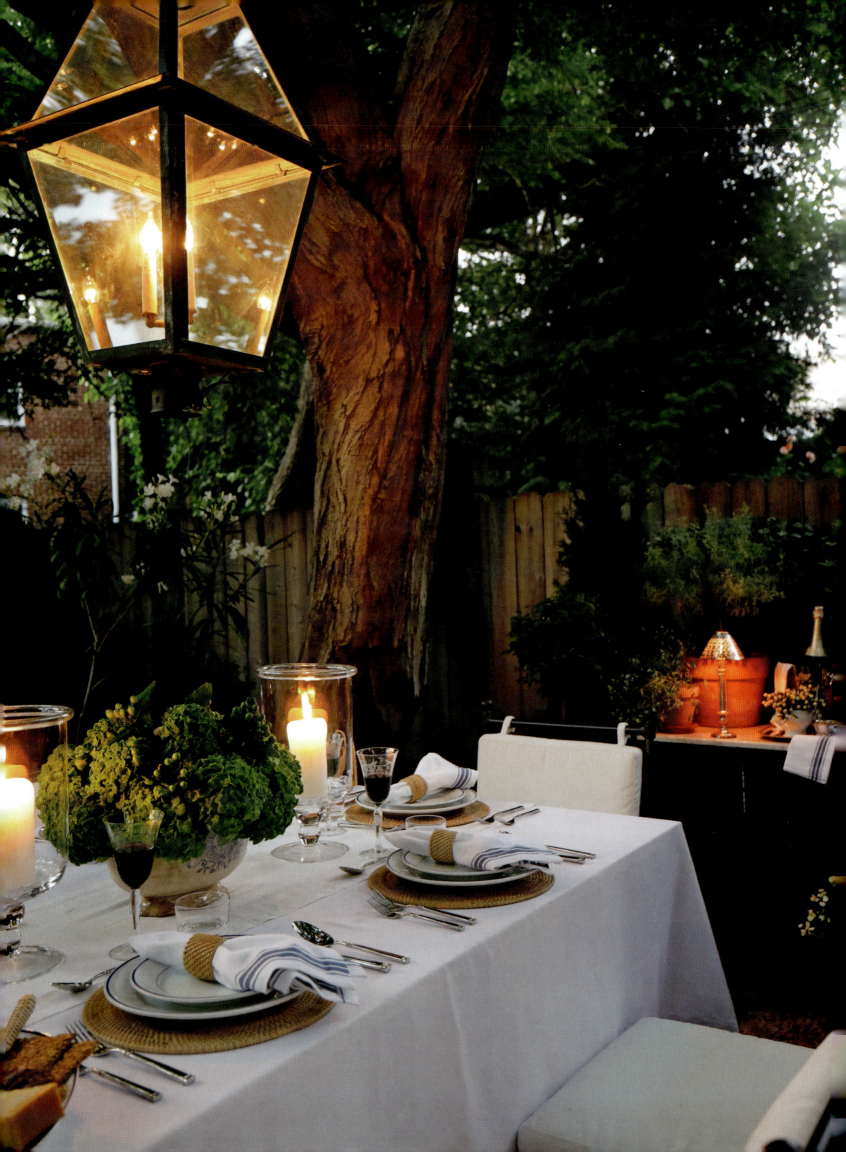

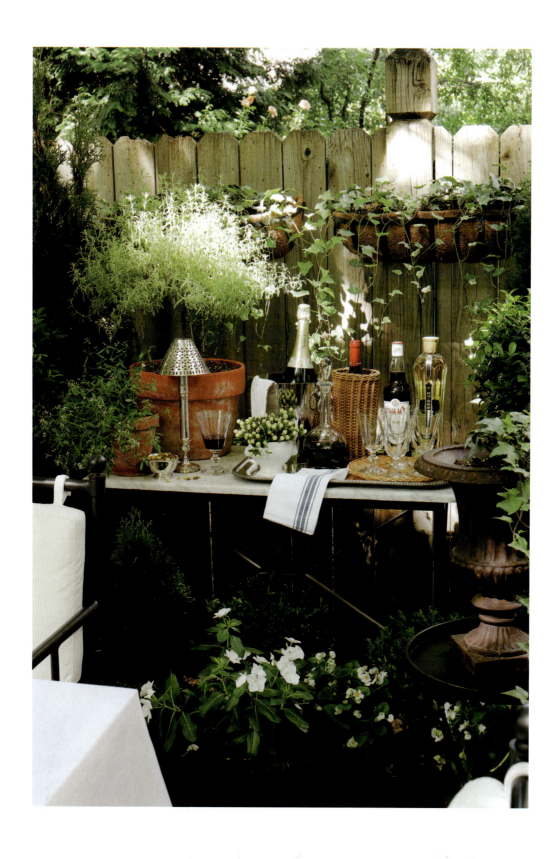

OPPOSITE AND ABOVE: There is no better ode to summer than dinner alfresco in the garden at our townhouse.

ACKNOWLEDGMENTS

This book is dedicated to everyone who has supported my work over the years. Thanks to you, this book is possible. It takes a village, and I'm forever thankful.

Thank you to my incredible literary agent, Berta Treitl, for believing in me and this project. To my dear friend Michelle Adams, who encouraged me to write it. To my editor, Kathleen Jayes, and designer Doug Turshen and his associate David Huang, who helped bring this project to life. To my amazing photographer, Kirsten Francis, for capturing it all so beautifully.

To my parents, Michael and Kori Young, for your continued love and support.

Most importantly, to my husband, Ignacio Martinez Alfaro. You've always believed in me, and I would be nothing today without your guidance and love.

Life is so much fun with you, Kito.

First published in the United States of America in 2024 by
Rizzoli International Publications, Inc.
300 Park Avenue South
New York, NY 10010
www.rizzoliusa.com

Copyright © 2024 Josh Young
Text: Josh Young
Photography by Kirsten Francis except:
Pages 16, 17, 37, 60, 61, 62, 63, 72, 73, 74, 77, 79, 84, 99, 132, 133, 149, 152, 164, 165, 167, 168, 169, 170, 171, 172, 173, 175, 177, 204, 252, 253 by Josh Young

Publisher: Charles Miers
Senior Editor: Kathleen Jayes
Design: Doug Turshen with David Huang
Production Manager: Alyn Evans
Managing Editor: Lynn Scrabis

All rights reserved. No part of this publication may be reproduced, stored in a retrieval system, or transmitted in any form or by any means, electronic, mechanical, photocopying, recording, or otherwise, without prior consent of the publishers.

Printed in China

2024 2025 2026 2027 / 10 9 8 7 6 5 4 3 2 1

ISBN: 978-0-8478-3039-8
Library of Congress Control Number: 2024933308

Visit us online:
Facebook.com/RizzoliNewYork
Twitter: @Rizzoli_Books
Instagram.com/RizzoliBooks
Pinterest.com/RizzoliBooks
Youtube.com/user/RizzoliNY
Issuu.com/Rizzoli

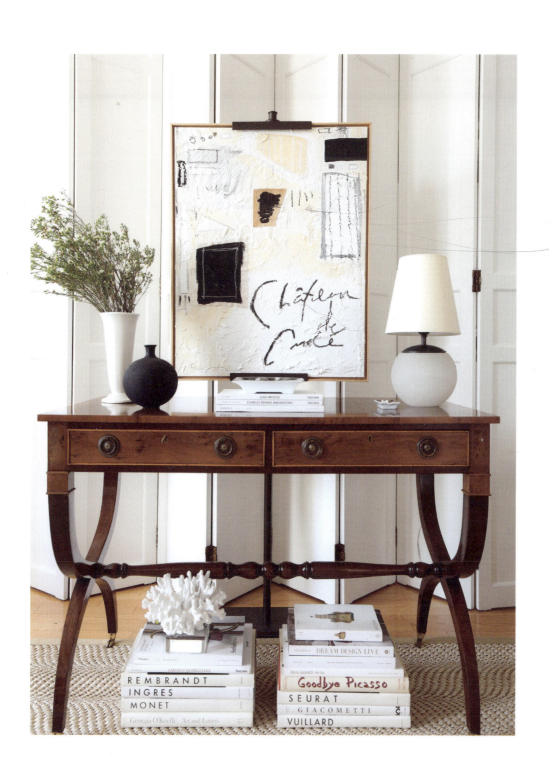

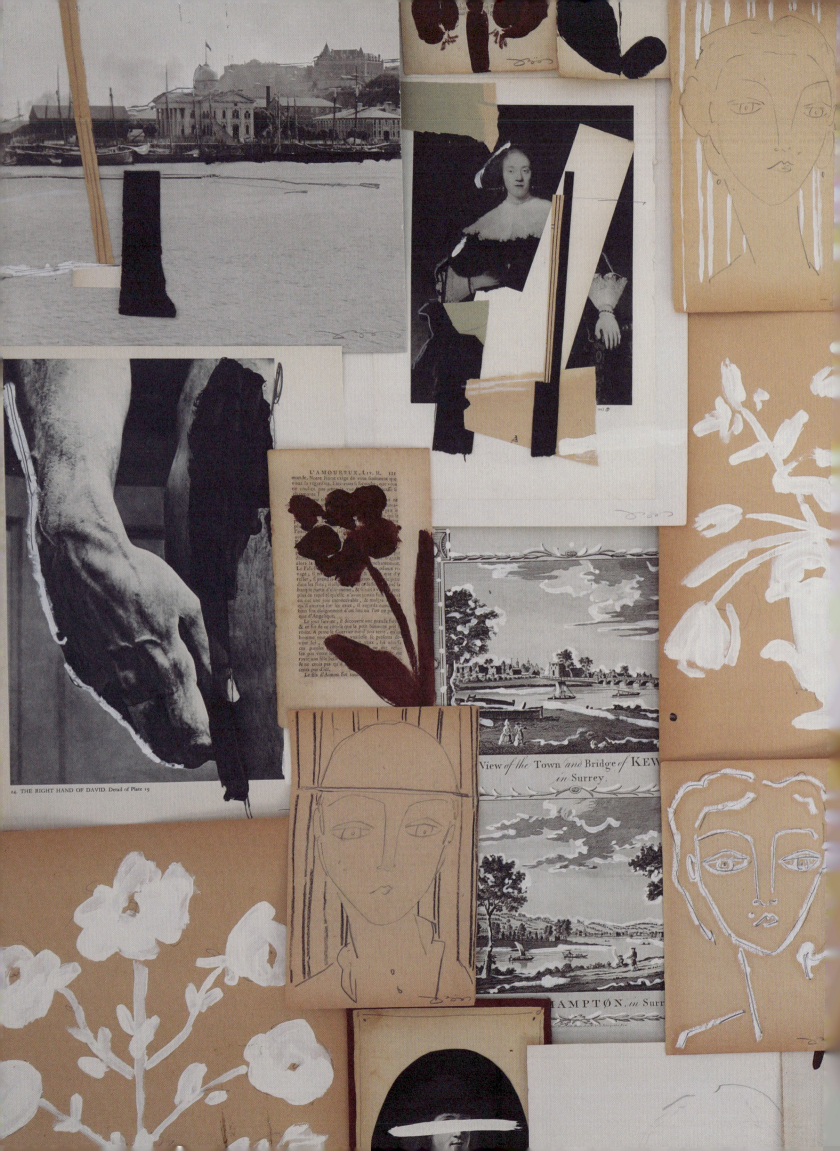